Mathematics, Culture, and the Arts

Series editors
Jed Z. Buchwald
Jeremy Gray
Marjorie Senechal

The series Mathematics in Culture and the Arts will publish books on all aspects of the relationships between mathematics and the mathematical sciences and their roles in culture, art, architecture, literature, and music. This new book series will be a major resource for researchers, educators, scientifically minded artists, and students alike.

More information about this series at http://www.springer.com/series/13129

Roman Kossak • Philip Ording

Editors

Simplicity: Ideals of Practice in Mathematics and the Arts

 Springer

Editors
Roman Kossak
Department of Mathematics
The Graduate Center
City University of New York
New York, NY, USA

Philip Ording
Department of Mathematics
Sarah Lawrence College
Bronxville, NY, USA

ISSN 2520-8578 ISSN 2520-8586 (electronic)
Mathematics, Culture, and the Arts
ISBN 978-3-319-85140-2 ISBN 978-3-319-53385-8 (eBook)
DOI 10.1007/978-3-319-53385-8

Printed on acid-free paper

This Springer imprint is published by Springer Nature
The registered company is Springer International Publishing AG
The registered company address is: Gewerbestrasse 11, 6330 Cham, Switzerland

The 24th problem in my Paris lecture was to be: Criteria of simplicity, or proof of the greatest simplicity of certain proofs. Develop a theory of the method of proof in mathematics in general. Under a given set of conditions there can be but one simplest proof. Quite generally, if there are two proofs for a theorem, you must keep going until you have derived each from the other, or until it becomes quite evident what variant conditions (and aids) have been used in the two proofs. . .

—David Hilbert

Preface

The conference "Simplicity: Ideals of Practice in Mathematics & the Arts" took place at the Graduate Center of the City University of New York during April 3–5, 2013. In 2007, Juliette Kennedy co-organized a symposium on mathematics and aesthetics at Utrecht University in the Netherlands and curated an accompanying art exhibition, *Logic Unfettered: European and American Abstraction Now*, at Mondriaanhuis: Museum for Constructive and Concrete Art in Amersfoort. The symposium, which she organized with Rosalie Iemhoff and Albert Visser, featured talks by mathematicians, philosophers, art historians, and a physicist, and for the exhibition Kennedy selected works of ten artists, including Fred Sandback's *Broadway Boogie Woogie (Sculptural Study, Twenty-part Vertical Construction)*, 1991/2011. It was a very successful combination; those artists who were present attended the talks, and then all participants gathered together for the opening of the show. It was an ideal opportunity for interactions and exchanges of ideas. Kennedy proposed that the three of us organize a similar conference in New York City, taking advantage of the inexhaustible New York art scene and focusing this time on the idea of simplicity. One motivation for the conference theme was Hilbert's recently discovered 24th problem.

At the second International Congress of Mathematicians in Paris in 1900, David Hilbert, one of the most influential mathematicians of the twentieth century, gave an address in which he presented a list of unsolved problems. He chose ten of them for his address and then presented the full list of 23 problems in the published version of his lecture. In 2000, Rüdiger Thiele discovered another problem in Hilbert's mathematical notebooks. Although his notes do not define it as precisely as the published problems, leaving some room for interpretation, in essence, the 24th problem was to find criteria for simplicity in mathematical proofs.[1]

In his contribution to this volume, Étienne Ghys writes "My job is to state and then prove theorems." This may be the simplest description of our profession.

[1] Rüdiger Thiele, "Hilbert's Twenty-Fourth Problem," *The American Mathematical Monthly* 110, no. 1 (January 2003): 1–24. We include an excerpt from Thiele's translation just before this Preface.

Indeed, stating and proving theorems occupied mathematicians from the time of the Pythagorean school. It was Hilbert's profound insight that this activity itself can become the subject of mathematical investigation. Later, in the 1920s, Hilbert formulated a program whose aim was to formalize all of mathematics. The first step was to establish a fixed set of basic facts that would serve as an axiomatic base and to specify the rules of deducing mathematical theorems as formal consequences of the axioms. Formalized this way, proofs became sequences of strings of characters in which new strings are derived from previous ones by mechanical rules following principles of logic. Once this is done, whole new areas of mathematical exploration open up. In particular, for a given theorem proved from a specific set of axioms, one can ask about the simplest such proof. How does one measure the simplicity of a proof? One can count the number of characters in the proof or count the number of applications of certain kinds of rules. One can ask about the smallest number of axiomatic premises that the proof uses, and one can categorize those premises with regard to their level of abstraction. All of this can be done, and indeed is done, in the discipline known as proof theory. Moreover, software is available to answer many such questions about the complexity of formalized proofs. Hilbert would have been very happy to see this.

While we know how to formalize mathematics, when we do mathematics there are almost no holds barred. We think by analogy, we draw rough diagrams, we speculate, we generalize, and most of all we try to *understand*. The final product is always a theorem or, even better, a theory, i.e., an organized collection of results in a specific area of mathematics. One could argue however that the real goal of mathematics is not just to accumulate useful facts but rather to unravel the reasons behind them. This process of unraveling is often perceived as one of simplification, whether or not the facts in question satisfy any formal criteria of simplicity. "For me, the search for simplicity is almost synonymous with the search for structure," Dusa McDuff stated in the talk transcribed for this volume.

That mathematicians attribute aesthetic qualities to theorems or proofs is well known. The question that interests us here is to what extent aesthetic sensibilities inform mathematical practice itself. When one looks at various aspects of mathematics from this perspective, it is hard not to notice analogies with other areas of creative endeavor—in particular, the arts.

The drive toward formal simplicity in 20th century Western art shares some of the values that motivated Hilbert: a desire for uniformity of means, necessity, and rigor. Examples include serialism in music, abstraction in painting, Bauhaus architecture and design, and conceptual and minimal art, among others. Thus, the serialist composer Anton Webern describes his 1911 *Bagatelles for String Quartet*, Op. 9 as

> perhaps the shortest music so far—here I had the feeling, 'When all twelve notes have gone by, the piece is over'...in short, a rule of law emerged; until all twelve notes have occurred, none of them may occur again.[2]

[2] Anton Webern, *The Path to the New Music*, as quoted in Arnold Whittall, *The Cambridge Introduction to Serialism* (Cambridge, UK: Cambridge University Press, 2008), 6.

Another expression of the role of simplicity in art making comes from visual artist Sol LeWitt's "Paragraphs on Conceptual Art" (1967):

> To work with a plan that is pre-set is one way of avoiding subjectivity...This eliminates the arbitrary, the capricious, and the subjective as much as possible...When an artist uses a multiple modular method he usually chooses a simple and readily available form. The form itself is of very limited importance; it becomes the grammar for the total work....Using complex basic forms only disrupts the unity of the whole.[3]

In some cases, artists seeking "simple and readily available form" have, like LeWitt, turned to mathematical forms, such as the cube or the grid, but generally, we find that a more profound connection between art and mathematics than any formal similarity is a similarity in method. For this reason the conference emphasized ideals of *practice*.

We advertised the conference as "Lectures by and conversations among twenty-six mathematicians, artists, art historians, philosophers, and architects, accompanied by a program of artist's films." Additionally, the artist Kate Shepherd installed *String Drawings* in the conference lobby. These works were pinned directly onto the linen-covered wall panels of the lobby (see page 205).

If the conference was a success, it was not only because of the quality of presentations but also due to the open and lively atmosphere at talks, panel discussions, and during breaks. A very accurate description of the conference appears in Allyn Jackson's report in the *Notices of the American Mathematical Society*, which she kindly permitted us to reprint in this volume.

Initially, there was the idea to organize a gallery exhibition to run parallel to the conference, continuing the pattern set by the Holland events. But, for reasons primarily having to do with securing a gallery space during the conference week, this did not happen. The constraint of presenting art within a conference auditorium and lobby led us to the idea of a film program. A potential offered by having an *in situ* arts program that we hoped for was its integration with conference talks, panels, and discussion.

We screened eight films by artists Andy Goldsworthy, David Hammons, Richard Serra, Andy Warhol, and William Wegman. All the films were non-narrative art films made by artists known primarily for their work in other media. Each was selected for the simplicity and directness with which it operates on our conception of art, in the sense of Joseph Kosuth:

> a work of art is a kind of proposition presented within the context of art as a comment on art...what art has in common with logic and mathematics is that it is a tautology; i.e., the "art idea" (or "work") and art are the same....[4]

[3] Sol LeWitt, "Paragraphs on Conceptual Art," *Artforum* 5, no. 10 (1967): 79–83.

[4] Joseph Kosuth, "Art After Philosophy (1969)," in *Art After Philosophy and After: Collected Writings, 1966–1990* by Joseph Kosuth (Cambridge, MA: MIT Press, 1991), 13–32.

One could try to put in words their visual propositions, but we might just comment that a common subject of these films is that of *looking*. Stills from several of the films appear as illustrations separating contributed essays.

The full program of the conference, including abstracts of all talks, details of the arts program, and notes from the panel discussions, appears in the appendix after Jackson's article. The events were ordered so that each day of the conference took into account a range of perspectives on the central theme of simplicity. The articles in this collection follow a similar pattern. We hope that the diverse selection of voices and opinions will serve as engaging reading as well as new material for further discussions.

We add to our preface a selection of quotes, one from each contributor to the volume. When read together the quotes are themselves a portrait of the conference in miniature, and they show the breadth of topics and the array of questions that simplicity as an ideal of practice in mathematics and the arts helps to bring out.

New York, NY, USA Roman Kossak
Bronxville, NY, USA Philip Ording
October 2016

Quotes

Today I want to express this very naïve idea for mathematicians that we should distinguish between two kinds of simplicities. Something could be very simple for me, in my mind, and in my way of knowing mathematics, and yet be very difficult to articulate or write down in a mathematical paper. And conversely, something can be very easy to write down or say in just one sentence of English or French or whatever and nevertheless be all but completely inaccessible to my mind. This basic distinction is something that I believe to be classical, but, nevertheless, we mathematicians conflate the two.

—Étienne Ghys

The difficulty of determining something as simple or complex in an artwork, arises from the fact that any artistic image—painting, poem, a piece of music, or architectural space— exists simultaneously in two realms, firstly as a material phenomenon in the physical world, and secondly as a mental image in the unique individual experience.

—Juhani Pallasmaa

In much of modern topology, even though the main object of study is a plain vanilla space, one often adds extra structure to make the space more understandable—without that it can be featureless and enigmatic, simple in one way because it has no discernible features but potentially very complicated.

—Dusa McDuff

Sandback's idea of wholeness, and the idea, as he wrote, that "in my works the unity is given from the beginning" implies a temporality of immediacy... It is art-making in a single, simple act of synthesis.

—Juliette Kennedy

One reason for simplicity's connection with time is the development of technology, in all its forms. For instance, the simplest way for two people to contact each other changes

throughout history. The same is true in mathematics. After certain techniques or tools are introduced it's often no longer simpler to not use these tools, even for very basic calculations. They become tools of the trade and so lose some of their apparent complexity.

—Maryanthe Malliaris and Assaf Peretz

Because we don't usually think of mathematical experience in aesthetic terms and because we perpetuate the myth of ahistorical measures of complexity in mathematics, we think of simplicity in this arena as something given in advance of any of mathematics' details. I only wanted to explain that as artistic simplicity derives from art itself, so do our judgements of mathematical simplicity derive from our experience with mathematics. And further, that as mathematics evolves, so do our judgements of what counts as simple.

—Curtis Franks

The Simplicity Postulate is history, but it says something still. Not in the precise, quantitative way its formulators had hoped, but as a lasting insight. We often *do* equate simplicity with probable truth, instinctively.

—Marjorie Senechal

Many truths are complex, and they are simpli*fied* at the cost of distortion, at the cost of ceasing to be truths. Why then do we valorize quantitative simplicity? Because getting rid of clutter—an action that facilitates potency of meaning—can involve tossing items out. But getting rid of clutter can also involve re-arranging the items that one has without throwing any of them away. And it is crucial to notice that the clearest or most compelling arrangement is not always the one whose components have been most strictly reduced.

—Jan Zwicky

If you are a mathematician you ought to look at everything around, including mathematics itself, from a mathematical viewpoint. But to see something interesting, something new, something you had no preconception of, you have to distance yourself from what you try to discern.

—Misha Gromov

Practices of simplicity in the arts are discursive, and because they are discursive, they are part of a network of enunciations which can never be unidirectional or simple. Whether the Plotinian One haunts the unitary object of minimalist aesthetics is contestable, but it is almost certain that there are no primary structures: *Il n'y a pas de Structures Primaires*.

—Riikka Stewen

Albert Einstein, in a famous quote has said: *I have deep faith that the principle of the universe will be beautiful and simple*. One possible interpretation of that statement, though not the only one, is that the foundations of physics can be captured in simple laws. Mathematicians and philosophers have shown similar belief in the simplicity of the fundamentals of mathematics. By trying to reduce mathematics to logic, for example. Here simplicity should, I think, be read as self-evident.

—Rosalie Iemhoff

Simplicity conceived in this way takes *communicability* to be a central feature, so it has a pragmatic flavor. One might think of it as a mere fiction. Yet, in the end, being indispensable, simplicity is an ideal that remains robust, repeatedly embodied, even while remaining part of an ongoing process reflecting our needs, desires, and discussions.

—Juliet Floyd

The history of typography is marked by a persistent drive to rationalize.

—Dexter Sinister

In this paper I illustrate the contrasting view that *complexification* sometimes not only helps to achieve simplification but often even seems to be a *necessary* feature of it, how at some

points apparent compromises of the simplifying process, apparent turns to complexity, may be needed in order to actually complete the move to simplicity.

—Andrés Villaveces

Roughly, a proof of a theorem, is "pure" if it draws *only* on what is "close" or "intrinsic" to that theorem. ... [M]athematicians have paid considerable attention to whether... impurities are a good thing or to be avoided, and some have claimed that they are valuable because generally impure proofs are *simpler* than pure proofs. ... After assembling evidence from proof theory that may be thought to support this claim, we will argue that on the contrary this evidence does not support the claim.

—Andrew Arana

Although not widely adopted, Brouwer's reorientation of mathematics to include an idealized subject and his critique of formalism have intriguing, and in some cases explicit, connections to music and art of the 1960s and '70s. In particular, the time and subject dependent form of Minimalist composition developed by the composer La Monte Young was later reinterpreted in light of such foundational concerns.

—Spencer Gerhardt

Restricting mathematics education to teaching "numeracy," "practical mathematics," "mathematics for life," "functional mathematics," and other *ersatz* products is a crime equivalent to feeding children with processed food made of mechanically reconstituted meat, starch, sugar, and salt... simplicity in mathematics education is not fish nuggets made from "seafood paste" of unknown provenance; it is sashimi of wild Alaskan salmon or Wagyu beef.

—Alexandre Borovik

Mathematicians often feel a mathematical story is not over until one sees the entire structure evolving painlessly from a quite small number of simple starting points.

—Dennis Sullivan

Acknowledgments

We would like to express our deepest thanks to Juliette Kennedy, without whom the conference that produced these proceedings would not have happened. We are grateful to all the contributors for their willingness to participate in this interdisciplinary project. We especially appreciate Kate Shepherd for contributing original art to the volume. We also want to thank Allyn Jackson and the *Notices of the American Mathematical Society* for granting us permission to reprint her review of the conference. Thanks to John Cancro, María Clara Cortés, Alejandro Martín Maldonado, and Wanda Siedlecka for sharing their photographs from the conference with us and granting us permission to reproduce them here. Numerous images of artworks reproduced in the book were kindly provided to us by several people and institutions. We would like to thank the Andy Warhol Museum; the Archives of the Mathematisches Forschungsinstitut Oberwolfach; David Zwirner Gallery, New York/London; the Fred Sandback Archive, Mel Bochner; Henry Flynt; Galerie Lelong, New York; Galerie Michael Werner Märkisch Wilmersdorf, Cologne and New York; Gordon Hamilton; Óscar Muñoz; David Reinfurt; Richard Serra; and William Wegman. Several students at Sarah Lawrence College gave their enthusiastic assistance during the preparation of the manuscript, including Lauren Bréard, Xueyi Bu, Isak McCune, and Ella Pavlechko, and we are very thankful for their help. Thanks also to Beth Caspar and Laurie Kirby for copyediting. At Springer, we would like to thank our editor Dahlia Fisch for her assistance. Finally, we want to thank Marjorie Senechal whose support was critical in the early stages of the book.

Contents

Contributors

Andrew Arana is a philosopher and mathematician. He is a lecturer at Université Paris 1 Panthéon-Sorbonne and a member of the Institut d'Histoire et de Philosophie des Sciences et des Techniques (IHPST). His recent publications include "Imagination in mathematics" in the *Routledge Handbook of the Philosophy of Imagination* (Routledge, 2016) and "On the depth of Szemerédi's theorem" in *Philosophia Mathematica* (2015).

Alexandre V. Borovik is professor of pure mathematics at the University of Manchester, UK. His principal research lies in algebra, model theory, and combinatorics. He has published several influential articles on mathematics education. In 2010 he published *Mathematics under the Microscope: Notes on Cognitive Aspects of Mathematical Practice* (AMS), which examines a mathematician's outlook on psychophysiological and cognitive issues in mathematics.

Juliet Floyd is professor of philosophy at Boston University. Her research focuses on the interplay between logic, mathematics, and philosophy in the eighteenth, nineteenth, and twentieth centuries as well as current philosophical implications of emerging computational technologies. A leading figure in the field of the history of the twentieth-century analytic philosophy, she has published on a diverse array of topics, including aesthetics, modernism, political philosophy, ordinary language philosophy, and American philosophy. She recently coedited (with A. Bokulich) *Philosophical Aspects of the Legacy of Turing: Turing 100* (Springer, forthcoming). Her current manuscript explores the significance of the interactions between Wittgenstein, Turing, and Gödel in the 1930s and 1940s.

Curtis Franks is associate professor and director of graduate studies in the Department of Philosophy at the University of Notre Dame. He studied mathematics and philosophy at Rice University in Houston and later at the University of California's Department of Logic and Philosophy of Science in Irvine. He describes his own interest as primarily the "conceptual problems, methodological scruples, and tendencies of thought that motivated logicians like Hilbert, Herbrand, Gödel, Gentzen, and Skolem, because [I see] the beauty of the science they forged as

evidence for the correctness of their views." His book *The Autonomy of Mathematical Knowledge: Hilbert's Program Revisited* was published by Cambridge University Press in 2009.

Étienne Ghys is a mathematician. His research focuses mainly on geometry and dynamical systems, though his mathematical interests are broad, including the historical development of mathematical ideas and especially the contribution of Henri Poincaré. He is a CNRS research director at the École Normale Supérieure in Lyon and a member of the French Academy of Sciences. In 2015 he was awarded the inaugural Clay Award for Dissemination of Mathematical Knowledge.

Spencer Gerhardt is a PhD candidate in mathematics at the University of Southern California. His current research interests lie in algebraic groups and representation theory. He also holds an MS in logic from the University of Amsterdam. He writes music and has studied privately with Charles Curtis and La Monte Young.

Misha Gromov is a permanent member of the Institut des Hautes Études Scientifiques in Bures-sur-Yvette, France, and professor of mathematics at New York University. His work has had great impact on the development of many areas of modern mathematics. His list of awards includes the Wolf Prize in Mathematics (1993), the Leroy P. Steele Prize for Seminal Contribution to Research (1997), the Lobachevsky Medal (1997), the Bolyai Prize (2005), and the Abel Prize (2009) for his revolutionary contributions to geometry.

Rosalie Iemhoff is a mathematician working in mathematical logic and proof theory. She is associate professor at Utrecht University in the Netherlands. She has published over 30 research articles in proof theory, modal logics, intuitionism, and constructive mathematics. She is an editor of the Review of Symbolic Logic and Mathematical Logic Quarterly and has been a member of the council of the Association of Symbolic Logic.

Allyn Jackson is senior writer and deputy editor of the *Notices of the American Mathematical Society*. She holds a master's degree in mathematics from the University of California at Berkeley. Her articles and interviews for the *Notices* have covered a wide variety of topics, including the application of mathematics to DNA research, the job market for mathematicians, developments in mathematics education, women in mathematics, and science policy issues.

Juliette Kennedy is a mathematician and philosopher. She has done research in mathematical logic, history and philosophy of logic, philosophy of mathematics, and set theory. She has edited several books including *Interpreting Gödel: Critical Essays* (Cambridge University Press, 2014). She has also written on aesthetics and art history and curated art exhibitions, including *Fred Sandback at Pori* and *Andy Goldsworthy*, both at the Pori Art Museum in Pori, Finland, in 2011.

Maryanthe Malliaris earned a PhD from the Group in Logic at Berkeley (in mathematics, specifically model theory). Malliaris has done postdoctoral work at

the University of Chicago and the Hebrew University, Jerusalem, and is currently assistant professor of mathematics at the University of Chicago. Malliaris has been awarded a Gödel research prize fellowship and an Alfred P. Sloan research fellowship in mathematics.

Dusa McDuff is the Helen Lyttle Kimmel chair of mathematics in Barnard College, Columbia University. Her research has focused on symplectic geometry. She was the first recipient of the American Mathematical Society's Satter Prize. She gave the Noether Lecture at the Joint Meetings of the AMS-MAA in 1998 and received the Hardy Fellowship, an award from the London Mathematical Society, in 1999. She is a fellow of the Royal Society and the American Mathematical Society and a member of the National Academy of Sciences, the American Philosophical Society, and Academia Europaea.

Juhani Pallasmaa is a Finnish architect and former professor of architecture and dean at the Helsinki University of Technology. He was a director of the Museum of Finnish Architecture 1978–1983 and head of the Institute of Industrial Arts, Helsinki. From 1991 to 2004 he was Raymond E. Maritz visiting professor of architecture at Washington University in St. Louis, and in 2013 he received an honorary doctorate from that university. He has also had a number of other visiting professorships in the USA. His exhibitions of Finnish architecture, planning, and visual arts have been displayed in more than thirty countries, and he has published over fifty books and written numerous articles on cultural philosophy, environmental psychology, and theories of architecture and the arts.

Assaf Peretz earned a PhD from the interdisciplinary Group in Logic at Berkeley. His thesis was in mathematics, more precisely in model theory, for which he received the Liftoff Fellowship from the Clay Mathematics Institute. His research on models continued in different fields, including writing a book, creating the novel social website www.THINQon.com, and research on economics.

Marjorie Senechal is a mathematician and historian of science. She is Louise Wolff Kahn professor emerita in mathematics and history of science and technology at Smith College and editor in chief of *The Mathematical Intelligencer*. In mathematics, she is known for her work on tessellations and quasicrystals. She wrote the biography *I Died for Beauty: Dorothy Wrinch and the Cultures of Science* (Oxford University Press, 2013).

Kate Shepherd is a New York-based painter known for her original use of color, scale, and delicate yet descriptive painted line. Shepherd has had solo exhibitions at the Phillips Collection, Washington, DC; Portland Institute for Contemporary Art, Portland, Oregon; Otis College of Art and Design, Los Angeles, California; the Lannan Foundation, Santa Fe, New Mexico; the Chinati Foundation, Marfa, Texas; and Wake Forest University, among many gallery exhibitions. She is represented by Galerie Lelong in New York and Paris, Anthony Meier Fine Arts in San Francisco, Barbara Krakow Gallery in Boston, and Hiram Butler Gallery in Houston. Shepherd is a member of the board of Triple Canopy.

Dexter Sinister is the compound name of David Reinfurt and Stuart Bailey. David graduated from the University of North Carolina in 1993 and Yale University in 1999 and went on to form O-R-G, a design studio in New York City. Stuart graduated from the University of Reading in England in 1994 and the Werkplaats Typografie in the Netherlands in 2000 and cofounded the arts journal *Dot Dot Dot* the same year. David currently teaches at Princeton University. Stuart currently teaches at the University of Geneva in Switzerland.

Riikka Stewen is an art historian and theoretician currently working as research professor in contemporary art at the University of the Arts Helsinki in Finland. In her research she addresses topics such as theories of memory and subjectivity and genealogies of modernity. Stewen has supervised several doctoral dissertations in modern and contemporary art history as well as directed doctoral studies in practice-based artistic research. She has also worked as a translator and published an art historical novel, *Niin kauan kuin rakastat* (Teos, 2011).

Dennis Sullivan is known for his work in algebraic and geometric topology and dynamical systems. He holds the Albert Einstein Chair at the Graduate Center of the City University of New York, and he is professor of mathematics at Stony Brook University. He is a recipient of a number of awards, including the National Medal of Science (2004), the AMS Steele Prize for lifetime achievement, the Wolf Prize in Mathematics (2010) for "his contributions to algebraic topology and conformal dynamics," and the Balzan Prize in Pure and Applied Mathematics (2014).

Andrés Villaveces is an associate professor at Universidad Nacional in Bogotá, Colombia. His research is on model theory and its connections with other parts of mathematics, including combinatorial set theory and arithmetic geometry. He has also worked in the philosophy of mathematics and the intersection between mathematics and art, for example, as co-organizer of the interdisciplinary event "Mapping Traces: Mathematics, Philosophy and Art in Bogotá" in 2014. Recently, he coedited *Logic Without Borders* (Ontos Mathematical Logic, 2015).

Jan Zwicky is a philosopher, poet, essayist, and musician. She has taught philosophy and interdisciplinary humanities courses at a number of North American universities including Princeton, the University of Alberta, and most recently the University of Victoria, where she is professor emerita. Her philosophical work includes *Lyric Philosophy* (University of Toronto Press, 1992) and *Wisdom & Metaphor* (Gaspereau Press, 2003). Her most recent collection of essays, *Alkibiades' Love* (McGill-Queen's University Press, 2015), contains a discussion of the connections between mathematical analogy and metaphorical insight. She has published nearly a dozen collections of poetry and has been awarded Canada's Governor General's Award, among other honors.

Andy Warhol
Empire, 1964
16mm film, black and white, silent
Duration: 8 hours, 5 minutes at 16 frames per second
©2016 The Andy Warhol Museum, Pittsburgh, PA, a museum of Carnegie Institute.
All rights reserved.
Courtesy the Andy Warhol Museum

Inner Simplicity vs. Outer Simplicity

Étienne Ghys

Editors' note: This text is an edited transcript of the author's conference talk.

For me, mathematics is just about understanding. And understanding is a personal and private feeling. However, to appreciate and express this feeling, you need to communicate with others—you need to use language. So there are necessarily two aspects in mathematics: one is very personal, emotional, and internal, and the other is more public and external. Today I want to express this very naïve idea for mathematicians that we should distinguish between two kinds of simplicities. Something could be very simple for me, in my mind, and in my way of knowing mathematics, and yet be very difficult to articulate or write down in a mathematical paper. And conversely, something can be very easy to write down or say in just one sentence of English or French or whatever and nevertheless be all but completely inaccessible to my mind. This basic distinction is something that I believe to be classical, but, nevertheless, we mathematicians conflate the two. We keep forgetting that writing mathematics is not the same as understanding mathematics.

Let me begin with a memory that I have from when I was a student a long time ago. I was reading a book by a very famous French mathematician, Jean-Pierre Serre entitled *Complex Semisimple Lie Algebras* [8]. Here is the cover of the book (Fig. 1). For many years I was convinced that the title of the book was a joke. How else, I wondered, can these algebras be complex and simple at the same time? For mathematicians, of course, the words "complex" and "semisimple" have totally different meanings than their everyday ones. "Complex" means complex number and "semisimple" means a sum of simple objects. So, for many, many years, I was convinced that this was a joke. Recently, actually one year ago, I had the opportunity to speak with Jean-Pierre Serre, this very, very famous mathematician, who is now

É. Ghys (✉)
Unité de Mathématiques Pures et Appliqués, Ecole Normale Supérieure de Lyon, Lyon, France
e-mail: etienne.ghys@ens-lyon.fr

© Springer International Publishing AG 2017

R. Kossak, P. Ording (eds.), *Simplicity: Ideals of Practice in Mathematics and the Arts*, Mathematics, Culture, and the Arts, DOI 10.1007/978-3-319-53385-8_1

Fig. 1 "Why is it funny?"
Cover of *Complex
Semisimple Lie Algebras* by
Jean-Pierre Serre

85 years old. I dared ask him the question: "is this a joke?" With sincere curiosity, he replied, "What? Why is it funny?" He never noticed the apparent contradiction. It was not a joke to him. Mathematicians use words as words, and they don't want to use the words with their meaning.

There is a famous quote attributed to David Hilbert that says you can replace all the words in mathematics arbitrarily. Instead of "line," you could say "chair," and instead of "point," you could say "bottle," and then you could say that "in between two bottles, there is one chair," and the mathematics would be unchanged. This is the point of view of Hilbert, which is not at all my point of view.

So this is the first aspect, that there is in mathematics an external simplicity which is conveyed by the language, and this language is somewhat artificial—it is made out of words which are not fully subject to meaning. Oversimplifying the picture, one could distinguish these two aspects by saying that on the logic side there is Hilbert writing words without looking for meanings for these words, while Poincaré is on the intuition side (Fig. 2).

Notice here that, and this is my favorite part, the latter image is from a chocolate bar wrapper. Poincaré was so famous they would use his photograph on chocolates. (Do you know one mathematician today whose picture could sell chocolate?) Hilbert was basically focused on transmitting mathematics, and Poincaré was focused on understanding mathematics. This is one way that I want to distinguish between inner and outer simplicity.

Before we start, since I am the first speaker, I thought it could be a good idea to open the dictionary at the words "simplicity" and "complexity" [5]:

> **simplicity** (n.) late 14c., from Old French *simplicity* (French *simplicité*), from Latin *simplicitatem* (nominative *simplicitas*) "state of being simple," from *simplex* (genitive *simplices*) "simple."
>
> **simplex** (adj.) "characterized by a single part," 1590s, from Latin *simplex* "single, simple" from PIE root **sem-* "one, together" (cf. Latin *semper* "always," literally "once for all;" Sanskrit *sam* "together;" see same) + **plac-* "-fold." The noun is attested from 1892.
>
> **complex** (adj.) 1650s, "composed of parts," from French *complexe* "complicated, complex, intricate" (17c.), from Latin *complexus* "surrounding, encompassing," past participle of *complecti* "to encircle, embrace," in transferred use, "to hold fast, master, comprehend,"

from *com-* "with" (see com-) + *plectere* "to weave, braid, twine, entwine," from PIE **plek-to-*, from root **plek-* "to plait" (see ply). The meaning "not easily analyzed" is first recorded 1715. *Complex sentence* is attested from 1881.

This is perhaps obvious, especially to such a scholarly and learned audience as I have here today, but I would add that it may not be as obvious for you as it is for French speaking people. The word "simple" comes from the French word *plier*, "to fold." Something simple is folded only once, and it's complex when it has many folds. (The closest cognates in English might be the verbs "ply" and "plait.") To explain something is to "unfold it." Complexity and simplicity are related to folding in all directions, and this is something we will keep in mind.

Let's begin with outer simplicity. Given its reliance on words, there is an obvious measure of complexity here: the so-called Kolmogorov complexity. In the 1960s, Andrey Kolmogorov (Fig. 3, right) had the idea of defining complexity of something to be the length of the shortest explanation of that something. By merely asking how many words are needed to describe something, you get a measure of the complexity of this object.

Complexity = Length of the shortest description

For an example, a simple example, take the 1915 painting entitled *The Black Square* by Kazimir Malevich, which appears on page 15.

I can describe it to you in, let's say, five or six sentences: it's a square with such size, and it's white, and inside it there is a smaller square which is black. I could give the precise blackness and whiteness of the two squares. So this is a very simple object. That was Malevich, let me show you my own art object (Fig. 3, left).

This is a totally random object. It's a square, and in the square there are many dots. I asked my computer to put yellow or orange dots here, but it's totally random. If you ask me to describe it to you in detail, the only way that I can do it is to describe it *dot by dot*. I will need a very, very long sentence that might begin "the first point is yellow; the second point is red..." It will be a very long description. So, in Kolmogorov's terminology, this is a complex object, and Malevich's is a simple object.

Fig. 2 Logic vs. Intuition. 1912 University of Göttingen faculty postcard for David Hilbert (*left*), photographer unknown. Circa 1903 Academie Française collectible card for Henri Poincaré (*right*), sold with Guérin-Boutron chocolate

Fig. 3 Andrey Kolmogorov (*right*) and examples of high (*left*) and low (*center*) Kolmogorov complexity. Photo by Konrad Jacobs, courtesy Archives of the Mathematisches Forschungsinstitut Oberwolfach

Here is the third object—one that is very famous, at least in the mathematical realm—the Mandelbrot set (Fig. 3, center).

It looks complicated and, mathematically, it is complicated. But for Kolmogorov it's a very simple object. In order to produce this picture, it may take a computer a long time, days, or weeks, or more, but the computer program that describes the Mandelbrot set is two lines long. So, from the Kolmogorov's point of view, this object is very simple. This is the first concept of simplicity, outside simplicity, the length of what you need to describe it. Clearly, it is not satisfactory. I mean, for me, I don't want to consider the Mandelbrot set as being something simple. This object is complicated for me. It is made out of many folds.

Let me give you another example, a personal example, of a simple linguistic thing that is complicated. Or, at least, it was complicated to me when I was a student. Again, I will take the example from Jean-Pierre Serre. Serre wrote a wonderful book for students on number theory called *Cours d'arithmétique*. I opened it when I was, I think, 19. Here is what I found on the first page (Fig. 4).

The first sentence of the book begins, "L'intersection..." (I'll explain in a moment why I am showing this in French). I can tell you that I spent two days on this one sentence. It's only one sentence, but looking back at this sentence, I see now that it is just perfect. There is nothing to change in it; every single word, even the smallest, is important in its own way. I wanted to show you the English translation, but the English translation is so bad compared to the French of Jean-Pierre Serre. Serre's language is so efficient, so elegant, so simple. It is so simple that I don't understand it. Even the smallest words, like "d'un corps K en," this two-letter word "en" is fundamental. Everything, every single word is fundamental. Yet, from the Kolmogorov point of view, this is very simple. But as a student I knew almost nothing about "anneaux intègres" and all these other things. It looked so complicated. Finally, at the end of the second day, all of a sudden, I grasped it and I was so happy that I could understand it. From Kolmogorov's point of view, it's simple, and yet for me—and, I imagine many students—it's not simple.

Fig. 4 *Cours d'arithmétique*
by Jean-Pierre Serre [7, p. 1]

CHAPITRE I

CORPS FINIS

Tous les corps considérés ci-dessous sont supposés commutatifs.

§ 1. Généralités

1.1. *Corps premiers et corps finis.*

L'intersection des sous-corps d'un corps K en est le plus petit sous-corps; il contient l'image canonique de Z, isomorphe en tant qu'anneau intègre à Z ou à Z/pZ avec p premier; il est donc isomorphe, soit à Q, soit au corps Z/pZ.

Fig. 5 An illustration,
reproduced from [2, p. 293]

Let me give you another example from Jean-Pierre Serre. I should mention that Serre is perhaps the most famous French mathematician. We mathematicians from France, we consider him to be some kind of (semi) God. He writes exquisitely. Most of my students, when they are writing their PhD theses, or whenever they write badly, which is usually the case, I say to them, "go to the library, open any book of Jean-Pierre Serre, and try to copy!" In terms of elegance and economy, there is nothing better. Back to the example I wanted to mention. A long time ago, maybe fifteen years ago, I was giving a talk in the Bourbaki seminar. I was describing a construction in dynamical systems due to Krystyna Kuperberg of a very fascinating counterexample to an old conjuncture of Herbert Seifert (the construction of a vector field on the 3-sphere with no periodic orbits). This is a wonderful, simple idea, really wonderful. For my talk, I prepared pictures, and here is one of the pictures that I showed (Fig. 5).

It's not important to my point that you understand what this object is. In my talk I explained the construction saying, you know, "you do this, and this. . . " [*gesturing towards the picture with both hands*]. After the talk, well, I thought it was successful, people were happy. Then Jean-Pierre Serre came up to me and said, "That was interesting what you said. I have a question." And he asked, "Would you consider this to be a theorem?" In other words, he was questioning whether the fact that I was using pictures, and not words, didn't disqualify me from transmitting mathematics. My feeling, and this feeling is shared by others who you will see in a second, is that pictures and, more than pictures, even movies, should be incorporated into the world of mathematics as genuine tools of proof. Not just for fun, but for veracity, and for presenting mathematics.

So let me explain something to show that I'm far from being the only one to think this way. We'll discuss Hilbert's twenty-fourth problem in this meeting, but today I want to discuss the zeroth Hilbert problem. When Hilbert gave his famous lecture in Paris on problems for the future of mathematics, his paper contained twenty-three problems. These were preceded by a general introduction on what makes a good problem, what is interesting, where should we go, etc. There is something in this introduction that I want to show you because I believe that, to this day, it presents a fundamental question for mathematics. The point is that we should incorporate pictures as genuine tools for understanding and transmitting mathematics. So, here's an extract from Hilbert's introduction of what I call his zeroth problem [3]:

> To new concepts correspond, necessarily, new signs. These we choose in such a way that they remind us of the phenomena which were the occasion for the formation of the new concepts. So the geometrical figures are signs or mnemonic symbols of space intuition and are used as such by all mathematicians. Who does not always use along with the double inequality $a > b > c$ the picture of three points following one another on a straight line as the geometrical picture of the idea of 'between'? Who does not make use of drawings of segments and rectangle enclosed in one another, when it is required to prove with perfect rigor a difficult theorem on the continuity of functions or the existence of points of condensation? Who could dispense with the figure of the triangle, the circle with its center, or with the cross of three perpendicular axes? Or who would give up the representation of the vector field, or the picture of a family of curves or surfaces with its envelope which plays so important a part in differential geometry, in the theory of differential equations, in the foundation of the calculus of variations and in other purely mathematical sciences?
>
> The arithmetical symbols are written diagrams and the geometrical figures are graphic formulas; and no mathematician could spare these graphic formulas, any more than in calculation the insertion and removal of parentheses or the use of other analytic signs.
>
> The use of geometrical signs as a means of strict proof presupposes the exact knowledge and complete mastery of the axioms which underlie those figures; and in order that these geometrical figures may be incorporated in the general treasure of mathematical signs, there is necessary a rigorous axiomatic investigation of their conceptual content. Just as in adding two numbers, one must place the digits under each other in the right order, so that only the rules of calculation, i.e., the axioms of arithmetic, determine the correct use of the digits, so the use of geometrical signs is determined by the axioms of geometrical concepts and their combinations.

So Hilbert is asking for a language of pictures, for ways of presenting mathematics simply while not restricted to the use of letters and languages. Recently I had a discussion with some choreographers, and they face a similar problem. They are looking for a notation for dance. How would you denote choreography? They have several ways of doing it, for example, one is called Benesh Movement Notation, but there are many other possibilities. And they have exactly the same problem: why should we restrict ourselves to a linear, totally ordered language in order to describe mathematics, since we are not linearly ordered in our mind? Or at least I am not. Again, from Hilbert [3]:

> The agreement between geometrical and arithmetical thought is shown also in that we do not habitually follow the chain of reasoning back to the axioms in arithmetical, any more than in geometrical discussions. On the contrary we apply, especially in first attacking a problem, a rapid, unconscious, not absolutely sure combination, trusting to a certain arithmetical feeling for the behavior of the arithmetical symbols, which we could dispense with as

little in arithmetic as with the geometrical imagination in geometry. As an example of an arithmetical theory operating rigorously with geometrical ideas and signs, I may mention Minkowski's work, *Die Geometrie der Zahlen.*

This is not the usual way that we think of Hilbert; here he is praying for a better use of pictures. Now let us get back to Poincaré. Poincaré was not at all motivated by words or language, which are on the outside of mathematics. He was motivated by the inside of mathematics, by intuition. He warns that we should not compare mathematics with the game of chess. Anyone can easily learn the rules of the game, you can check if a game is fulfilling the rules, but it is clear that you are not a mathematician if you only know the rules of the game. You need to have some global understanding of the subject, and from that point of view logic is totally useless. Here's what he writes [6]:

> If you are present at a game of chess, it will not suffice, for the understanding of the game, to know the rules for moving the pieces. That will only enable you to recognize that each move has been made conformably to these rules, and this knowledge will truly have very little value. Yet this is what the reader of a book on mathematics would do if he were a logician only. To understand the game is wholly another matter; it is to know why the player moves this piece rather than that other which he could have moved without breaking the rules of the game. It is to perceive the inward reason which makes of this series of successive moves a sort of organized whole. This faculty is still more necessary for the player himself, that is, for the inventor.

This reminds me of something. When you use your smart phone to look up direction with Google Maps, it's amazing how quickly it finds the best path from A to B. Basically, this is what we are trying to do in mathematics. We want to go somewhere, and we are looking for the best path. I don't know if any of you have looked at the algorithm that Google Maps uses. It's called the A* algorithm. It's a very, very clever way of finding your way in an unknown country, and I strongly suggest that you take a look at this remarkable algorithm. Maybe it could be used, by analogy, to understand better how mathematicians work, how sometimes we try to move forward by first moving backward so as to change course.

What I want to say is that at present the connection between mathematics on the outside and the inside is not good. We should improve it. We should write mathematics in a different way. Hilbert is suggesting that we should use pictures, I would even add that we should use movies.

Let me give you an example. There is this theorem of Stephen Smale that implies that, in a particular sense, it is possible to turn the 2-sphere inside out (we can evert it in 3-space). This is not an easy theorem to prove, the proof is formal and difficult to understand. However, about 20 years ago, Silvio Levy, Delle Maxwell and Tamara Munzner created a movie on this result called *Outside In* [4], which is based on ideas of Bill Thurston (Fig. 6). This 22-min long movie uses extraordinary computer graphics to show you how the eversion works. Of course, it still would not qualify as a proof, but it comes very close to a proof. And if we follow the advice of Hilbert, we ought to devise the rules with which to transform such a film into a genuine proof. In the future, maybe tomorrow, or in ten years, one should be able to

Fig. 6 *Outside In* sequence. ©1994 The Geometry Center, University of Minnesota

publish proofs using movies, as soon as they are certified by some certification that we do not as yet know how to do.

Another thing that I consider important is that we should think of the way we write mathematics. For many years we have written papers from A to Z, and it is well-known that no mathematician would open the paper or book and start by the beginning and go to the end. We go forward, we jump, we come back, we go to some other place. So we should be able to write mathematics (and not only mathematics, actually) in a non-linear way. Today's technologies—computers, e-books, the Internet—make it possible to do. So why don't we do that? I think it's time to create papers that are not just standard papers going from A to Z.

An exciting possibility, at least for me, in this direction will begin next week, when I will meet with a group of eighteen mathematicians who plan to write a new book on algebraic topology for graduate students. We want to do it this way. We don't want to write a book with pages. We want to write a book that is completely electronic, in which you can travel in a way that is adapted to you as a reader. Of course, this requires some planning before we start. But we feel that we have to try to adapt the outer ways of describing mathematics to the inner ways of our readers.

Here is a very different idea about mathematical writing. This is this crazy idea that comes from Paul Erdős that somewhere in heaven there is THE BOOK and in it are some jewels, some wonderful proofs and we should work toward these beautiful proofs, simple proofs, elegant proofs.

Martin Aigner and Günter Ziegler's book *Proofs from THE BOOK* is supposed to contain a few hundred of those jewels. I'm not really convinced. I don't know how many of you read this book, but some of the theorems inside this book are really wonderful. But I tried myself to read it, and I can guarantee that in most proofs, not all but most, they are just wonderful. And then you close the book, and let's see, now it's one year later, I have forgotten them. This is a bad sign. I mean, when I understand something, by definition, I don't forget it. The concept of beauty here, in my opinion, cannot be the correct one. Simplicity is not the correct one.

I would like to finish by explaining some mathematics. I'm not sure if it's true in this country as well, but when I was a student, I was told that you should never,

Fig. 7 Examples of networks: a neural network (*left*, image source BrainMaps.org, courtesy UC Regents Davis campus), the Internet (*center*, image courtesy The Opte Project), a mathematical network (*right*)

never, never give a talk, without stating a theorem. So I decided that maybe I could spend the last minutes of this talk mentioning a theorem that I understand and that I think I will never forget. I will not give you the proof, but I will explain this theorem because I believe it reveals something about the way the brain understands mathematics. I'm not a neurobiologist, I know even less about psychology, but I think it's something fundamental. It's a simple, fundamental idea, and I want to share it with you.

What I'd like to try is to discuss how we can understand large networks. To begin, here is a picture of a network of neurons (Fig. 7, left). You have hundreds of thousands of neurons, and they are connected in a way that you don't really understand. And you want to describe this structure. Do you know how many neurons I have in my brain? [*Audience member: "A hundred billion."*] I think I have only ten billion in my brain. Okay I think it's ten billion. For comparison, consider the Internet (Fig. 7, center).

How many HTML pages are there in the world? Ten billion. So the number of pages in the Internet is approximately the same as the number of neurons in your brain. The difference is in the connectivity of these two networks. A typical webpage is connected to about twenty other webpages. But a typical neuron is connected to ten thousand neurons, so things are much more connected in my brain. Another main difference is that communication is much faster on the Internet than in my brain. This is because Internet connections use electricity or light, while communications in my brain use biological or chemical reactions, which are much slower. So my brain is slower but better connected, and the Internet is less connected but faster.

How can we understand these two huge structures? This is part of the motivation for the theorem I want to mention. It's a theorem of Endre Szemerédi (Fig. 9, left) called the Szemerédi regularity theorem. As you will see, it's a very general theorem that is true for all networks. It conveys the idea that all networks, no matter how big they are, can be understood in finite terms, so to speak.

Let me explain. Here's a network (Fig. 7, right). A network is just a bunch of points, which could be whatever you want, and some of them are connected by links, or edges, which you draw between the points as in the picture. Of course, this picture

Étienne Ghys

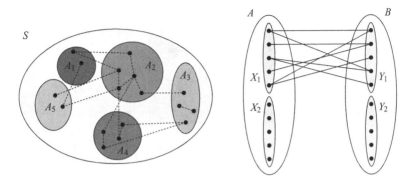

Fig. 8 Simplifying a network and defining ϵ-regularity

is reasonable because the number of dots used is small. It's totally impossible for me to draw a picture of a complex network like the Internet. Now here's the question: How could I draw the Internet? What would be a good picture of Internet? Clearly, the number of pages on the Internet in the world is so big that it's impossible to draw it here. There are more points on Internet than pixels on the screen. So there's no way of drawing a picture of the actual Internet. How can I draw a fairly accurate picture of large networks? This is what Szemerédi's theorem tells you. It is possible to do something, and that's what I want to express.

Here's a network (Fig. 8, left).

You have dots and you have links between them, and the idea is that we want to group vertices or dots into several groups. We want to replace the complicated picture having many dots by a much simpler picture with fewer dots. Instead of having maybe twenty dots, you'll collapse these into only five dot-groups, A_1, A_2, A_3, A_4, A_5, which you'll think of as new dots. Now let me give a definition and then state the theorem, since this is my job. My job is to state and then prove theorems.

You have two sets, A and B. Inside A and B you have subsets, X_1 and Y_1, where X_1 is subset of A, and Y_1 is subset of B. (See Fig. 8, right.)

And then we define some numbers, the first number is called the *density*. To calculate the density $d(X, Y)$ of X and Y, you count how many edges go from X to Y; that is, the total number $e(X, Y)$ of connections going from some point of X to some point of Y. You then divide this number by the product of the number $|X|$ of points in X and the number $|Y|$ of points in Y.

$$d(X, Y) = \frac{e(X, Y)}{|X||Y|}$$

The density tells you the probability of connecting two points in X, Y. You say that two sets A, B are ϵ-*regular* if for every subset $X \subset A$ and $Y \subset B$, the density $d(X, Y)$ and the density $d(A, B)$ agree up to a small number $\epsilon > 0$. Here is the formal

Fig. 9 Endre Szemerédi (in 2010) and a small graph of the Internet, reproduced from [1, Fig. 9]

definition: A pair of sets (A, B) is ϵ-regular if for every $X \subset A$ with $|X| > \epsilon|A|$ and every $Y \subset B$ with $|Y| > \epsilon|B|$, we have

$$|d(X, Y) - d(A, B)| < \epsilon.$$

In other words, A and B are ϵ-regular if any part of A and any part of B are connected basically in the same way. Now I can state the theorem of Szemerédi, which says that every graph or network, for a given ϵ, can be approximated by a smaller graph with a number of points independent of the original size of the graph but only dependent on ϵ.

Theorem 1 *For every $\epsilon > 0$, there are positive integers m and M such that every finite graph can be partitioned in n parts A_i in such a way that*

- $m \leq n \leq M$
- *All A_i have approximately the same size:* $(1 - \epsilon)|A_i| \leq |A_j| \leq (1 + \epsilon)|A_i|$
- *Among the n^2 pairs (A_i, A_j) at least $(1 - \epsilon)n^2$ are ϵ-regular.*

This means that, whatever the size of the original network, you can approximate it by a small graph which gives you almost all the information you want about the connectivity inside your original network.

Let me end by showing you one example. This is a famous picture, an old picture, of the Internet (Fig. 9, right). Of course, it's a very naïve image of Internet. It tells you that you can, roughly speaking, decompose the Internet into several parts. You have the "SCC," that means the strongly connected core. It's about one-third of the total internet world. This is the part in which everybody interacts with everybody, it's highly connected. Then you have "OUT," which are the pages, where everybody goes, but nothing goes out of them. About the same size, you have "IN," which consists of the pages that are not interesting to anybody, but which are interested in everybody. Apart from these, there are some disconnected components, I don't know what exactly those are, maybe the stamp collectors. The point is that this theorem of Szemerédi, in a word, explains that any network, even very big ones like the Internet network, can be described in such a way with a simple picture. It doesn't tell you

everything about the structure of the graph or network, but it tells you something about the global picture of it.

I wanted to mention this theorem to you primarily because it's an example of a theorem for which the published proof is complicated, but nevertheless I understand it. For me it's simple. I think I will never forget the proof because I understand it. And this is the exact opposite of the one-line by Jean-Pierre Serre, which was so short that it took me days to understand it. When you read the long proof of this theorem, once you get it, you will say "Well...I understand it, but why did they write such a long book on this?"

References

1. Broder, Andrei, Ravi Kumar, Farzin Maghoul, Prabhakar Raghavan, Sridhar Rajagopalan, Raymie Stata, Andrew Tomkins, and Janet Wiener. "Graph Structure in the Web." *Computer Networks* 33, no. 1 (2000): 309–320.
2. Ghys, Étienne. "Construction de champs de vecteurs sans orbite périodique." *Séminaire Bourbaki* 36 (1995): 283–307.
3. Hilbert, David. "Mathematical Problems." Translated by M. W. Newson. *Bulletin of the American Mathematical Society* 8, no. 10 (1902): 437–80.
4. Levy, Silvio, Delle Maxwell, and Tamara Munzner. *Outside in.* Geometry Center, University of Minnesota, 1994. Videorecording.
5. Online Etymology Dictionary. Accessed July 20, 2016. http://www.etymonline.com/.
6. Poincaré, Henri. "Intuition and Logic in Mathematics," in *The Value of Science: Essential Writings of Henri Poincaré.* New York: Modern Library, 2001.
7. Serre, Jean-Pierre. *Cours D'arithmétique.* Paris: Presses Universitaires de France, 1970.
8. ———. *Complex Semisimple Lie Algebras.* New York: Springer-Verlag, 1987.
9. Szemerédi, Endre. "Regular partitions of graphs." *Problèmes combinatoires et théorie des graphes* (Colloq. Internat. CNRS, Univ. Orsay, Orsay, 1976), Colloq. Internat. CNRS 260, 399–401. Paris: CNRS, 1978.

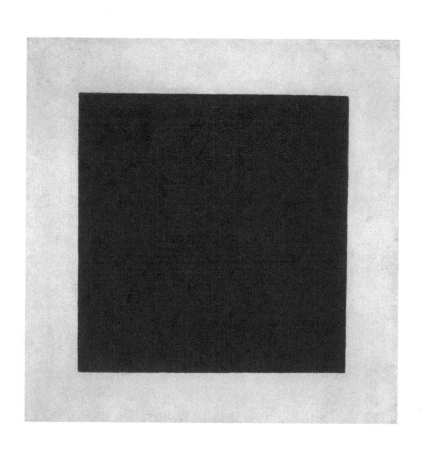

Kazimir Malevich
The Black Square, 1915
Oil on linen
31 1/4 × 31 1/4 inches
Courtesy Tretyakov Gallery, Moscow

The Complexity of Simplicity: The Inner Structure of the Artistic Image

Juhani Pallasmaa

The means with which one paints can never be simple enough. I have always forced myself to become simpler. But the maximum simplicity coincides with the maximum fullness. The simplest means frees the eye for vision to the maximum of clarity. And in the long run only the simplest means is convincing. But courage has always been required in order to be simple. I think there's nothing harder in the world. Those who work with simple means should never be afraid of becoming apparently trite.[1]
—Henri Matisse (1869–1954)

Making the simple complicated is commonplace, making the complicated simple, awesomely simple, that's creativity.[2]
—Charles Mingus (1922–1979)

We tend to think of simplicity and complexity as polar and exclusive opposites. When speaking of phenomena in logic, this view may well be acceptable, but our mental lives and artistic imagery do not follow rules of rationality and logic. While the logical processes focus, the emotive artistic exploration opens up and widens; a logical entity is exclusive, whereas artistic imagery aspires to inclusivity. The objective of art is always to evoke something about the entity of human existential experience. And our minds are in constant flux of images, thoughts, associations, recollections, emotions, and dreams. This existential and mental fusion of irreconcilable categories is the essential realm of art.

[1] Henri Matisse in a conversation with Gotthard Jedlich, 1952. Text was displayed in the exhibition *Henri Matisse: Arabesque*, Scuderia del Quirinale, Rome, 2015.

[2] The quote originates in a letter by Michael Matiisen to the author, dated January 2013.

J. Pallasmaa (✉)
Juhani Pallasmaa Architects, Helsinki, Finland
e-mail: jpallasmaa@gmail.com

© Springer International Publishing AG 2017
R. Kossak, P. Ording (eds.), *Simplicity: Ideals of Practice in Mathematics and the Arts*,
Mathematics, Culture, and the Arts, DOI 10.1007/978-3-319-53385-8_2

17

In his book *The Philosophy of No: A Philosophy of the New Scientific Mind*, Gaston Bachelard (1884–1962), the French philosopher of science and poetic imagery (whose book *The Poetics of Space* has been one of the most influential texts in architectural theory since its publication in 1958), argues that all scientific thought develops along a predestined path: from animism through realism, positivism, rationalism, and complex rationalism to dialectic rationalism [2, p. 15]. "The philosophical evolution of a special piece of scientific knowledge is a movement through all these doctrines in the order indicated," he argues [2, p. 16]. In my view, artistic thinking aspires to advance in the opposite direction; the arts work their way from the realist, rational, intellectual, and analytic understanding of the world back towards a unifying mythical and animistic experience, and art seeks to re-mythicize, re-enchant, and re-eroticize our relationship with the world.

Paradoxically, the notion of simplicity is commonly used both in a pejorative sense and in acknowledgement of a distinct quality. Also the notion of complexity has a dual essence, it implies both something chaotic or unresolved, and a synthetic unity of a multifaceted field of phenomena. To further confuse the interplay of the two notions in the arts, the fundamental meaning of artistic and architectural works is always beyond the material work itself, as it evokes and mediates relationships and horizons of perception, feeling, and understanding. As Maurice Merleau-Ponty (1908–1961) points out: "We come to see not the work of art, but the world according to the work."[3] This philosopher's observation also applies to architecture; a profound building frames and guides our perceptions, actions, thoughts, and feelings instead of being the objective itself. It projects an epic narrative of human life and culture. As a consequence, the entire complexity of life becomes part of even the simplest of artistic or architectural works. As Jean-Paul Sartre (1905–1980) suggests: "If the painter presents us with a field or a vase of flowers, his paintings are windows which are open on the whole world" [16, p. 272]. This openness to the world of feeling and interpretation is an inherent quality of all profound artistic images.

Instead of analyzing and separating things, art is fundamentally engaged in merging and fusing opposites. Alvar Aalto (1898–1976), the Finnish master architect, for one, argued that only by means of uniting opposites, can an artistic work achieve meaningfulness. "Whatever our task...[i]n every case [of creative work] opposites must be reconciled...Almost every formal assignment involves dozens, often hundreds, sometimes thousands of conflicting elements that can be forced into functional harmony only by an act of will. This harmony cannot be achieved by any other means than art."[4]

The art form of architecture is logically an "impure" or "messy" category, as it contains and fuses ingredients from conflicting and even irreconcilable categories, such as materiality and feeling, construction and aesthetics, physical facts and

[3]Maurice Merleau-Ponty, as quoted in [10, p. 409].

[4]Alvar Aalto, "Taide ja tekniikka" (Art and technology), lecture, Academy of Finland, October 3, 1955, in [1, p. 174].

beliefs, knowledge and dreams, past and future, means and ends. In fact, it is hard to imagine a more complex and internally more conflicting human endeavor than architecture.

Such an array of unrelated and conflicting factors, aspects, requirements, and concerns can only be brought to a synthesis—or harmony, to use Aalto's notion—through a creative process based on deep mental identification, embodied metaphors and the fusion of doubt and certainty, emotion and judgement, intuition and feeling, belief and desire. The mediating and reconciliatory task of architecture is twofold; it fuses a multitude of dimensions into an experiential and structured entity, and it serves as an essential fusion of the world and the self. In this fusion we are encountering the miracle of the poetic image and imagination. Architectural projects and propositions are lived spatial metaphors which have their impacts largely on a prereflective and unconscious level. Colin St John Wilson (1922–2007), the architect of the British Library whose former house at Cambridge currently houses the Wittgenstein archive, describes this impact convincingly [20]:

> It is as if I am manipulated by some subliminal code, not to be translated into words, which acts directly on the nervous system and imagination, at the same time stirring intimations of meaning with vivid spatial experience as though they were one thing. It is my belief that the code acts so directly and vividly upon us because it is strangely familiar; it is in fact the first language we ever learned, long before words...now recalled to us through art, which alone holds the key to revive it...

The utterly reductive spatial works of the American artist Fred Sandback (1943–2003) exemplify the perceptual interplay of an extremely simple image and an unexpectedly complex and sensorially subtle experience. In their material essence his works are as minimal as artworks can possibly be, only a few thin lines stretched in space. They could be regarded as "minimalism," but the artist himself did not like the label and preferred to call his pieces "sculptures" or "constructions" [15]. The notion of minimalism is altogether problematic, as usually the characterization is based on a purely formal understanding of the work, or a process of deliberate formal simplification as a stylistic preconception. Sandback defines his works as "simple facts" without any representational intentions.[5] Yet, the artist's statement of his conscious intention cannot void the perceptual and cognitive processes that his works set in motion in the observer's mind. Regardless of the artist's expressed view, his works automatically complete their gestalt in the viewer's mind, and seek their meanings. Frank Stella famously described his intention: "What you see is what you see,"[6] but in the phenomenon of art, what you experience is never what you actually see. A profound work opens up a wide field of images, meanings, associations, recollections and intuitions. Every great work of art is an open excavation. In the

[5]"A sculpture made with just a few lines may seem very purist or geometric at first. My work isn't either of these things. My lines aren't distillations or refinements of anything. They are simple facts, issues of my activity that don't represent anything beyond themselves. My pieces are offered as concrete, literal situations and not as indications of any other sort of order [14, p. 106].

[6]Source unidentified.

light of current neurological studies the process of "seeing" is far more complex than has been assumed; the process of perception always fuses observation, memory, and imagination and it is essentially a creative act.

The hidden complexity of Sandback's spatial configurations arises from our perceptual mechanism, the *gestalt* power of geometry, and the convention of reading spatiality in a drawing, as well as from the essential and unavoidable ambivalences and tensions between the material and imaginative realities in art. Besides, we constantly seek meaning because the act of giving meaning is built into our system of perception itself. Sandback's nearly immaterial lines of acrylic yarn, tensioned in space, are essentially philosophical questions: why and how does a spatial image arise; what is the reality of this mental unreality; why does a thing exist rather than not?

Sandback's works are essentially spatial drawings: his lines make us see a specifically shaped figure of space, an imaginary shape or volume set on the floor, leaning against a wall, or suspended in the air. The connected lines, arranged as planar configurations in a corner of a gallery, or suspended between the walls, ceiling, and/or floor, lose their linear nature as a drawing, as they become immaterial spaces with ideated materiality. The air inside the imaginative figure seems denser and of a slightly different consistency than the air outside the figure. The nonexistent plane even acquires an experiential color and weight. This artistic alchemy is particularly effective in the constructions of four lines that make us conceive a rectangular plane leaning against a wall. The imagined rectangle transforms into a sheet of glass-like transparent but non-existent matter, and the construction seems paradoxically both to invoke an imaginary volume and to annul weight and gravity. The "plane" leaning against the wall appears to bend of its own weight. These experiences or perceptions are likely to be a result of our empathetic capacity brought about by our mirror neurons and systems; we feel the imaginary plane through our unconscious bodily mimesis, or embodied simulation, and our combined sense of balance and gravity. Similarly, we experience the weight and ideated movement of Richard Serra's pieces of steel through our muscles and bones, skin and sense of balance. We re-enact what we see through the empathetic capacity of our body. Without being conscious of it, we become the artistic work that we are looking at, listening to, or reading. "Be like me," is the demand of every poem to its reader, according to Joseph Brodsky (1940–1996), and this unconscious identification applies to all art, including architecture [6].

Yet, visual tricks and illusions are mere perceptual demonstrations of the psychologist or the magic of an illusionist, whereas an artistic impact calls for a metaphoric and existential content. Profound artistic works are always about the world and the perceiver's own life situation and consciousness. A work of art makes us encounter a specific world, which is not symbolic, but real in its own right. What are the hidden metaphors of Sandback's constructions? Don't his works question the assumptions of naive realism, and don't they reveal to us the relativity and dialectical nature of our experience of reality. We do not live in a given and objective world, but one of our own making, and this world and our self constitute an entity

and continuum. "In a word, the [artistic] image is not a certain meaning…but an entire world reflected in a drop of water," as the great Russian film director Andrei Tarkovsky (1932–1986) suggests [18, p. 110].

A work of art has a double existence: it takes place in its own reality of matter and execution, on the one hand, and in an imaginative world of perception, association, thought, and emotion, on the other. We do not usually see the silhouette of a figure as an independent line because we perceive the physical object that it encloses, and we name that very object. The focusing on one aspect of our perceptual field tends to make us loose sight of the other aspects. We do not primarily experience the physical matter of sculpture either, as we perceive the volume and shape of the piece in its suggestive and imaginative reality. Similarly, in a building we do not experience the meaningless physical space as we are affected by the architecturally articulated space possessing specific intentionalities and meanings. Art makes visible the invisible and gives meaning to the meaningless. A tension between these two realities is fundamental for the magic of art.

The ultimate ideal of all art (and an impossibility, we must admit) is to fuse the complexity of human experiences into a singular image, or "the oceanic feeling" of unity and oneness of the child in the mother's womb, as psychoanalytic thinking suggests. Rainer Maria Rilke (1875–1926) writes touchingly about the ingredients of this poetic condensation: "[V]erses are not, as people imagine, simply feelings— they are experiences. For the sake of a single verse, one must see many cities, men and things, one must know the animals, one must feel how the birds fly and know the gesture with which the little flowers open in the morning" [12, p. 26]. The poet continues his list of experiences required for the writing of a single verse for the length of a full page. He lists roads leading to unknown regions, unexpected encounters and separations, childhood illnesses and withdrawals into the solitude of rooms, nights of love, screams of women in labor, and tending the dying. But even all of this together is not sufficient to create a line of verse. In the poet's view, one has to forget all of this and have patience to wait for the distilled return of these experiences. Only after all our life experiences have turned to our own blood within us, "not till then can it happen that in a most rare hour the first word of a verse arises in their midst and goes forth from them" [12, p. 27]. The poet's powerful description makes clear that a poem is not a formal invention; it is a poetically constructed world.

In the mental and artistic realms a special form of complexity in simplicity is the archetype. The concept originates in Sigmund Freud's (1856–1939) idea of "archaic remnants" of the mind. Later, Carl Jung (1875–1961) defined the archetype as a tendency of an image to evoke distinct associations, feelings and meanings in our collective memory. Again, the openness and layeredness of the mental phenomenon is essential—a wealth of associations mediated by a collectively identifiable image, instead of a specific and closed meaning. In their desire to fuse the primordial mythical past and the lived actuality, works of art tend to approach the concept of the archetype, or these works touch upon a hidden imagery of primordial power.

Barnett Newman (1905–1970), the American Abstract Expressionist painter, entitled some of his paintings, consisting of a single linear element against the

background of a single color, *Onements*. The painter condenses a multitude of existential experiences into an ultimately simple image. Kazimir Malevich's (1879–1935) painting of a black square on white ground and Yves Klein's (1928–1962) mono-chromatic paintings, as well as James Turrell's (1943–) skyspaces, are similar "onements," which fuse the multiplicity of experiences into a singular indivisible whole. There are no "elements" in these works, only their singularity. Do they represent simplicity or complexity?

These works derive their richness from their enigmatic nature; they are inexhaustible generators of questions and feelings. The experience of encountering a work of art is not simply a matter of looking at or hearing the work. The process is a complex interaction and exchange between the work and the embodied mind of the person experiencing it. Ingredients of one's individual memory as well as archetypal meanings and feelings enter the process; the encounter unveils layers of the work at the same time that the work unveils layers of the perceiving mind. In Lucio Fontana's (1899–1966) famous slashed canvases, for instance, the violent act of gashing is certainly present as an unconscious mimetic experience; when looking at his works, I feel the threatening sharpness of the blade, and the "pain" of the canvas being slashed. Viewing an artwork is not unlike an archeological excavation in which both the depth of the work and the perceiving mind are being simultaneously excavated.

The difficulty of determining something as simple or complex in an artwork, arises from the fact that any artistic image—painting, poem, a piece of music, or architectural space—exists simultaneously in two realms, firstly as a material phenomenon in the physical world, and secondly as a mental image in the unique individual experience. In the first sense, the *Black Square* of Malevich is just a simple geometric figure in black against a white ground, executed by the painter's brush. However, the painted surface, crackled by time, gives the painting a sense of uniqueness and authenticity, reality and age, beyond its geometric essence, as well as its iconic authority and aura. Old icon paintings possess a similar authority and radiance. The work is in a dialogue with artistic works before its creation as well as with ones that have come after it. Its mental image is numerous things at the same time, which connect it to existential, philosophical, metaphysical, religious, and symbolic fields. The viewer's imagination and autonomous search for meaning sets a never ending process of association and interpretation in motion. It is the provocative undefinedness and openness of the poetic suggestion that gives it its evocative richness, sense of life, and mental complexity. Simplicity turns into labyrinthian complexity. A profound artistic or architectural work is always a never-ending mental rhizom. Devoid of the enigmatic suggestiveness of the poetic image, a square remains a mere lifeless geometric figure without deeper meanings and the capacity to evoke emotions. Profound architectural simplicity condenses imagery and meaning similarly. The geometry of architectural constructions and spaces turns into spatial mandalas, devices that mediate between the cosmos, the world and the self. Also in architecture, formal simplicity, devoid of poetic intention and richness of feeling, results in mere construction.

The Wittgenstein House, which Ludwig Wittgenstein (1889–1951) designed and built in Vienna in 1928, is an illuminating case regarding the necessary interaction of formal simplicity and complexity of context and content. Conceived by a major philosopher of the twentieth century, it is undoubtedly a product of serious and precise thinking, which has reduced all architectural elements into their minimum essence. The fact that Wittgenstein had the intermediate floor plate chiseled away and recast three centimeters higher, convinces us of the author's uncompromising architectural ambition. However, the building remains curiously mute and lifeless. What seems to be missing in this ultra-rational piece of architecture is the mental complexity and contextual dialogue, sense of embodiment and poetic sensuality. "I am not interested in erecting a building, but in. . . presenting to myself the foundation of all possible buildings," Wittgenstein himself confessed [22, p. 9]. It seems that exactly this rationalized generality makes the Wittgenstein House appear mute; it feels like a logical formula for a house rather than a specific and authentic building in the "flesh of the world," to use the suggestive notion of Maurice Merleau-Ponty.[7] The work hardly evokes associations, or feelings, it merely exists as itself and reflects its uncompromising system of proportions and structure.

Today's Minimalist architecture usually implies the application of a formal stylistic preconception, whereas meaningful artistic simplicity and abstraction is a result of a laborious and gradual process. The word "abstraction" suggests misleadingly a subtraction or reduction of contents and meaning, but a pregnant artistic abstraction that has the capacity to touch our emotions and charge our imaginations can only arise from the opposite process of distillation or compression. Constantin Brancusi (1876–1957), the master sculptor, gives us a significant piece of advice: "Simplicity is not an end in art, but one arrives at simplicity in spite of oneself, in approaching the real essence of things. . . simplicity is at bottom complexity and one must be nourished on its essence to understand its significance" [4]. What does the artist mean by "in spite of himself"; does he suggest that simplicity has its own gravity that pulls the artist to go for it regardless of his true nature?

A true abstraction condenses countless ingredients of the creative exploration into an artistic singularity. At the same time, the work takes a determined distance from the subjectivity of the author towards universality and anonymity. Balthus (Balthasar Klossowski de Rola) (1908–2001), one of the greatest figurative painters of last century, makes a surprising and thought provoking comment on artistic expression. "If a work only expresses the person who created it, it wasn't worth doing. . . Expressing the world, understanding it, that is what seems interesting to me" [13, p. 18]. Later, Balthus reformulated his argument: "Great painting has to have a universal meaning. This is really no longer so today and this is why I want

[7]In "The Intertwining—The Chiasm" Merleau-Ponty describes the notion of the flesh as follows: "My body is made of the same flesh as the world. . . and moreover. . . this flesh of my body is shared by the world" [11, p. 248] and "The flesh (of the world or my own) is. . . a texture that returns to itself and conforms to itself" [11, p. 146].

to give painting back its lost anonymity, because the more anonymous painting is, the more real it is" [3, p. 6]. This is a thought-provoking argument, but the same argument could surely be made of architecture. In its obsessive search for uniqueness, architecture of our time has often become meaningless.

All meaningful works of art are microcosms, miniaturized and condensed representations of a metaphoric and idealized world. This is an internal universe of the work itself, the *Weltinnenraum*, to use a beautiful notion of Rilke [8, p. 8]. The poetic image keeps guiding our minds to constantly new contexts: clarity contains inviting obscurity, and formal simplicity turns into an experiential complexity. "What is there more mysterious than clarity?" Paul Valéry (1871–1945), the poet asks [19, p. 107]. William James (1842–1910), the visionary American psychologist, describes the essential fluidity and open-endedness of mental imagery: "Every definite image in the mind is steeped and dyed in the free water that flows around it. With it goes the sense of its relations, near and remote, the dying echo of whence it came to us, the dawning sense of whither it is to lead. The significance, the value of the image, is all in the halo or penumbra that surrounds and escorts it" [9]. Clarity has value in art only when it projects a potent field of crisscrossing associations and impression. The most simple of poetic images, which arises from an authentic process of artistic distillation, keeps suggesting images and echoes and endlessly seeking new meanings.

The associative imagery of art is existential rather than aesthetic and it addresses our entire sense of being. Instead of offering mere visual pleasure, architecture, also, stirs up deep layers of the mind and sense of self, or more precisely, true architectural images evoke multi-sensory and embodied memories, making the architectural entity part of our bodily constitution and sense of existence. Through our body, we re-enact and mimic unconsciously whatever we encounter in the world; this is called "embodied simulation." As neurological studies have recently confirmed, every meaningful work of art and architecture actually changes our brain, behavior, and self-understanding.[8]

In addition to the sphere of the arts, the interaction of simplicity and complexity is especially impressive and inspiring in the natural and biological world. Here the constant interaction of simple principles and causalities creates a never ending flow of subtle variations and complexities. The complexity of the biological world is normally underestimated as we tend to overvalue our own understanding and achievements. Edward O. Wilson (1929–), the world's leading myrmecologist and the spokesman of Biophilia, the science and ethics of life, makes the staggering argument, that the "superorganism" of a leafcutter ant community is "one of the evolution's master clockworks, tireless, repetitive and precise, and more complicated than any human invention and unimaginably old" [21, p. 37]. No wonder, complicated traffic systems are designed today using models of ant behaviour, and new types of super-fast computers are being developed using our own neural network as the model. At the same time, Semir Zeki, a neurobiologist and professor

[8]Fred Gage, as quoted in [7, p. 135].

of neuroaesthetics, who has applied the recent knowledge of the neurosciences on artistic phenomena, suggests "a theory of aesthetics that is biologically grounded" [23, p. 1]. What else could beauty be than nature's ultimate principle of bringing complexity into the stunning coherence of seemingly self-evidently simple beauty. Joseph Brodsky declares this view with the assurance of a great poet: "The purpose of evolution, believe it or not, is beauty [6].

I wish to end my essay on the interplay of simplicity and complexity in the arts with Constantin Brancusi's powerful and poetic statement on the fundamental requirement of a true artistic work: "Art must give suddenly, all at once, the shock of life, the sensation of breathing."[9]

References

1. Aalto, Alvar, "Alvar Aalto In His Own Words." Edited and annotated by Göran Schildt. Helsinki: Otava, 1997.
2. Bachelard, Gaston, *The Philosophy of No: A Philosophy of the New Scientific Mind*. New York: The Orion Press, 1968.
3. Balthus. *Balthus in His Own Words: A Conversation with Christina Carrillo de Albornos*. New York: Assouline, 2001.
4. Brancusi, Constantin in 1926 Brancusi Exhibition Catalogue, Brummer Gallery, New York. Republished in [17].
5. Brodsky, Joseph. *On Grief and Reason: Essays*. New York: Farrar, Straus and Giroux, 1995.
6. ———. An Immodest Proposal, in [5, p. 208].
7. Eberhard, John Paul. "Architecture and Neuroscience: A Double Helix." In *Mind in Architecture*. Edited by Sarah Robinson and Juhani Pallasmaa. Cambridge, MA: The MIT Press, 2015.
8. Enwald, Liisa. *Hiljainen taiteen sisin: kirjeitä vuosilta 1900–1926*. In Finnish. Helsinki: TAIteos, 1997.
9. James, William. *Principles of Psychology*. Cambridge, MA: Harvard University Press, 1983.
10. McGilchrist, Iain. *The Master and His Emissary: The Divided Brain and the Making of the Western World*. New Haven, CT: Yale University Press, 2010.
11. Merleau-Ponty, Maurice. *The Visible and the Invisible*. Edited by Claude Lefort. Evanston, IL: Northwestern University Press, 1969.
12. Rilke, Rainer Maria. *The Notebooks of Malte Laurids Brigge*. London: W.W. Norton & Company, 1992.
13. Roy, Claude. *Balthus*. Boston: Little, Brown and Company, 1996.
14. Sandback, Fred. *Fred Sandback*. Edited by Friedeman Malsch and Christiane Meyer-Stoll. Ostfildern: Hatje Cantz, 2005.
15. ———."Untitled", in [14].
16. Sartre, Jean-Paul. *What Is Literature?* Gloucester, MA: Peter Smith, 1978.
17. Shanes, Eric. *Brancusi*. New York: Abbeville Press, 1989.
18. Tarkovsky, Andrei. *Sculpting in Time: Reflections on the Cinema*. London: The Bodley Head, 1986.
19. Valéry, Paul. "Eupalinos or the Architect." In *Dialogues*, translated by William McCausland Stewart. New York: Pantheon Books, 1956.

[9]Constantin Brancusi, as quoted in [17, p. 67].

20. Wilson, Colin St John. "Architecture—Public Good and Private Necessity." *RIBA Journal*, March 1979, 107–115.
21. Wilson, Edward O. *Biophilia: The Human Bond With Other Species*. Cambridge, MA: Harvard University Press, 1984.
22. Wittgenstein, Ludwig. *Culture and Value*. Chicago: University of Chicago Press, 1984.
23. Zeki, Semir. *Inner Vision: An Exploration of Art and the Brain*. Oxford: Oxford University Press, 1999.

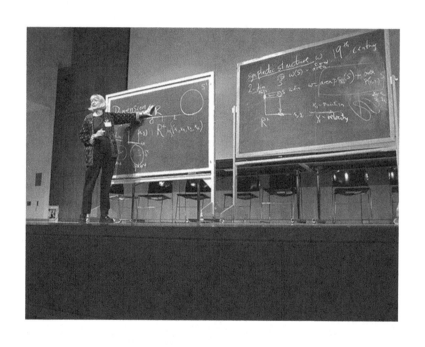

Dusa McDuff
Photo by María Clara Cortés

Thinking in Four Dimensions

Dusa McDuff

Editors' note: This text is an edited transcript of the author's conference talk.

I've got the rather foolhardy idea of trying to explain to you the kind of mathematics I do, and the kind of ideas that seem simple to me. For me, the search for simplicity is almost synonymous with the search for structure.

I'm a geometer and topologist, which means that I study the structure of space. Geometers make measurements in space, while topologists tend to look at spaces with no extra structure with the aim of understanding their basic possible shapes. In the particular geometry that I want to tell you about, which is called *symplectic geometry*, we make a rather idiosyncratic kind of measurement. Instead of measuring one-dimensional things like the length of a line segment, we measure two-dimensional things such as the area of a piece of surface. I want to explain to you why that's interesting, why one would ever do such a thing. I also want to point out that adding extra structure in this way is not so unusual. In much of modern topology, even though the main object of study is a plain vanilla space, one often adds extra structure to make the space more understandable—without that it can be featureless and enigmatic, simple in one way because it has no discernible features but potentially very complicated.

For example, the three-dimensional Poincaré conjecture states that if a three-dimensional space looks as though it should be a sphere because it has no obviously disqualifying features, then it really is a sphere. Despite many efforts, this deceptively simple conjecture took over 100 years to establish. The new idea was to put a metric on the space, which allows you to measure the distance between any

D. McDuff (✉)
Mathematics Department, Barnard College, Columbia University, New York, NY, USA
e-mail: dusa@math.columbia.edu

© Springer International Publishing AG 2017 29
R. Kossak, P. Ording (eds.), *Simplicity: Ideals of Practice in Mathematics and the Arts*,
Mathematics, Culture, and the Arts, DOI 10.1007/978-3-319-53385-8_3

two points. By looking at the properties of these metrics and various complicated but natural differential equations they satisfy, Perelman was finally able to prove that the conjecture is true.

The similar conjecture in four dimensions is still unsolved, though it has been solved in dimensions five and above: curiously this kind of problem becomes easier as the dimension increases because there's just more room to do things. That's one of the reasons that four dimensions is interesting. Another is that for the kind of structure I look at, which is a symplectic structure, four dimensions is really the first interesting case.

Let me now tell you a little bit about dimension. I know that you're not all mathematicians, and so when I talk about spaces of a particular dimension, I should explain what that means. Well, start with one dimension—that's easy, that's just a line, an infinite line which we think of as the real numbers. We can describe a line just by taking a point and numbering where we are, how far we are along the line, positive or negative. (This fits very well with the previous talk [by Andrea Worm, "Constructing the Timeline: Simplicity and Order as Guiding Principles for the Visualisation of History"] because this was the notion of time discussed.) But a line can also wrap up on itself to form a circle, and notice that a little piece of the circle looks like a little piece of the line. So, the circle is another one-dimensional space.

Two-dimensional spaces are also easy to understand. A typical example is the surface of this blackboard. Why is that two-dimensional? Well, if you want to describe where you are in the space you need two numbers: one number which tells you how far you've gone in the horizontal (or x) direction and another number which tells you how far you've gone in the vertical (or y) direction. In all, you're located by a pair of numbers x, y, which makes the space two-dimensional. Similarly, a three-dimensional space has three different directions—say "up," "forward," and "sideways"—and you need three numbers x, y, z to describe where you are, while in four dimensions, you need four numbers x, y, z, t, and so on.

In each dimension there is a simplest space called Euclidean space that extends uniformly without end: the line \mathbb{R} in one dimension, the plane \mathbb{R}^2 in two dimensions, the familiar three-space \mathbb{R}^3 in three dimensions, the four-space \mathbb{R}^4 in four dimensions, and so on. Just as a one-dimensional space can wrap up on itself making a circle, there are more complicated, wrapped-up forms of spaces of other dimensions. Locally, such a space would look like a piece of Euclidean space, but globally it would twist around. Then, you might want to know how it twists around and know all the possible ways that it might do this.

Given such a space in two dimensions (often called a surface), you can draw pictures to illustrate how it is wrapped up. For example, we can sketch the surface of a sphere (which is just the surface of a ball) or the surface of a donut (often called a torus; see Fig. 2). It is much harder to picture a three-dimensional space that is globally twisted—you can't draw it in three-dimensional space because you run out of room: you start with a little piece of three-dimensional space and then to describe how it curves you have to go out of standard three-dimensional space. In four dimensions it's even more of a problem because there is the extra dimension to take account of.

Now as I said I don't study plain vanilla spaces, but spaces with a particular kind of structure, called a *symplectic structure*. This structure had its beginnings in the work of the nineteenth century Irish physicist, astronomer, and mathematician William Hamilton. He was interested in understanding the basic equations of motion, how a planet moves around the sun, or how a rotating top behaves. A top spinning on the floor exhibits all kinds of complicated behaviors; it precesses, wobbles and wanders around obeying a set of very complicated equations that on the face of it look impossible to understand or solve. Hamilton realized that, because the motion conserves energy, the equations have a very special structure. He cleverly used this structure as a guide to choosing specially adapted coordinates in which the equations are so simple that they can be solved. This underlying structure was later made more explicit and formulated in terms of a symplectic structure as we understand it today. So symplectic geometry actually began as a computational device, but later on mathematicians realized that it is one of the very few fundamental kinds of geometry.

Let me explain how symplectic geometry differs from the more familiar Euclidean geometry. In Euclidean geometry you measure length, which is a one-dimensional measurement, while in symplectic geometry you measure area, a two-dimensional measurement. This difference means that symplectic geometry exists only in even-dimensional spaces, so we have two-, four-, or six-dimensional symplectic geometry, but for instance no three-dimensional symplectic geometry.

The way you measure area in symplectic geometry is with a *symplectic form* which is traditionally called omega, ω. If you have a little bit of surface S in a two-dimensional space, then the form ω gives a number $\omega(S)$, which you can think of as the area of S except that it's allowed to be negative as well as positive: for example if you take a surface with positively measured area and flip it over, then its measure becomes negative.

How does this work in the four-dimensional space \mathbb{R}^4? Now we have four coordinates or directions—often called x_1, y_1, x_2, y_2—but can only measure the size of two-dimensional objects S in the space. The idea is this. Given such a piece of surface S in \mathbb{R}^4 we project it—think of shining a light on it to cast a shadow—to a two-dimensional space in two different ways and then add the resulting areas. Thus, to begin we project S onto the first two coordinates x_1 and y_1, getting a projection or shadow that forms some two-dimensional region, and we measure its area. Next we project onto the second two coordinates x_2, y_2 to get a second shadow with a second area. Finally we add these two areas to get the measure $\omega(S)$. (See Fig. 1.)

It's hard to see why this measurement has meaning, but it does. Before I said that this geometry arose from trying to understand motion, and I want to give you some idea of why this measurement might be relevant in this context. Suppose you have something which is moving in one dimension, such as a particle confined to a line. There are two relevant numbers: the first x_1 is the position of the particle, and the second y_1 is its velocity or the speed, i.e. how fast it's moving. If we know the forces that are acting, then the position and velocity at one time determine these two numbers at all subsequent times. Now, if you need two numbers to describe the motion of a particle in a single direction, you need four numbers to describe its

Fig. 1 A symplectic form

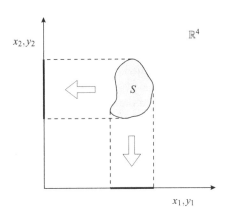

motion in the plane—two numbers (say x_1 and x_2) to describe its position and two numbers (say y_1 and y_2) to describe its velocity, where y_1 measures how fast it is moving in the x_1-direction and y_2 measures how fast it is moving in the x_2-direction. In this way we can describe the motion of a particle in the plane in terms of the four coordinates (x_1, y_1, x_2, y_2) of a four-dimensional space. The symplectic form is the sum of one measurement involving the pair x_1, y_1 together with another involving x_2, y_2. Thus it is a combined measurement of position and velocity that, as I explained above, turns out to be a fundamental and simplifying structure. Note also that although the measurement takes place in dimension four (or six or higher), it is intrinsically two-dimensional.

Here is a different simplifying idea. So far, I've described geometry using the real numbers as our basis. The real numbers form a line; they are complete, and they are ordered. But there's another kind of number that I want to talk about called *imaginary* numbers. The simplest imaginary number is $i = \sqrt{-1}$, the square root of minus one, that is, you have a number with the strange property that when you square it (multiply it by itself), you get -1. Clearly, i is not a real number because the square of any real number is positive. But people slowly discovered the importance of considering numbers with negative square in the Renaissance. At that time, people hardly thought that negative numbers were proper numbers, so they certainly didn't think that these were proper—hence the name "imaginary" numbers.

One useful property of imaginary numbers is that you can add them to real numbers. The sum of an imaginary number with a real number is called a *complex* number. For example, the complex number $2 + 3\sqrt{-1}$ is the sum of a real part 2 and an imaginary part $3\sqrt{-1}$ or $3i$. You can picture these numbers as belonging to a two-dimensional space because you have one coordinate for the real part, in this case 2, and another for the imaginary part, in this case 3. So complex numbers belong to a plane that we call the *complex plane* and denote \mathbb{C}. It is not very difficult to see that you can add two complex numbers by adding the real parts and the imaginary parts separately. But it is really quite surprising that you can also multiply and divide them, getting a set of numbers with all the arithmetic properties of the real numbers but that are intrinsically two-dimensional.

I have always thought complex numbers are magical, and one of the reasons is this: by introducing just one new number i to the real numbers you get an entirely new number system. There's something more if you consider the situation in terms of equations and basic algebra. Take the equation $x^2 = -1$. If you try to find a real number x that satisfies this equation, you cannot. But the new number i is precisely a solution to this equation. So, by creating the complex numbers you have supplied a number that satisfies this equation. The amazing fact now is that if I write down *any* other polynomial equation, such as $3x^5 + \pi x^3 - \sqrt{2}x + 59 = 0$ then I can solve it using complex numbers. (In fact, this equation being of degree five has exactly five solutions, if these are counted correctly.) Thus, just by adding one number to the reals to solve one particular equation, we have created a set of numbers that solve *all* possible polynomial equations. These are really powerful numbers!

There is still more magic to complex numbers if you know about functions and calculus. A *complex function* is a rule that to every complex number gives you another complex number. In other words, it is an input–output device that returns a complex number for every complex input. Normally these two numbers are completely different from each other. But you could ask that the function have nice properties, like being continuous. This would mean when the input changes a little the output also only changes a little. A stronger property is that the function is differentiable, meaning that you can measure how fast the output changes with respect to the input. A complex differentiable function is called a *holomorphic function*. These have an amazing property: if you know the output values for inputs in just a little piece of the complex plane then you know the output values for *any* possible input. So there's a remarkable uniqueness and rigidity about functions of a complex variable. Going along with this is the fact that complex geometry is a very rigid kind of geometry.

Now one of the interesting things about symplectic geometry is that it has a really deep connection to complex geometry. We have already discussed how symplectic geometry lives only in even dimensions. Remember also that in order to define the symplectic form in four-dimensional space \mathbb{R}^4 the coordinates are grouped into pairs (x_1, y_1) and (x_2, y_2). Out of these pairs we can make two complex numbers by thinking of each pair as the real and imaginary parts of a single complex number, written as $z_1 = x_1 + iy_1$ and $z_2 = x_2 + iy_2$. Thus, out of four real numbers we make two complex numbers, which means that instead of thinking of our space as four-dimensional \mathbb{R}^4 we can think of it as two-dimensional \mathbb{C}^2. That's a huge simplification.

Well of course you could say, "Alright you could do that, but does it have any meaning?" In other words, is this complex structure merely *imposed* on the symplectic space or is it *intrinsic* to the space? Suppose you have a four-dimensional space that locally looks like Euclidean space and is equipped with a symplectic form, a so-called *symplectic manifold*. It turns out—actually this is one of the big innovations that Misha Gromov made to the field—that although you can't quite locally identify the neighborhoods of this manifold with the neighborhoods of \mathbb{C}^2, there is something good enough, a remnant of complex geometry called an *almost complex structure* that is sufficiently intrinsic. This is an enormously

Fig. 2 A Morse function

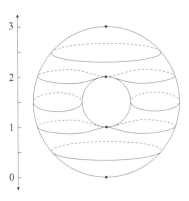

simplifying idea. It means that instead of looking at four separate coordinates that could twist separately across your manifold you've really only got two things to worry about. Moreover, this structure means that you can look inside a symplectic manifold for particular surfaces that are described by a single complex coordinate, and so in a sense are one dimensional—namely, curves. If you can find such complex curves they give you a lot of information, and so people have developed many theories for trying to find them.

One last way that I will try to explain the simplifying power of this idea of using complex coordinates is through a complex version of what's known as *Morse theory*. The basic idea is to try to understand the structure of a manifold by putting a (real-valued) function on it. The best example to start from is a torus, which remember is a two-dimensional manifold in the shape of the surface of a donut. If you imagine the donut positioned upright in Euclidean space in such a way that you can see through the hole in the middle, then a simple function on the torus is the *height function*. (See Fig. 2.) If for some choice of coordinates on Euclidean space a point P on the torus has the three real numbers (x, y, z) as coordinates, then the height function of P just takes the value z. We'll set things up so that the bottom of the torus is at the height 0, the bottom of the donut hole is at height 1, the top of the donut hole is at 2, and the top of the donut is at 3. Then the set of points at any given height form a curve called a *level set*, whose shape varies: for example at height $\frac{1}{2}$ you have a circular loop, at height 1 a pair of circles joined at a point, at height $1\frac{1}{2}$ two separate circles, at height 2 again a pair of joined circles, at height $2\frac{1}{2}$ another circular loop and then finally at height 3 a single point.

What this function does for you is decompose the manifold, which is two-dimensional, into a sequence of one-dimensional level sets in such a way that you can understand how the structure changes. In particular, the points where the structure changes abruptly, which we call *singularities*, are especially significant. In the case of a torus, as we move up the levels, the level sets are first a point, then some circles, which are at first joined but then separate for a while before coming together again and eventually disappearing—so they give you a sort of movie of what the manifold is like. That's what a real—as opposed to complex—Morse function shows you.

One of the recent discoveries in this area of mathematics, proven by Donaldson, is that in the symplectic world there's a complex analog of a Morse function. A complex Morse function would not take values in an interval anymore; rather its values lie in a region of the complex plane—i.e. a two-dimensional space that we can assume looks like a disc. Now if you consider a level set of such a function (the set of all points where the function takes a given fixed value) it would be a one-dimensional complex object, i.e. a complex curve (which is of course a two-dimensional real object). So what this function does is take the manifold, which is an unknown and rather incomprehensible four-dimensional space, and decompose it into a family of two-dimensional objects. Moreover, since the function that produces this decomposition is complex, it has some very nice properties that are related to the complex curves I was talking about earlier. So that gives a whole lot of structure to your manifold, reducing something four-dimensional to families of two-dimensional things, which are much, much easier to understand.

I should mention that not all four-dimensional manifolds have a symplectic structure. But it turns out that you can adapt the Morse function idea to find similar decompositions for arbitrary manifolds. Overall, the decomposition of four-manifolds into families of two-manifolds has turned out to be a very fruitful way to probe the structure of four-dimensional spaces—though still many mysteries remain.

In this talk I have tried to explain some of the ideas that are used to understand the structure of low-dimensional spaces. These ideas bring simplification in the sense that they allow you to convert what seems initially unknowable into a more orderly, even if complicated, landscape of different possibilities and structures.

References

1. McDuff, Dusa. "Symplectic Structures—A New Approach to Geometry." *Notices of the American Mathematical Society* 45 (1998): 952–960.
2. ———. "What is Symplectic Geometry?" In *European Women in Mathematics: Proceedings of the 13th General Meeting, University of Cambridge, UK, 3–6 September 2007*, edited by Sylvie Paycha, 33–51. New Jersey: World Scientific, 2010.

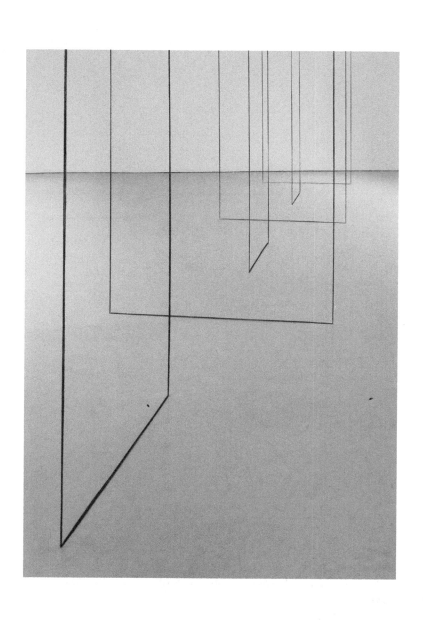

Fred Sandback
Untitled (Sculptural Study, Six-part Construction) (detail), ca. 1977/2008
Black acrylic yarn
Dimensions vary with each installation
©2016 Fred Sandback Archive
Courtesy David Zwirner, New York/London

Kant, Co-Production, Actuality, and Pedestrian Space: Remarks on the Philosophical Writings of Fred Sandback

Juliette Kennedy

> *My mom told me about this Charlie Chaplin film... said she enjoyed a clip of Charlie Chaplin eating an artichoke. Finding himself befuddled at a fancy dinner, he took one leaf off, looked at it, and threw it over his shoulder. And so on through the meal until he got to the lovely heart, he looked at it, and regarded it a little longer and threw it over his shoulder. And at that age when mom told it to me it was still already a potent image of moving on beyond Immanuel Kant and the thing itself and leaving that borderline with Platonism behind in the dust somehow. All right, so much for that.*[1]
> —Fred Sandback, 2002

> *Understanding something often means dissecting it into its component parts. My work resists that kind of understanding, as it's all one thing to start with.*[2]
> —Fred Sandback, 1975

Fred Sandback

The sculptor Fred Sandback, born in 1943 in Bronxville, New York, was an iconic figure in contemporary art.

Sandback's sculptures are drawn in space with acrylic yarn, creating "habitable drawings" [19] in which huge triangles lean against the wall, and crowds of vertical lines occupy the space like living presences.

[1] Notwithstanding Sandback's remark, it appears likely that the film was from an episode of *The Little Rascals*. This quote is found in [20].

[2] Sandback's writings are available online at the Fred Sandback Archive [8]. This quote appears in [12].

J. Kennedy (✉)
Department of Mathematics and Statistics, University of Helsinki, Helsinki, Finland
e-mail: juliette.kennedy@helsinki.fi

© Springer International Publishing AG 2017
R. Kossak, P. Ording (eds.), *Simplicity: Ideals of Practice in Mathematics and the Arts*,
Mathematics, Culture, and the Arts, DOI 10.1007/978-3-319-53385-8_4

Sandback's stated intention for the work is that it is brought into being by three things: the physical material, the surrounding architecture, and the viewer—a "strong, immediate, and beautiful situation," as Sandback put it [12], which, though perhaps related to Minimal and Conceptual art practices, ultimately leaves both behind.

Sandback died in 2003, but his work lives on in the permanent collections of major museums all over the world, and in numerous exhibitions of his work worldwide.

This essay is about Sandback's writings.

Philosophy at Yale

In writings of great lucidity, written over a period of more than three decades, Sandback explained the evolution of thought behind his work. Sandback's training in philosophy while an undergraduate at Yale during the period 1962–1966, one of the great philosophy departments in the United States at the time, not only informs the writings but, as Kant scholars may notice upon contact with the texts, certain critical philosophical terms appearing in the more philosophical writings to be found among the texts point toward Kant's philosophy as a possible formative influence. In fact the period coinciding with Sandback's undergraduate years as a philosophy major at Yale was something of a Kantian age in the department, through the presence of Wilfrid Sellars and Ruth Millikan.[3] Of course, Sandback's art is in no way a product of this or that philosophical system, nor can it be said that Sandback ever had, or was ever interested in, developing such a system for himself. And yet, the thread of philosophy is woven into the writings, in particular the specifically Kantian philosophy to which Sandback would have been exposed at Yale. Thus it seems appropriate to give a reading of the texts that takes Sandback's philosophical training into account.

In the brief remarks that follow we juxtapose certain aspects of Kant's philosophy with texts of Sandback's, in an attempt to begin to bring out what may be considered the philosophy of Sandback's writings—a philosophy that lives an independent life in those writings, while at the same time it may also inform, in some way, the work.

We do not wish to assert direct cause and effect here; we merely wish to point out a shared philosophical language and a thread of ideas that, while perhaps not explicitly Kantian, nevertheless subsists as a certain Kantian *something* in the writings.

[3]The list of courses Sandback took while an undergraduate are follows: logic, the history of classical and modern philosophy, "The Philosophy of Existence," "Symbolism and Experience," described as "an examination and critical reconstruction of four conflicting theories of literal and metaphorical meaning: logical positivism, traditional rationalism, existentialism, and the neo-Kantian positions of Cassirer and the later Wittgenstein"; "The Ways of Knowing," a course on Kant taught by Richard Bernstein, an admirer of pragmatism; and finally an independent study course with the art historian George Kubler. For Sandback's Yale transcript see [21, p. 71].

Kantianism, Co-Production, and the Sublime

The distinction between the world as it is and the world as it appears; between the raw, unconceptualized domain of things in themselves, on the one hand, and conceptualized space (and time) on the other; the distinction between sense— that most raw and unconceptualized thing of all—and our cognition of sense, is a commonplace in philosophy, if not the spark that ignited the whole field in the pre-classical era.

It is sometimes thought that phenomenology is the philosophy of Minimalism, because of the way phenomenology (and Minimalism) forefront the body.[4] But Fred Sandback's idea—actually, *ideal*—of getting, through the work, at unconceptualized experience *directly*—veridical, unmediated, and most of all, unrepresented, is also resonant with the problem posed in Kant's philosophical writings, how do we come to experience the outer world and then to go on to have knowledge of it? The world *out there*, so to speak, mind-independent but nevertheless accessible to perception and understanding.

"Space is in us," was, in brief, the Kantian solution. That is, consciousness is structured around the *a priori* categories of space and time, *forms of intuition*, in Kant's terminology, that function as media through which the raw stuff that flows into perception in various ways, is molded *by us* into the world we know. And this— what we have, in some sense, made—is all we know. The *noumenal realm*, that is, the domain of pure reality or things-in-themselves, though it is an object of continual philosophical and artistic aspiration and attention, cannot itself be the subject of any of our knowledge claims. This is because while the noumenal inflects and shapes experience, it is at the same time closed off from perception.

So as to the question, how it is that we who are "locked inside," as it were, can come to have knowledge of the outer world? Kant's answer was that we are, in a special sense, the world's author; and therefore as such, the products of our own constituting consciousness cannot fail to become known to us.

Sandback's term *co-production* is meaningful here [14]:

> ... not to control [space]—that is the wrong word—but to cooperate with it, to co-produce with it.

And in 1986 [15, italics ours]:

> I don't see various sculptures so much as being discrete objects, but rather more as instances of a generalized need to be in some sort of *constituting material relationship* with my environment.

Dualism comes under attack, as well as a certain kind of idealist solipsism—for how can dualism be right when nothing knowable lies outside of human experience? And how can solipsism be right when space is in us? Dualist/idealist dichotomies are thus supplanted by a kind of radiant wholeness, both programmatically, in the

[4]See e.g. Fer's discussion of the point in [1, p. 134].

artist's act of bringing together "the view from inside," so to speak, and the world; and methodologically, in forms of art-making that are subject to the artist's own transcendentalist aims—aims that find expression in a critique of hiddenness and a rethinking of the artwork's embodiment.

For it is simply the case that an object, whether it is to be considered a work of art or not, defines a boundary between itself and all that it is not;[5] effects a—to Sandback—*regressive* splitting of space into the space of the artwork on the one hand, and the space of the viewer on the other [14]:

> I was still thinking in terms of sculptural space … But it was unavoidable to perceive that the sculptures didn't stop where the lines did, and that the situation had gotten more complex.

And furthermore [15, italics ours]:

> … it's the tonality or, if you want, *wholeness* of a situation that is what I'm trying to get at.

"Pedestrian space," a term invented by Sandback and Dan Edge in 1968, codifies this idea of shattering the artwork's "spatial pedestal," as Sandback put it. From the philosophical point of view the ideology of pedestrian space reads as a kind of monism. For it calls for a new kind of *diffuse* space, as Sandback called it, not a third thing in a, as it were, triple ontology of architecture, viewer, and sculpture—but the *one thing* [18]:

> [Pedestrian space] was related to the idea of wanting to get off the pedestal, get off the canvas. And I think it was coined with an awe of other cultures where art seemed to fit in the middle of things rather than on the periphery.…I wanted to be in the middle of it, whatever "it" was. Whether it was culture, or life, whatever.…Pedestrian space had a different intonation but it certainly was related to the literal space that Don Judd wanted to occupy.

Sandback's aspiration toward wholeness, his critique of the surface (see below), and his idea of a new, pedestrian space seem to resonate with the objectives of literalism and the language of Donald Judd's "Specific Objects" [3]. And although a different spatial agenda seems to be at stake in that text from the pedestrian space point of view, we take a moment to consider "Specific Objects."

Judd's call to "[exclude] the pictorial, illusionistic and fictive in favor of the literal" is implemented through the suppression of an artwork's "neutral or moderate areas or parts, any connections or transitional areas" [3]. The ideology of *literal space* and the "single object" rejects the idea of *pictorial space*, the situation in which the artwork sits, in some sense, on the exterior of the object, what faces the viewer; or sculptural space, as Sandback puts it. Read through the lens of "Specific Objects" the artwork's interior became, in Judd's work, a "site of anxiety" in the words of Briony Fer;[6] and if such concerns would be superseded

[5]As Sandback put it in 1975: "A line of string isn't a line, it's a thing, and as a thing it doesn't define a plane but everything else outside its own boundaries" [12].

[6]As Fer puts it [1, p. 149]: "This is played out [in Judd's work] on the border between inside and outside and and where a breach or threatened injury to that 'skin' may generate a situation of anxiety. …At stake is not only control over the object but over the relations of inside and outside and anxiety over whether such control is ever to be achieved."

by subsequent developments, installation-based practice and the expansion of the artwork's experiential envelope did originate then and are now at the center of the artist's range of possibilities.

Beyond serving as a possible initial impetus, the lasting impact of "Specific Objects" on the ideology of pedestrian space is not clear. Sandback is drawn to an ambivalence between exterior and interior; but the concern here is with the positioning of the self in the work, with the *habitability* of the work.[7] For this Sandback cites Pollock as a precedent, whose concept of "overall painting" was meaningful to him.[8] We have wanted to separate the work from the writings, but we will permit ourselves to say that a sense of sublimity seems to hover around Sandback's sculpture, or, as Sandback called it, a sense of mysticism; and it is striking that early notions of the sublime thought of it as being precipitated by a sense of overallness, the sense of being everywhere at once. The 18th century aesthetician A. Gerard, for example, thought of the sublime as a state in which "the mind sometimes imagines itself present in every part of the scene it contemplates" [2].

Our contention here is that Sandback's conceptualisation of interior and exterior, the desire to obliterate the distinction,[9] may have been stimulated by Kant's world-changing philosophical move, namely the dissolution of the idea of interior and exterior, relative to the subject. We are not attempting a proof in these brief remarks, but it was a move that revolutionized philosophy; and it was very likely the centerpiece—or at least one of them—of Sandback's philosophical training at Yale.

We take a moment to return to this move, again. The *sideways-on view*, also called *the view from nowhere*, is the idea of an unembodied perspective from within which the conceptual order can be appraised—from the "outside," as it were.[10] The idea is rooted in "the paradox of man's encounter with himself," as Wilfrid Sellars called it [22], the paradox being that a person is forced to act out two roles in that conceptual order, to wit: the person is both the source of the conceptual framework, and also subject to it. To be in the world, according to the sideways-on-view, is to be subject to the causal effects of brute, meaningless, exterior reality, while all the experience of *meaning* takes place wholly within. Of course in the end, that

[7] Sandback writes [19]: "Early on, though, I left the model of such discrete sculptural volumes for a sculpture which became less of a thing-in-itself, more of a diffuse interface between myself, my environment, and others peopling that environment, built of thin lines that left enough room to move through and around. Still sculpture, though less dense, with an ambivalence between exterior and interior. A drawing that is habitable."

[8] "The idea of 'overall painting' was much more stimulating to me at the time than were the particular paintings" [18].

[9] "I did have a strong gut feeling from the beginning though, and that was wanting to be able to make sculpture that didn't have an inside. Otherwise, thinking about the nature of place, or a place—my being there with or in it—and the nature of the interaction between the two was interesting" [15].

[10] The sideways-on-view was attributed to Wilfrid Sellars by John McDowell, critically [6].

conception of a "meaningful inside and a meaningless outside" [5, p. 20] may or may not have been Sellars's own world picture (though it was attributed to him).

Our interest here is in tracking the way Kantian ideas are transposed and recoded in Sandback's writings by drawing out resemblances in the use of language and a possible correspondence of ideas. From this point of view then, Sandback's engagement with wholeness offers us a confrontation between art-making and the view from nowhere, a confrontation that happens in the writings, and which gives us, instead of the view from nowhere, *the view from everywhere.*

It would be remiss not to refer to certain ideas that were in the air at the time. We mentioned "Specific Objects" but behind that text is the fact that the artists of Sandback's generation, that is of the post-Abstract Expressionist era, were working in a revolutionary context. "Linear history had unraveled somewhat," as Judd put it in "Specific Objects," and the "inherited format," in Judd's terminology, was no longer credible [3]:

> There was a lot in the air at the time, especially the painting of the 1950s. The factuality of Pollock's paintings, for example, was so dense, so direct and real, that it only seemed like a small step towards having no sign, nothing at all on the canvas—to simply putting the sign into the room, creating something that had an objective, three-dimensional reality, instead of a reality that always needed the illusion, the being-elsewhere. The strength of that painting was the struggle it involved, between the actual space in which it unfolded and the non-concrete space which up until then it always had to use. Thus it offered the possibility of creating different things.

Synthesis

Though Sandback resisted conceptualist readings of his work, he did write at times of an emphasis on "the thinking" rather than "the doing" [15]:

> And at that point the thinking was perhaps more interesting than the doing, though it's of course the latter that has sustained my interest.

and of the sense of ambivalence toward the sculptural artifact itself [17]:

> In the main, it is our terms, as maker and user, which are significant, and the terms of the work of art "on its own" may be less important.

Putting it in Kant's terminology, one would say that the forms themselves do not create experience on their own. It is only the forms *together with* the faculties of the understanding that offer purchase on synthesis; that create the possibility for knowledge and experience. This is a fundamental feature of Kant's notion of synthesis, an account of mental processing by which the objects of experience are given through the *a priori* concepts of space and time.

In his account of "the more complete situation that I'm after," Sandback describes his own art-making as offering a synthesis [16]:

> My marks are the gap between the spectator and the space that allow him to create his own conception of reality.

From our point of view, then, insofar as co-production is not specialized to the artist, rather it is the artist and the viewer together who constitute the work, Sandback's subject—in his terminology, the maker, the user, the viewer, the participant—is a *Kantian* subject, as it were: one whose cognitive capacities are implemented through the *a priori* categories of space and time, an implementation which is then acted upon by the artist, who intervenes in it, overlaying and replicating that process of synthesis in the work.

Sandback's Yale transcript lists an individualized course taken with the art historian George Kubler. Sandback's reference to the gap between spectator and space (see above)—the place where his "marks" are situated—calls up George Kubler's concept of *actuality*. For Kubler, actuality is what exists in the liminal space of the objects of perception [4, p. 17]:

> Actuality is when the lighthouse is dark between flashes: it is the instant between the ticks of the watch: it is a void interval slipping forever through time: the rupture between past and future: the gap at the poles of the revolving magnetic field, infinitesimally small but ultimately real. It is the interchronic pause when nothing is happening. It is the void between events.

For Kubler, this is all the reality we can ever know, all we can grasp. By contrast, Sandback's actuality language seems to place actuality out of grasp—a target toward which we are, in our perceptual capabilities, compelled, but which is nonetheless beyond perception. The idea of the noumenal comes to mind, the things in themselves that give rise to reality, but which are themselves closed off from perception.

At the same time Sandback is clearly drawn to the idea of liminal space in the writings, and we have a very direct source of influence via Kubler, who ties actuality and temporality together, creating the conditions, perhaps, for a time-based model of viewership.[11] We will take up actuality again below.

Temporality

Sandback's idea of wholeness, and the idea, as he wrote, that "in my works the unity is given from the beginning" [13] implies a temporality of immediacy and all-at-once-ness that resonates with the Kantian ideas of cognitive spontaneity and the innate creativity of the mind. It is art-making in a single, simple act of synthesis [11]:

> I don't have an idea first and then find a way to express it. That happens all at once.

And in 1975 [12, italics ours]:

> I am interested in a strong, *immediate*, and beautiful situation.

[11]We thank the anonymous referee for drawing our attention to this passage from Kubler's *The Shape of Time: Remarks on the History of Things*, 1962. We also thank him or her for the suggestion of the last sentence of this paragraph.

Thus time functions bivalently for Sandback, according to what the line does (its meaning) vs. what it is (its existence) [9]:

> A line has direction—a point of origin and a point of termination. A line is also a discrete entity which exists altogether at the same time.

Sandback is remarking here on the line's dual nature and through this time's dual nature: time must begin and end, just as anything does that exists in the world. But time also exists as an object of our thought.

Actuality

Sandback's philosophical shapeshifting revolved mainly around spatiality. But *surface* and *representation* are taken up in the writings too and seem linked to his concept of *actuality* [10]:

> There isn't an idea which transcends the actuality of the pieces. The actuality is the idea.

The writings here declare an intention for the work that it bend toward the *factual*, or in other passages, the *objective*, the *concrete*, or finally the *particular*, in addition to the *actual*. A constant of the writings, the principle of actuality requires the repudiation of narrativity, of anything symbolic. We mentioned the influence of Sandback's teacher George Kubler, and the idea of actuality's liminal space. But the concept of actuality in the writings also seems to signify something like the *noumenal*—reality as it is in itself. From "Statements 1975" [12]:

> I intend what I do to be concrete and particular. It's just the opposite of abstract art, which is derived, deduced, or refined from something else. It's a point of origin rather than a conclusion.

Among Sandback's numerous writings that mention factuality, one of the most striking describes how that orientation of the work accounts for the sense of mysticism that hovers over it [12]:

> The inherent mysticism resides in persisting in wanting to make something as factual as possible and having it turn out just the other way—the immediate positive engagement with the way situations always transcend our perceptions of them—the realization that the simplest and most comfortable of perceptions are shadows.

We noted that actuality may be tied, through the writings of Kubler, to what exists in liminal space, which is all and only what can be known. At the same time the concept appears to stand in for Sandback, for reality in the form of the aspired to *un*known, what Kant called the noumenal, which is known only through transcendence. This apparent doubling of the concept of reality, as that which is both available to the subject and not, falls away in the writings, in the presence of the artwork. This is because the orientation of the artwork toward actuality produces transcendence, in the writings.

Narrativity on the other hand is tied to unreality, the *phenomenal* realm, or the realm of "false appearances" (in Kant's terminology) [14]:

> ...it was this narrative pictorial quality that didn't make sense to me.
> Prokopoff: Can you describe what you mean here by narrative?
> Sandback: I mean the way in which a completed sculpture, an existing thing, might be a picture of the voyage of a line in space. It's a little story about a little line which is once removed from the original line.

Sellars's idea of the *unreality of the manifest image*, a Kantian view of perceptual objects as apparent or "illusory effects of imperceptible things in themselves..." [7] was a view of perceptual objects qua *phenomena* which seems to have been absorbed by Sandback [11, italics ours]:

> Illusionism is making a picture of something...I'd rather be in the middle of a situation than over on one side either looking in or looking out. Surfaces seem to imply that what's interesting is either in front of them or behind them.

Of course for Sellars it would be science that unmasks reality *as it is in itself*, not art.

As to being in the middle of a situation, Sandback is speaking literally here—to experience his work one must place oneself in its midst. But he is also speaking metaphorically. Ideas also have a surface—an ideological surface, if you will—that acts as a boundary, dissipating and obstructing the immediate and veridical experience of the artwork.

"It Is of No Assistance..."

With these brief remarks we hoped to indicate a line from Sandback's philosophical education at Yale to his writings. Drawing a line from the writings to the art is more difficult. Was Sandback's art related to the aims of transcendental philosophy? Sandback's dream of merging with an *a priori*, more fundamental form of life, through his work; his bend toward *actuality*—his word, we proposed, for the *noumenal*; his concept of the *situation* that pedestrian space brings into being; the idea of *co-production*; Sandback's problematization of surface and interior; and finally his attunement to the distinction between meaning and existence lend philosophical vibrancy to the writings.

Clearly, Sandback's art exceeds philosophy—even his own philosophy. And indeed, if we think the philosophical writings may shed light on the work, Sandback warns us from making too much of them [19]:

> Whatever philosophical, historical, or literary artillery I bring to the workplace, it is of no assistance in the art of trying to stretch a line between two points. In that I am alone and voiceless.

It is nevertheless true that Sandback developed a distinctly philosophical vision for the work in his writings. He created a plainspoken philosophical environment—a kind of monism, as we called it—in which the work, the space and the viewer all rise, magnificently, together.

How fortunate we are to have the work, and how fortunate we are to have the writings.

Acknowledgements This paper was first presented at the Institute for Advanced Study in 2011. Subsequently it was presented at a number of other seminars, and I thank those audiences for their questions and comments. This paper was completed whilst the author was a visiting fellow at the Isaac Newton Institute for Mathematical Sciences in the programme "Mathematical, Foundational and Computational Aspects of the Higher Infinite" (HIF). I thank the INI for this support as well as the University of Helsinki for their additional support. I also wish to thank Emily Brady, Harry Cooper, David Gray, Alistair Rider and the anonymous referee, whose comments and corrections led to many improvements in the paper. Finally I wish to express my deepest thanks to Amy Sandback for her generosity in welcoming a mathematician's fascination with the work and writings of Fred Sandback.

References

1. Fer, Briony. *On Abstract Art*. New Haven, CT: Yale University Press, 2000.
2. Gerard, Alexander. *An Essay on Taste* (1759). Gainesville, FL: Scholars' Facsimiles and Reprints, 1963.
3. Judd, Donald. "Specific Objects." *Arts Yearbook* 8 (1965): 74–82.
4. Kubler, George. *The Shape of Time: Remarks on the History of Things*. New Haven, CT: Yale University Press, 1962.
5. Macbeth, Danielle. *Realizing Reason: A Narrative of Truth and Knowing*. Oxford, UK: Oxford University Press, 2014.
6. McDowell, John Henry. *Having the World in View: Essays on Kant, Hegel, and Sellars*. Cambridge, MA: Harvard University Press, 2009.
7. Pinkard, Terry. "Sellars the Post-Kantian." In *The Self-correcting Enterprise: Essays on Wilfrid Sellars*, edited by Michael P. Wolf and Mark Norris Lance. Amsterdam: Rodopi, 2006.
8. The Fred Sandback Archive. "Artist's Texts." 2007. http://www.fredsandbackarchive.org/texts.html.
9. Sandback, Fred. "1970s Untitled." In [8].
10. ———. "1973 Notes." In [8].
11. ———. "1975 Notes." In [8].
12. ———. "1975 Statements." In [8].
13. ———. "1975 Interview by Ingrid Rein." In [8].
14. ———. "1985 An Interview: Fred Sandback and Stephen Prokopoff." In [8].
15. ———. "Remarks on My Sculpture, 1966–86." In [8].
16. ———. "1992 Interview." In [8].
17. ———. "1995 Interview by Kimberly Davenport." In [8].
18. ———. "1997 Interview by Joan Simon." In [8].
19. ———. "1999 Statement." In [8].
20. ———. "Conversation with Fred Sandback." In [8].
21. ———. *Fred Sandback: Drawings*, Düsseldorf, Germany: Richter Verlag, 2014.
22. Sellars, Wilfrid. "Philosophy and the Scientific Image of Man." In *Frontiers of Science and Philosophy*, edited by Robert Colodny, 35–78. Pittsburgh, PA: University of Pittsburgh Press, 1962.

David Hammons
Phat Free, 1995–1999
Color video, sound, transferred to digital video
Duration: 5 minutes, 20 seconds
©2016 David Hammons
Courtesy David Zwirner, New York/London

What Simplicity Is Not

Maryanthe Malliaris and Assaf Peretz

There is a duality in mathematics between proofs and counterexamples. To understand a mathematical question one investigates the limits. To investigate Hilbert's 24th problem, and a mathematical concept of 'simplicity of a proof' we deal here with both sides, focusing on what simplicity is not.

1. Simplicity is not outside existence

> *I am convinced that the philosophers have had a harmful effect upon the progress of scientific thinking in removing certain fundamental concepts from the domain of empiricism, where they are under our control, to the intangible heights of the a priori.*
> —Albert Einstein, *The Meaning of Relativity* [2]

Einstein took concepts that were considered outside the realm of pure scientific research and pulled them down from the heavens to embed them in the empirical point of view. Einstein complained about philosophy removing fundamental concepts from empiricism (taking elements from physics into metaphysics). Let us start by not similarly erring, removing simplicity from mathematics to metamathematics.

M. Malliaris (✉)
Department of Mathematics, University of Chicago, Chicago, IL, USA
e-mail: mem@uchicago.edu

A. Peretz
New York, NY, USA
e-mail: mont@cal.berkeley.edu

© Springer International Publishing AG 2017
R. Kossak, P. Ording (eds.), *Simplicity: Ideals of Practice in Mathematics and the Arts*,
Mathematics, Culture, and the Arts, DOI 10.1007/978-3-319-53385-8_5

To continue with Einstein and the wave/particle duality, there are two basic ways that infinity appears in mathematics. It appears as a limit point and as a property of the size of a mathematical object. David Hilbert describes these as a "potential" and an "actual" infinite [5]. These two approaches lead to a different sensation of simplicity.

An apparently simple proof by James Ax of the theorem that any injective polynomial map from \mathbb{C}^n to \mathbb{C}^n is surjective may be described as saying: using model theory, reduce to the finite, where it is obvious by counting! This proof uses the actual infinite and turns it into a limit, a potential infinite. The reader's sense of infinity will alter what is simple and is not.

A different example of the power of actualizing infinity and structuring it as a limit point is the invention of perspective in painting. What is simple without perspective and what is simple with it is very different.

Mathematicians often have their own perspective on the nature of the objects or concepts they study, but formal proofs rely only on what is given in the definitions. If two mathematicians have different private opinions or working models of certain objects, they may agree that a proof is mathematically correct while disagreeing about its naturalness, its clarity, or even its novelty.

Moreover, a mathematical proof is never complete, given our human constraints of time. It always calls forth our intuition and beliefs to accept it as a proof. (An attempt at giving a complete proof, as Russell and Whitehead did in *Principia Mathematica*, we would hardly call simple.) Thus there is an inherent dependence in a mathematical notion of simplicity.

Are we already giving up on a mathematical concept of simplicity of proofs if we introduce the empirical world? Aren't all mathematical concepts absolute? We will return to this question at the end.

2. Simplicity is not totally subjective

The "straight line" is usually the simplest.

Note that a straightforward proof is not necessarily simple.

3. Simplicity is not necessarily timeless

One reason for simplicity's connection with time is the development of technology, in all its forms. For instance, the simplest way for two people to contact each other changes throughout history. The same is true in mathematics. After certain techniques or tools are introduced it's often no longer simpler to not use these tools, even for very basic calculations. They become tools of the trade and so lose some of their apparent complexity.

However, new tools are often simple in some ways but complex in others, and so a certain oscillation may begin. For instance, Szemerédi's celebrated regularity lemma gives a precise description of how sufficiently large finite graphs may be compactly approximated by much smaller random graphs [10]. The actual finite bounds involved in the regularity lemma, however, are enormous. Nearly forty years after the lemma was introduced, it has been useful to re-prove certain known consequences of the regularity lemma without using regularity in the proofs, so as to improve the bounds [4].

Technology is not the essential feature of such examples. It seems to be an instance of a much more basic phenomenon of simplicity's disruptive relation to the passage of time. Even the same person may find a given idea simple at some times and not at others. In this sense, although simple and obvious are not the same, there is a famous joke which illustrates some of their common qualities. A professor states to a graduate class that a certain theorem is obvious. A student in the front row asks whether it is really obvious. The professor thinks for a while, leaves the classroom, walks up and down the hallway for the better part of an hour, and finally returns and announces with satisfaction: Yes, it's obvious. (We can think of the relation between what is funny and what is simple.)

Still, we should be careful of the possible trap of equating simplicity with an advance. Sometimes the true advance is the perception of complexity. For example, it took mathematics two millennia to discover that there were non-Euclidean geometries. Or recall how Walter Benjamin describes Proust [1, p. 205]:

> We do not always proclaim loudly the most important thing we have to say. Nor do we always privately share it with those closest to us, our intimate friends, those who have been most devotedly ready to receive our confession. If it is true that not only people but also ages have such a chaste—that is, such a devious and frivolous—way of communicating what is most their own to a passing acquaintance, then the nineteenth century did not reveal itself to Zola or Anatole France, but to the young Proust... It took Proust to make the nineteenth century ripe for memoirs. What before him had been a period devoid of tension now became a field of force in which later writers aroused multifarious currents.

A perception of simplicity may reflect insight, yet it may also reflect blindness.

4. Simplicity isn't necessarily functional

For instance, Turing machines may be said to be simpler than mainframes or smartphones.

5. Simplicity isn't necessary

Proofs which are not simple also work! [8]

6. Simplicity does not equal perfection

Sometimes an insight or breakthrough appears almost *miraculous* in its simplicity. This often occurs when the process of thinking, the means of arrival at the idea, is collapsed or elided so that the idea appears fully formed and without history. We are not carried to a new place but just appear there. It has been said of more than one mathematician that the clarity of the published presentation of results allowed for almost no insight into the ideas: "the fox in the snow dragging his tail behind him to hide his tracks." Sometimes that which appears perfectly constructed can seem closed and impenetrable, a sheer rock face, and part of understanding how to go further is how to find a hand-hold in the rock which will allow you to climb. Climbers who fill in the imperfections of the wall as they climb don't show climbing as easy—except as an illusion—but instead make it harder to climb.

A brilliant short story on simplicity and perfection is Kleist's "On the Marionette Theater" [7]. A character in the story says of the Marionettes:

> "These marionettes," he said, "have another advantage. They haven't discovered the law of gravity. They know nothing about the inertia of matter. In other words they know nothing of those qualities most opposed to the dance. The force that pulls them into the air is more powerful than that which shackles them to the earth."

The appearance of perfection hides the very forces on which dancing is based. Their grace does not come from carrying us without weight, but from the hiding of the puppeteer.

Mathematical proofs based on tricks are usually of that form. They are proofs made after the discovery, finding a way to hide the puppeteer, so to speak.

7. Shallowness is often the wolf in simplicity's clothing

Consider the difference between looking at a work of art, and looking at a poster reproduction of it. Looking at the poster certainly feels simpler, as it carries less weight with it. But you shouldn't be fooled into thinking that you are actually encountering the picture with its real depth. Seeing a poster version of an Yves Klein blue painting has as much to do with the experience of a Klein blue painting as a bottle has to a Klein bottle. It still gives you something, but its ease comes from shallowness, not from the depth of simplicity.

Kids find it simpler to swim in shallow water they can stand in, without the fear of depth, drowning, and having to get to the other side. It is not simplicity that makes shallow water easier to swim in, but shallowness and safety. Flattening arguments so as to make them more approachable thus has its place, but its place shouldn't be mistaken for simplicity.

8. Shorter does not equal simpler

Paul Cohen famously defined a *deep* proof as a proof which is forty pages long when it's first written and twenty years later is five pages long. There are a few reasons the shorter proof is not simpler, as we discussed earlier. Relativity (§ 1), time-dependence (§ 3), shallowness (§ 7), and perhaps a trick (§ 6). Tricks do not make for simple proofs, just short ones.

One reason for the time-dependence is that the shortening of the proof often reflects the effect of such a proof in re-orienting the field, re-structuring certain basic paradigms and assumptions so that the theorem in question appears, to later students, as much closer to the source.

9. Simplicity can always be improved upon

In Kleist's story of the Marionettes he also tells of a master swordsman fighting a chained bear. *"Like the finest fencer in the world, the bear met and parried each thrust, but he did not respond to feints; (no fencer in the world could have matched him in that). Eye to eye, as if he read my soul, he stood with his paw lifted, ready to fight; and if I did not intend my thrust, he remained immobile."* Kleist concludes that the only way to return to the simplicity of the bear is to slowly go through infinity: *"Just in this way, after self-consciousness has, so to speak, passed through infinity, the quality of grace will reappear."*

There is the simpleness of the ingénue, the single dot, the absence of knowledge. But once knowledge appears on the scene, it sets things in motion, and there is always a next step. Everything then can be made even simpler. (Kleist seems to suggest that these two versions of simplicity would meet in a kind of compactification point.)

If Fermat's last theorem may have once seemed simple (even to him), only to fall into a difficult proof, still we may suppose that the mathematical research it has generated will at some point allow for ever simpler and more elegant proofs of the theorem, so as to eventually be taught in high school.

10. Simplicity resides in movement

In understanding mathematical proofs we go from point A to point B, and the movement happens in a certain way. It has a certain choreography. It can be complex, it can have an enormous weight, it can take a long time, but still it can carry itself lightly. That feeling and that quality of movement inform our experience of simplicity—both the movement itself (the revealing of the truth) and its appearance (the way the truth appears).

'Simple' proofs make this movement feel light and, well, simple [9].

For example: if we found ourselves in a village in antiquity with none of our current theory or tools, it might seem daunting to prove to the locals that the earth was round. What data would we have to gather? How would we make such an argument? The idea that ships' masts appear to sink over the horizon is hardly water-tight: perhaps the earth is a cylinder. Yet Copernicus mentions a very simple proof, already known to the Greeks: the earth is round, he says, because it casts a round shadow during an eclipse.

This is a proof hidden in plain sight and conjured, so to speak, by the passage of time. Observation over many planetary cycles shows us the projections of the earth from different sides, so that we conclude it is a three-dimensional solid all of whose projections are circles. Mathematical understanding always has this quality of being threaded through with time. Copernicus' argument, while deep, sophisticated, and whatever other adjectives you would want to add, is simple. Its simplicity, perhaps, comes from the light touch whereby the truth is arrived at and revealed.

Endnote: A mathematical concept of "Simplicity" and "Depth"

We have argued that a mathematical concept of simplicity is both empirical, and not timeless. May it have a mathematical meaning then, usefulness, and a place within mathematics? We think that indeed it may. In keeping with the light touch, let us suggest a response.

To make the question precise, recall Hilbert's 24th problem (as found in his notes, and translated, by Rüdiger Thiele) [6]:

> The 24th problem in my Paris lecture was to be: Criteria of simplicity, or proof of the greatest simplicity of certain proofs. Develop a theory of the method of proof in mathematics in general. Under a given set of conditions there can be but one simplest proof. Quite generally, if there are two proofs for a theorem, you must keep going until you have derived each from the other, or until it becomes quite evident what variant conditions (and aids) have been used in the two proofs. Given two routes, it is not right to take either of these two or to look for a third; it is necessary to investigate the area lying between the two routes. Attempts at judging the simplicity of a proof are in my examination of syzygies and syzygies between syzygies. The use or the knowledge of a syzygy implies in an essential way a proof that a certain identity is true. Because any process of addition [is] an application of the commutative law of addition etc. [and because] this always corresponds to geometric theorems or logical conclusions, one can count these [processes], and, for instance, in proving certain theorems of elementary geometry (the Pythagoras theorem, [theorems] on remarkable points of triangles), one can very well decide which of the proofs is the simplest.

Before showing some of the errors in Hilbert's suggestion for a proof, it is very important to note that while Hilbert saw the importance and potential of the problem, he also understood that his original thoughts on it were lacking, as indeed he didn't include the problem in his talk or paper.

We showed above that simplicity is not absolute, that it has an important element of time, that it is not perfection, and that it resides in movement. This is a surprising

discovery, and right away it suggests a surprising first response to Hilbert: that (§ 3, 6, 8, 9) *there can never be a simplest proof.*

While some of the reasons we mentioned, such as advances of the field leading to a reorientation (§ 8), may be, to some extent, circumvented by Hilbert's demand of "given a set of conditions," this can only be partially circumvented. Moreover, it seems Hilbert—in his sketch of a possible way to advance—was hoping for a way to e.g. use syzygies to get to a shortest = simplest proof. But no serious proofs are even close to being complete (§ 1), which undercuts the idea of a shortest proof, nor would the shortest necessarily be the simplest.

Yet there is a strong clue of a deep and important issue here around Hilbert's suggestion of syzygies as one of the tools in judging simplification. Hilbert's substitutions are static. In contrast, we mentioned Einstein's wave/particle duality, where light can be seen as either a wave or a particle. Einstein and Infeld write [3, p. 278]:

> It seems as though we must use sometimes the one theory and sometimes the other, while at times we may use either. We are faced with a new kind of difficulty. We have two contradictory pictures of reality; separately neither of them fully explains the phenomena of light, but together they do.

We gave a similar example with the two aspects of the phenomenon of infinity (§ 1). This move away from the static is key. When dealing with the movement of a proof, it is a choreographed movement in time and space, and to capture the simplicity of this movement takes a new viewpoint.

And so we find ourselves again faced with the question of whether this concept of simplicity of a proof, a mathematical concept which Hilbert felt was so important to develop, can actually be a useful part of mathematics. We suggest a resounding yes, but it won't be easy.

Einstein took the clock and space, which were outside of the frame of physics, and extended the frame to include them within. He made them empirical properties. While Hume's discovery of a problem with science called the entire endeavor into question and put limits on its scope, Einstein's work extended the limits of science. His move to add relativity within science significantly strengthened its explanatory abilities. (In fact, from his viewpoint, it may have even furthered objectivity.)

Let us suggest, as a possibility, a path: investigating simplicity of proofs, or depth of proofs, is not to be found just in the static formal representation of a proof, but in the phenomenon of a proof—in the proof's empirical existence as a process with a viewer/participant. Indeed, extending the frame of mathematics to include such elements may increase its power and scope. Our view of mathematics as investigating only *a priori* given properties may be limiting what it can actually do.[1]

[1]It is important to note that, in fact, our field is already digging in a new problematic area—computer aided proofs—that may lead to a new collapse/breakthrough similar to non-Euclidean geometry. Computations by computer happen in the empirical world and in space-time, and it could actually turn out that they are dependent on certain rules of physics we are unaware of and are proving theorems which would not be valid elsewhere.

To take the example of time, it seems to us in writing this article that the presence of time in our subject is a mathematical, say, rather than a sociological or historical, phenomenon, and if so, it is interesting to ask how we might rigorously begin to observe it—how we might detect and record the entry of time into mathematics, both historical time and the time within the machinery of a proof. Perhaps our perception of simplicity in mathematics is just such an observable trace of time (and even more so, the concept of mathematical depth, which already Cohen defined in relation to time).

References

1. Benjamin, Walter. "The Image of Proust." In *Illuminations*, translated by Harry Zohn. New York: Schocken Books, 1968.
2. Einstein, Albert. *The Meaning of Relativity: Four Lectures Delivered at Princeton University, May, 1921*. Translated by E. P. Adams. Project Gutenberg. May 29, 2011 [EBook #36276].
3. Einstein, Albert and Leopold Infeld. *The Evolution of Physics*. Cambridge, UK: Cambridge University Press, 1938.
4. Fox, Jacob. "A new proof of the graph removal lemma." *Annals of Mathematics* 174 (2011): 561–579.
5. Hilbert, David. "On the infinite." (1925). In *From Frege to Gödel, A Source Book in Mathematical Logic, 1879–1931*, edited by Jean van Heijenoort. Cambridge, MA: Harvard University Press, 2002.
6. Hilbert, David. "Hilbert's twenty-fourth problem" translated by Rüdiger Thiele. https://en. wikipedia.org/wiki/Hilbert's_twenty-fourth_problem (2003).
7. Kleist, Heinrich von. "On the Marionette Theater." 1810. Translation quoted from http://ada. evergreen.edu/~arunc/texts/literature/kleist/kleist.pdf.
8. M. Malliaris. "Independence, order, and the interaction of ultrafilters and theories." *Annals of Pure and Applied Logic* 163 (11) (2012):1580–1595.
9. A. Peretz. "Geometry of forking in simple theories." *Journal of Symbolic Logic* 71 (1) (2006): 347–359.
10. Szemerédi, Endre. "On sets of integers containing no k elements in arithmetic progression." *Acta Arithmetica* 27 (1975): 199–245.

Here we should mention the very interesting direction of theoretical computer science, which is developing different "dynamic" aspects of proofs involving the viewer/reader (e.g. efficiency, zero-knowledge proofs, probabilistically checkable proofs).

Taking concepts such as "a deep proof," and turning them into an accepted mathematical concept, with mathematical utility, will not be easy. Yet, if this path is to be investigated, the present volume should be understood not as a literary exercise but as a beginning.

Richard Serra
Color Aid, 1970–1971
16 mm, color, sound, camera: Robert Fiore
Duration: 36 minutes
©2016 Richard Serra/Artists Rights Society (ARS), New York
Courtesy the artist

Constructing the Simples

Curtis Franks

The Complexity of Simplicity

On April 4th, 2013, we heard Juhani Pallasmaa's presentation, "The complexity of simplicity," about phenomenology and art. I'm sure others agree with me that it was a highlight of the symposium. Earlier I had spoken about mathematics, mostly about Bolzano, Gauss, and Hilbert. As chance would have it, I used the same title. I have chosen a different title for this redaction, but I want to motivate the remarks ahead by recalling how architectural theory and the history of mathematics were discussed in many of the same terms, and under the same banner, that morning.

Professor Pallasmaa's task was unenviable. Art historians do not need to be told that our judgements of elegance and noise are historical contingencies. At least since Bachelard's *La Poétique de l'Espace* [2], architectural theorists have known that the ways we see art are shaped by the fact that we carry out our lives within art. From these theoretical starting points, Professor Pallasmaa pointed us to the delicate interactions between simplicity and complexity within individual artistic experiences. Some of those observations struck me as being on the brink of ineffability, and it took a poet's craft to lay them bare.

Contrast my humdrum task. Because we don't usually think of mathematical experience in aesthetic terms and because we perpetuate the myth of ahistorical measures of complexity in mathematics, we think of simplicity in this arena as something given in advance of any of mathematics' details. I only wanted to explain that as artistic simplicity derives from art itself, so do our judgements of mathematical simplicity derive from our experience with mathematics. And further, that as mathematics evolves, so do our judgements of what counts as simple.

C. Franks (✉)
Department of Philosophy, University of Notre Dame, Notre Dame, IN, USA
e-mail: curtis.d.franks.7@nd.edu

© Springer International Publishing AG 2017
R. Kossak, P. Ording (eds.), *Simplicity: Ideals of Practice in Mathematics and the Arts*,
Mathematics, Culture, and the Arts, DOI 10.1007/978-3-319-53385-8_6

In some way my suggestion should be seen as resistance against David Hilbert's injunction to "find a criterion of simplicity" that our curators chose as a thematic focal-point for the symposium. For I claim that there is no criterion of simplicity that can survive the historical unfolding of mathematics. By even looking for one we loose sight of the ways in which mathematics' own disregard for such things is a source of its depth and development.

But I want to begin this essay the same way I ended my talk in Manhattan. Hilbert asked us to look for a criterion of simplicity, and, if I am right, then in a serious way it is important to do just this. The wrinkle that I should add is the further injunction never to stop looking. Part of the way that mathematics develops is through mathematicians looking again and again, within mathematics itself, for such criteria. So asked if I think we should heed Hilbert's directive, I say, "Yes! And rather than ever think ontological or phenomenological investigations have settled this matter once and for all, return to the task often."

It is not hard to find examples of other mathematicians who, like Hilbert, assume that standards of mathematical simplicity and rigor are absolute. Writing about "The nature of mathematical reasoning," Poincaré asked, "Why is so long a preparation necessary to become habituated to this perfect rigour, which, it would seem, should naturally impress itself upon all good minds?" Poincaré called this "a logical and psychological problem well worthy of study" but said he could not let it detain him as he was interested in other things [14, Sect. 3].

Let us consider Poincaré's problem. Again, my solution is that what might strike Poincaré as natural in mathematics as well as his judgement of perfect rigor is in fact the product of habituation: too many good minds are responsible for giving shape to modern mathematics for us to expect that its basic contours would naturally conform to the patterns of thought of the uninitiated. So when Poincaré asks why so much effort is required from us to master the basic concepts of rigorous mathematics despite the reality that these concepts are in fact simple and natural, he has things importantly backwards. The examples I will present suggest that mathematics' development generates new fundamental ideas as it leaves us with solutions to problems. These ideas' "naturalness" is an illusion brought about by the fact that experiencing them as simple is the by-product of learning how they serve, to use Hilbert's own phrase, as "guideposts on the mazy paths to hidden truths" [13, ¶6].

In his powerful essay on "The pernicious influence of mathematics upon philosophy," Gian-Carlo Rota recalls this image from Hilbert's talk and reminds us that [15, p. 169]:

> As mathematics progresses, problems that were once difficult become easy enough to be assigned to school children. Thus Euclidean geometry is now taught in the second year of high school. Similarly, the mathematics that mathematicians of my generation learned in graduate school has now descended to the undergraduate level, and the time is not far when it may be taught in high schools.

Of course, this descent depends on an overall reshaping of the mathematical landscape, one that is not attained by mere theorem proving and cracking unsolved problems. We need to rethink what we know and how it hangs together with other

things we know, to reposition facts that were once on the horizons of our knowledge store closer to home because of their incisive connections with other things we know, and to replace old criteria of simplicity with those manifest in the direct route to understanding the now central phenomena. As we do this, the task of habituating new classes of students changes according to the contours of our new criteria.

As a thought experiment, inspired by Étienne Ghys, consider the impact on mathematics education a verification of the Riemann Hypothesis would make in only a few generations. This unsolved problem has fairly direct consequences in several branches of mathematics. Some of these consequences are already known to be true through complicated demonstrations drawing from specific features of the problems' local mathematics. A proof of the Riemann hypothesis would therefore put at our disposal a way of thinking that leads uniformly to multiple results, revealing in this way strong connections across mathematics. The advance in mathematical understanding will be far greater than the advance in our knowledge of mathematical facts. In this new understanding, particular insights and definitions will emerge as central. They will be understood at first by only a few but will eventually become basic elements of mathematical thought.

Later we will consider William Thurston's spirited case for viewing the representation of mathematical knowledge so that it is accessible to ever broader audiences as a fundamental part of mathematical progress, right alongside solving new problems. He claimed that mathematics and the world would benefit if contributions along these lines were awarded more professional credits and acknowledgement. This view, according to which facilitating mathematical experience and understanding is the goal of mathematical activity, resonates with the picture of mathematics that Dusa McDuff and Dennis Sullivan shared, a picture in which mathematics is readily seen according to the same categories as art.

The Dream

The most Panglossian exponent of the view I want to question is Bernard Bolzano, who sought to shift mathematics' focus away from understanding mathematical phenomena and occasions of mathematical experience (*bloßer Schlußsatz*) towards uncovering the "objective" dependence relations of facts on one another (*eigentliche Folge*). Bolzano's theory of *Abfolge* admitted only a single criterion of simplicity: those basic truths resting on no other facts are the simples. Intuition is no route to their discovery, as self-evidence is neither necessary nor sufficient for a fact to play this role. Facts are complex according to the length of the chain of dependence relations leading from them to the simples [5, II Sect. 2]:

> [I]n the realm of truth, i.e. in the sum total of all true judgments, a certain *objective connection* prevails which is independent of our actual and *subjective recognition* of it. As a consequence of this some of these judgements are the grounds of others and the latter are the consequences of the former. To represent this objective connection of judgements, i.e. to choose a set of judgements and arrange them one after another so that a consequence

is represented as such and conversely, seems to me to be the proper *purpose* to pursue in a scientific exposition. Instead of this, the purpose of a scientific exposition is *usually* imagined to be the greatest possible *certainty* and *strength of conviction*.

According to this scheme, a proof must track the objective *Abfolgen* between propositions. Individual mathematical truths therefore have at most one proof, [5, Sect. 5], and the division of mathematical truths into those that have proofs and those basic truths for which no proof can be given is not a matter of convention but is objectively determined and there for us to discover [5, Sect. 13].

Bolzano motivated all this by urging three benefits of his view, all of which are important in our discussion.

Foremost, he felt, a scientific development that ignores the objective grounds for the truths we discover could be no more than a tally of results. The way these results lend support to one another is a feature of the world forever unknown to us if we ignore questions of ultimate fundamentality. Science should not simply record but also explain facts, and to do this we have to know not just how we can verify a statement but the real reason for its truth.

Bolzano further hinted that because of these features his proofs facilitate the discovery of new truths. In his 1804 *Betrachtungen*, after claiming that "one must regard the endeavor of unfolding all truths of mathematics down to their ultimate grounds ... as an endeavor which will not only promote the *thoroughness* of education but also make it *easier*," Bolzano wrote [4, Preface Sect. I]:

> Furthermore, if it is true that if the first ideas are clearly and correctly grasped then much more can be deduced from them than if they remain confused, then this endeavor can be credited with a *third* possible use—the *extending* of the science.

There is also an aesthetic value to Bolzano's proofs. Through them, one is able to see one's way to a mathematical truth without recourse to ideas and terms that are "off topic." "[I]f there appear in a proof *intermediate concepts* which are, for example, *narrower* than the subject, then the proof is obviously defective; it is what is usually otherwise called a μετάβασις εἰς ἄλλο γένος[5, II Sect. 29].

This notion of topical purity has motivated undeniably deep results in proof theory in the twentieth Century. Rosalie Iemoff and Andy Arana have explained to us competing views about the relevance of such a standard on proofs to simplicity. It is important to recall that the notion has a storied history, having perhaps first been promulgated by Aristotle in the *Posterior Analytics*. In the following passage, Aristotle explicitly connects demonstrations that deliver "essential" knowledge and disclose objective reasons with proofs whose intermediate steps share a topic with axioms and the demonstrated truth [1, Book I, Part 6]:

> Because accidents are not necessary one does not necessarily have reasoned knowledge of a conclusion drawn from them (this is so even if the accidental premises are invariable but not essential, as in proofs through signs; for though the conclusion be actually essential, one will not know it as essential nor know its reason); but **to have reasoned knowledge of a conclusion is to know it through its cause**. We may conclude that the middle must be consequentially connected with the minor, and the major with the middle.

Speaking explicitly about mathematics, Aristotle anticipates the most striking prohibitions of Bolzano's *Abfolge* [1, Book I, Part 7]:

> **It follows that we cannot in demonstrating pass from one genus to another. We cannot, for instance, prove geometrical truths by arithmetic.** For there are three elements in demonstration: (1) what is proved, the conclusion—an attribute inhering essentially in a genus; (2) the axioms, i.e. axioms which are premises of demonstration; (3) the subject-genus whose attributes, i.e. essential properties, are revealed by the demonstration.

I trust that the flaws of this Aristotelian fantasy will be recognized by any mathematician who reflects on his or her working life, and in the following pages I will provide episodic evidence against both the purity ideal and, more generally, the essentialist account of axiomatics that motivates it. But in order to provide a stage for that evidence I first turn to direct assaults on the univocal view of simplicity itself.

Possibly more than anyone else, Wittgenstein, in the *Philosophical Investigations* questioned the very intelligibility of objective standards of simplicity. For this purpose he described completely general examples in which the "primary elements" are manifest in the descriptions and staged mocked debates with himself about the propriety of those descriptions. ("'But are these simple?'—I do not know what else you would have me call 'the simples,' what would be more natural in this language game," [20, Sect.48].) Wittgenstein did not mean actually to raise questions about whether the things we take to be simple truly are. Instead he used these questions as device to expose the errors in the presuppositions that motivate them.

In this way Wittgenstein tried to undermine the entire dialectic between those who would say that the things we take to be primary elements might not be the real simples, the right starting points, and those who counter by saying that simplicity is merely a matter of convention, that we can take whatever we want as starting points. In fact, Wittgenstein stressed, we cannot choose our starting points arbitrarily. Some things are simpler than others, and our choices are constrained by this fact. But just as crucially, the relative simplicity and complexity of things is not independent of our practices—the very distinction between simplicity and complexity is a result of contingent features of our endeavors, interests, and scientific investigations. According to Wittgenstein, "essentialism" and "relativism" about categories like "the simple" are not just both wrong: the two doctrines trade in a common misunderstanding of the sort of thing simplicity is.

Thus, contra Bolzano (and, more importantly for Wittgenstein, Frege, Russell, and the prevailing modern ideology), mathematical simplicity cannot remain forever hidden away from those who never step outside mathematical activity to look for it. Simplicity is immanent in practice.

This line of Wittgenstein's has proved to be subtle enough to inspire endless interpretive debates to the point that one would be excused for thinking that the exact message cannot possibly have practical relevance for the proper way to think about anything like mathematics. But I agree with Wittgenstein that a close look

at the details of events in mathematical history can help us see why the appeal of absolute standards of simplicity such as those Bolzano and Aristotle dreamed of is both so strong and so deceiving.

The Artworld

The lure of essentialism hasn't been nearly as strong outside of mathematics. Social theorists have long held that the basic elements of social practice are basic precisely in the context of that practice but endlessly complex from any external "point of view" from which we might try to describe them. Thus Benedict [3, p. 2]:

> The inner workings of our own brains we feel to be uniquely worthy of investigation, but custom, we have a way of thinking, is behaviour at its most commonplace. As a matter of fact, it is the other way round. Traditional custom, taken the world over, is a mass of detailed behaviour more astonishing than what any one person can ever evolve in individual actions no matter how aberrant.

The point is repeated and further developed in Sacks's "On doing being ordinary," [16], Schegloff's "The routine as achievement" [17].

But reflections on our experience of art rather than on our embedment in social space provide the best analogue for the facets of mathematics I want to highlight.

Arthur Danto resorted to irony to describe why questions about art can rarely be easily answered by artists: ". . . what prevents Oldenburg's creation from being a misshapen bed? This is equivalent to asking what makes it art, and with this query we enter a domain of conceptual inquiry where native speakers are poor guides: *they* are lost themselves" [8, p. 575].

The difficulty is not, of course, that artists are somehow under-informed about their craft. On the contrary, artists' ability to respond to and produce art depends on the assimilation of so much information that a new way of seeing becomes available [8, p. 581]:

> What in the end makes the difference between a Brillo box and a work of art consisting of a Brillo box is a certain theory of art. It is the theory that takes it up into the world of art, and keeps it from collapsing into the real object which it is. Of course, without the theory, one is unlikely to see it as art, and in order to see it as part of the artworld, one must have mastered a good deal of artistic theory as well as a considerable amount of the history of recent New York painting. It could not have been art fifty years ago. The world has to be ready for certain things, the artworld no less than the real one.

They are "poor guides" because their every observation is laden with the theory that their tourist is missing. The are lost because they have shed the point of view from which the terms built into their every experience are complex and theoretical.

It is the emergence of new simples: at once blinding and enriching. So long as one fastens onto the basic terms and distinctions one has been handed, one is in a position to see great complexities in the development of art. In fact, though, the development is so complex that it will remain for the most part unintelligible.

The aesthete, on the other hand, draws new terms and distinctions into his or her vernacular. Only by sublimating all this development as simple, i.e. precisely by no longer being in a position to see it as complex, he or she is able to see "members of the artworld" as art [8, p. 583]:

> It is this retroactive enrichment of the entities of the artworld that makes it possible to discuss Raphael and De Kooning together, or Lichtenstein and Michelangelo. The greater the variety of artistically relevant predicates, the more complex the individual members of the artworld become; and the more one knows of the entire population of the artworld, the richer one's experiences with any of its members.

It is perhaps controversial to say, with Danto, that with the historical development of art always become available richer artistic entities. Today's simples might be informed by a longer history without being able to promote richer experiences. One wonders if Danto wasn't drawing from the well of fundamental complexity the water he used to try to wash away its traces.

But one can set aside those complications and just note, with Pierre Bourdieu, that "what is forgotten in self-reflective analysis is the fact that although appearing to be a gift from nature, the eye of the twentieth-century art lover is really a product of history," [6, p. 202], that "certain notions which have become as banal and as obvious as the notion of artist or of 'creator,' as well as the words which designate and constitute them, are the product of a slow and long historical process," [6, p. 204]. In his elaboration of this theme, Bourdieu emphasizes that categories of art like elegance, accident, and disruption, are historically constituted [6, p. 202]:

> What the ahistorical analysis of the work of art and of aesthetic experience captures in reality is an institution which, as such, enjoys a kind of twofold existence, in things and in minds. In things it exists in the form of an artistic field, a relatively autonomous social universe which is the product of a slow process of constitution. In minds, it exists in the form of dispositions which were invented by the same movement through which the field, to which they immediately adjust themselves, was invented.

The physical description of the social universe that houses artwork will have its complications. The physiological account of the dispositions that creators and audiences must display might be more or less complex. Just as intricate will be the genealogical record of the gradual constitution of aesthetic categories. "But," in speaking about the terms of art and the richness of artistic experience the relevant measure is not the one that lays bare the origins or structure of aesthetic criteria, but the aesthetic criterion itself, and "in that case it is quite evident that 'essences' are norms," [6, p. 206]. As soon as one even asks if today's simples are in fact suppressing more theory and more complexity than yesterday's, one has changed the subject.

Among the most dramatic effects of viewing art in these terms is a broadening of the field of its producers. The "slow process of constitution" and the continuous adjustment of our dispositions to its terms is surely a social process. It is no glib historicism to say, with Danto, that "the world has to be ready" for some things, that today's artwork could not have been produced a century earlier. Habituation requires a community of produces and receivers with whom to fall into step. The creation of a new artwork on its own does not reconstitute our sense of the banal [6, p. 205]:

Thus as the field is constituted as such, it becomes clear that the "subject" of the production of artwork—of its value but also of its meaning—is not the producer who actually creates the object in its materiality, but rather the entire set of agents engaged in the field. Among these are the producers of works classified as artistic, critics of all persuasions, collectors, middlemen, curators, etc.

Mathematics

It is easy to understand why one would resist thinking of mathematics in the way Danto and Bourdieu have described art—the lure of the Aristotelian dream. The proper account of mathematics, it is thought, must foremost be an account of its distinguishing features: the objectivity of its truths, the permanence of its results, the rigor of its demonstrations, the isolation of its subject matter from the contingencies of the real world. I don't want to belittle the importance of sorting out the details of these features of mathematics. But with Wittgenstein, I suspect that our fascination with them smuggles in a presupposition that mathematics must be utterly different from those human endeavors in which "essences are norms," that its complexity measure is absolute and uninfluenced by our ways of thinking, and that its subject matter is independent of our interests and practices.

Many mathematicians express surprise that philosophers have considered this rarefied view of mathematics a compliment. Rota, echoing Bourdieu's reminder that the artistic eye is the product of history rather than a gift from nature, calls mathematics "a historical subject par excellence" [15, p. 174]. According to Thurston, the resulting image of mathematics is actually an insult because it masks the bulk of its intrigue. Mathematicians, he claims, are not simply trying to fill a repository of facts. Nor are they primarily interested in solving problems. Because what they are ultimately after is a better understanding of mathematics, their main interest is in devising new ways of thinking that foster this understanding. "If what we are doing is constructing better ways of thinking," he wrote, "then psychological and social dimensions are essential to a good model for mathematical progress" [19, p. 162]. No informed view of mathematics could maintain that mathematics proceeds, or ought to proceed, independently of the social.

According to Thurston, the way mathematicians devise new ways of thinking mirrors the construction of aesthetic criteria. Just as the aesthetic mind adapts by adjusting itself to the evolving artistic field, so "as mathematics advances, we incorporate it into our thinking." New mathematical concepts follow: "As our thinking becomes more sophisticated, we generate new mathematical concepts and new mathematical structures," and, far from being determined in isolation from our interests, "the subject matter of mathematics changes to reflect how we think" [19, p. 162].

As with terms from art, simplicity itself is reconstructed along the way. For part of the "real joy in doing mathematics" is that more than they lead to the discovery of

new facts, these "new ways of thinking ... explain and organize and simplify" [19, p. 171]. Thurston gives some examples [19, p. 168]:

> ... mathematicians sometimes invent names and hit on unifying definitions that replace technical circumlocutions and give good handles for insights. Names like "group" to replace "a system of substitutions satisfying ..." and "manifold" to replace "We can't give coordinates to parametrize all the solutions to our equations simultaneously, but in the neighborhood of any particular solution we can introduce coordinates $(f_1(u_1, u_2, u_3), f_2(u_1, u_2, u_3), f_3(u_1, u_2, u_3), f_4(u_1, u_2, u_3), f_5(u_1, u_2, u_3))$ where at least one of the ten determinants [of matrices of partial derivatives] is not zero."

Notice in the first case we aren't just abbreviating; we are leaving behind the idea of substitution, generalizing. And in the second case, Thurston is explicit about changing our focus, learning to be interested in something else, treating something else as basic.

One is reminded of Bourdieu: "Certain notions which have become as banal and as obvious as the notion of artist or of 'creator,' as well as the words which designate and constitute them, are the product of a slow and long historical process." But on Thurston's account, the reconstitution of the obvious is not drawn out over history in quite the same way, for "[e]ntire mathematical landscapes change and change again in amazing ways during a single career" [19, p. 170].

And as with art, the fact that in mathematics "the aspects of things that are most important for us are hidden because of their simplicity and familiarity" [20, Sect. 129] does not derive from a merely individualistic habituation. "Mathematical knowledge and understanding [are] embedded in the minds and in the social fabric of the community of people thinking about a particular topic" [19, p. 169]. So as Bourdieu maintains that "the 'subject' of the production of artwork ... is not [merely] the producer who actually creates the object in its materiality, but rather the entire set of agents engaged in the field," one expects the same could be said about the production of mathematics. Thurston agrees [19, p. 172]:

> If what we are accomplishing is improving human understanding of mathematics, then we would be much better off recognizing and valuing a far broader range of activity. The people who see the way to proving theorems are doing it in the context of a mathematical community; they are not doing it on their own.

Impurity

I believe that the full force of the account of mathematical simplicity just described can be felt most readily in modern mathematics' violation of the Aristotelian prescription of topical purity. Just as Aristotle, and Bolzano after him, saw a direct link from the notion of absolute simplicity which they insisted must attain outside our experiences with mathematical thought to a prohibition against "crossing over to another kind" in mathematical demonstration, so actual mathematics, in its total abandon of the absolute, fosters understanding most often by uncovering relationships across topics.

James Joseph Sylvester chose this striking feature of mathematics as the topic of his 1869 Presidential Address to the British Association [18, ¶21]:

> Time was when all the parts of the subject were dissevered, when algebra, geometry, and arithmetic either lived apart or kept up cold relations of acquaintance confined to occasional calls upon one another; but that is now at an end; they are drawn together and constantly becoming more and more intimately related and connected by a thousand fresh ties Geometry formerly was the chief borrower from arithmetic and algebra, but it has since repaid its obligations with abundant usury

Even those mathematicians working most directly on foundational questions, whom one would most expect to resist this view in favor of the dream of uncovering proofs that expose the objective reasons for the truths of mathematics, spoke explicitly against the ideal of purity even as they announced their own foundational innovations.

Here Dedekind, in the celebrated essay "Was sind und was sollen die Zahlen?", denounces the fetish of producing purely number theoretic proofs of complex mathematical facts. The reason? While a certain foundational doctrine suggests that numerical techniques are in some sense more basic, the "new concepts" in higher mathematics are the ones actually simpler to deploy [9, Preface to the First Edition]:

> From just this point of view it appears as something self-evident and not new that every theorem of algebra and higher analysis, no matter how remote, can be expressed as a theorem about natural numbers But I see nothing meritorious ... in actually performing this wearisome circumlocution and insisting on the use and recognition of no other than natural numbers. On the contrary, the greatest and most fruitful advances in mathematics and other sciences have invariably been made by the creation and introduction of new concepts, rendered necessary by the frequent recurrence of complex phenomena which could be mastered by the old notions only with difficulty.

Similarly Cantor [7, Sect. 4, ¶8]:

> I cannot believe that mathematicians started from these principles and were led to the discovery of new truths; for although I grant that these maxims have many good aspects, I nevertheless hold them strictly speaking as *erroneous*. We are indebted to them for no true progress, and if they were actually to be followed, then science would be held back or banished into the narrowest confines.

The insight should have been available to anyone familiar with mathematics. Even Bolzano confessed that "[c]oncepts which are completely simple are needed only rarely in social life" and so presumably would have gone in for impurity if he hadn't been so pessimistic about the situation of mathematics within social life [5, 1810, II Sect. 8].

Residues

I wish to illustrate how the emergence of impure concepts as basic facilitates depth of understanding with a specific example.

After cautioning against thinking that the in-principle availability of number theoretical proofs is any reason to strive for methodological purity, Dedekind remarked that he "gave a lecture on this subject before the philosophical faculty in the summer of 1854 on the occasion of [his] habilitation as *Privat-Dozent* in Göttingen" and that "[t]he point of view ... met with the approval of Gauss" [9, Preface to the First Edition]. So let us look at some of Gauss's work to see what in his experience would have prepared him to agree with Dedekind.

Gauss's 1831 "Notice on the theory of biquadratic residues" is famous for its defense of the reality of the imaginary numbers. The story I was told as a student is that Gauss, together with Argand and others, sweet-talked the mathematical community into embracing these things after nearly a century of skepticism by giving them a geometric interpretation. Here are some passages suggestive of this [11, ¶24, ¶17]:

> If one formerly contemplated this subject from a false point of view and therefore found a mysterious darkness, this is in large part attributable to clumsy terminology. Had one not called $+1, -1, \sqrt{x}$ positive, negative, or imaginary ... units, but instead, say, direct, inverse, or lateral units, then there could scarcely have been talk of such darkness.

> Moreover, in this way the true metaphysics of the imaginary quantities is placed in a bright new light.

But if one looks carefully at Gauss's paper one can see clearly that Gauss's own reasons for accepting the imaginary numbers as legitimate were entirely pragmatic: They embodied the ideas needed in order to foster a fuller understanding of a great many already known truths about natural numbers.

Gauss said that "to transfer the theory of biquadratic residues," which is superficially a set of questions about the relationships that attain among natural integers, "into the domain of the complex numbers might seem offensive and unnatural" [11, ¶16]. He suspected that [11, ¶18]:

> ... the imaginary quantities [would be] merely tolerated rather than fully accepted, and therefore appear more like a game with symbols, ... without, however, [anyone] wishing to scorn the rich rewards which this game with symbols achieved for our understanding of the relationships of the real quantities.

Driven by these suspicions, Gauss offered his metaphysical account of the complex plane, situating the imaginary numbers on the same ontological footing as the reals. But clearly Gauss felt that there was something fishy about acknowledging the benefits to "our understanding of the relationships of the real quantities" while harboring misgivings about the "reality" of the benefactors. Only reluctantly did he indulge an audience with these backwards demands with his geometric interpretation. For Gauss, the way the imaginary numbers shed light on the reals was all the evidence one needed for their legitimacy.

A quick review of the concepts Gauss worked with will underline the significance of his pragmatism.

Definition An integer k is called a *quadratic residue* with respect to an arbitrary integer p if there are numbers of the form $x^2 - k$ that are divisible by p, and in case no such numbers are divisible by p, k is called a *quadratic non-residue*.

Definition An integer k is called a *biquadratic residue* with respect to an arbitrary integer p if there are numbers of the form $x^4 - k$ that are divisible by p (i.e., there is an x such that x^4 is congruent to k mod p.), and in case no such numbers are divisible by p, k is called a *biquadridic non-residue*.

In studying biquadratic residues, one need only consider the case where p is a prime integer of the form $4n + 1$ that does not divide k. For such p, one then seeks a scheme to classify integers k as (1) biquadratic residues, (2) biquadratic non-residues that are quadratic residues, or (3) biquadratic non-residues that are quadratic non-residues (actually this third class bifurcates).

Gauss mentions that "the theory of this classification is completely worked out" for the cases $k = -1$, $k = 2$, and $k = -2$—i.e., it is decidable to which class such integers belong with respect to a given p. He then indicates how to extend these decision procedures to larger values of k and remarks [11, ¶4]:

> But easy though it is to discover such special theorems by induction, it is extremely difficult to discover in this way a general law for these forms—even though many similarities leap to the eye; and it is even harder to find proofs of these theorems. The methods used in the first treatise for the numbers $+2$ and -2 cannot be applied here, and although other methods might serve to settle the question about the first and third classes, these methods do not suffice for *complete* proofs.

Here Gauss is calling for a single method to cover all cases; what will make the proof "complete" is the unification it brings about. "Accordingly, one quickly sees that one can make progress in this rich domain of higher arithmetic only by employing methods that are entirely new" [11, ¶6]. He wrote:

> This [widening] is nothing less than the following: For the true grounding of the theory of biquadratic residues, one must extend the field of higher arithmetic which has hitherto been confined to the real integers, into the imaginary integers, and must concede to the latter the same legitimacy as the former. As soon as one has seen this, that theory appears in an entirely new light, and its results acquire a startling **simplicity**.

Not only does Gauss explicitly insist that the availability of "complete proofs" about real numbers *via* the imaginary numbers is grounds for the legitimacy of the latter, he singles out "simplicity" and "seeing things in a new light" as the hallmarks of the gains made.

After describing how a celebrated theorem of Fermat can be elegantly recast in the language of complex integers, Gauss remarks [11, ¶9]:

> But it is particularly noteworthy that the fundamental theorem for quadratic residues in arithmetic has its perfect, but **simpler**, counterpart here; namely, if $a + bi$ and $A + Bi$ are complex prime numbers such that a and A are odd, b and B even, then the first is a quadratic residue of the second, if the second is a quadratic residue of the first, whereas the first is a quadratic non-residue of the second, if the second is a quadratic non-residue of the first.

Thus the very statement of the classification problem for quadratic residues is simplified when recast in terms of the complex integers. Just as Gauss bemoaned the unfortunate associations with the word "imaginary" in this domain, leading as they did to a suspicion about the legitimacy of the concepts involved, so might he have decried the use of the word "complex": For in the solution as well, it is

through connections with the complex numbers that the disarray of pure methods is overcome and a uniform and simple classification of the integers is attained [11, ¶10, ¶11]:

> If the modulus is a complex prime number $a + bi$, where it is always presupposed that a is odd and b even, and where $aa + bb$ is abbreviated by p, and where k is a complex number not divisible by $a + bi$, then $k^{(p-1)/4}$ is always congruent with one of the numbers 1, i, -1, -i, and thereby justifies a distribution of all numbers not divisible by $a + bi$ into four classes, which are assigned, in sequence, the characters 0, 1, 2, 3. Clearly character 0 pertains to the biquadratic residues, the others to the biquadratic non-residues, and in such a way that quadratic residues correspond to character 2, while quadratic non-residues correspond to characters 1 and 3.
>
> One easily sees that it is primarily a matter of being able to determine this character for values of k that are themselves complex prime numbers, and here induction leads at once to **extremely simple results**.

In order to appreciate this discussion one should recall that a real prime number viewed as a complex integer can be either prime or composite according to whether it has complex factors. Thus 3 is a complex prime but $5 = (1+2i)(1-2i)$ is not. This distinction, while superficially complicating the investigation of quadratic residues, paved the way for Gauss's "complete" proof. "Not only is every mathematical every problem solved," Rota says, "but eventually, every mathematical problem is proved trivial" [15, p. 169]. In Gauss's discussion the role of impurity in the push towards triviality is vivid. Our understanding of facts that we might already have been able to verify comes hand-in-hand with the adoption of new starting points and ways of looking at our subject matter.

Creation

What did Hilbert mean when he asked us to look for a criterion of simplicity?

In one discussion at our symposium, Étienne Ghys remarked that he could not understand how someone so deeply entrenched and remarkably able in mathematical research could have thought mathematics was beholden to any such criteria. Was Hilbert himself not famous for solving problems by generalizing their statements and re-contextualizing them in ever more sophisticated settings?

I do not know exactly what Hilbert had in mind, but the record indicates that his suggestion could not have been so straightforward as to be undermined by any of the considerations I'm putting forward. In his *Grundlagen der Geometrie* (1899), Hilbert announced the following FUNDAMENTAL PRINCIPLE of his axiomatic method: "to make the discussion of each question of such a character as to examine at the same time whether or not it is possible to answer this question by following out a previously determined method and by employing certain limited means" [12, p. 130].

The context of the discussion of this principle is the impossibility proofs of Abel, Lindeman, and others, which he says take shape only if a definite notion of solvability is specified in advance. Hilbert then observes that there is a connection

between his principle and the popular criterion of purity of methods, "which," Hilbert reminds us, "in recent times has been considered of the highest importance by many mathematicians"—the most obvious point of contact being the shared concern with restricted means of demonstration [12, p. 131].

But in his elaboration of this point, Hilbert does not embrace any ideal of topical purity and instead declares that his interests diverge from it [12, p. 132]:

> The foundation of this condition [purity of topic] is nothing else than a subjective conception of the fundamental principle given above. In fact, the preceding geometrical study attempts, in general, to explain what are the axioms, hypotheses, or means, necessary to the demonstration of a truth of elementary geometry, and it only remains now for us to judge from the point of view in which we place ourselves as to what are the methods of demonstration which we should prefer.

Thus while the popular idea is to look at, say, a geometrical problem and ask whether a purely geometrical solution for it can be found—this is a "subjective conception" of what one might do instead to the greater advancement of mathematics: namely, to have no preconception at all about what the proper means of solution of a problem are, but rather to engage in a systematic study to discover which means are most appropriate. The two principal considerations determining which "methods of demonstration we should prefer" being the desire to solve problems ("what are the means necessary to the demonstration?") and the desire to generate theoretically significant unsolvability results.

This suggests that the task of specifying methods and isolating principles, even in the context of axiomatic investigations, is for Hilbert never ending. Our received view of a problem's topic is a merely subjective conception. The ideas that seem simplest and most basic according to this understanding might be obstacles to proof. As mathematicians we have to be prepared to question this view and to "place ourselves" in different ones. To this end, we have to learn to abandon the norms that shape our mathematical gaze and to devise new ones. After a little success working with these norms, they become further domesticated. In this way simplicity is a mathematical creation.

"... in order to awaken today's aesthete ... one must apply a shock treatment to him á la Duchamp or Warhol, who, by exhibiting the ordinary object as it is, manage to prod in some way the creative ..." [6, p. 208].

References

1. Aristotle. *Posterior Analytics.* 2nd ed. Translated with a commentary by Jonathan Barnes. Oxford: Clarendon Press, 1994.
2. Bachelard, Gaston. *La Poétique de lÉspace.* Paris: Presses Universitaires de France, 1958.
3. Benedict, Richard. *Patterns of Culture.* New York: Houghton Mifflin, 1934.
4. Bolzano, Bertrand. "Betrachtungen über einige Gegenstände der Elementargeometrie." In [10].
5. ———. "Beyträge zu einer begründeteren Dartellung der Mathematik." Translated by S. Russ in [10], 174–224.
6. Bourdieu, Pierre. "The historical genesis of a pure aesthetic." *The Journal of Aesthetics and Art Criticism* 46 (1987): 201–210.

7. Cantor, Georg. "Grundlagen einer allgemeinen Mannigfaltigkeitslehre." Translated in [10].

8. Danto, A. "The artworld." *The Journal of Philosophy* 61, no. 19 (1964): 571–584.

9. Dedekind, Richard. "Was sind und was sollen die Zahlen?" Translated in [10].

10. Ewald, William. *From Kant to Hilbert: A Sourcebook in the Foundations of Mathematics*, vols. I and II. New York: Oxford University Press, 1996.

11. Gauss, Carl Freidrich. "Theoria residuorum biquadraticorum, Commentatio secunda." Translated in [10].

12. Hilbert, David. *Foundations of Geometry*. Translated by E. J. Townsend. 3rd ed. La Salle, IL: Open Court, 1938.

13. ———. "Mathematical Problems." Reprinted in [10].

14. Poincaré, Henri. "On the nature of mathematical reasoning." Reprinted in [10].

15. Rota, Gian Carlo. "The pernicious influence of mathematics upon philosophy." *Synthese* 88, no. 2 (1991): 165–178.

16. Sacks, Harvey. "On doing 'being ordinary.'" *Structures of Social Action: Studies in Conversational Analysis*. Edited by J. Maxwell Atkinson and John Heritage. New York: Cambridge University Press, 1984.

17. Schegloff, Emanuel. "The routine as achievement." *Human Studies* 9 nos. 1–2 (1986): 111–151.

18. Sylvester, James. "Presidential address to Section 'A' of the British Association." Reprinted in [10].

19. Thurston, W. "On proof and progress in mathematics." *Bulletin of the American Mathematical Society* 30, no. 2 (1994): 161–177.

20. Wittgenstein, Ludwig. *Philosophical Investigations*. 2nd ed. Translated by G. E. M. Anscombe. Oxford: Blackwell, 2001 (1953).

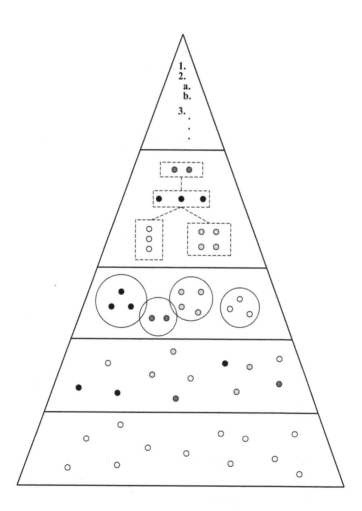

The stages of scientific evolution according to Dorothy Wrinch:

1. (bottom level): brute facts.
2. The facts are grouped into classes.
3. Theories link the classes and explain the facts.
4. The theories are organized logically.
5. The logical structure is axiomatized.

From blog.oup.com/2013/01/dorothy-wrinch-euclidean-geometry-biology/
By Marjorie Senechal

The Simplicity Postulate

Marjorie Senechal

"Simplicity" conjures a string of synonyms, not necessarily synonymous with one another. *Ease*, as in the Simplicity® patterns I learned to sew with in junior high school (back then girls were taught to sew). *Unpretentious*, as in the Shaker song "Simple Gifts": "'Tis a gift to be simple, 'tis a gift to be free,/'Tis a gift to come down where we ought to be." *Minimal*, as in lifestyle. I think of my friend who would go to a shoe repair shop, hand her shoes to the proprietor, and sit down to wait. "Why don't you leave them and pick them up later?" I asked her. "Because these are my only shoes," she replied. "One pair is all I need." Easy, unpretentious, minimal: "simplicity" evokes these synonyms in math and science too, and there are more.

Probable is probably not on anyone's list today. Yet this synonym, proposed nearly a century ago, caused waves that still ripple. That *simplicity = probability* was the insight of two young Cambridge-pedigreed mathematicians, Dorothy Wrinch (1894–1976) and Harold Jeffreys (1891–1989). At the time, circa 1920, Wrinch was teaching mathematics at University College, London, and Jeffreys was working in the London Meteorological Office. She played tennis and piano, in much the same style. He was an avid cyclist and rode his bike everywhere into his 90s. She was sharp of mind, eye, and tongue and firm of opinion. He was taciturn, hard to talk to. Both were drawn to probability theory, a controversial subject at the time.

I knew Wrinch well in her last decade. I had just joined the Smith College mathematics department. She was a "retired" professor of physics. We met through our common interest in symmetry and crystals. She was an improbable character. After excelling in math at Girton College, she studied Russell and Whitehead's *Principia Mathematica* with Bertrand Russell himself; his enthusiasm for foundations failed to take root in her, but they remained friends. She taught mathematics briefly at

M. Senechal (✉)
Department of Mathematics, Smith College, Northampton, MA, USA
e-mail: senechal@smith.edu

© Springer International Publishing AG 2017
R. Kossak, P. Ording (eds.), *Simplicity: Ideals of Practice in Mathematics and the Arts*,
Mathematics, Culture, and the Arts, DOI 10.1007/978-3-319-53385-8_7

University College and then at Oxford for 14 years. At the beginning of World War II, she emigrated to the United States. After a brief stint in the Johns Hopkins chemistry department, she was invited to Smith College to teach molecular biology for a year—the first course on this new subject anywhere. She stayed on as a *de facto* permanent visitor in the physics department. Visiting status left her free to follow the hunches of her restless mind, which had already blazed trails through mathematics, sociology, philosophy, seismology, protein chemistry, and crystallography. She crossed disciplinary boundaries easily, without glancing for oncoming trains [5].

But back to 1920. Wrinch had joined the Aristotelian Society, a London philosophical club of which Russell was a stalwart. Jeffreys attended as her guest. They were fascinated by a problem much discussed by the Aristotelians, a problem that straddled philosophy and psychology: scientific method. Not the feedback loop of hypothesis, experiment, and analysis we call scientific method today, but the question, "How do scientists choose between competing theories?" The question was live: the 1919 solar eclipse was to be the *demonstratio crucis* for Einstein's theory of gravitation. Yet Arthur Eddington, later Sir, who led the expedition to Africa to photograph it, had no doubt before he set forth that Einstein would prevail.

Like many in that rarified intellectual atmosphere, Wrinch and Jeffreys believed that every science will look like Euclid's *Elements* when it grows up. All sciences, they said, evolve from fact-gathering to axiomatizing; choosing among theories was a stage in the evolutionary process. In their time and for centuries before, the *Elements* was the second-most widely read book in England, after the Bible. Children learned his axioms, definitions, and propositions along with their Shakespeare. It wasn't just about the triangles. Euclid sharpened your mind, trained your logic. His clever proofs were the very model of argument. To master Euclid was to master the world, the world around you and beyond. "Nature and Nature's laws lay hid in night/God said, let Newton be, and all was light." And what did Newton's lamp look like? See for yourself in his *Principia Mathematica* [3]. "All human knowledge begins with intuitions," said Kant, "proceeds from there to concepts, and ends with ideas." Where do you think he got that?

Scientific method, then. A science begins with "brute facts," like (Wrinch's favorite example) the days that birds begin to sing in the spring. Next, the facts are grouped into classes. In the third stage, theories are proposed to link the classes. Scientists bow out at stage 4 and logicians enter, to clarify the logical structures of the theories and the relations between them. In the fifth and final stage of evolution, the pyramid is turned upside down. The science is recast in axioms and definitions from which the rest flows upward logically (see diagram on page 77).

For Wrinch and Jeffreys, steeped in Cambridge-style mathematical physics, theory meant natural law. A law, Henri Poincaré explained in *The Value of Science* [4], "is a constant relation between the phenomena of today and that of tomorrow, in a word, it is a differential equation." Thus Wrinch and Jeffrey's question narrowed to how scientists choose among equations that account for the same set of facts.

Is this logic, or is it psychology? Wrinch and Jeffreys argued that logic plays the larger role. Scientists choose the *simplest* equations, for starts: straight lines before quadratics, quadratics before cubics. And "simple" isn't fuzzy: simplicity can be

measured. Differential equations are characterized by their order, degrees, and the absolute values of their coefficients. These are all positive integers, and their sum, said Wrinch and Jeffreys, is a measure of the equation's simplicity. The smaller the sum, the simpler the equation is; the greater the sum, the more complex.

So far, so good, but working scientists faced with competing differential equations don't tally these sums and choose accordingly. Nevertheless, they do opt for simplicity as a first approximation. Why? Is it because simple equations are easier to work with? Or because our minds construe nature in simple images? Or because nature is simple? None of these, said Wrinch and Jeffreys. Scientists opt for the simpler laws because they are more probable. They believe the simpler law is more likely to be true.

This Simplicity Postulate, as Wrinch and Jeffreys called it, didn't spread fast nor did it last long. Simplicity's role in scientific thought was not quite as simple as that. Yet this was the beginning, not the end, of the story. The Simplicity Postulate had an impact on the other side of the equal sign: it brought what's now called Bayesian statistics to the fore. If you are one of N people with lottery tickets and the draw is fair, your chance of winning is $1/N$; that's Classical Statistics 100. But Jeffreys was grappling with questions for which no draw can be designed, like the probability that the earth's core is molten. (This was still an open question at that time; Jeffreys himself would soon help to close it). For questions of this sort, scientists make educated guesses. They use what they know about the earth, revising their probability estimate as they learn more. Wrinch and Jeffreys called this inverse probability because it's calculated from the outcome instead of vice versa. Inverse probability seemed fuzzy and subjective to their critics at the time, but Jeffreys would hone it to respectability.

After writing seven papers together, Wrinch and Jeffreys went their separate ways. In addition to developing Bayesian statistics and writing many influential books, among them Scientific Inference, Jeffreys became an eminent geoscientist, a Fellow of the Royal Society, knighted, and the winner of just about every prize except the Nobel. He always acknowledged his debt to Wrinch. "I should like to put on record my appreciation of the substantial contribution she made to this work, which is the basis of all of my later work on scientific inference," Sir Harold wrote after her death [2].

Wrinch was drawn to biology. This wasn't sudden: her friend D'Arcy W. Thompson, author of the magisterial *Growth and Form*, had been nudging her in that direction for several years. Everyone except perhaps biologists agreed that biology was ripe for an overhaul, with theory and experiment, not classification, at its base. The Rockefeller Foundation funded mathematicians and physicists, Wrinch among them, to apply their insights to its fundamental questions. She helped found the Theoretical Biology club, a small, diverse, and influential group that tried to map its logical pyramid. Another founder, in thrall to Russell's logic, planned a *Principia Biologica*. For her part, Wrinch took aim at the chromosome, "looking forward to a future in which the ... chromosome [is] recognized as providing the most delicate and illuminating object for the demonstration of the principles of the mathematical theory of potential and the concepts of pure physical chemistry" [6, p. 551]. But

soon she turned from chromosomes to proteins, not as a logician cleaning up a theory-strewn landscape, but as a theorist in the thick of the Stage 3 fray.

Experiments in the nascent science of protein structure suggested that proteins were molecules, not colloids. This meant they had definite shapes. The cage-like model she proposed, the first ever for protein molecules, catalyzed a complicated uproar on both sides of the Atlantic. The bones of contention were not differential equations but the relative values of vision and fact. Her model seemed to explain and predict protein folding, the numbers of amino acids in protein molecules, and the symmetries of protein crystals. It even suggested the possibility of designer drugs. The devil lurked in the details of these explanations and predictions: what mechanisms accounted for folding? There wasn't enough room in the cage for the protein's amino acids! The chemical bonds that snapped her cages shut might not really exist! In hindsight we can see that the probabilities her supporters and detractors assigned to her model varied directly with their affinities for simplicity. The main idea is simple and elegant, her supporters argued; let's develop its implications and address the details later. No! her opponents retorted, sometimes in unprintable language: if the details are wrong, the model is nonsense. Nor was it just about science. Turf wars, anti-feminism, and clashing personalities kept the cauldron boiling for years.

Winch lost out in the end, but she never accepted the polypeptide structure for proteins, not even after Nobel prizes were awarded for it. Instead, she refined her model, over and over, to the end of her life. In a curiously parallel postscript, Sir Harold held out against continental drift to the end of his life, though scientists around the world had accepted it.

The Simplicity Postulate is history, but it says something still. Not in the precise, quantitative way its formulators had hoped, but as a lasting insight. We often *do* equate simplicity with probable truth, instinctively. Let's return to the brute facts of birdsong in the spring. Each fact should be written on a separate sheet of paper, Winch said. We'll leave her there (as she never took it farther); we can only guess how she would group the sheets, and with what theories she might link them. But we can answer the question, where, on the Wrinch-Jeffreys evolutionary scale, is this science today? I google *why do birds sing in the spring*, get about 154,000,000 results in 1.02s, and find it's reached stage 4. My question, I learn, was settled in 2008. "Bird brain study sheds light on why they sing in spring," said the Telegraph [1]. British and Japanese scientists had established beyond doubt that "cells on the surface of the brain trigger hormones when the days get longer." British newspapers, and the BBC, trumpeted the story to the world. Yet the reporters are unlikely to have read the scientific papers. So why their enthusiasm? Because an explanation so simple surely must be true.

Postscript: this hormone action can probably be modeled by differential equations.

References

1. Highfield, Roger. "Bird Brain Study Sheds Light on Why They Sing in Spring." *The Telegraph*, March 19, 2008.
2. Hodgkin, Dorothy Crowfoot and Harold Jeffreys. "Obituary—Dorothy Wrinch," *Nature* 260 (April 8, 1976): 564.
3. Newton, Isaac. *Isaac Newton's Philosophiae Naturalis Principia Mathematica*. Cambridge, MA: Harvard University Press, 1972.
4. Poincaré, Henri. *The Value of Science: Essential Writings of Henri Poincaré*. New York: Modern Library, 2001.
5. Senechal, Marjorie. *I Died for Beauty: Dorothy Wrinch and the Cultures of Science*. Oxford: Oxford University Press, 2012.
6. Wrinch, Dorothy M. "On the molecular structure of chromosomes." *Protoplasma* 25, no. 1 (1936): 550–569.

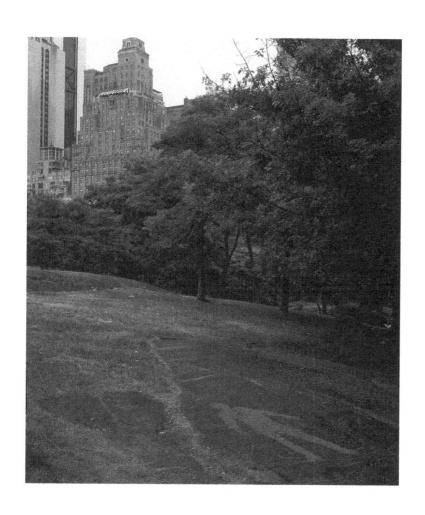

Andy Goldsworthy
Rain Shadow, 19 June 1993
Central Park, New York
Courtesy Galerie Lelong, New York

The Experience of Meaning

Jan Zwicky

In one of his best-known poems, Rilke describes his encounter with a headless Greek sculpture:

> We can't know that fabulous head
> where eyes like apples ripened. But
> his torso glows still like a candelabra
> in which his gazing, though it's shrouded,
>
> rivets us and gleams. Otherwise, the prow
> of his breast could not blind you, and no smile
> would ripple down the slight twist of the loins,
> there, to the core, which held his sex.
>
> Otherwise this stone would stand defaced, cut off
> under the shoulders' diaphanous plunge,
> and wouldn't shimmer like the pelt of some wild beast;
>
> and wouldn't burst from all its boundaries
> like a star: for there is no place
> that does not see you. You must change your life.

The poem is a testament to the power of art. It is also an extraordinarily vivid description of the experience of meaning wherever we encounter it, and it captures that experience in a startling image. Although the statue is headless, what we see is its gaze—a gaze that remains present, tangible, in the eyeless marble of the torso. The radiance of this gaze informs the fragment, and it informs us, too. It reaches right into us and demands a response.

J. Zwicky (✉)
P.O. Box 51, Heriot Bay, British Columbia, Canada
e-mail: cashion@uvic.ca

© Springer International Publishing AG 2017
R. Kossak, P. Ording (eds.), *Simplicity: Ideals of Practice in Mathematics and the Arts*,
Mathematics, Culture, and the Arts, DOI 10.1007/978-3-319-53385-8_8

The prospectus for this conference asked: *Why is the idea of simplicity so important in scientific practice?* My proposal is that in many cases it's not simplicity itself that we're after—at least not simplicity in any quantitative sense. What we're after is the phenomenon described in Rilke's poem. Once the question of truth is settled, and often prior to it, what we value in a proof or conjecture is what we value in a work of lyric art: potency of meaning. There is something *like* quantitative simplicity that matters here, namely an absence of clutter: lyric artifacts possess a resonant clarity that allows their meaning to break on our inner eye like light. But this absence of clutter is not tantamount to 'being simple' and it has nothing to do with minimum numbers of components, axioms, or procedures: consider Eliot's *Four Quartets*, for instance, or Mozart's late symphonies. Many truths are complex, and they are simpli*fied* at the cost of distortion, at the cost of ceasing to be truths. Why then do we valorize quantitative simplicity? Because getting rid of clutter—an action that facilitates potency of meaning—can involve tossing items out. But getting rid of clutter can also involve re-arranging the items that one has without throwing any of them away. And it is crucial to notice that the clearest or most compelling arrangement is not always the one whose components have been most strictly reduced. The case that springs to mind is our present model of the solar system. Attempts to explain apparent planetary motion with one focus—the centre of a circle—generated clutter; attempts to explain it with two foci precipitated an experience of meaning so powerful that it changed the intellectual life of Europe. It is that experience we seek—the flash of insight, the sense we've seen into the heart of things. I'm going to try to say something about what is involved in such recognitions; and then I'll try to say something about why an absence of clutter matters to them.

<div align="center">*</div>

A sustained attempt to discuss the experience of meaning in scientific terms was undertaken by a group of philosopher-psychologists in Germany in the first half of the twentieth century: they called it Gestalt perception. By the mid-1930s, the three leading exponents of the Gestalt school—Max Wertheimer, Wolfgang Köhler, and Kurt Koffka—had emigrated to the US. Despite considerable contemporary interest in their views, Gestalt theory was eclipsed in North America by behaviorism; it also declined in post-war Germany for reasons that are complex.[1]

The central tenet of Gestalt theory is often represented as the claim that the whole is greater than the sum of its parts. This representation is not entirely accurate. What Gestalt theorists maintained was that wholes are *different* than the sums of their parts; and we perceive wholes first. Wholes, they argued, are both logically and epistemologically prior to their parts: "parts do not become parts, do not function as parts, *until there is a whole of which they are parts*" [55, p. 213]. A Gestalt itself (hereafter, simply "gestalt") may be defined as a structure all of whose aspects

[1]For a discussion of proposed explanations for Gestalt theory's decline in post-war Germany see [4, pp. 405–412].

are in dynamic interrelation with each other and with the whole. It is "an integrated totality" in which each part has a place, or functions in a way, that enables the whole to be, stably, what it is [55, p. 210]. A gestalt, in other words, very much resembles an ecosystem.

Some examples may help focus this conception. One of the most striking is melody.[2] Many of us with no musical training can hum, on demand, any number of popular songs and Christmas carols; but if we're asked to specify the notes we're singing or the intervals between them, we have to shrug. Yet we can transpose the melody, as a whole, into a new key with little effort; we can recognize it speeded up, or slowed down, or in an unfamiliar arrangement, and even when it's hummed out of tune, or with a few wrong notes. These facts are inexplicable on the view that melodies are aggregates of elements, each of which we perceive individually and then stick together with some sort of epistemic glue. Melodies are aural *shapes*, and we perceive these shapes, not their constituents, spontaneously.

Another good example is the face. Most of us instantly recognize hundreds of them. But if asked to draw them, or to describe individual features, we flounder. Our experience is not of perceiving an eye of a particular shape and color, a nose of a particular length and width, another eye, a mouth, a couple of eyebrows, scattering some virtual plus signs among them, and *concluding* from the aggregate that the person we've glimpsed through the window of the passing cab is our downstairs neighbour. "What on earth is she doing in New York?" we exclaim in the split second it takes for the cab to draw away. Laboratory experiments have shown that we are in fact better at recognizing faces if we have not tried to use an Identi-Kit to reconstruct individual features first [31, 50].

What Wertheimer and his colleagues maintained is that all productive thinking— thinking that involves insight, thinking that precipitates an experience of meaning— involves the experience of gestalts. Such experience comes in two types. In some cases, we move from a chaotic situation—a jumble of lines, concepts, sounds, or data—to a situation in which we discern pattern or structure: the face springs out at us; the identity of the culprit dawns. In the second type of gestalt experience, we see a given thing or image as something else. Some of the most famous discoveries in the history of science and mathematics are examples of such gestalt shifts: Poincaré's famous description of his recognition that the transformations he had used to define Fuchsian functions were identical with those of non-Euclidean geometry; or Newton's equally famous account of the origin of his conjecture about the nature of gravity. Figure 1 offers a standard visual proof of the Pythagorean theorem which depends on seeing the area of the square with side c as the combined areas of the squares with sides a and b.

Insight, the experience of meaning, fundamentally involves the spontaneous perception of structure: not analytic order—one brick stacked on another—but resonant internal relations. We might describe these internal relations by saying

[2]The recognition that perception of melodies involves gestalt comprehension predates Wertheimer and may be found in [13].

Fig. 1 Visual proof of the
Pythagorean theorem

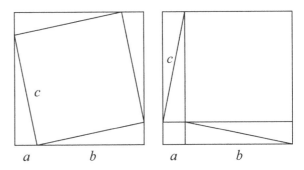

that the aspects of a gestalt are *interdefined*. In a culture that identifies thinking with the aggregation of atoms or elements, the acknowledgement of such wholes is difficult: the dominant epistemology makes them, literally, unthinkable. Critics of Gestalt theory, like logical positivists, especially dislike the concept of "internal relations." Virgil Aldrich provided a classic statement of the complaint: "[Couldn't Prof. Wertheimer have] written at least one... chapter of Gestalt theory of learning without once using the semi-metaphorical term 'inner'[?] Doubtless there are 'inner meanings' to be apprehended, but a theory of these should contain some literal analysis of the term, to provide means to identify and manipulate them in an objective way" [2, p. 1471].

No metaphors! Literal analysis! Objectivity!—This is not a critique of Gestalt theory but a statement of the view that it must be wrong. One way of attempting to understand the Gestalt project is to say that Wertheimer put the concept of metaphor—more precisely, the concept of significant similarity and the notion of internal relations on which it depends—where standard theory puts the concept of epistemological atoms. The appeal to internal relations isn't an attempt to avoid the issue, it is an attempt to state what the real issue is. Wertheimer did not pretend all the problems with such a fundamental re-formulation had been solved: "My terms should not give the impression that the problems are settled; they themselves are loaded with—I think—[the very kinds of] problems [I am trying to draw to your attention]" [53, p. 4].[3] Or: we should expect to feel some discomfort with Gestalt theory's observations and proposals. This is because our way of talking is itself epistemologically loaded: the reductionism that is part of the *texture* of acceptable academic speech won't allow us to express what is fundamental to the view in compelling terms. This is why it is crucial to keep reminding ourselves of our actual experience of meaning, those times when our breath has been taken away, when our vision has been altered. When we focus on this experience, we know, immediately, that it is important: it is one of the grand reasons for getting out of bed in the morning. And so, if we keep its image before us, we will want to tell the

[3]I am indebted to D. Brett King's and Michael Wertheimer's book [24] for drawing my attention to Aldrich's review, and for suggesting that Wertheimer had anticipated and replied to Aldrich's complaint.

Fig. 2 Puzzle image and
Necker cube

truth about it; we will be willing to struggle to find a way to do so. Because there is overwhelming evidence that we do, often, think and perceive things in ways that standard aggregative theories cannot account for, I think it is reductionist prejudice that has to go, not gestalts. This is not to say that aggregative synthesis is not a kind of thinking. It is to say that it is not the only kind there is, and that it is not always the most important kind.

Figure 2 illustrates the two types of insight. In the first (left), the figure appears initially to have no meaning; and then suddenly, when we see it as a word connected to its own mirror image, it does. The effect is the mental equivalent of dropping a crystal of sodium acetate into a supersaturated solution. In the second figure (right), we perceive, spontaneously, a transparent box projecting either up and to the right or down and to the left. The first time we are exposed to the figure, it is usually stable in one orientation and we have to be invited to perceive it in the other. But, once we've experienced the shift, we can re-perform it at will. We frequently use the vocabulary of recognition to describe our experiences of insight, and this is no accident: the experience is indeed one of re-cognizing a situation.

The word "recognition," however, implies, as does the word "insight," that we've grasped something true—and not all gestalts are veridical. Wertheimer's first laboratory experiment was in fact designed to demonstrate the intransigence of a demonstrably *false* gestalt—the so-called *phi* phenomenon [51]. If a subject is positioned at a certain distance from two separate lights that flash on and off in a certain rhythm, she will perceive not two distinct flashes, but a single light moving continuously between the two positions. Kepler's vision of the relations of the planetary orbits to the five perfect solids also proved illusory—although it struck him with such tremendous force that it continued to inspire his thinking even after he himself had demonstrated that it was false [23].[4] What this reveals is that the experience of meaning is not always an experience of truth. What it does *not* show

[4]The appearance of the polyhedral hypothesis has many of the classic features of a gestalt shift: Kepler had been puzzling over the problem for some time, but the idea came to him "by a certain mere accident" [*leui quadam occasione propius*] during the course of a lecture in July of 1595 [23, pp. 65/64]. "What delight I have found in this discovery I shall never be able to express in words." [*Et quidem quantam ex inuentione voluptatem perceperim, nuquam verbis expressero* [23, pp. 69/68]] As E.J. Aiton writes in his introduction to *Mysterium Cosmographicum*, "Almost all the astronomical books written by Kepler (notably the *Astronomia nova* and the *Harmonice mundi*) are concerned with the further development and completion of themes that were introduced in the *Mysterium cosmographicum*. The ideas of this work did not constitute just a passing fancy of youth but rather the seeds from which Kepler's mature astronomy grew. When a new edition was called for, he decided against changing the text itself, for a complete revision would have required the

is that gestalts are generally unreliable, much less that they are merely "subjective" impressions. The *phi* phenomenon is as "objective" as perceptions get—everyone sees one moving light instead of two lights flashing on and off.

"But surely," someone will protest, "gestalts aren't as 'real' as elementary sensations. The downward-projecting box and the upward-projecting box are just interpretations of an array that is, in fact, neither." But this is once again a restatement of reductionist prejudice. It misses the point that our immediate experience of the Necker cube is of one box or the other: "an array of lines that is neither" is an *abstraction* from immediate experience.[5] I don't want to deny that "elementary sensations" exist; I'm not expert enough in neuropsychology to know one way or the other. I want only to note that there is no perceptual evidence that "elementary sensations" are the building blocks of our experience of the world. They don't exist *the way* perceptions do. "I stand at the window and see a house, trees, sky," writes Wertheimer. "Theoretically I might say there were 327 brightnesses and nuances of color. Do I *have* '327'? No. I have sky, house, and trees" [52, p. 301].[6] Are skies, houses, and trees, melodies and faces, real?

They are what we perceive.

<div align="center">*</div>

If this is what it is to experience meaning—to have a gestalt crystallize out of chaos, or to sense the internal relations between one gestalt and another—why or how does an absence of clutter matter to this process?

That it matters, at least in some cases, is clear. Ben Shahn, the painter and printer, said that one of the most important stages in the emergence of a work of art is "the abolishing of excessive content,...the abolishing of...whatever material is extraneous to inner harmony, to the order of shapes [that has been] established" [47, p. 70]. It is important to remember that this is no minimalist manifesto: Shahn intended his remark to have wide application, and his own work is warm and richly textured. Among lyric poets, too—lyric writers in general—*less is more* is one of the few near-universal precepts. *Bartlett's* cites Robert Browning as its source in English [9]; but the thought is as old as Hesiod.[7]

Why should this be so? How *could* less be more?

Towards the end of *War and Peace*, Tolstoy's protagonist, Pierre Bezukhov, is captured by the French, imprisoned in a rudimentary camp for a month, and then forced to march west with the French as they retreat. It is October. He has no shoes. On the first evening of the march, Pierre moves off by himself and settles on the

inclusion of all the main ideas of his other books" [23, p. 29]. (Aiton refers his readers to [22, pp. 8, 10].)

[5]The relations among interpretation and gestalt comprehension are complex. It is clear there is overlap, and also clear that there are differences. Wittgenstein's discussion in [57, II, §xi] lays a fine foundation.

[6]This translation is from an abridged version of the paper in [16, p. 71].

[7]Hesiod, *Works and Days*, line 40: νήπιοι, οὐδὲ ἴσασιν ὅσῳ πλέον ἥμισυ παντός. . . .

frozen ground by a cart wheel to think. He is motionless for over an hour, and then suddenly bursts into a huge happy laugh. It's so loud that people around the campfires turn in astonishment, and someone comes to investigate. Pierre moves farther away, staring out across the complex and beautiful landscape now revealed by the moon [49, p. 1020]:

> "And all this is mine, and all this is in me, and all this is me!" thought Pierre. "And all this they've caught and put in a shed and boarded it up!" He smiled and went to his comrades to lie down and sleep.

This is the moment of Pierre's inner transformation, the effects of which will play out over the remainder of his life. Tolstoy describes the key to this transformation as Pierre's recognition that "all unhappiness comes not from lack, but from superfluity" [49, p. 1060].

Months later, rescued, recovered from a serious illness, Pierre appears, Tolstoy tells us, "almost unchanged in his external ways": he looks the same, he's still absent-minded, kind and distracted. His servants, however, notice that he has become "much simpler"; and he has ceased being a talker, and become an exceptional listener. Before his experience in the war, he had appeared unhappy, whereas now he seemed always to be smiling [49, pp. 1104–5]:

> Formerly he had been unable to see the great, the unfathomable and infinite, in anything. He had only sensed that it must be somewhere and had sought for it.... He had armed himself with a mental spyglass and gazed into the distance Now he had learned to see [it] in everything, and...joyfully contemplated the ever-changing, ever-great, unfathomable, and infinite life around him.

There is a great deal going on here—psychologically, sociologically, and culturally, as well as philosophically; *War and Peace* is a big novel. But one way of summarizing Tolstoy's insight is this: Paring life to its basics allows one to experience its ontological core, which is that the natural world—in all its magnificent complexity—is a resonant whole. One becomes able to perceive this resonance in individual beings and this perception brings joy.[8]

The American poet Robert Hass, discussing the imagism of haiku, says something eerily reminiscent of Pierre's changed perception of individual things [18, pp. 274–5]:

> Often enough, when a thing is seen clearly, there is a sense of absence about it...as if, the more palpable it is, the more some immense subterranean displacement seems to be working in it; as if at the point of truest observation the visible and invisible exerted enormous counterpressure.

[8]Why it's human social preoccupations, luxuries and comforts that obscure resonance rather than a proliferation of leaves, pebbles, or waves is a very interesting question. Another equally interesting question is what, exactly, the "natural" world includes—for Pierre's delight does seem to comprehend a range of artifacts that have been taken up into people's lives. These are not issues that I can pursue here, though many will recognize that the observations that underlie them inform ascetic practice in many cultures. For an excellent preliminary discussion see [1, pp. 63–65].

To put this in gestalt terms: the whole is experienced through the particular, which is an aspect of it. This is possible only if every part is internally related to every other part: if it is the nature of the whole that determines both what and that any part is.

Visualize a geodesic sphere. Because its nodes are dimensionless points, each exists only as a set of angles. Now imagine the sphere's lines are threaded with elastic, so that any or all of the nodes can move. If any one of them does move, this will affect the angles that define it: some will contract, some will expand. *As will the constituting angles of every other node.* Now, put the whole thing in motion. Each node will be in interdefined dynamic relation with every other node; and each will, necessarily, reflect the state of the whole at every moment.

It is in some such way, Tolstoy is claiming, that Pierre came to experience the world through its individual beings.

Here, an observation from Arne Næss, the environmental philosopher and scholar of Spinoza, is crucial. Næss points out that ecosystems theory draws a distinction between complexity and complicatedness [34, Point 6]. What is *complicated* is disunified, chaotic—Næss gives the example of trying to find your way through a huge unfamiliar city without a map. What is *complex*, by contrast, may be intricate, but it is not chaotic; it has a unifying gestalt—Næss's example, of course, is an ecosystem. By definition, a complex thing cannot be simple in the sense of having no parts or divisions. It will have multiple aspects, and there are often many different relations among these aspects. But complexity is uncluttered. Everything fits. Clutter, then, may be defined as that which does not belong to a gestalt, that which has no internal relation to other aspects of an array. Another way to describe Pierre's transformation, then, is to say that he ceased to experience the world as complicated, and came to experience it as complex.

The geodesic sphere, talk of "arrays"—these are visual images. Ben Shahn, you'll recall, speaks of "abolishing...whatever material is extraneous to inner harmony." His image is aural. It suggests that in powerful gestalts, we experience the presence of internal relations as the mutual attunements of parts or aspects. Because of this attunement, the gestalt as a whole is resonant: when one part sounds, other parts sound as well. Clutter is anything that damps down or muffles this resonance. Mies van der Rohe, who was himself fond of the phrase *less is more*, also often said *God is in the details*. What he was pointing to, I believe, is that we experience meaning as resonant interior attunement.[9]

*

[9]Ludwig Wittgenstein, who placed the concept of internal relations at the centre of his theory of meaning in *Tractatus Logico-Philosophicus*, also maintained that, architecturally speaking, God is in the details. A notebook entry from 1938 says that the following lines from Longfellow's "The Builders" could serve him as a motto: "In the elder days of Art, / Builders wrought with greatest care / Each minute and unseen part, / For the gods are everywhere" [58, p. 34]. The stanza in Longfellow places a semi-colon at the end of the third line; and the last line reads "For the gods see everywhere."

I said at the outset that what we prize in mathematical demonstrations is what we prize in works of art: the ability to precipitate an experience of meaning. Marjorie Wikler Senechal puts it this way [46, p. xiii]:

> Paul Erdős, the great twentieth-century mathematician who loved only numbers, an atheist, claimed that God has a book in which the best proof of every theorem is written. Erdős never listed the criteria a proof must satisfy to be inscribed in God's book: he didn't need to. Though no one has seen the book or ever will, all mathematicians know that Euclid's proof of the infinitude of primes is in it, and no mathematician doubts that computer-generated proofs, the kind that methodically check case after case, are not. The proofs in God's book are elegant. They surprise. In other words, they are light, quick, exact, and visible.

In other words, the proofs in God's book involve gestalt shifts: they are potent with meaning. They may be complex, but they are not complicated: there is no clutter. They do not tediously spell everything out; they invite us to *see* what they are saying. Arthur Koestler describes his experience with Euclid's proof of the infinitude of primes in the following way (he was, at the time, in a Spanish prison, anticipating execution at any moment) [25, pp. 351–2]:

> Since I had become acquainted with Euclid's proof at school, it had always filled me with a deep satisfaction that was aesthetic rather than intellectual. Now, as I recalled the method and scratched the symbols on the wall, I felt the same enchantment.
>
> And then, for the first time, I suddenly understood the reason for this enchantment: the scribbled symbols on the wall represented one of the rare cases where a meaningful and comprehensive statement about the infinite is arrived at by precise and finite means.... The significance of this swept over me like a wave..., leaving in its wake only a wordless essence.... I must have stood there for some minutes entranced,... until I noticed some slight mental discomfort nagging at the back of my mind—some trivial circumstance that marred the perfection of the moment. Then I remembered the nature of that irrelevant annoyance; I was, of course, in prison and might be shot. But this was immediately answered by a feeling whose verbal translation would be: "So what? is that all? have you got nothing more serious to worry about?"—an answer so spontaneous, fresh and amused as if the intruding annoyance had been the loss of a collar-stud.

I have quoted at length because the echoes of Pierre's experience are so striking.

Mathematical demonstrations like Euclid's proof involve the crystallization of certain internal relationships: we *see* that the theorem has to be so. They are like haiku: single images through which the resonance of something much larger sounds. Other demonstrations—like Gauss's insight that there's an easy way to obtain the sum of any sequence of consecutive integers—involve gestalt shifts. We see things first one way, and then we see them—the same things!—another way. This is the essence not of haiku, but of metaphor: x is not y; and yet it is. It is the dawning of the second gestalt, in relation to the first, that is the experience of meaning.

In either case—whether the gestalt crystallizes or shifts—if there are pieces left over, details that don't fit, we may, as Ptolemy, and subsequently Copernicus, did, ignore them—tuck them away into eccentrics and epicycles. We don't *see them as* details that don't fit. Sometimes, though, they start to bother us; and once that happens, we've become aware of them *as* clutter; we want to clear them up; what was once a gestalt—something we *saw*—becomes merely a model, an *interpretation* of the data. That model may still have the weight of cultural authority behind

it, but it doesn't ring with its own authority. We keep revisiting the clutter—as Kepler did Tycho's observations of Mars—until the penny drops. We don't like messy or complicated models in science or messy and complicated images in poems because, even when they save the phenomena, they don't precipitate an experience of meaning.

So we come to understand that a gestalt is false, that an alleged proof is in error, because we acknowledge the existence of perceptions or data that don't fit; we experience irresoluble clutter that blocks a satisfying experience of meaning. But now: what is the ontological status of that clutter? How, on the Gestalt account, if parts are not spontaneously perceived but are perceived subsequent to wholes—how do we become aware of this recalcitrant data in the first place? Come to that, how is it that we can perceive aspects, details, parts—whatever we want to call them— at all? We may be spontaneously aware of faces as wholes, but we can certainly attend to their eyes and noses, and experience them spontaneously *as* eyes and noses, too. Indeed, it appears that we perceive those eyes and noses as integrated wholes themselves—we recognize them without being able to draw or accurately specify *their* "elemental" building blocks either. When we focus on them, ignoring their context, we perceive them as though they were gestalts. That's because they *are* gestalts.

Noses, eyes, motifs in melodies, individual triangles in a visual proof, anything we see or understand as a *thing*—each has shape, is a whole whose own aspects are internally related. And it works the other way as well: a face can become an aspect of a photograph, or a painting, or a crowd; a melody can become an aspect of the first subject of a movement in a sonata which, in turn, can become an aspect of the movement as a whole. The world, in other words, is an immense complex of subordinate and superordinate gestalts.[10] To paraphrase the homespun philosopher, it's gestalts all the way down.[11] And up, too.

It's also gestalts sideways. What is the ontological status of clutter? Clutter consists of what we might call con- or peri-ordinate gestalts—things that don't fit; facts we say we don't understand, but wish we did; recalcitrant data. It consists of gestalts that don't seem to belong to a superordinate gestalt; or, to put it another way, of gestalts that don't seem to have internal relations to other subordinate gestalts. Their perception therefore does not precipitate an experience of meaning. This failure to precipitate an experience of meaning is the hallmark of conordinate gestalts. I believe this is what Richard Feynman had in mind when he claimed that nobody understands quantum mechanics [17, pp. 122–3]. Why not? Because, according to Feynman, nothing in our experience is analogous to the behavior of electrons and photons. At the core of the Gestalt theory of learning is the view that to *understand* something just is to perceive its relevant structural similarity to some other thing or situation. The perception of telling similarity is the litmus that understanding has occurred [56, esp. p. 24], [55, esp. pp. 210 & 230–1],

[10] I owe the terms to Arne Næss. See [35, p. 241].

[11] For a version of the story of this possibly apocryphal figure, see [19, p. 1].

[57, § 151]. Where such perception is absent, we may have "the facts" but we have no superordinate gestalt; we don't see why they are the facts; we don't know what they *mean*. So we keep looking at them this way, that way, hoping we can sense connexions.

The fact of false gestalts—the tangled history of European views of planetary motion, for example—raises another issue about the relation between meaning and absence of clutter. A desire for truth, for accuracy, is part of the picture, but it's not the only part. Tycho, who made the observations on which Kepler's view is founded, was himself a geocentrist. And Kepler made a number of mistakes in the calculations he based on Tycho's data. But he refused to believe that the cosmological picture could be geometrically complicated. So he kept returning to Tycho's observations and at last, after years of effort, they precipitated a beautiful uncluttered ellipse for the orbit of Mars. (Indeed it may have been a concern with cosmological clutter that made Copernicus reluctant to publish his own increasingly epicycle-ridden view.[12]) We ourselves look at Kepler's three laws and marvel. "Ah!" we say, sweeping the epicycles off the table, "of course."

What, though, is the foundation of that "of course"? Why keep plugging away at Tycho's observations? Why keep trying to "understand" quantum mechanics? Aristotle said it was simply what humans do, that by nature we want to grasp the similarities that unify our experience and make it whole.[13] I think Aristotle was right: it's a raw fact about our intelligence: we prefer less complicated gestalts to more complicated ones. The Gestalt theorists characterized our preference in terms of the so-called Law of *Prägnanz*, a word that might be translated as 'concision' or "pithiness," and which, in Gestalt theory connotes pattern, regularity, and orderliness.[14] They further specified aspects of the Law of *Prägnanz*—features possessed by subordinate gestalts that will make them tend to "hang together": similarity, closure, proximity, unified movement, and the like. Critics have urged that the notions of *Prägnanz* and its various subspecies are too vague to be useful. Tendencies, they point out, aren't laws.

But the thing is: it isn't just any arrangement that does genuinely "hang together." Or, better, even in a case of extraordinary ontological insight like Pierre Bezukhov's, things don't hang together in any old way. It isn't, as Poincaré notes, *any* odd

[12]Copernicus argued that his system was to be preferred to Ptolemy's because it had fewer spheres [11, p. 20, lines 43–8]. The problem was, and Copernicus came to see this, his system actually required more epicycles than Ptolemy's. See [26, Part III, Chapter 2], "The System of Copernicus."

[13]Aristotle, *Metaphysics* A, 980a21 and 981a5–7. The verb usually translated "to know" in Aristotle's famous opening line is εἰδέναι a word that connotes seeing that something is so, "getting it." This kind of knowing, based in experience, is the foundation of τέχνε or art, which is described as "a grasp of those similarities in view of which they are a unified whole" (trans. Richard Hope).

[14]The term *Prägnanzstufen* (stages of configural stability) first occurs in Wertheimer's published work in 1923 [52]. However, D. Brett King and Michael Wertheimer [24] offer evidence that the "law of the *Prägnanz* of the Gestalt" had occurred to Max Wertheimer as early as 1914. See also [27, Pt IV, §V, esp. subsec. 264] or [16, pp. 17–54, esp. p. 54].

or bizarre combination of facts or objects that will be mathematically fertile [40, p. 386]; and it isn't *any* juxtaposition of images in a poem or painting, nor any harmonic sequence in a string quartet, that will strike us as profound. To deny this, to claim that anything can be as meaningfully connected to one thing as to another, is to fail to be responsible to our experience. I do not think we have explanations of the tendencies the Gestalt theorists identified. This does not mean we should think the tendencies don't exist.

<div align="center">*</div>

Great physicists, mathematicians, and philosophers have argued that the big cosmological picture has to be simple.[15] They have good reason. There is a remarkable fit between a number of clear, simple geometrical figures (spheres, ellipses, cubes, spirals, parabolas, pentagons, for example) and a good of deal of what goes on in the visible universe (planets, their orbits, pyrite, the construction of many biological organisms, gravitational field strength, quasi-crystals, for example). There are also remarkably clear, simple algebraic expressions for the geometrical relationships involved.

And yet there is not a similarly good fit between geometry (and its algebraic expression), on the one hand, and arithmetic, on the other. Some of the relationships we grasp—so immediately, so concretely—turn out not to have finitely calculable

[15]Or, in some cases, as simple as possible. And whether what is involved is a commitment to quantitative simplicity or to absence of clutter is, in some cases, unclear. See, for example:

Aristotle, *De Caelo* I.4, 271a33 ("God and nature create nothing that is pointless," trans. J.L. Stocks); *Posterior Analytics* I.25, 86a33 ("Let that demonstration be better which, other things being equal, depends on fewer postulates or suppositions or propositions," trans. Jonathan Barnes);

Ptolemy, *Almagest* III.1 ("We consider it wholly appropriate to explain the phenomena by the simplest hypotheses possible, in so far as there is nothing in the observations to provide a significant objection to such a procedure," trans. Gerald Toomer);

medieval axioms cited by scholars from Odo Rigaldus through Duns Scotus and Ockham ("A plurality is not to be posited without necessity" and "It is useless to do with more what can be done with fewer"; see [32] for an overview);

Thomas Aquinas, *Summa Theologica*, Part I, Q 2, Third Article, Objection 2 ("...it is superfluous to suppose that what can be accounted for by a few principles has been produced by many," trans. Fathers of the English Dominican Province);

Nicolaus Copernicus, see Footnote 12 above;

Isaac Newton, Rule I at the opening of Book III of *Principia Mathematica* ("We are to admit no more causes of natural things than such as are both true and sufficient to explain their appearances. To this purpose the philosophers say that Nature does nothing in vain, and more is in vain when less will serve; for Nature is pleased with simplicity, and affects not the pomp of superfluous causes." [37, p. 160]);

Albert Einstein, in [14, p. 13] ("conceptual systems...aim at greatest possible sparsity of their logically independent elements (basic concepts and axioms)," trans. Paul Arthur Schilpp);

Richard Feynman in [17, pp. 51–2] ("It always bothers me that, according to the laws as we understand them today, it takes a computing machine an infinite number of logical operations to figure out what goes on in...a [tiny] region of space...So I have often made the hypothesis that ultimately physics will not require a mathematical statement...and the laws will turn out to be simple").

arithmetical values. The diagonal of any given square is incommensurable with its sides; the golden section, like π, cannot be expressed as a ratio of integers. Why is this? We don't know. But it complicates the demand for simplicity in a culture that privileges calculative results above results of other kinds.

The puzzle, I believe, is generated by that privileging: the idea that only calculative results matter, only they are really "real." This is not, however, what the evidence suggests. The evidence suggests that gestalt thinking and perception constitute one kind of intelligence, and that calculation constitutes another; and that neither comprehends the other, neither can fully translate the other into its own terms. I know of no concerted efforts to document this claim. But there are a number of studies that document a related claim: that gestalt comprehension and language-use are somehow at odds.

Wertheimer suspected this was the case, and in an essay entitled "Einstein: The Thinking that Led to the Theory of Relativity" he includes a footnote in which Einstein reports that it was a long time before he formulated his insights axiomatically. "These thoughts did not come in any verbal formulation," he said. "I very rarely think in words at all." Wertheimer pushed him, responding that many people claim that they always think in words; Einstein, reports Wertheimer, merely laughed [53, p. 228, ftnt. 7].

More recently, over the past two decades, an American experimental psychologist, Jonathan Schooler, has made laboratory experiments that repeatedly confirm a phenomenon that he has dubbed "verbal overshadowing."[16] Schooler and his associates have shown that the ability to recognize previously seen faces or previously heard segments of music, to perform gestalt shifts of the Necker cube variety,[17] to perceive analogies, and to solve insight problems are impaired by attempts to describe the face, figure, or thought processes involved. He also points out that cognitive psychology has not been keen to embrace this fact. In one of his earliest papers, Schooler cites mid-twentieth-century studies that demonstrated the effect, but whose results were subsequently overlooked [42, p. 67].[18] He lists later twentieth-century studies in which the effect shows up, but whose authors have concluded not that verbalization interferes with our ability to think in certain

[16]The studies are legion. I here mention, in chronological order, only a few of the most notable. Those with asterisks contain useful summaries of earlier research: [42], [45], [7], [44], [43]*, [48], [28], [10]*.

Schooler has also been at the centre of a controversy over the repeatability of his results and his attempts to call attention to the so-called "decline effect." See [30]. Recently, the results of a very large, multi-site replication study were released, confirming unequivocally that verbal overshadowing exists. See [3]. It is important to note that it's not just Schooler's results, nor even just results in psychology, that show the decline effect. The problem appears to afflict many branches of science. Schooler is to be commended for his insistence that the problem requires attention from all scientists. It is far from clear what underlies it. See [41].

[17]The figure used was a version of Jastrow's duck-rabbit (familiar to those who know the work of Ludwig Wittgenstein). See [7]. Jastrow, in [20, p. 295], reports that the drawing in his own text is "[f]rom *Harper's Weekly*, originally in *Fliegende Blätter*."

[18]The studies mentioned are [6] and [21].

ways, but that it uses up time that might otherwise be devoted to "visual encoding" [5, 36]; or that presenting subjects with schematic sentences caused them to focus on schematic aspects of pictures [39]; or that the negative effects observed were anomalous [59]; or that training may need to be more intensive if it is to produce results [15].[19] As Schooler says, "verbal processing has been assumed to be the 'deepest' and most memorable form of processing....the present Zeitgeist emphasizing the value of verbal processing has caused...researchers to generally overlook or simply disregard its potential to produce interference" [42, p. 67]. This Zeitgeist has also caused most Western intellectuals to ignore or to reject the importance of gestalt comprehension, and thereby to avoid serious contemplation of the experience of meaning.

Without such contemplation, however, I do not think we can come to an accurate appreciation of why we prefer some mathematical and scientific theories to others. We turn to theories for insight, for a shift from what seems to be a complicated situation—one that consists of a bunch of conordinate gestalts, or, sometimes, even a mass of inchoate impressions—to a complex one—one in which parts and whole are interdefined. Insight does not require reducing the number of aspects to a minimum nor does it require limiting the types or amounts of interdefinition. It requires the absence of things that don't fit.

There are, notoriously, no criteria in the arts or sciences for achieving or executing integrated wholes. But the absence of such criteria need not mean that the wholes themselves are suspect; it could mean, and I think it does, that the demand for criteria is, sometimes, misplaced.

In addition to the worry that there are no reductionist definitions of its key terms, one of the major objections to Gestalt theory has been that there are no exceptionless laws that apply to all cases, no formulae that accurately predict what gestalt will emerge in any given situation. But gestalt thinking does not occur verbally, even when the result is a word-complex like a poem.[20] Computers cannot describe insight accurately because computational structures, of their essence, consist of discrete, non-interdefined elements arranged in rule-governed sequences: this is exactly what a gestalt is not. Perhaps—perhaps—as we come to understand more about how brains work, we will be able to formulate reductionist biophysical laws that underlie gestalt thinking and perception. Or perhaps we will come to appreciate that we are looking for a kind of representation of gestalt thinking that we cannot have, that gestalt thinking will always *underlie* any "satisfactory" biophysical laws we formulate, and the deep mystery will remain. The deep answer starts to look like Plato's: *being* consists of gestalts. What *is* is shape. Except it's shape in motion— there's nothing changeless or eternal about it. The view of Herakleitos, then, the

[19] In [15], Ellis is clear, however, that face-recognition involves gestalt perception [15, pp. 13, 35], and that it is extremely difficult both to maintain the image of a face in memory and to "decompose" it in order to extract information from it [15, p. 35].

[20] The non-verbal nature of poetic insight is well-documented. See for example [8, pp. 15–16], [12, p. 15], [29, p. 180], [33, p. 26], [38, p. 47].

riddler, who saw change and unity and dynamic interdefinition as the fundamental features of the cosmos, and who was quite content to allow the strain on language, in the form of repeated and multiple paradoxes, to stand unresolved. Who asserted that this bending and breaking of linguistic intelligence was the price of understanding.

Schooler and his colleagues have explicitly tied the lab-tested phenomena of "verbal overshadowing" to classic discussions of insight and creativity—things that, as a culture, we claim to value—but there is little evidence that we are paying attention. In North American philosophy, for example, computational models of learning have linked hands with logico-linguistic analysis and penetrated deeply into the idea of what epistemology *is*. Analogical thinking is dismissed as weak or inferior. The idea that there might be philosophically significant thought that occurs without words is still a kind of heresy. The idea that meaning itself might be a nonverbal phenomenon is not even on the radar.

But I am convinced it is the truth. The famous anecdotes from the history of science, mathematics, and the arts, the repeated lab experiments with hundreds of unremarkable undergraduates confirm it: insight is not verbal. If you try to make it verbal, you shut it down. By demanding that people think verbally, we are depriving them of the experience of meaning. They will know, increasingly, *what* is the case, but less and less will they have a sense that they understand why.

Yet a sense that we understand why is one of the things human beings most deeply desire. It's what we want from mathematics, science, and the arts; I think it's even what we want from philosophy: the revelation of meaning. We want to experience gestalts so powerful they make us change our lives. I do not know why we want this. One possibility is that that's what being itself is: the resonance of gestalts. When we experience meaning, we are, to a greater or lesser degree, filled with resonance ourselves. And if being is resonance, then, in such moments, we more completely are.

Acknowledgements My gratitude to Warren Heiti and to Robert Bringhurst for insightful criticisms of earlier drafts of this essay.

References

1. Abram, David. *The Spell of the Sensuous: Perception and Language in a More-Than-Human World*. New York: Vintage (Random House), 1996.
2. Aldrich, Virgil C. "Learning by Insights: *Productive Thinking* by Max Wertheimer." *Christian Century* 63, no. 49 (4 December 1946): 1471.
3. Alogna, V.K. et al. "Registered Replication Report: Schooler & Engstler-Schooler (1990)." *Perspectives on Psychological Science* 9, no. 5 (2014): 556–578.
4. Ash, Mitchell G. *Gestalt Psychology in German Culture, 1890–1967: Holism and the Quest for Objectivity*. Cambridge, UK: Cambridge University Press, 1995.
5. Bahrick, Harry P., and Barbara Boucher. "Retention of Visual and Verbal Codes of the Same Stimuli." *Journal of Experimental Psychology* 78, no. 3 (1968): 417–422.
6. Belbin, Eunice. "The Influence of Interpolated Recall upon Recognition." *Quarterly Journal of Experimental Psychology* 2, no. 4 (1950): 163–169.

7. Brandimonte, Maria A., and Walter Gerbino. "Mental Image Reversal and Verbal Recoding: When Ducks Become Rabbits." *Memory & Cognition* 21, no. 1 (1993): 23–33.

8. Bringhurst, Robert. "Everywhere Being is Dancing, Knowing is Known." In *Everywhere Being is Dancing: Twenty Pieces of Thinking*. Berkeley: Counterpoint, 2009.

9. Browning, Robert. "Andrea del Sarto." First published in *Men and Women*. London: Chapman and Hall, 1855.

10. Chin, Jason M., and Jonathan W. Schooler. "Why do Words Hurt? Content, Process, and Criterion Shift Accounts of Verbal Overshadowing." *European Journal of Cognitive Psychology* 20, no. 3 (2008): 396–413.

11. Copernicus, Nicolaus. *On the Revolutions*. Edited by Jerzy Dobrzycki, translated by Edward Rosen. Baltimore, MD: Johns Hopkins University Press, 1978.

12. Domanski, Don. *Poetry and the Sacred*. Nanaimo, BC: Institute for Costal Research, 2006.

13. Ehrenfels, Christian von. "Über 'Gestaltqualitäten.'" *Vierteljahrsschrift für wissenschaftliche Philosophie* 14 (1890): 249–292.

14. Einstein, Albert. "Autobiographical Notes." Translated by Paul Arthur Schilpp. In *Albert Einstein: Philosopher-Scientist*. Edited by Paul Arthur Schilpp. New York: Harper Torchbook, 1959.

15. Ellis, Hadyn D. "Practical Aspects of Face Memory." In *Eyewitness Testimony: Psychological Perspectives*, edited by Gary L. Wells and Elizabeth F. Loftus, 12–37. Cambridge, UK: Cambridge University Press, 1984.

16. Ellis, Willis D. *A Source Book of Gestalt Psychology*. London: Routledge & Kegan Paul, 1938.

17. Feynman, Richard. *The Character of Physical Law*. New York: Modern Library, 1994.

18. Hass, Robert. "Images." In *Twentieth Century Pleasures: Prose on Poetry*, 269–308. New York: Ecco, 1984.

19. Hawking, Stephen W. *A Brief History of Time*. Toronto: Bantam, 1988.

20. Jastrow, Joseph. *Fact and Fable in Psychology*. Boston: Houghton, Mifflin and Company, 1900.

21. Kay, Harry, and Richard Skemp. "Different Thresholds for Recognition—Further Experiments on Interpolated Recall and Recognition." *Quarterly Journal of Experimental Psychology* 8, no. 4 (1956) 153–162.

22. Kepler, Johannes. *Gesammelte Werke*, Bd. I. Edited by Walther von Dyck et al. Munich: C.H. Beck, 1937.

23. ———. *Mysterium Cosmographicum: The Secret of the Universe*. Edited by E.J. Aiton, translated by A.M. Duncan. New York: Abaris Books, 1981.

24. King, Brett D., and Michael Wertheimer. *Max Wertheimer & Gestalt Theory*. New Brunswick, NJ: Transaction Publishers, 2005.

25. Koestler, Arthur. *The Invisible Writing*, New York: Macmillan, 1954.

26. ———. *The Sleepwalkers*. London: Arkana, 1989 [1959].

27. Köhler, Wolfgang. *Die physischen Gestalten in Ruhe und im stationären Zustand, Eine naturphilosophische Untersuchung*. Braunschweig, Germany: Friedr. Vieweg & Sohn, 1920. An abridgement of this book is available in English in [16, pp. 17–54].

28. Lane, Sean M., and Jonathan W. Schooler. "Skimming the Surface: Verbal Overshadowing of Analogical Retrieval." *Psychological Science* 15, no. 11 (2004): 715–719.

29. Lee, Dennis. "Poetry and Unknowing." In *Body Music*, 179–196. Toronto: Anansi, 1998.

30. Lehrer, Jonah. "The Truth Wears Off." *The New Yorker* 86, no. 40 (13 December 2010): 52–57.

31. Malpass, R.S. "Training in Face Recognition." In *Perceiving and Remembering Faces*, edited by G.M. Davies, H.D. Ellis, and J.W. Shepherd, 271–285. London: Academic Press, 1981.

32. Maurer, Armand. "Ockham's Razor and Chatton's Anti-Razor." *Medieval Studies* 46 (1984): 463–475.

33. McKay, Don. "Baler Twine." In *Vis à Vis: Fieldnotes on Poetry and Wilderness*, 11–33. Kentville, NS: Gaspereau Press, 2001.

34. Næss, Arne. "The Shallow and the Deep, Long-Range Ecology Movements: A Summary." *Inquiry: An Interdisciplinary Journal of Philosophy* 16 (1973): 95–100.

35. ———. "Ecosophy and Gestalt Ontology." In *Deep Ecology for the 21st Century*, edited by George Sessions, 240–245. Boston: Shambhala, 1995.

36. Nelson, Douglas L., and David H. Brooks. "Functional Independence of Pictures and their Verbal Memory Codes." *Journal of Experimental Psychology* 98, no. 1 (1973): 44–48.

37. Newton, Isaac. *The Mathematical Principles of Natural Philosophy*, Volume II. Translated by Andrew Motte. London: H.D. Symonds, 1803.

38. Page, P.K. "Traveller, Conjuror, Journeyman." In *The Filled Pen: Selected Non-fiction*, 43–47. Toronto: University of Toronto Press, 2007.

39. Pezdek, Kathy et al.. "Picture Memory: Recognizing Added and Deleted Details." *Journal of Experimental Psychology: Learning, Memory and Cognition* 14, no. 3 (1988): 468–476.

40. Poincaré, Henri. "Mathematical Creation," Ch. III, *Science and Method*. In *The Foundations of Science*, translated by George Bruce Halsted. New York: The Science Press, 1929.

41. Schooler, Jonathan W. "Turning the Lens of Science on Itself: Verbal Overshadowing, Replication, and Metascience." *Perspectives on Psychological Science* 9, no. 5 (2014): 579–584.

42. Schooler, Jonathan W., and Tonya Y. Engstler-Schooler. "Verbal Overshadowing of Visual Memories: Some Things Are Better Left Unsaid." *Cognitive Psychology* 22 (1990): 36–71.

43. Schooler, Jonathan W., Stephen M. Fiore, and Maria A. Brandimonte. "At a Loss From Words: Verbal Overshadowing of Perceptual Memories." *Psychology of Learning and Motivation: Advances in Research and Theory* 37 (1997): 291–340.

44. Schooler, Jonathan W., and Joseph Melcher. "The Ineffability of Insight." In *The Creative Cognition Approach*, edited by Steven M. Smith, Thomas B. Ward, and Ronald A. Finke, 97–133. Cambridge, MA: MIT Press, 1995.

45. Schooler, Jonathan W., Stellan Ohlsson, and Kevin Brooks. "Thoughts Beyond Words: When Language Overshadows Insight." *Journal of Experimental Psychology: General* 122, no. 2 (1993): 166–183.

46. Senechal, Marjorie. "Introduction." In *The Shape of Content: Creative Writing in Mathematics and Science*, edited by Chandler Davis, Marjorie Senechal, and Jan Zwicky. Wellesley, MA: A.K. Peters, 2008.

47. Shahn, Ben. *The Shape of Content*. Cambridge, MA: Harvard University Press, 1957.

48. Sieck, Winston R., Clark N. Quinn, and Jonathan W. Schooler. "Justification Effects on the Judgment of Analogy." *Memory & Cognition* 27, no. 5 (1999): 844–855.

49. Tolstoy, Leo. *War and Peace*. Translated by Richard Pevear and Larissa Volokhonsky. New York: Random House, 2007.

50. Wells, Gary L., and Brenda Hryciw. "Memory for Faces: Encoding and Retrieval Operations." *Memory & Cognition* 12, no. 4 (1984): 338–344.

51. Wertheimer, Max. "Experimentelle Studien über das Sehen von Bewegung". *Zeitschrift für Psychologie* 61 (1912): 161–265. Available in English in [54].

52. ———. "Untersuchungen zur Lehre von der Gestalt. II." *Psychologische Forschung* 4 (1923): 301–350. Available in English in [54].

53. ———. *Productive Thinking*, enlarged edition. Edited by Michael Wertheimer. New York: Harper & Row, 1959.

54. ———. *On Perceived Motion and Figural Organization*. Edited by Lothar Spillman. Cambridge, MA: MIT Press, 2012.

55. Wertheimer, Michael. "Gestalt Theory of Learning." In *Theories of Learning: A Comparative Approach*, edited by G.M. Gazda and R.J. Corsini, 208–253. Itasca, IL: F.E. Peacock Illinois, 1980.

56. ———. "A Gestalt Perspective on Computer Simulations of Cognitive Processes." *Computers in Human Behavior* 1, no. 1 (1985): 19–33.

57. Wittgenstein, Ludwig. *Philosophical Investigations*. Oxford: Basil Blackwell, 1958.

58. ———. *Culture and Value*. Edited by G. H. von Wright and Heikki Nyman, translated by Peter Winch. Chicago: University of Chicago Press, 1980.

59. Woodhead, M.M., A. D. Baddeley, and C.C.V. Simmonds. "On Training People to Recognize Faces." *Ergonomics* 22, no. 3 (1979): 333–343.

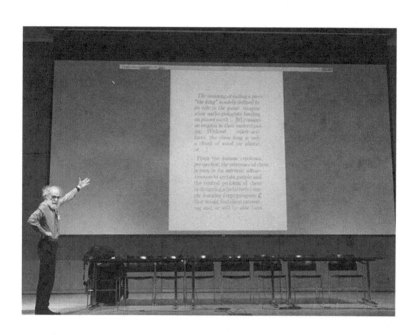

Mikhail Gromov
Photo by María Clara Cortés

Math Currents in the Brain

Misha Gromov

> *Cogito ergo sum.*
> —René Descartes

What is mathematics, and how did it originate? Where does the stream of mathematical ideas flow from? What is the ultimate source of mathematics in the brain? These are reminiscent of the ancient question, "What does the Earth rest on?" with our instincts pushing us toward *On-a-Giant-Turtle* answers.

Rather than rushing to say something clever about mathematics, let us search for a *general context* for these questions. Our candidate for such a context is a class of *mathematical models*[1] of *universal learning processes* that we call *ergosystems*. Without a theory of such or similar "systems" a discussion on the "nature of mathematics" will remain a rattle of words.[2] (In science, nothing can be understood within itself: particular notions, objects, and phenomena are almost invariably

[1] A "mathematical model" is understood here in the physicist's sense with mathematical rigor being a secondary issue.

[2] "Ergo" is not a definite thing but, to a large extent, a certain mindset for directing the study of the mechanics (most of which are hypothetical) of "deep learning" and related structures, such as the body of mathematics. It has nothing to do with wetware or with anything else expressible in a few words.

M. Gromov (✉)
Institut des Hautes Études Scientifiques, Bures-sur-Yvette, France

Courant Institute of Mathematical Sciences, New York University, New York, NY, USA
e-mail: gromov@ihes.fr

© Springer International Publishing AG 2017 107
R. Kossak, P. Ording (eds.), *Simplicity: Ideals of Practice in Mathematics and the Arts*,
Mathematics, Culture, and the Arts, DOI 10.1007/978-3-319-53385-8_9

Fig. 1 A busy ant highway
between an anthill and a
source of food usually
implements a nearly shortest
possibility. Photo by Roman
Kossak

defined and analyzed within general contexts. What of worth can you say about Earth if you are oblivious to stellar evolutions, nuclear fusion, planetary systems, carbon chemistry, heteropolymers, etc?[3])

The existence of such "systems" is manifested by the ability of the brain to build coherent structures, such as visual images and mathematical theories, from seemingly chaotic flows of electrochemical signals that the brain receives. There is further evidence in favor of such "systems," yet, their existence remains conjectural.[4]

A lively objection to the possibility of a mathematical resolution of the problem of mind was articulated by J.B.S. Haldane[5] [12, p. 162]:

> If my opinions are the result of the chemical processes going on in my brain, they are determined by the laws of chemistry, not those of logic.

Convincing?...unless you realize that the persuasive power of the above "determined," "laws of chemistry," and "logic" depends on a metaphoric use of these notions outside their proper contexts.

But ants, for instance, make no such epistemological mistake: their collective mind employs the "laws of chemistry" to "logically determine" shortest paths between locations in a rugged terrain. (See Fig. 1.) How do they do it? (If you fail to guess how this works, do not blame your brain. Much of it, similarly to the brains of ants, was configured by brutally chopping off branches from the potentially exponentially growing *Tree of Life*,[6] where Nature had less time and opportunities

[3]Those who are not attuned to science would find all this more far-fetched than the idea of a *Giant Turtle*. An intelligent Cro-Magnon hunter-gatherer, for instance, would laugh at a learned scientist trying to teach him/her what *his/her* Earth is.

[4]See our two "ergo-articles" [6, 8].

[5]Haldane (1892–1964) was a mathematically minded evolutionary biologist and a famous science populariser.

[6]This process of mutilation, euphemistically called *natural selection*, serves to curb rather than foster evolutionary diversity.

tinkering with our genomes than with the genomes of insects.[7]) Solution: ants mark their trails with pheromones and themselves tend to choose the routes that have stronger pheromone odors. All things being equal, *the number of ants that pass back and forth on some track, say during one hour, is inversely proportional to the length of this track*; hence, the shortest track eventually becomes the smelliest—and most preferred—by the ants.[8]

What has made this algorithm evolutionarily attainable is its simplicity and universality. And the basic programs running within our minds, just in order to exist at all, must be comparably universal, simple, and beautiful.

Psychology of Mathematics and Mathematics of Psychology

Mathematicians, as much as everybody else on Earth, marvel at themselves. Henri Poincaré , for instance, speaks of a random dance of glimmering specks of dust in his mind that coalesce into mathematical ideas in eureka moments [21, p. 58]:

> Of the very large number of combinations which the subliminal ego blindly forms almost all are without interest and without utility. But, for that very reason, they are without action on the aesthetic sensibility; the consciousness will never know them...
> A few only are harmonious, and consequently at once useful and beautiful, and they will be capable of affecting the geometrician's special sensibility I have been speaking of; which, once aroused, will direct our attention upon them, and will thus give them the opportunity of becoming conscious...
> In the subliminal ego, on the contrary, there reigns what I would call liberty, if one could give this name to the mere absence of discipline and to disorder born of chance. Only, this very disorder permits of unexpected couplings.[9]

Jacques Hadamard collects poetic accounts of mental experiences by scientists, including those by Poincaré and Albert Einstein, in his book *The Mathematician's Mind: The Psychology of Invention in the Mathematical Field* [11].[10]

[7]Probably, the evolutionary development of most complicated and interesting patterns in behavior of *social* insects, similarly how it is with human brains, followed the routes *transversal* to the (stochastic) gradient of unrestricted selection.

[8]Richard Feynman , while explaining how the phase cancellation in his integral implies the least action principle, jokes of particles that "smell" neighboring paths to find out whether or not they have more action.

[9]A corresponding *Neural Darwinism* model of brain function was suggested by Gerald Eidelman, probably motivated by the immunological selection mechanism of antibody proteins.

On the other hand, the *subliminal ego* of Poincaré serves as a precursor to what we call "*ergo-brain*." But "*ergo*" entails, albeit stochastic, a high level of structural organization unlike this "ego."

[10]Also see: *How Mathematicians Think* by William Byers [1], *The Mathematician's Brain* by David Ruelle [22], *The Number Sense* by Stanislas Dehaene [3], *The Math Instinct* by Keith Devlin [4], and *Where Mathematics Comes From* by George Lakoff and a Rafael Núñez [15].

The discouraging upshot of Hadamard's book, in accord with Poincaré, is that the essential mental processes are *unconscious*[11] and run *in parallel* along several lines. (Of course, the latter implies the former: our conscious mind is almost fully ordered by the time coordinate.) All by itself, introspective self-analysis, even by brilliant minds, cannot elucidate the nature of mathematics. (Indeed, can fish develop a theory of liquids? Does experiencing gargantuan appetites advance one toward understanding metabolism?[12] Do waves of artistic feeling in the heart of a performing dancer reveal the principles of mechanical motion?)

But, unlike searching our own souls, our experience with building elaborate mathematical/mental structures may help. Coming from a different angle, psychologists have been trying to use mathematics to study psychological phenomena, but this does not include modeling higher levels of learning (e.g. a mother tongue by a child or a mathematical theory by a mathematician).[13]

Universality and Evolution

Every connected graph decomposes into its *core* and *periphery*,

$$G = G_{core} \cup G_{peri},$$

where G_{core} is a subgraph with *no vertices of degree one* and G_{peri} is a disjoint union of *trees*, each attached to G_{core} at a single vertex.

The human/animal psyche is like such a graph G, where "G_{peri}" corresponds to what is directly observable in the human/animal behavior and/or what is accessible to the human conscious mind. Much of "G_{peri}" depicts evolutionarily selected programs that control behavior of an individual and his/her conscious thinking. These programs stay on guard of one's personal survival and the conservation of relevant genes in the population.

Our cherished ideas about ourselves, our thinking, our intelligence, our intuition, etc. are products of these programs running our minds.[14] Irreplaceably useful? Yes.

[11]Do not confuse this with the *subconscious*, which is usually understood as a part of consciousness.

[12]This, for instance in the case of eating candies, is an elaborate chain of chemical reactions of the oxidation of acetate derived from carbohydrates into carbon dioxide and intracellular chemical energy in the form of adenosine triphosphate.

[13]I must admit that I only briefly browsed through a few randomly chosen papers, e.g. "The mathematics used in mathematical psychology" by Robert Duncan Luce [16], *Logical and Mathematical Psychology* by Nicolae Mărgineanu [17], *Mathematical Psychology: An Elementary Introduction* by Clyde Hamilton Coombs, Robyn M. Dawes, and Amos Tversky [2], and "Mathematical Psychology: Prospects for the twentieth Century" by James T. Townsend [25].

[14]Most "very human ideas," are driven by the core behavior programs that originated—let us be generous—in the nervous systems of the worm-like ancestors of animals about 500 million years ago. These programs are invisible to our inner eye.

But the practical usefulness of these ideas does not make them scientifically valid[15] nor does it bring structural beauty, unity, and universality to "G_{peri}." It is up to politicians, educators, psychologists, and writers of psychological fiction to explore and to look after the wild forest of trees in "G_{peri}" that have resulted from a series of biological/historical accidents; this is not the business of mathematicians.

What we want to understand and mathematically model is *the invisible interface* between the *electro-chemical neurophysiology* of the brain and the *psychology* of basic learning processes, where we single out learning mathematics by future mathematicians as the purest kind of learning. This interface, symbolized by "G_{core}," that we expect to be organized according to general, semi-mathematical principles plays a role vaguely similar to that of the machinery of

$$molecular\ cell\ biology\ +\ embryology,$$

that transforms/translates genetic information into the dynamical architectures of living organisms.[16] Unlike "G_{peri}," much of "G_{core}" is of a *universal nature* that was not specifically selected by evolution but was chosen out of sheer logical necessity, similarly to how

$$one\text{-}dimensionality\ +\ 3d\text{-}folding\ of\ polypeptides$$

was promoted by Nature to the principal role in cellular biochemistry.[17]

Two instructive instances of "psychological universality" are the following.

1. Imprinting in young animals. How does a baby animal know who its mother is? Whom to trust and whom to love? The illuminating answer—mother is *the first moving object*—was suggested and experimentally verified by Douglas Spalding.[18] The baby brain has no idea of *mother, love,* or *trust* but operates with

[15]These ideas are much further removed from "the true laws of thinking" than the perception of motion installed into our motor control system is from the Newtonian laws of mechanics.

[16]Embryogenesis remains an unresolved mystery of Life. How does a developing organism implement the design that is encoded in the genome?

[17]Polypeptides are polymeric chains of amino acids (typically, with 100–300 units in them) that, upon being synthesized in cells, *fold* into definite 3d-conformations.

(This happens essentially spontaneously in accordance with attraction/repulsion forces between residues; yet, no present day mathematical theory is able to fully account for the dynamics of *protein folding*, which is a "baby version" of embryogenesis.)

The resulting (properly) folded conformations, called *proteins*, perform most functions in cells, including the polypeptide synthesis itself—which is the most elaborate chemical process taking place in our Universe.

[18]This is recorded in Spalding's short note "On instinct" [24]. His contribution to fundamental psychology was forgotten for years and revived relatively recently. It remains overshadowed by hordes of experiments, answering "profound questions" of the kind: What percentage of people would steal if certain of impunity? For something more amusing, see http://list25.com/25-intriguing-psychology-experiments/.

universal mathematical concepts of *first, change/motion, object*, which were not subjected to evolutionary selection.[19]

2. The hawk/goose effect. A baby chick does not have any built-in image of a "deadly hawk" in its head but distinguishes *frequent*, hence harmless, shapes sliding overhead from potentially dangerous ones that appear *rarely*. Similar to "first," "frequent" and "rare" are *universal concepts* that were not specifically designed by evolution for distinguishing hawks from geese.

This kind of universality is what, we believe, supports the hidden wheels of the human thinking machinery.

Learning Languages and Learning Mathematics

It is counterproductive to attempt to even define what "thinking" and "intelligence" are, but *learning* is a different matter. Learning is a clearly observable phenomenon, where the following three instances of learning are, probably, run by essentially identical programs.

1. Learning native tongues.
2. Learning to play chess
3. Learning mathematics.

As far as languages are concerned, almost every child learns one, and this is the most common instance of "deep structural learning" by humans. No one has a constructive idea[20] of what lies at the bottom of it and how it may work.

In mathematics, a brilliant example is that of Srinivasa Ramanujan . Ramanujan, upon reading a book containing 5,000 theorems and formulas, wrote down 4,000 new formulas himself, where one of the first was

$$\sqrt{1 + 2\sqrt{1 + 3\sqrt{1 + 4\sqrt{1 + 5\sqrt{1 + \cdots}}}}} = 3.$$

Learning appears here in one of its purest forms as *a process of "construction" of an "operator" in the brain* that manifestly transforms one set of formulas to another such set. No general learning theory can be taken seriously unless it indicates, at least in outline, universal rules of such a "construction." (A misuser of statistics may reject the *Ramanujan phenomenon* as "a fluke of chance," but, in fact, the

[19]It is unlikely that Nature tried and rejected "second moving," "third unmoving"...

[20]"Constructive" means having a potential of being turned into a computer program that would function with an input that possesses the same (high) levels of diversity and (low) structural organization as what goes into the human brain.

miracle of Ramanujan forcefully points toward the same universal principles that make possible mastering native languages by billions of children.[21])

Playing Chess is a model thinking process. It has been examined from different angles by philosophers, psychologists, computer programmers, and mathematicians. According to Sigmund Freud , the interest in playing chess by human males is driven by their subconscious urge to kill their fathers.[22] According to Ludwig Wittgenstein, performance of mature players is governed to a greater extent by the *conventional relations* between pieces than by their *internal composition*; thus, he concludes, they would not consume chess pieces as food, even if they were made of chocolate.[23] In 1836, Edgar Allan Poe argued that due to its nondeterministic logic (a kind of NP), no automaton designed similarly to "the Babbage machine"[24] can play good chess. In 1957, a simple-minded program implemented on a computer by Alex Bernstein and his collaborators defeated Hubert Dreyfus—one of the twentieth century's opponents of the existence of such a program. In 1997, *Deep Blue*, which could evaluate 200 million positions per second, defeated the world champion Garry Kasparov, 3.5–2.5.[25] In 2014, no human would even dream of competing in chess against a computer, but. . . the following "chess learning problems" remain as widely open today as they were two hundred years ago.

- Level 1. Design a universal algorithm/program that, upon observing a few thousand (rather than hundreds of millions of) chess games, would reconstruct the rules of chess.
- Level 2. Design a universal algorithm/program that, after some period of learning, would be able to distinguish games played by masters from those by beginners.
- Level 3. Design a universal algorithm/program that, after a brief exposure to chess, will start teaching itself to play and, eventually, will play by orders of magnitude better than any conceivable knowledge-based chess program with comparable computational resources (and/or initial access to the chess literature).

In all three instances, "universal" means that the corresponding algorithms should not be specific to chess, but be meaningfully applicable to a class of *input*

[21]*Supernovae* seem very different from slow burning stars. They have enormous intensities of energy output, some as bright as 100 billion suns. And they are as rare in the skies as Ramanujans are on Earth—none was observed in our galaxy with 300 billion stars since October 9, 1604. Yet both processes depend on the same general principles of gravitation and nuclear fusion; probably about a billion stars in our galaxy will eventually explode as supernovae.

[22]We present a futuristic perspective on Freudian complexes in Sect.6.7 of our *Structures, Learning and Ergosystems* [6].

[23]The philosopher does not describe any experiment verifying his idea.

[24]In his article "Maelzel's Chess-Player" [20] about the fake chess playing machine invented by Wolfgang von Kempelen in 1769, Poe apparently refers to the *Difference Engine* described by Charles Babbage in 1822 rather than to the universal computer (*Analytic Engine*) proposed by Babbage in 1837 (99 years before Alan Turing).

[25]This notwithstanding, Poe's skepticism, which unlike the argument of Dreyfus was based on lucid thinking, can be justified: Poe clearly saw limitations of sequential computing devices available/imaginable in the nineteenth century.

signal flows, desirably, including those originated from natural languages and/or mathematical texts.[26] For example, a Level-3 universal program, when applied to a flow of *informally presented* mathematical theorems and formulas, should work as a mathematician's brain does and generate an output flow of new theorems and formulas.

Such high-level learning algorithms operate in the unconscious minds of all human beings on Earth, and we conjecture that the potential resources of present-day mathematics can help to bring these algorithms to the open and to design corresponding computer programs.

On the other hand, if you look at the Wikipedia pages on topics concerning learning, such as: educational psychology, behaviorism, conditioning, cognitivism, instructional theory, multimedia learning theory, social cognitive theory, connectivism, constructivism, transformative learning theory, educational neuroscience, a brain-based theory of learning, machine learning, decision tree learning, association rule learning, artificial neural networks, inductive logic programming, support vector machines, clustering, Bayesian networks, reinforcement learning, representation learning, similarity and metric learning, sparse dictionary learning... you hardly find ideas that direct you toward solving the problem of high level learning; yet, some bits and pieces may be of help.

Our guiding principle of fundamental learning, both natural and artificial, reads: *the core processes of learning are universal, goal free, and essentially independent of an external reinforcement.* This idea is (almost) equivalent to that of *curiosity-driven learning* suggested by roboticists Jürgen Schmidhuber, Frédéric Kaplan, and Pierre-Yves Oudeyer, who developed algorithms for a robot's behavior depending on the *information/prediction profile*[27] of the flow of signals the robot receives.[28]

What we see as another key ingredient of the future theory is a description of combinatorial structures that would imitate the multi-level architectural arrangement of "ideas in the brain." Essential (but not the only) "interatomic" constituents of this architecture, as we see it, are the following:

- equivalence-like relations of various kinds and strengths, $x_1 \sim_\kappa x_2$,
- partly composable classifier/reduction arrows of various kinds, $x \to_\mu y$,
- cofunction collaboration associations of various kinds, $x_1 \smile_\phi x_2$,
- and, most importantly, analogous relations "\sim", "\to", and "\smile" between "the kinds" κ, μ, ϕ themselves.

But it is not *a priori* clear how to properly define such *self-referential labeled polygraph structures* that would encompass the above ingredients consistently with the following provisions.

[26]No algorithm can be efficiently applicable to *all* flows of signals; in fact, our framework of learning does not even admit the mathematical concept of unrestricted *all*.

[27]See also Jeff Hawkins' lecture on the brain: https://www.youtube.com/watch?v=G6CVj5IQkzk.

[28]See references at the end of this text.

- Our "polygraph" must incorporate some features of *n-categories* (for $n = 2$? 3?) and *self-similar fractal sets* at the same time.
- In order to define a desirable class of "polygraph structures," one has to depart from traditional logic and operate in terms of what we call *ergo-logic*; in particular, one needs to rethink the ideas of "there exists," "all," "equality," "number," and "set," "infinity."
- Learning algorithms for building these "polygraphs" must tackle large volumes of data, where the concept of "statistics" applicable to our case does not fit into the frame of traditional probability theory. The latter needs to be modified along with "sets" and "numbers."

Currently, I am struggling with these issues; I wrote down 20–30% of the intended article: *Understanding Languages and Making Dictionaries.*

Comments and Links

If you are a mathematician you ought to look at everything around you, including mathematics itself, from a mathematical viewpoint. But to see something interesting, something new, something you had no preconception of, you have to distance yourself from what you try to discern.

Prior to turning to mathematics one may think of science. I collected some ideas expressed by scientists through the ages and indicated what a mathematician can make out of these in two partly overlapping short essays: "Introduction aux mystères" (2012) [10] and "Quotations and Ideas" (2016) [9].

Dazzlingly interesting ideas come from Poincaré. For instance, one finds in his *Science and Hypothesis* (1905) [21] among many other things, a mathematician's perspective on fundamental problems in visual perception.[29] This is the starting point of what we call "*ergo*-thinking." Another source of inspiration for what we call "*ergo*" originates in the overall structure of biology, especially molecular biology: *the mathematics of mathematics is closer to the mathematics of Life than to the mathematics of the physicist's non-Life.*

An enjoyable book for a mathematician to read is *The Logic of Chance* by Eugene Koonin (2011) [14], which is about statistics and the evolution of genomes. The author demonstrates how the telescopic power of *sequence alignment techniques* enables one to discern the outlines of Life on Earth as it was $3\frac{1}{2}$ billion years ago.[30]

[29]Only recently, comparable general ideas were developed by people in the vision community.

[30]Reading some sections in this book requires a minimal prerequisite in molecular biology. Such a prerequisite, we believe, is also needed for understanding the nature of mathematics by mathematicians.

In our articles "Structures, Learning, and Ergosystems" [6] and "Ergostructures, Ergologic and the Universal Learning Problem" [8] we present an *ergo* perspective on the natural and artificial learning processes.

This came very close to what has already been understood by some roboticists quite a while ago and expressed under the heading of "intrinsically motivated and/or curiosity driven learning":

1. "Formal Theory of Creativity, Fun, and Intrinsic Motivation (1990–2010)" [23] by Jürgen Schmidhuber[31]
2. "Intrinsic Motivation Systems for Autonomous Mental Development" by Pierre-Yves Oudeyer, Frédéric Kaplan, and Verena V. Hafner [19][32]

Also the following two books promote *ergo*-like ideas: *Sparse Distributed Memory* (1988) [13] by Pentti Kanerva describes a stochastically homogeneous model of memory based on the law of large numbers. *Aux sources de la parole. Auto-organisation et évolution* (2013) [18] by Pierre-Yves Oudeyer, suggests a simple mathematical model for the formation of different "species of languages."

Ergo Within Math Some mathematicians instinctively follow the guidelines of what we call *ergo-logic* in doing math, with Alexander Grothendieck being ahead of the rest of us. I tried *ergo* in math, starting with the article "Mendelian Dynamics and Sturtevant's Paradigm" [5]. My progress is slow with many projects remaining a dream. I explain some of it in "In a Search for a Structure, Part 1: On Entropy" [7].

Psychology, Science, Ergo Our *"ergo"* originates in ideas about the human mind that make mathematicians edgy. Can psychology be taken seriously? Is it a true science? Isn't it too slippery to be grasped by a mathematician's mind? We cannot answer these questions since we are even less *ergo*-prepared to define what a science is than what mathematics is. And, mathematically speaking, the interesting question is that of the *classification of levels of structural organizations*[33] of different bodies of knowledge rather than assigning complimentary or derogatory labels to them, such as "science" and "pseudoscience." Even though much of what is poured into our brains under the name of *"psychology"* is indigestible by mathematicians, there are quite a few intellectual gems that we may appreciate. Historically the first (as far as we know) of these was the aforementioned *universality of imprinting* revealed by Spalding in 1872; below is another instance of something non-trivial.

[31] See also http://www.idsia.ch/~juergen/ and http://www.idsia.ch/~juergen/interest.html.

[32] See also https://flowers.inria.fr/, www.pyoudeyer.com/, https://flowers.inria.fr/ICDL12-MoulinFrier-Oudeyer.pdf, https://flowers.inria.fr/IMCleverWinterSchool-Oudeyer.pdf, http://csl.sony.fr/publications.php?keyword=curiosity.

[33] Representations of these "bodies" by networks G can be characterized by their *normalised connectivities* that are the ratios:
[*the first Betti number of G*]/[*the number of nodes in* G].

Synesthesia Suppose somebody, call the person X, claims that he/she perceives different *graphemes*, e.g. figures 5 and 7, in different colors, e.g. 5's as yellow and 7's as red. Can you verify that the person is telling you the truth rather than making fun of you? It seems impossible. After all, "color" in one's mind is not something that has the status of "objective existence," unless you believe in *red fairies* with *yellow qualia*. However the following ingenious experiment[34] shows that your "logical intuition" fails you. Let X out of the room and randomly draw 5's and 7's on a blackboard B, densely spread, and 50:50 distributed everywhere except for a *region $D \subset B$* where you draw 30–60% more 7's than 5's. If X indeed sees figures in colors, then upon entering the room, he/she will instantaneously notice a *reddish spot* against an orange background on the blackboard.

Apparently, our visual system systematically teaches itself to make new *units of perception* from old ones,[35] but no present-day universal man-made algorithm would come up with anything like the "*ergo*-formula" $5 \times 18 \simeq 7$:

$$7 \sim \overset{\text{5555555}}{7} = 5 \times 18.$$

References

1. Byers, William. *How Mathematicians Think: Using Ambiguity, Contradiction, and Paradox to Create Mathematics.* Princeton, NJ: Princeton University Press, 2010.
2. Coombs, Clyde Hamilton, Robyn M. Dawes, and Amos Tversky. *Mathematical Psychology: An Elementary Introduction.* Englewood Cliffs, NJ: Prentice-Hall: 1970.
3. Dehaene, Stanislas. *The Number Sense: How the Mind Creates Mathematics.* Oxford: Oxford University Press, 2011.
4. Devlin, Keith. *The Math Instinct: Why You're a Mathematical Genius (Along with Lobsters, Birds, Cats, and Dogs).* New York: Basic Books, 2006.
5. Gromov, Mikhail. "Mendelian Dynamics and Sturtevant's Paradigm." In *Geometric and Probabilistic Structures in Dynamics*, edited by Keith Burns, Dmitry Dolgopyat, and Yakov Pesin. Vol. 469. Contemporary Mathematics, American Mathematical Society, 2008.
6. ———. "Structures, Learning, and Ergosystems." Last modified December 30, 2011. www.ihes.fr/~gromov/PDF/ergobrain.pdf.
7. ———. "In a Search for a Structure, Part 1: On Entropy." Last modified June 25, 2013. http://www.ihes.fr/~gromov/PDF/structre-serch-entropy-july5-2012.pdf
8. ———. "Ergostructures, Ergologic and the Universal Learning Problem." Last modified October 8, 2013. http://www.ihes.fr/~gromov/PDF/ergologic3.1.pdf.
9. ———. "Quotations and Ideas." Last modified April 15, 2016. http://www.ihes.fr/~gromov/PDF/quotations2016.pdf.
10. Gromov, Mikhail, and Giancarlo Lucchini. *Introduction aux mystères.* Paris: Fondation Cartier pour l'Art Contemporain/Actes Sud, 2012.

[34] If you've already guessed how this should be designed, you must have heard about it and forgot.

[35] Isolating and/or creating such *units* is the main and often most difficult task faced by an *ergo*-system.

11. Hadamard, Jacques. *The Mathematician's Mind: The Psychology of Invention in the Mathematical Field*. Princeton, NJ: Princeton University Press, 1945.

12. Haldane, John Burdon Sanderson. *The Inequality of Man and Other Essays*. London: Chatto & Windus, 1932.

13. Kanerva, Pentti. *Sparse Distributed Memory*. Boston: MIT Press, 1988.

14. Koonin, Eugene V. *The Logic of Chance: The Nature and Origin of Biological Evolution*. Upper Saddle River, NJ: FT Press, 2011.

15. Lakoff, George, and Rafael E. Núñez. *Where Mathematics Comes From: How the Embodied Mind Brings Mathematics into Being*. New York: Basic Books, 2000.

16. Luce, R. Duncan. "The mathematics used in mathematical psychology." *The American Mathematical Monthly* 71, no. 4 (1964): 364–378.

17. Mărgineanu, Nicolae. *Logical and Mathematical Psychology: Dialectical Interpretation of Their Relations*. Cluj-Napoca: Editura Presa Universitara Clujeana: 1997.

18. Oudeyer, Pierre-Yves. *Aux Sources de la Parole: Auto-Organisation et Évolution*. Paris: Odile Jacob, 2013.

19. Oudeyer, Pierre-Yves, Frédéric Kaplan, and Verena V. Hafner. "Intrinsic Motivation Systems for Autonomous Mental Development." *IEEE Transactions on Evolutionary Computation* 11, no. 2 (2007): 265–286. Accessed August 1, 2016. http://www.pyoudeyer.com/ims.pdf.

20. Poe, Edgar Allan. "Maelzel's Chess-Player." *Southern Literary Messenger* 2, no. 5 (1836): 318–326.

21. Poincaré, Henri. "Intuition and Logic in Mathematics," in *The Value of Science: Essential Writings of Henri Poincaré*. New York: Modern Library, 2001.

22. Ruelle, David. *The Mathematician's Brain*. Princeton, NJ: Princeton University Press, 2007.

23. Schmidhuber, Jürgen. "Formal Theory of Creativity, Fun, and Intrinsic Motivation (1990–2010)." *IEEE Transactions on Autonomous Mental Development* 2, no. 3 (2010): 230–247. Accessed August 1, 2016. http://www.ece.uvic.ca/~bctill/papers/ememcog/Schmidhuber_2010.pdf.

24. Spalding, Douglas. "On instinct." *Nature* 6 (1872): 485–486.

25. Townsend, James T. "Mathematical psychology: Prospects for the 21st Century: A Guest Editorial." *Journal of Mathematical Psychology* 52, no. 5 (2008): 269–280.

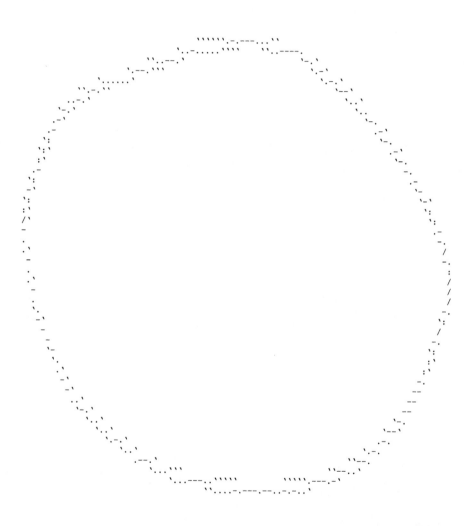

Kate Shepherd
bc, becuz, because ASCII, 2015
Drawing converted into ASCII, at three different image widths
©2015 Kate Shepherd
Courtesy the artist

bc, becuz, Because ASCII

Kate Shepherd

Editors' note: The previous pages display original drawings that Kate Shepherd made in 2015 specifically for this volume. In his catalog essay for a recent exhibition of the artist's painting, Paul Bright wrote, "Her paintings in most instances investigate how much visual information is both necessary and sufficient for a viewer to conjure a figure, without resorting to 'expressive' line, without modeling and shading, without detailed depiction" [1, p. 8]. Each of the drawings here is made up of printed characters that approximate a single hand-drawn figure. There is an algorithmic middleman, a computer program, that makes the specific choice of ASCII (American Standard Code for Information Interchange) character and position based on a source drawing, which in this case is a simple line drawing of a circle. The program also allows for control of the character width of the drawing, which partially explains the variation within the series. At first glance, especially when approaching the smaller drawings, the shape of the figure is the dominant impression, and we hardly register that the marks are printed type. But the type asserts itself as more characters are added and the image enlarges. Despite the medium here, which is new for Shepherd, these drawings could be thought of as a logical extension of recent work she has made using computer drawing tools. For example, her 2014 exhibition at Galerie Lelong, *Fwd: Telephone Game* featured finely painted white lines that were derived from opensource digital 3D wire frame models. She describes a breakthrough when she realized that repeated subdivision of the straight lines of a wireframe had the potential to approximate curves. Nevertheless, she added that while "The exercise starts akin to life drawing or drafting, [it] changes when the lines no longer capture what was 'there' and instead become the subject themselves" [2, p. 2]. As monospaced typewritten works, these drawings bring to mind the more conceptual among Concrete poets, including

K. Shepherd (✉)
Galerie Lelong, New York, NY, USA
e-mail: art@galerielelong.com

© Springer International Publishing AG 2017
R. Kossak, P. Ording (eds.), *Simplicity: Ideals of Practice in Mathematics and the Arts,*
Mathematics, Culture, and the Arts, DOI 10.1007/978-3-319-53385-8_10

Carl Andre and Jiří Valoch. Even if the constellation of marks does not evoke even a partial reading, nevertheless, once our eye consciously or unconsciously recognizes the characters, they punctuate our visual apprehension of the figure as a whole.

References

1. Bright, Paul. "Kate Shepherd: Lineaments." In *Kate Shepherd: Lineaments*, 7–10. Exhibition catalog. Winston-Salem, NC: Charlotte and Philip Hanes Art Gallery, 2015.
2. Shepherd, Kate. *Kate Shepherd: Fwd: The Telephone Game*. Exhibition booklet. New York: Galerie Lelong, 2014.

Marcel Broodthaers
Il n'y a pas de Structures Primaires, 1968
Oil on canvas
30 3/4 × 45 1/4 inches
Courtesy Galerie Michael Werner Märkisch Wilmersdorf, Cologne and New York

"Abstract, Directly Experienced, Highly Simplified, and Self-Contained": Discourses of Simplification, Disorientation, and Process in the Arts

Riikka Stewen

Primary Structures, Forms, Ideas

In 1969, Marcel Broodthaers painted one of his very few paintings, *Il n'y a pas de Structures Primaires*. A Belgian poet, filmmaker, and inventor of new art forms, he is credited as being the first to produce what is now known as institutional critique. The title *Il n'y a pas de Structures Primaires* refers directly to the groundbreaking exhibition *Primary Structures* that took place in 1966 at the Jewish Museum in New York, an exhibition that brought contemporary minimalist works out of the closed world of advanced contemporary art and into the public domain [1, pp. 53–64]. In the exhibition catalogue the curator Kynaston McShine described the new minimalist works as "abstract, directly experienced, highly simplified, and self-contained," pointing out that the structures shown were conceived as "objects" (his quotation marks) and that they rejected all forms of anthropomorphism [1, p. 59].

All the qualities of minimalist art mentioned by McShine are conspicuously absent from Broodthaers' painting. First of all, the piece is very clearly a painting, not an "object," and unusually for Broodthaers, it is also a classical painting done in oil.[1] Secondly, it is full of pentimenti and traces of multiple efforts at signature in the form of the initials "M.B." that have been crossed out and rewritten repeatedly. The painting's main motifs seem, in fact, to be those of deferred authorship and pentimento, both of which emphasize the temporality of the process of painting by simultaneously foregrounding and questioning the anthropogenic and processual signs present in it.

[1]Broodthaers tended to use more experimental techniques such as vacuum-formed and silk-printed "industrial poems." See [7].

R. Stewen (✉)
University of the Arts Helsinki, Helsinki, Finland
e-mail: riikka.stewen@helsinki.fi

© Springer International Publishing AG 2017
R. Kossak, P. Ording (eds.), *Simplicity: Ideals of Practice in Mathematics and the Arts*,
Mathematics, Culture, and the Arts, DOI 10.1007/978-3-319-53385-8_11

Il n'y a pas de Structures Primaires figured as an argument in an ongoing art theoretical discussion on the relation between abstraction and simplicity that drew attention in the 1960s. The discussion was predominant in American art theory in the 1950s and '60s, but it had far earlier roots, for it originated in the subtle dialectic of pictorial illusion and surface materiality in 19th century modern painting. In France, Édouard Manet was not the only painter whose work undermined illusionism and representation: even the more academic Salon artists were extremely concerned with "la facture" and "la patte"—terms used to designate the non-representational materiality of the painted surface and the indexical signs left by the artist's hand. In the 1890s, Maurice Denis, a member of the Nabis group that formed around Paul Gauguin in Pont-Aven in Bretagne, posed the question of *representation* versus *surface* as follows [11]: "un tableau est—avant d'être un cheval de bataille, une femme nue, ou une quelconque anecdote—essentiellement une surface plane recouverte de couleurs en un certain ordre assemblées."

In 1950s American art theory, the concept of surface was discussed at length in the art criticism of Clement Greenberg, whose texts warned against the dangers of kitsch and mass entertainment on the one hand, and socialist realism—the predominant official style in the Soviet bloc during the Stalinist regime—on the other.[2] In its American (Greenbergian) reinvention, the material support of painting was reduced to the flat surface and frame. The Greenbergian theory circumscribed the discipline of painting and presented *flatness* as the critical essence of the art of painting, which, in practice, meant the annihilation of any last trace of optical illusion and suggestion of perspective.[3] The final theoretical object that could be considered a painting was a canvas set on stretchers: a kind of marker or sign for painting that would exist in solipsistic autonomy, completely cut off from any kind of context.

The Greenbergian view decontextualized painting and reduced its history to a very limited period, that of easel painting, choosing to forget the much longer time period during which paintings had been done on supports like walls and wooden panels. For example, Greenberg did not consider the Paleolithic artist a proper painter because she worked with conditions set by nature, such as the arbitrary forms of a rock or a cave wall, and produced "images"—signs of animals and natural things—instead of "pictures" [14].

Contrary to the Greenbergian notion, modern artists seeking novel, simplified forms at the end of the 19th century had in fact sought inspiration in earlier, more "primitive" periods, studying Egyptian and medieval art, looking at early Renaissance wall paintings and frescoes. Consequently, Symbolist and other Post-Impressionist art theories eschewed the creation of optical illusion and praised simplified forms and colors for their general intelligibility and decorative effect. In

[2]On Greenberg's politics, see [28].

[3]See T.J. Clark's description of Greenberg's politics and his critical assessment of central tenets in Greenberg's theories of art [10].

1891 the French critic Gustave-Albert Aurier wrote the first important critical text on Paul Gauguin, in which he argued that artists should avoid trompe l'oeil effects and illusionism to underline that objects in paintings are simply signs, or verbs. Aurier believed that art should be decorative, subjective, synthetist, symbolist, and ideist, and he ended his article with the words, "walls! walls! give him walls!" expressing his conviction that Gauguin's art should not be restricted to the small audience of cognoscenti who visited Salons, art galleries, and industrialist expositions [4].

For Aurier, the simplification of signs in painting was a way of making ideas visible, and he felt that Gauguin had accomplished this in an exemplary manner in his painting *La lutte de Jacob avec l'Ange*. Aurier argued that imitation in art had the opposite effect, suffocating ideas and acting "idéicidement" on the viewer, to use the neologism he coined in this context. Aurier therefore defined Gauguin's work as Idéiste. According to Aurier's theory, the Idéiste painter sees visible reality as consisting of signs which it is his task to simplify and clarify in painting, [4, pp. 161–162]. Simplicity and savagery were related in Aurier's mind, and he praised Gauguin for having the soul of "a primitive."

This Post-Impressionist/Symbolist tendency to correlate simplicity and "primitive" approaches to form was taken up by Clive Bell, who wrote in 1913 that most people who care about art find that they are moved by art which is called primitive. Bell's examples of works that fell into his "Primitive Ideal" included San Vitale in Ravenna, Sumerian and early Greek sculptures, T'ang masterpieces, Japanese Boddhisattvas, Mexican carpets, Persian bowls, and paintings by Poussin, El Greco, Cézanne and Matisse [5]. His eclectic list was meant to support the thesis that the essential quality in art is significant form which "compels" aesthetic emotion, and it is evident that by "significant" he meant "simplified" or stylized, which was yet another contemporary term used to refer to non-illusionistic art. Questioning why certain arrangements and combinations of form move us, he asked the reader to join him in imagining that "behind the world of appearance lies a world of reality" where "certain combinations and relations are perceived to be right and necessary although by the rules of the world we have left they are nothing of the sort" [5, p. 229].

Bell called the question of the potential significance of arrangements and combinations "the metaphysical question." In doing so he joined many theorists and practicians of early 20th century simplification and abstraction who thought that a necessary relation must exist between abstraction and a higher reality composed of Platonist—or Neo-Platonist—forms or ideas. It is precisely this metaphysical quality inherent in the concept of "primary structure" that Broodthaers questioned in his painting *Il n'y pas de Structures Primaires* through his use of pentimenti, crossing out, eliding, and deleting, which made the very temporality of the process of différance visible.

The art historian Mark Cheetham has pointed out that it is possible to interpret the progressive simplification of form in late 19th and early 20th century art and art theory as bringing together two Platonic doctrines: that of the higher spiritual reality of ideas and that of anamnesis and remembrance, discussed in the *Phaedrus*

[8].[4] The many-faceted Platonism of the Post-Impressionist/Symbolist generation of artists turned out to be a generative force in the creation of the first abstractions in 1913.[5] However, in the minimalist generation's later theoretical discussions and in particular in the writings and works of Robert Morris, both the Platonist context of abstraction and Greenbergian ideas concerning the autonomy of the individual artwork were superceded by phenomenological questions about the nature of perception. The metaphysical question of simplified—"primitive"—arrangements and combinations therefore gave way to the question of how the object appears in its simple objecthood in a particular situation.

Object

> *It is a matter of understanding how a determinate shape or size—*
> *true or just apparent—can come to light before me, become crystal-*
> *lized in the flux of my experience, and, in short, be given to me.*
> *Or, more concisely still, how can there be objectivity?*
> —Maurice Merleau-Ponty [21, p. 300]

When Robert Morris reflected retrospectively on the structures produced by minimalist art in the 1960s, he described them as ordinary objects charged "with an uncanny absence of signs" and "those perceptual features that only fully three-dimensional objects near the body and near the body's scale present" [24, pp. 76–99; 89]. The curator of *Primary Structures* had described the objects shown in the exhibition as "directly experienced, highly simplified, and self-contained." By the time McShine introduced the concept of "primary structures," the metaphysical, Platonist, elements of the first abstract works by Mondrian, Malevich, and Kandinsky had mostly been forgotten but the lexical terrain of "primary structures" was nevertheless defined by the discursive network of art theoretical enunciations first expressed in 19th century modern art theory.[6] Abstraction, simplification, stylization, self-containment—these, to a great extent interchangeable, terms were hardly ever given precise definitions, but they were part of a new way of thinking about the relationship of art and the visible world; and it was through this interconnected lexical family that the modern revolution of the visual arts was gradually effected.

[4] See also [9].

[5] See the exhibition catalogue The Spiritual in Art: Abstract Painting 1890–1985 edited by Maurice Tuchman [30].

[6] However, McShine asserted that many of the sculptors' work in particular had become "purposely more philosophical and conceptual in content," quoted in [1, p. 59]. And, viewing his work later, W. J. T. Mitchell described Morris as "the philosophical artist," the artist's artist, see [23, p. 248]. Mitchell underlines that even though Robert Morris was the most eloquent spokesperson for minimalist art theory, his own artistic practice cannot be defined as strictly minimalist. See also Annette Michelson's seminal text [22].

Morris developed his theory of the unitary sculptural object both as a critique and development of the Greenbergian aesthetics of flatness. He described the latter as a "long dialogue with a limit" and summarised its results, referring to both Greenberg and Michael Fried, as follows: "The structural element has been gradually revealed to be located within the nature of the literal qualities of the support" [25]. He also claimed that painting could never deliver "the whole thing" because "the frontal address required of pictures on the wall" prevented the perception of the whole [24, p. 89].

In his *Notes on Sculpture*, published in 1966, Morris suggested that sculpture, not having a tradition of illusionism, was far better suited than painting to eliminate illusion and to "approach the object."[7] The simplified sign quality in Gauguin's art, praised by Aurier, was now replaced by the actual object, the thing in itself, which was seen as approachable, if not graspable. Morris was interested in the phenomenological conditions of perception and in the viewer's potential ability to understand a piece of sculpture immediately, even if seeing the work—often a simple cube or symmetrical polyhedron—required moving around it. There is in fact a kind of temporality involved in the perception of a unitary object, and Morris criticized what he called the retrograde cubist approach of dividing the visual aspects of an object and then presenting them simultaneously. In the *Notes*, Morris' main interest was in the publicness of human scale, and his lack of interest in monumentality or in intimate objects such as Byzantine ivories testifies to his concern with the particular phenomenological situation of the perceiving body and the intersubjectivity of perception in general.

Michael Fried wrote a famous criticism of minimalist aesthetics in his essay "Art and Objecthood" in 1967 in which he claimed that minimalist and literalist works were not autonomous but the opposite: particularly dependent on performative situations and therefore bound up in theatricalism. Paradoxically, Fried's critique, with its emphasis on minimalism's spatial and durational qualities, recontextualized the minimalist object in the intersubjective realm of perception and action as it became the prevalent interpretation of minimalism.

In his *Notes on Sculpture*, Morris also wrote about the viewer's experience of minimalist objects, stressing the fact that simplicity of shape did not necessarily entail simplicity of experience [25, p. 228]. He did not explicitly thematize the kind of experience he felt the minimalist object was intended to bring about, but it was clearly not intended to be intimate or monumental. Largely inspired by phenomenological Gestalt theory, he saw the human scale of the Gestalt-like minimalist object as primarily intended to incite reflection on the condition of perception.

[7] "Sculpture on the other hand never having been involved with illusionism could not possibly have based the efforts of fifty years upon the rather pious, if somewhat contradictory act of giving up this illusionism and approaching the object" [25, p. 223].

Dissolution of the Object/Form Unitary Object to Processes

By the mid-1960s American artists only slightly younger than the first minimalist generation were seeking to interpret experience beyond the minimalist set-up of single objects and unitary pieces. Eva Hesse, Bruce Nauman, and Richard Serra, among others, developed new practices which deconstructed the apparent self-evidencies of previous minimalist aesthetics.[8] Experience would no longer be describable in simple minimalist terms or in terms of "maximum resistance to perceptual separation."[9]

The Anti-Illusion: Procedures/Materials exhibition at the Whitney Museum of American Art in 1969 presented the newest work of the emerging generation of American visual artists, musicians, and composers. In the introduction, the curators Marcia Tucker and James Monte underlined the unprecedented, processual nature of the exhibition during which the majority of works on show would be composed or created. They wrote [2, p. 30]:

> If a work of art offers us various components, arranged and assembled into a coherent whole, there is the assumption that such order is meaningful, either in terms of the work itself or in terms of our experience of the world. Much of the work in this exhibition denies this premise and disorients us by making chaos its structure. The pieces shown cannot, therefore, be precisely understood in terms of our previous experience of "art." They are not attempts to use new materials to express old ideas or evoke old emotional associations, but to express a new content that is totally integrated with material.

The curators mentioned Hesse and Serra in this context. Hesse had decided to only use materials she could make herself, nothing that was cast or moulded. Serra had come up with the idea for his work while studying in Europe: he had brought lead for material and a saw to work with it [2, pp. 9, 16].

With his *Splash* pieces and *Props* Serra examined what it meant to give up casting and moulding and define sculpture as gravity and action. Other actions Serra researched were listed as verbs in 1967–1968 on a to-do list he used to explore what had formerly been called sculpture. John Rajchman later suggested that through these actions Serra researched sculpture's unconscious and reintroduced thinking into art [29]. But it could equally be claimed that Serra continued the problematisation of the unitary, self-enclosed minimalist object, implicit in Morris' statement that *simplicity of shape* does not necessarily entail *simplicity of experience*, explicit in works such as the *Box with the Sound of Its Making* and the *I-Box*. Rosalind Krauss has in fact underlined the genealogical continuity between "minimalist"

[8]In an interview with Hal Foster on April 30, 2014, talking about his early work in an art book event organized by the New York Public Library, Richard Serra described the 1960s American art world as very small. He was acquainted with older artists such as Robert Morris, and he said he was lucky to have Richard Bellamy as a witness and messenger for his work as there were not many people who actually saw it. The interview audio recording is accessible on the NYPL website: http://www.nypl.org/audiovideo/early-work-richard-serra-hal-foster-art-book-series-event.

[9] This was one of the ideas Robert Morris touched on in his [25, p. 226].

and "post-minimalist" work—Donald Judd's and Dan Flavin's more "pictorial" work constituting exceptions—and pointed out the multifaceted continuity of Robert Morris' thought [17].

Anti-Illusion: Procedures/Materials showed art as a procedure, a material process that does not necessarily produce a finished object, but it also underlined the thought processes involved in art-making. In their introductory text, the curators suggested that the artists whose works were displayed doubted the coherence of contemporary experience of the world and that this existential feeling of meaninglessness influenced both the internal structure and the external relations of their artworks. When Krauss reflected back on the American art of the 1970s she felt she could discern a crisis of meaning—an erosion of representation and a trauma of signification—as the background for what she called the indexical re-grounding of art in presence [16].

Another, equally important and perhaps more potent criticism of minimalist aesthetics came from emerging feminist art theory.[10] Even if Eva Hesse herself claimed to "cancel" gender difference, her work was perceived as foregrounding the fragile corporeality of experience suppressed by most minimalist theorizing. Already in 1966, critic and curator Lucy Lippard had brought together works by Hesse and Louise Bourgeois in *Eccentric Abstraction*. This seminal exhibition acted as a way to allow for a return of the repressed temporality and corporeality, showing work which brought about a powerful sense of overturning conventions and norms in favor of a much broader spectrum of experience than the minimalist orthodoxy allowed.

In a slightly different sense, the tendency towards chaos and the disorientation of experience described by the *Anti-Illusion* curators suggests the erosion of the theoretically-defined, minimalist, single or unitary object in front of the viewer, likewise understood as unitary, unified, and in possession of her autonomous self.

The erosion of the unitary subject became an important theme for emerging conceptual feminist artists, in particular for Mary Kelly whose work developed minimalism's more conceptual aspects by turning to theories of subject formation in the new Freudianism of Jacques Lacan. However, as this falls outside the scope of discussion of discourses of simplicity, I shall next look into how the minimalist theory of simplicity collapsed from within, as its internal contradictions—structures of supplementarity—undermined its overt logic.

Chaos/Creative Processes/Multiplicity in the One: *La Chair du Visible*

The French philosopher Maurice Merleau-Ponty believed that perception—the way in which the world appears to and is known by the subject—was the most important

[10] See [18, p. 60].

philosophical topic of all time, which is approached in some way by each thinker and each new school of philosophy. He consequently regarded art as a form of philosophical thinking on perception, and this sustained his continuing interest in the work of artists, particularly in the work of Paul Cézanne. For Merleau-Ponty, understanding vision and visibility was central to epistemology; he saw them as inextricably intertwined and believed that the failure to admit their interdependence would cause epistemologies to contain what he called "shreds of poorly understood visibility" that would ultimately undermine them [20, p. 140].

The topic of visibility recurs throughout Merleau-Ponty's work. In his early book *The Phenomenology of Perception* he quoted research by Von Senden on how people born blind conceived of forms (Gestalt) and space. Merleau-Ponty was particularly impressed by something a blind boy of twelve said, quoting him as follows: "Those who can see are related to me through some unknown sense which completely envelops me from a distance, follows me, goes through me, and from the time I get up, to the time I go to bed, holds me in some way in subjection to it" [21, p. 224]. Merleau-Ponty believed this description gave insight into the dimensions of sight, and the twelve-year old boy's definition of sight stayed with him to become the main theme of the notes that constitute his posthumously published work *The Visible and the Invisible*.

Perhaps still thinking on the blind boy's definition of vision, Merleau-Ponty wrote: "It is as though our vision were formed in the heart of the visible, or as though there were between it and us an intimacy as close as between the sea and the strand… but something to which we could not be closer than by palpating it with our look, things we could not dream of seeing 'all naked' because the gaze itself envelops them, clothes them with its own flesh" [20, pp. 130, 131]. The editor included sentences Merleau-Ponty had added between the lines: "It is that the look is itself incorporation of the seer into the visible, quest for itself, which is of it, within the visible… a connective tissue of exterior and interior horizons" [20, p. 131].

This commingling of subject and object in vision is reminiscent of how Merleau-Ponty's predecessor Henri Bergson defined intuition: "intuition signifie… vision qui se distingue à peine de l'objet vu, connaissance qui est en contact et même coïncidence" [6, pp. 36–37]. For him, there is no separation between subject and object in intuition, just as there is no separation between subject and object in what Merleau-Ponty called "la chair du visible."

It could be claimed that Merleau-Ponty's "flesh of the visible" reiterates Cézanne's "solar warmth" which burns in the membranes of the world, in all creatures and things. Cézanne evoked the same kind of commingling of subject and object when he described the process of painting: he was looking at Mont Sainte-Victoire, one of his favourite subjects, when suddenly he was unable to see the mountain at all: everything had turned into an iridescent chaos. Finally he began to separate himself from the chaos, could look around himself and see the mountain as a mountain. This moment inspired him to describe what he felt to be a profound connection between all things on earth, each creature a little bit of stored warmth from the sun: "un peu de chaleur emmagasinée" [13, pp. 135–136].

Merleau-Ponty claimed that when the separation of subject and object had become too marked, and when concepts in philosophy had consequently become too empty, it was necessary to begin again by returning to experience that was not "worked over" and in which "subject" and "object" were not separate from each other [20, p. 130]:

> If it is true that as soon as philosophy declares itself to be reflection or coincidence it prejudges what it will find, then once again it must recommence everything, reject the instruments reflection and intuition have provided themselves, and install itself in a locus where they have not been distinguished, in experiences that have not yet been "worked over," that offer us all at once, pell-mell, both "subject" and "object," both existence and essence, and hence give philosophy resources to redefine them. Seeing, speaking, even thinking...are experiences of this kind.

Perhaps, in the mid-1960s, minimalist discourse had come to a point where its concepts suddenly seemed empty and where it became necessary to return to experience not yet "worked over," to propose chaos as structure and seek experience that was both disoriented and disorienting, as the *Anti-Illusion* curators wrote of the new work in their exhibition. Or, perhaps, "post-minimalist" interpretations of minimalist aesthetics, by deconstructing the minimalist *dispositif* of a unified subject gazing at a unitary object, actually made visible the temporality of the act of perception, glossed over and supplemented by the minimalists' rhetorical construction of the simple spatiality of the object.

In Book VII of Plato's *Republic*, a passage occurs in which Socrates and his interlocutors discuss numbers. Socrates convinces his listeners that numbers bring clarity, and that only numbers can help you escape from the sea of change, temporality, and visibility, where everything is chaos, categorization is impossible, and not even "subject" and "object" can be separated. The Greek word for number, *arithmos*, means unchanging, and *arithmoi* are situated above this sea of change. Numbers can therefore help the philosopher who desires to get out of the cave and look at the real sun, which stands for truth and knowledge in the metaphor of the cave. In the *Republic*, Socrates condemns the visual arts precisely because of their connection with the sea of change.

For Merleau-Ponty on the other hand, the interconnectedness of seeing and knowing meant that it was imperative for a philosopher to examine vision and visibility closely, and to recognize the interdependence of thought and vision. He therefore overturned the givens of the Socratic notion of truth and immutability completely and insisted that ideas could not be separated from sense perception.

For the minimalists, the unitary object had a theoretical similarity to Socrates' numbers, and yet something remained beyond Frank Stella's tautology: "what you see is what you see." When it came to the experience generated by minimalist objects, their singleness was not without contradiction or residue; the object was not completely reducible to what was there to be seen in a single instant. In a way, it was the *Anti-Illusion* exhibition which made the un-thought or unconscious of minimalism visible by manifesting the temporality of perception, its disorientation and chaos—just beyond or around the unitary minimalist object and its perfect number-like Gestalt.

What had actually been made visible here, in the extremely simplified, singular minimalist object, was perhaps the unavoidable, originary, temporality of vision and visibility. The French philosopher and art historian Georges Didi-Huberman offered this explanation of minimalist aesthetics in his book *Ce que nous voyons, ce qui nous regarde* in which he describes the single object in terms of the Benjaminian dialectical image. He points out that the minimalist tautology "what you see is what you see" represses the work of memory and latency in the image [12, pp. 32, 35, 125–133]. The Benjaminian *aura*, another effort at defining the dialectical image with its interweaving of distance and nearness in terms of space and time, points toward the original, simultaneous constitution of the subject and its objects in perception. Didi-Huberman compares the dialectical image to the dialectics of presence and absence in the Fort-Da play of the infant in the process of acquiring language described by Sigmund Freud.

If we accept Didi-Huberman's interpretation of the minimalist object, there never was a single or unitary object in front of the viewer, but rather a dialectical ur-object hovering between absence and presence just above the Socratic sea of change, pointing towards the possibility of the formation of the subject in language and significance. Like Didi-Huberman, the American art historian and critic Craig Owens, in the early 1980s, had been thinking about the equivocal temporality and latency of the minimalist object when he analyzed minimalist aesthetics as a form of repression of temporality.[11] Owens also turned to Benjamin's theory of allegorical temporality when analyzing minimalist theoretical discourse.

In its interlinking and montaging of presence and absence, Didi-Huberman's interpretation of the Benjaminian dialectical image performs in a way that is analogous to Bergson's concept of the intermediary image. Bergson defined what he called the intermediary image as a kind of translation of the philosopher's originary thought: a sort of primary movement of thought—an embryonic projection which would later become language (*parole*). For Bergson, the intermediary image inhabited the space between the simplicity of the philosopher's intuition and the multiplicity of ways the simple intuition could perhaps be translated. The most personal element in every philosopher's thinking was, according to Bergson, something so extraordinarily simple that no philosopher ever managed to express it. According to him, philosophical attempts at formulating this infinitely simple intuition would face complication after complication, until finally the complexity of the doctrine could only signify the vast gap between the simple intuition and the means available for expressing it. Bergson compared the movement of intuition to a *tourbillon*— a whirlwind that could uproot everything in its way and leave a completely new pattern of objects—scattered bits and pieces of former philosophical doctrines— behind it. For Bergson, only the intermediary image would ever become visible as a fortuitous translation of the ineffable simplicity of intuition.

[11] Didi-Huberman's book appeared in 1992. He makes no reference in it to Craig Owens' 1980s texts on the postmodern allegory.

Fragments of Discourse (Forest Paths)

The unitary minimalist object exists as an intermediary image: a translation of the original projection of thought—if this liminal intuition can even be described as thought—attempting to grasp perception at its most elementary stage, at the moment when the object, like Cézanne's Mont Sainte-Victoire, emerges into visibility. Perhaps Merleau-Ponty was right when he said that one does not possess the objects of thought: "To think is not to possess the objects of thought: it is to use them to mark out a realm to think about and which we therefore are not yet thinking about" [19, p. 160].

The objects of art theory that can be used for marking out, defining and delimiting an area to think about perception and intuition form a discontinuous, non-linear conversation that spans very different periods in the history of thought. The French art historian Daniel Arasse underlined the fact that art theory is necessarily anachronistic, and that fragments of former discussions have endless potential for revival [3, pp. 219–231].[12] In principle, there is no end to possible reorganizations of the landscape of art history, for new works of art traverse history like gusts of wind, leaving a completely rearranged pattern of objects, fragments of art theory and philosophy in their wake.

Theoretical discourses on simplicity, disorientation, and chaos form a complex network which stretches back to Plato and Book VII of the *Republic* where numbers offer the possibility of ordered perception, of emancipation from chaos, the ever-changing sea of visibility, and the complete intertwining of "subject" and "object"—where they are not as "yet" separated—and where number lifts us above the sea of visibility and makes vision and seeing, "subject" and "object," possible. These discourses can also be traced back to Plato's theory of love as aesthetics in the *Phaedrus*, and to the Neo-Platonist Plotinus, where the One is absolute unity, and yet shines on every object. Everything that is emanates from this perfect unity, this perfect simplicity of the One. As Pierre Hadot said [15, p. 50]:

> For Plotinus, if things were nothing other than what they are, in their nature, essence and structure, they would not be lovable. In other words, love is always superior to its object, however lofty the latter may be. Its object can never explain or justify it. There is in love a something more, something unjustified; and that which, in objects, corresponds to something more, is grace, or Life in its deepest mystery. Forms and structures can be justified, but life and grace cannot. They are something more, and this gratuitous surplus is everything.

In this timeless network of discursive enunciations not everything remains connected: different memory routes may be taken and this makes tracing the changing concept of simplicity very complicated. The scenery resembles the Heideggerian forest of history and change in which different paths crisscross the woods, some unused for so long that they are nearly invisible, yet still there to be rediscovered if someone happens to wander away from the main track. Practices of simplicity in

[12]See also [26].

the arts are discursive, and because they are discursive, they are part of a network of enunciations which can never be unidirectional or simple. Whether the Plotinian One haunts the unitary object of minimalist aesthetics is contestable, but it is almost certain that there are no primary structures: *Il n'y a pas de Structures Primaires*.

References

1. Altshuler, Bruce. *Biennials and Beyond—Exhibitions That Made Art History 1962–2002*. London: Phaidon, 2013.
2. *Anti-Illusion: Procedures/Materials*. Edited by James K. Monte and Marcia Tucker. New York: Whitney Museum of American Art, 1969. Exhibition catalog.
3. Arasse, Daniel. "Heurs et malheurs de l'anachronisme." In *Histoires de Peintures*, Paris: Éditions Denoël/Gallimard, 2004.
4. Aurier, Gabriel-Albert. "Le Symbolisme en Peinture: Paul Gauguin." *Mercure de France*, Mars 1891, 165.
5. Bell, Clive. "Post-Impressionism and Aesthetics." *Burlington Magazine*, January 1913, 226–230.
6. Bergson, Henri. *La Pensé et le Mouvant*. Paris: Presses Universitaires de France, 1938.
7. Buchloch, Benjamin. "Open Letters, Industrial Poems." *October* 42 (Autumn 1987): 157–181.
8. Cheetham, Mark. "Rhetorics of Purity." In *Essentialist Theory and the Advent of Abstract Painting*. Cambridge, UK: Cambridge University Press, 1991.
9. ———. *Abstract Art Against Autonomy: Infection, Resistance, and Cure since the 60s*. Cambridge, UK: Cambridge University Press, 2006.
10. Clark, T. J. "The Politics of Interpretation." *Critical Inquiry* 9, no. 1 (September 1982): 139–156.
11. Denis, Maurice. "La Définition du Néo-traditionnisme." *Art et Critique*, 23 août, 1890. Reprinted in *Théories 1890–1910, Du symbolisme et de Gauguin vers un nouvel ordre classique*, Paris, 1912.
12. Didi-Huberman, Georges. *Ce que nous voyons, ce qui nous regarde*. Paris: Les Éditions de Minuit, 1992.
13. Gasquet, Joachim. *CéŐzanne*. Paris: Bernheim-Jeune, 1926 (1921).
14. Greenberg, Clement. "Modernist Painting," in *The New Art: A Critical Anthology*, edited by Gregory Battcock. New York: Dutton, 1966.
15. Hadot, Pierre. *Plotinus or the Simplicity of Vision*. Translated by Michael Chase. Chicago: University of Chicago Press, 1994.
16. Krauss, Rosalind. "Notes on the Index: Seventies Art in America." *October* 3 (Spring 1977): 68–81.
17. Krauss, Rosalind, Denis Hollier, Annette Michelson, Hal Foster, Silvia Kolbowski, Martha Buskirk, and Benjamin Buchloch, "The Reception of the 60s." *October* 69 (Summer 1994): 3–21.
18. Lichtenstein, Jacqueline. *The Eloquence of Color, Rhetoric and Painting in the French Classical Age*. Berkeley: University of California Press, 1993.
19. Merleau-Ponty, Maurice. "The Philosopher and His Shadow," in *Signs*. Evanston, IL: Northwestern University Press, 1964.
20. ———. *The Visible and the Invisible*. Translated by Alphonso Lingis. Evanston, IL: Northwestern University Press, 1968.
21. ———. *The Phenomenology of Perception*. Translated by Colin Smith. London: Routledge & Kegan Paul, 1986.
22. Michelson, Annette. "Robert Morris: An Aesthetics of Transgression." In *Robert Morris*, Corcoran Gallery, Washington D.C., 1969.

23. Mitchell, W.T.J. *Picture Theory, Essays in Verbal and Visual Representation*. Chicago: University of Chicago Press, 1994.

24. Morris, Robert. "The Labyrinth and the Urinal." *Critical Inquiry* 36, no. 1, Autumn 2009.

25. ———. "Notes on Sculpture." Reprinted in *Minimal Art: A Critical Anthology*, edited by Gregory Battcock. Berkeley: University of California Press, 1995 (1968).

26. Nagel, Alexander and Christopher S. Wood. *Anachronic Renaissance*. Cambridge, MA: MIT Press, 2010.

27. Owens, Craig. "The Allegorical Impulse: Toward a Theory of Postmodernism." *October* 12 (Spring 1980): 67–86.

28. Pollock, Griselda and Fred Orton. *Avant-Gardes and Partisans Reviewed*. Manchester, UK: Manchester University Press, 1997.

29. Richard Serra: Forty Years. Edited by Kynaston McShine and Lynne Cooke. New York: Museum of Modern Art, 2007. Exhibition catalog.

30. *The Spiritual In Art: Abstract Painting, 1890–1985*. Edited by Maurice Tuchman, Judi Freeman and Carel Blotkamp. New York: Abbeville Press, 1986. Exhibition catalog.

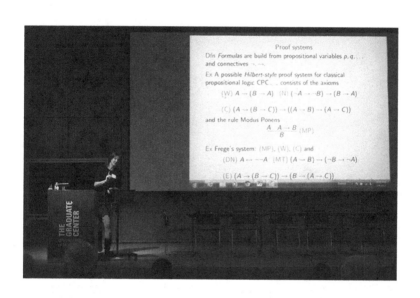

Rosalie Iemhoff
Photo by María Clara Cortés

Remarks on Simple Proofs

Rosalie Iemhoff

This note consists of a collection of observations on the notion of simplicity in the setting of proofs. It discusses its properties under formalization and its relation to the length of proofs, showing that in certain settings simplicity and brevity exclude each other. It is argued that when simplicity is interpreted as purity of method, different foundational standpoints may affect which proofs are considered to be simple and which are not.

Introduction

Mathematics is the science par excellence that can be simple and complex at the same time. Complex in its intricate arguments, yet simple in the structure that proofs are required to have, or in the theories that underlie these proofs. In contrast with the use of the word in daily life, in mathematics, a simple argument does not necessarily mean that it is easy to find. As we will see below, there exist simple yet ingenious proofs that took some years to be discovered. And it often is the case that the first proof found for a theorem is not the most simple one and that only later simpler proofs than the original one are discovered.

What then are simple proofs? That question is not easy to answer, and I will not attempt to do so here. Rather, this note addresses certain aspects of that question. In particular, its possible meaning in the setting of formal systems, and its relation to the notion of purity of method. It is furthermore claimed that in certain settings some forms of simplicity exclude brevity or shortness of argument in that there are theorems for which no proof can be both short and simple.

R. Iemhoff (✉)
Department of Philosophy, Utrecht University, Utrecht, The Netherlands
e-mail: r.iemhoff@uu.nl

© Springer International Publishing AG 2017

145

R. Kossak, P. Ording (eds.), *Simplicity: Ideals of Practice in Mathematics and the Arts*,
Mathematics, Culture, and the Arts, DOI 10.1007/978-3-319-53385-8_12

This note is loosely based on a talk that I presented at the conference "Simplicity: Ideals of Practice in Mathematics & the Arts" that took place at City University of New York, April 3–5, 2013. It is not meant to be a philosophical account of simplicity in mathematics, but rather a collection of observations from a working mathematician on the matter.

Formalization

Most of us will agree that Carl Friedrich Gauss' famous argument that the sum of the first n natural numbers is equal to $n(n+1)/2$ is simple:

Proof The following sum shows that $2\sum_{i=1}^{n} i = n(n+1)$.

$$
\begin{array}{ccccccc}
1 & + & 2 & + \ldots + & n & & \\
n & + & n-1 & + \ldots + & 1 & & + \\
\hline
n+1 & + & n+1 & + \ldots + & n+1 & = & n(n+1)
\end{array}
$$

Therefore $\sum_{i=1}^{n} i = n(n+1)/2$.

And most of us will also agree that the proof by Andrew Wiles of *Fermat's Last Theorem* is complex (even without having seen it).

The two proofs illustrate many aspects of simplicity: the first is short and the reasoning is elementary, the second one is long and complicated, too complicated for most mathematicians to understand, actually. Gauss' proof also illustrates something else, namely that the simplicity of a proof may depend on the background theory that in the practice of mathematics is mostly kept implicit. It uses, for example, several facts about the operations of addition and multiplication on the natural numbers that are not explicitly mentioned.

The proof given above we call *informal* to contrast it with a proof in a formal theory in which every step is made explicit. Now although a formal proof in general does not look like an informal proof, still, given a theory, one can speak of an informal proof being *expressed formally* in the theory. This means that what one considers the *proof idea* in the informal proof, its essence, is faithfully translated into the formal setting. For example, in Gauss' proof above, one could require of a faithful formalization that the idea of summing up the first n numbers twice is part of the formalization.

One would expect that the simplicity of an informal proof is somehow reflected in faithful formalizations. On the other hand, the form of the foundational theory very much influences the form of its proofs.

Clearly, in a formal theory that is minimal, proofs of even the simplest facts may be long and cumbersome. And the richer and stronger the theory, the simpler the proofs will be.

In the extreme case a proven statement could be added to a theory as an axiom and the statement thereby receives a trivial and certainly simple proof in the new system thus obtained.

This, however, does not seem to be a strong argument against the independence of the notion of simplicity from formalization, as the theories in which we wish to carry out the formalization should be foundational theories, meaning that on the one hand they consist of axioms and rules which are evidently true and on the other hand are strong enough to formalize all or almost all of mathematics.

Therefore we will only consider foundational theories as formal theories in which to formalize mathematical proofs. In general, adding a theorem to a formal system will result in a theory not satisfying the first requirement of a foundational theory, which is why the extreme case described above does not have to be considered.

One could require of the foundational theory that the *idea* of Gauss' proof as given above is expressible in a natural way and then claim that proof is simple and will be so in every sufficiently strong foundational theory. But although this sounds perfectly natural at first, it may not always be easy or possible to determine which foundational theories satisfy these constraints. To explain my point, let us consider two foundational theories: type theory and set theory.

Over the last years type theory, and in particular homotopy type theory, has gained increasing attention as a foundational theory for mathematics, while set theory has for a long time already been considered by many to be the main foundational theory. Interestingly, fundamental concepts such as the natural numbers are treated very differently in type theory and set theory. Thus it is conceivable that certain intuitive proof ideas can in one theory be captured by simple and natural formulations and in the other theory only by complicated ones or cannot be captured in a faithful way at all. For such statements the notion of simplicity still makes sense for the informal proof, but it is not quite clear how to transfer it to their formalized versions, as it seems to depend very much on whether one works in the type-theoretic or the set-theoretic framework.

Thus the above argues that while simplicity, even though hard to define, seems to be a genuine property of informal proofs that some satisfy and others do not, it may be hard to determine how far such a property is preserved under formalization and to establish which foundational theory captures the informal arguments best.

Foundational Theories

What about foundational theories themselves? Is there a way to distinguish the simple from the complex as it comes to foundational theories? Do there exist simple foundations for mathematics?

Albert Einstein, in a famous quote has said: *I have deep faith that the principle of the universe will be beautiful and simple.*[1] One possible interpretation of that statement, though not the only one, is that the foundations of physics can be captured in simple laws. Mathematicians and philosophers have shown similar belief in the simplicity of the fundamentals of mathematics. By trying to reduce mathematics to logic, for example. Here simplicity should, I think, be read as self-evident.

The existence of a self-evident foundational theory would, of course, not exclude the possibility that some theorems have complicated proofs, but it would show that ultimately, truths can be reduced to a set of simple principles. Under the strict interpretation, meaning that the theory should be complete and really elementary, Kurt Gödel has proved this to be impossible. But under the weaker interpretation, meaning that the theory, although possibly not elementary or complete, is evident and large parts of mathematics can be carried out in it, such theories do indeed exist.

Given such foundational theories, the question naturally arises, which is the most fundamental, or self-evident, or simplest one. Three questions that although not strictly equal are intimately linked.

The discussion above about set theory and type theory indicates that it may be hard to conclusively state which theory is more fundamental or self-evident than the other. And it may well be that it depends on the subject one wishes to capture in the foundational theory which is the better choice in terms of simplicity and self-evidence.

Purity of Method

Closely related to simplicity is the notion of *purity of method* which refers to the property of proofs of being pure, where, following [4], proofs are called *pure* if they concern themselves only with the concepts contained in the theorems proved.

Such pure proofs should, for example, not contain reasoning about geometric objects when the conclusion of the proof is a statement about the natural numbers. The *Prime Number Theorem* roughly stating that the asymptotic behavior of the number of primes not exceeding a given number n is $n/\log n$, illustrates this phenomenon nicely. The first proofs of this theorem were given by Jacques Hadamard and Charles Jean de la Vallée Poussin independently [7, 10]. These proofs were not elementary in that they referred to objects far more complex than numbers, using techniques from complex analysis, while the elementary proofs later found independently by Atle Selberg [9] and Paul Erdős [6] did not.[2]

[1] Another quote on simplicity by Einstein that I love but that is somewhat beside the point here: Everything should be made as simple as possible, but not simpler.

[2] Interestingly, Dorian Goldfeld [8] cites Godfrey Harold Hardy from a lecture to the Mathematical Society of Copenhagen in which he says about the theorem [1]: *A proof of such a theorem, not fundamentally dependent on the theory of functions, seems to me extraordinarily unlikely.*

But is it correct to consider the later proofs more elementary than the first ones? In some cases it seems more or less clear that a proof method is not pure, as is the case for the use of mechanics in analysis.

As pointed out in [4] (footnote 6 on page 165), the mathematician Joseph-Louis Lagrange tried to liberate analysis from such impure notions, and Bernard Bolzano's search for a purely analytic proof of the intermediate value theorem is another example of this phenomenon, given in [5].

However, in other cases it is not so clear what purity means, especially in the context of logics that can be presented both syntactically and semantically. Consider, for example, category theory or algebra versus proof theory. In which of these formalisms should the proofs of theorems about logical notions such as, for example, unifiers and interpolants, be carried out? The fact that proof-theorists, like myself, sometimes reprove theorems for which the original proof is categorical and category-theorists do the converse, seems to support the idea that not for every theorem there always is an obvious purest proof.

In category theory one aims to put a notion into its proper categorical context in order to start reasoning about it. In proof theory one does the same, but then for a proof-theoretic rather than a categorical context. These contexts are very different in nature. Broadly, one could say that in category theory one provides a lot of structure and then considers a notion as part of that large framework. Proof theory, on the other hand, is in general more concerned with the generation of structure from below: one supplies some minimal principles that should be satisfied and then reasons about the notion on the basis of these principles. Either of the two approaches is superior over the other with respect to some theorems in that these theorems have shorter proofs in that foundational system than in the other. Therefore it seems at present hard to decide which foundational view is likely to produce more or purer proofs than the other, and it may well be that the outcome depends on the theorem or subject at hand.

Arana and Detlefsen [5] discuss the epistemological significance of a conception of purity that they call *topical*. They argue convincingly that this significance lies in providing stable means of reducing certain ignorance in investigations. I would like to add that the distinction between proof-theorists and category-theorists elaborated on above may be exploited here as well. Namely, it shows that in practice it may be hard to settle whether there has been sufficient reduction of ignorance, since an argument may reduce the ignorance of a logician of the first kind more than of a logician of the second kind, or vice versa. Still, given a specific view on mathematics, be it proof-theoretical or categorical or otherwise, I think the notion of purity is meaningful against such a background and the theory developed in [5] insightful and plausible.

Brevity

Jean Dieudonné wrote: *... and that it is good discipline for the mind to seek not only economy of means in working procedures but also to adapt hypotheses as closely to conclusions as possible* [3, p. 11]. When interpreting closeness as not containing notions that are not directly related to those in the theorem, then the question arises whether what Dieudonné aims for can always be achieved, that is, whether proofs can be both short and simple. In this section, a proof is considered to be simple if it is close to the theorem it proves, and thus does not contain notions with no or only a distant relation to the ones in the theorem.

There are examples in the literature that suggest that at least in certain settings proofs cannot be both short and simple in the sense just defined. For example, in the setting of predicate logic a somewhat restrictive but reasonable interpretation of closeness could be that of being cut-free, where proofs are presented in a sequent calculus. The sequent calculus is a proof system (or rather a family of proof systems) that manipulates sequents, expressions consisting of and corresponding to formulas, in an elegant, concise manner, which renders it convenient for reasoning about meta-mathematics. Without defining what cut-free means, what is important for this exposition is that in cut-free proofs all formulas are, in some sense of the word, subformulas of those in the conclusion of the proof, which is why being cut-free may be considered a reasonable interpretation of closeness.

Since it has been shown that there exist tautologies that have short proofs but no short proofs that are cut-free, under this interpretation there are theorems for which there do not exist proofs that are both short and simple.

This phenomenon, that proofs cannot be both short and close to the theorem they prove, also occurs elsewhere. In propositional logic it is possible to express for every n the n-th Pigeonhole Principle stating that when $n + 1$ pigeons are placed in n holes at least one hole must contain more than one pigeon. These principles have simple proofs in the sense of being close to the principle they prove, but these proofs are long, of size exponential in n. Sam Buss [2] developed an ingenious method to express and use counting in propositional logic and obtained short proofs of the Pigeonhole Principles that are of size polynomial in n. These proofs, however, are complicated and could be considered less close to the Pigeonhole Principle and thus less simple. Therefore the example of the Pigeonhole Principle suggests that also under this reading of simplicity shortness and simplicity may in certain settings exclude each other.

Proofs, Short and Simple

In conclusion, drawing from my own experience I have argued in the above that it may be hard to establish whether simplicity is preserved under formalization, and whether a foundational theory is simpler or more fundamental than another. I have

discussed aspects of the concept of purity in the setting of proofs and provided examples illustrating that for certain interpretations of simplicity, shortness and simplicity exclude each other in that there are true statements that cannot have proofs that satisfy both properties, as least in certain settings.

These observations are meant as food for thought rather than as a full account of the notion of simplicity of proofs.

The notion is a natural albeit complicated one, which is why the title of this section is meant slightly ironically, as in the study of simplicity in the context of proofs hardly anything is ever short and simple.

Acknowledgements Support by the Netherlands Organization for Scientific Research under grant 639.032.918 is gratefully acknowledged. I thank an anonymous referee for useful remarks on an earlier draft of this paper.

References

1. Bohr, Harold. "Address of Professor Harold Bohr." In *Proceedings of the International Congres Mathematicians: Cambridge, Massachusetts, U.S.A., August 30-September 6, 1950* vol. 1, 127–134. Providence, RI: American Mathematical Society, 1952.
2. Buss, Samuel. "Polynomial size proofs of the propositional pigeonhole principle." *Journal of Symbolic Logic* 5, no. 2 (1987): 916–927.
3. Dieudonné, Jean. *Linear Algebra and Geometry*. Boston: Houghton Mifflin Co.,1969.
4. Detlefsen, Michael. "Purity as an Ideal of Proof." In *The Philosophy of Mathematical Practice*, edited by Paolo Mancosu, 179–197. Oxford, NY: Oxford University Press, 2008.
5. Detlefsen, Michael and Andrew Arana. "Purity of Methods. " *Philosophers' Imprint* 11, no. 2 (2011): 1–20.
6. van der Corput, Johannes Gaultherus. *Démonstration élémentaire du théorème sur la distribution des nombres premiers*. Amsterdam: Mathematisch Centrum, 1948.
7. Hadamard, Jacques. "Sur la distribution des zéros de la fonction zeta(s) et ses conséquences arithmétiques." *Bulletin de la Société Mathématique de France* 24 (1896): 199–220.
8. Goldfeld, Dorian. "The Elementary Proof of the Prime Number Theorem: An Historical Perspective." In *Number Theory*, edited by David Chudnovsky, Gregory Chudnovsky, and Melvyn B. Nathanson, 179–192. New York: Springer, 2004.
9. Selberg, Atle. "An Elementary Proof of the Prime Number Theorem." *Annals of Mathematics* 50 (1949): 305–313.
10. de la Vallée Poussin, Charles Jean. "Recherches analytiques la théorie des nombres premiers." *Annales de la Société Scientifique de Bruxelles* 20 (1896): 183–256.

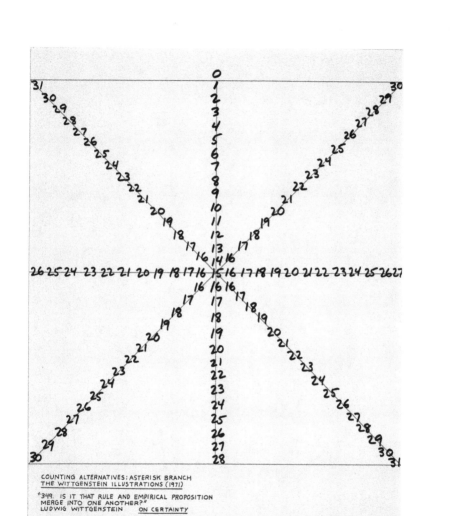

COUNTING ALTERNATIVES: ASTERISK BRANCH
THE WITTGENSTEIN ILLUSTRATIONS (1971)

"349. IS IT THAT RULE AND EMPIRICAL PROPOSITION
MERGE INTO ONE ANOTHER?"
LUDWIG WITTGENSTEIN ON CERTAINTY

Mel Bochner
Counting Alternatives (The Wittgenstein Illustrations): Asterisk Branch, 1971/1991
Photogravure
20 × 15 inches
Courtesy the artist

The Fluidity of Simplicity: Philosophy, Mathematics, Art

Juliet Floyd

Simplicity is not simple. It wears many faces, and stands for a host of factors we use in argumentation. In the following narrative, the notion will not be analyzed. Instead, a parade of different observations about simplicity will be run through, drawing on philosophy, mathematics, and art. This run-through is designed to allow a certain ideal of simplicity to emerge. This ideal, as it happens, has been explicitly adhered to by a wide variety of modern thinkers: philosophers, mathematicians, and artists. Our aim is to characterize it.

The philosophers used as our primary touchstones will be Kant, Quine, Putnam, and Wittgenstein. The mathematicians will be Hilbert and Turing. The artists will be Mel Bochner (1940–) and Fred Sandback (1943–2003).

To anticipate our view: simplicity recurs as a call to the rigorous in the sense of the concrete, the everyday, the communicable, the sensible. It reflects our insistence on drawing out what ordinary human beings can appreciate and share. It also reflects our tendency to take certain procedures, default assumptions, and "natural" ideas as unrevisable, and overlook alternatives. In one bright flash, a simplification sometimes makes us see that we could think and proceed otherwise, more simply.

As we shall show in what follows, in philosophy, in mathematics, and in art there has been a repeated conceptual turn, a transition from simplicity to other idealizing notions: that of systematicity, that of rigor, and from here back to that of simplicity understood as common sense and shared understanding, virtues that overcome false rigor.

Simplicity conceived in this way takes *communicability* to be a central feature, so it has a pragmatic flavor. One might think of it as a mere fiction. Yet, in the end, being indispensable, simplicity is an ideal that remains robust, repeatedly embodied, even while remaining part of an ongoing process reflecting our needs, desires, and

J. Floyd (✉)
Department of Philosophy, Boston University, Boston, MA, USA
e-mail: jfloyd@bu.edu

© Springer International Publishing AG 2017 155
R. Kossak, P. Ording (eds.), *Simplicity: Ideals of Practice in Mathematics and the Arts*,
Mathematics, Culture, and the Arts, DOI 10.1007/978-3-319-53385-8_13

discussions. At the same time, simplicity cannot be taken to cover all the virtues of a theory, and the assumption that it itself is simple can lead to the illusion of understanding.

Because of its ties to the notions of rigor and systematicity, simplicity has often been equated—especially in modernism—with formality and dematerialization, a cutting through the dross of tradition and conventional machinery to get directly to unanalyzeable, immediately given, uncriticizable elements. Here we advocate a different, broader view. We shall resist the conflation of simplicity with formalism, minimalism, and conceptualism. We shall also deny that it delivers us truth on its own. But we shall simultaneously insist that it cannot be fully reduced to psychology, much less something merely "subjective" or fictive.

Simplicity and complexity may be wrongly regarded as opposites, contrasting qualities along a line of hierarchical, ordered development. "Simple," on this view, is no term of approbation, embedded as it is in the notions of "simplistic" and "simpleton". In Kant's *Critique of Judgment* [22], which we shall reconsider below, "simplicity" [*Einfalt*] is defined as "artless purposiveness" (5:275). Kant uses it to characterize naïveté (5:335), the simple-mindedness of peoples and children at whom we laugh (5:356), the common skeletal structures of lower animals that higher ones have in common with them (5:418), and the simplicity of the language of religion in comparison to that of philosophy (5:472). By contrast Kant treated geometrical simplicity [*Einfachkeit*] as something merely formal [22, 5:366].

On our view both the idea of sophistication as loss or overcoming of simplicity and the idea of purely formal simplicity require revision. We shall revisit Kant's philosophy below to find better strands in his thought. For us simplicity is not lost in maturation through education, for we know that simplicity does not exclude sophistication. In fact it requires it. In mathematics, philosophy, and art, simplicity is achieved, created, designed, aimed for, recovered. It is a normative notion, and so complex [27, Chap.2].

Section "Characterization of the Ideal" characterizes our ideal of simplicity before we return to Kant in section "Reflecting Judgment". Section "The Fluidity of Simplicity" treats Wittgenstein's and Turing's embrace of the fluidity of simplicity and its tie to "common sense." Section "Simplicity as Artistry" shows the artistic instantiation of our ideal of simplicity in several works of Bochner and Sandback.

Characterization of the Ideal

The Renaissance ideal of simplicity was of harmonies engraved in the nature of the human and the cosmos, underwritten by the languages of geometry and perspective. But with the rise of modern science, the emphasis fell more and more on human nature and reasoning itself. As Kant said—rejecting the idea that there could be a science of something as ephemeral as fleeting consciousness—"there is only so much science in a subject as there is mathematics" [23, 8:7]. He meant that our own

human forms of intuition of time and space—revealed in arithmetic and Euclidean geometry—give us the structured shape of possible empirical reality as we can know it.

Turning to mathematics, we know that all the same, non-Euclidean geometries were soon developed. And then their relevance, given the relativity of time and space, were established empirically within physics. Moreover, mathematics grew increasingly variegated and complex. As has been recently remarked, mathematics as a whole "has undergone something like a biological evolution, an opportunistic one, to the point that the current subject matter, methods, and procedures would be patently unrecognizable a century, certainly two centuries, ago" [21, p. 21].

For this reason simplicity has remained a central value and lodestar in mathematics, even if an altered one. Hilbert enlarged on Kant when he wrote that "our entire modern culture, insofar as it rests on the penetration and utilization of nature, has its foundation in mathematics" [20, p. 1163]. But this Kantian-sounding claim required novel defense and articulation. Embracing and furthering the old Greek practice of axiomatics while exploiting the formalization and mathematization of logic that had occurred at the end of the nineteenth century, Hilbert wanted to organize, titrate, and systematize the blossoming complexity and fertility of modern mathematics. Given its rapidly increasing diversity, there remains an increasingly felt need for trimming, organizing, and making the garden of knowledge surveyable, comprehensible, shareable.

This very complexity is, as Franks argues in this volume, just why Hilbert's demand for a mathematical criterion of simplicity, his recently discovered 24th problem, must seem at first blush like a far-fetched dream.[1] Nevertheless, Hilbert may have had in mind, in his specific context, an architectonically achievable aim. For him, mathematics is self-authenticating, alone competent to characterize its own ideas. And in proof theory certain measures of mathematico-logical simplicity make sense—albeit within certain parameters, and subject to the fact that simplicity evolves, is never finished.

Generalizing to philosophy, we can say this. We value simplicity partly because we are continually revising certain apparently stable elements of what we once had, even the most permanent markers of education and science itself. Indeed, the idea of an evolution of unthinkability, a revising of what is taken at one time to be *a priori* necessary has become, as Putnam argued, part of epistemology, part of the very notion of the *a priori*, of logic and reasoning itself [26]. This implies that simplicity and rigor can meaningfully emerge as ideals only against a complicated backdrop of thinking, tradition, convention, needs, purposes, understandings, and aims.

And yet, just because it is historically and culturally saturated, just because it evolves in the midst of ongoing discussion, it is seriously misleading to say that simplicity (whether in philosophy, mathematics, or art) is "subjective" or merely "psychological" or a "fiction."

[1]For a discussion of Hilbert's 24th problem, see [36].

First, as Anscombe pointed out, "subjective" and "objective" have reversed roles more than once in the history of philosophy [1]. "Subject" can mean the subject-matter, and also the observer affected by it; "Object" can transform itself from the aim or goal of an intentional actor to something independent of the (or any) action. Thus it is no help to insist that simplicity is *either* "objective" or "subjective" without further ado.

Second, distinctions between action and passion, seer and thing seen, simplifier, simplification, and simplified are not always straightforward to draw: there is no ultimate *there* there. Philosophers repeatedly try to get past reliance on the relata of such distinctions, straddling or rejecting them. Thus DeBeauvoir wrote of "Woman" versus "women," eliding social and biological kinds, activity and passivity, persons, concepts, and objects. Goodman wrote of the "entrenchment" of predicates. Wittgenstein wrote of "aspects" of things that are there to be seen and show themselves. Heidegger wrote of the thing thinging. Most famously of all, Plato analogized philosophical knowledge to reminiscence and midwifery, the drawing forth of what is there to be drawn out, by means of questions. In the same vein, we must reject the idea that easy dichotomies will tell us anything of interest about the notion of simplicity.

Third, what is seen or appreciated in a simplification may be as much a possibility as an actuality, and possibilities may be as objective as you like, there to be seen (even if not, strictly speaking, perceived with the five senses). Because of this— not in spite of it—it very much matters how we talk about and conceive simplicity, what standpoint we bring, how we set the parameters of our discussions. Simplicity is, like inductive inference, not wholly formalizable, while remaining a ubiquitous and unavoidable feature of our discussions of scientific success. Insofar, it is a fundamental notion at work in intelligible generalization as such [29, p. 72], [30, p. 245], [32, p. 20].

From what has so far been said, simplicity may seem to fall on the side of epistemology alone, taken to be a feature of how we come to know or take certain objects, events, or facts. Yet simplicity has rightly been taken to play a significant role in ontology and metaphysics, where we are discussing what there is. "Occam's razor" utilizes simplicity, rightly or wrongly, as a weapon to shave away needless ontological proliferation. This can obscure the role of truth, which should not be conflated with simplicity [28, p. 69].

Yet this tendency toward conflation should not surprise us. Ontology involves argumentation and rationalization, hence, discourse about things in which the technology of logic is coupled with our power to creatively go beyond adduced cases of usage and make ourselves intelligible to one another. Our ability to communicate and take patterns in, applying logic creatively in speech, is fundamental to it.[2]

[2]"Mathematosis," coined by Quine, is the unrigorous and haphazard throwing of mathematical materials at philosophical problems, without the draw of ideals of everydayness and intelligibility. Fads of expertise in mathematics, Quine writes, can "[foster] adherence to in-group fads of jargon and notation at the expense...of mathematical elegance and simplicity" [31, pp. 127–129]. This

Simplicity cannot be reduced at one stroke to a stipulation or mere convention, for it is always under discussion. This is why it is neither something wholly "subjective," nor wholly "objective," and is parochial, yet robust. It is neither compromised by the epistemological, nor capable of evading its reaches. It is necessary as an ideal because there is no overarching system of concepts by means of which the logic of the world may be planned in general, apart from the activity of theorizing about and within experience itself. We have to speak and critique and improvise as we go.

On this last point philosophers, mathematicians, and artists are in remarkably full agreement. Simplicity is important in science, life, and art, not as a criterion of evidence, nor as a Pythagorean metaphysical assumption about nature's being generally fitted to our parochial faculties. Instead it is an ideal engendering, as Quine put it, "good working conditions for the continued activity of the creative imagination; for, the simpler a theory, the more easily we can keep relevant considerations in mind" [32, p. 20]. This allows us to communicate with one another about how to design the setup.

This last point is evinced when we look at further and further reaches of the axiomatic tradition, that tradition within which logic as dialogue and dialectic, the very idea of unfolding aspects of concepts by way of simples, originated—initially in geometry, later on throughout mathematics, and finally in logic and philosophy.

Axioms boil concepts down to simple elements, what Euclid called the "data," the "given," i.e., that from which we construct something else, something begun with. As the process of regressive analysis back to fundamental concepts succeeds in finding agreed upon starting points, and progressive analysis of theories and proofs are shown to follow, the simple elements are seen, or taken in, setting in place the irreducibles, the framework within which argumentation and communication will take place.

Of course the power, the context, may become more and more complex, and shift, even (and especially) as ideas are condensed and uniformized, procedurally, into step-by-step routines of proof. The resulting starting points or "simples" are, as we work with them, something of great sophistication, a cultural and intellectual achievement.

Proceduralization in logic—a basic feature of the axiomatic method—is now a ubiquitous feature of our algorithmicized world. Step-by-step procedures of a calculative kind, offloadings to simples and apps, are—as Turing showed us—modelled and implemented by algorithms, ultimately computable ones. Within the massive resulting proceduralization of our lives, our societies, and our world, we can see more, and more directly, the power of simplification into step-by-step routines. Though we may understand less and less of what we once grasped intuitively, new

reminds us of Hilbert, with his drive to use mathematics to enhance the intelligibility and control of mathematics itself; but here the point is generalized across all of logic.

forms of intuitiveness, of simplicity, constantly arise within algorithmic compressions. What counts as "simple," as "common sense," as "necessarily" or "obviously" true, finds itself ever awash in ever evolving, novel regions of possibilities and prospects.

In a massively connected, rapidly evolving world, this is precisely why the notion of simplicity remains a value we cannot do without. For simplicity ultimately has to do with intelligibility and with communication. We need to discuss the very process of simplification, if only in order to settle our starting points. For that, we must discuss, argue, contest, and speak about these.

"Reflecting" Judgment

We are arguing against the idea that simplicity is a simple ontological or a simple epistemological notion, and denying that it is formalizable. But suppose we ask, can we make sense of simplicity as an experience? The answer is again, no, not as a simple or fundamental one. For this idea, we should return to Kant.

Kant argued explicitly that simplicity is something only experienced in complexes and systems, and denied that the process of fashioning a systematic theory of the world could be wholly formalized. At the same time, he tied his ideal of simplicity directly to the those of systematicity and rigor, and embedded these directly into the foundations of logic. He did this by treating all of these notions as part and parcel of our capacity for judgment.

Kant's judgment-constituting ideal of simplicity pushes back against the empiricist tradition's ideal of simplicity as a directly perceivable, contextual feature of human experience. For the traditional empiricist, the experience of simplicity was construed not only psychologistically, but also in terms of a perceptual immediacy and clarity, so as to provide a fixed, incorrigible basis for knowledge and meaning. From Hume to Russell, simple experiences, impressions, or "sense data" are directly caused mental events immediately wedded to simple words. The idea is to begin with singular thought and fix simplicity bottom-up, for purposes of knowledge, reasoning, and practical social action. The role of inductive inference in scientific method would use "simplicity" measures, mathematical or purely formal aspects of empirical theories capable of telling us how to choose among them.

Kant rejected the adequacy of such empiricist ideals of simplicity, as do we. His argument was that experience and logic, and even the notion of simplicity itself, require the idea of an unformalizable capacity for sound human judgment. This idea requires us to make fundamental use of what he called "reflecting," as opposed to "determining," judgment.

In uttering the truth "the stone is round," I make a "determining" judgment, sorting my experience into conceptual elements and ordering them through predication. But in "reflecting" I also see that I am doing something else: I put forward my judgment as *exemplary*, a form of taste or good, or sound, judgment.

According to Kant, this different dimension—involving judging well or poorly, sagaciously or unsagaciously, purposively—is an element of the whole critical foundation, not only of philosophy and aesthetic appreciation, but also of cognition in general. For it is part of our very notion of logic that logic can be applied well within conversation and experience.

When I judge with *these* concepts, I propose connecting my own particular experience with a whole host of other judgments implicated and involved in roundness and stones, systematic orderings of other judgments about riverbeds or architectural forms or traditions or human intent or pleasure. I make a claim to intersubjective communicability, I try to make a relevant, good, point. Kant called this our capacity to judge by speaking, each one of us in our own voice, in "a universal voice" [22, 5:216].

For Kant, the essentially "subjective" character of our capacity for reflecting judgment emerges from a problem about following a rule. If one thinks of judgment as a faculty of rules (or concepts), then we face the problem of a potential regress of rules for the application of rules. We cannot have an *a priori* rule for the faculty of judgment, for judgment is the capacity to apply rules well or poorly, and for this there is no stopping point of a pre-determined kind: if we thought we had a rule, there would be a question about how to apply *it*, and then the regress of rules for rules, or faculties of judgment for good judging, would never end.[3]

The only way Kant saw to stop the regress of rules for judgment without generating haphazardness was to invoke something belonging to logic. "Reflecting" judgment is that aspect of judging in which the very description of the situation at hand is devised to so as to draw in a contingent range of concepts, when we could have drawn in a different range of concepts. It is a normative notion. One fashions a rule to be followed, a starting point of discussion. One does not simply apply a set of concepts by applying a given rule. The overarching ideal is that of "purposiveness" [*Zweckmässigkeit*], the harmony and the meaningfulness, the inner systematicity of the whole, including society.

Aesthetic judgment exhibits this ideal of common voice most immediately, for it is clear that in responding to nature and to art we are bound often to disagree, to use different concepts, not be able to determine any particular response as fixed or correct. Yet, as Kant insists, we judge aesthetically all the same. The point is that we are capable of judgment without requiring any particular fixed foundation in singular experience or concepts. What we fundamentally require, instead, is an ideal of systematicity and commonality.

Thus Kant connects aesthetic pleasure and "subjectivity" with the ideals of rigor and systematicity, as well as the notion of common sense (*sensus communis*): the organizing of our judgments, perceptions, and feelings in a communicable system, rather than a haphazard, chaotic or disjointed whole. We persist in judging, we continue to embrace these ideals, even when we know in advance that there are an unlimited number of ways in which we might experience, categorize, and organize nature, individually and collectively.

[3]For an analysis, see [11].

Kant explains to us why clinching and principled proofs—whether aesthetic, mathematical, or logical—cannot be given to justify judgments of simplicity, even ones appreciated by most judgers. Simplicity is not intrinsic as a property in this kind of way. It requires reflective response and sharing to be appreciated, a sense of contingent ordering which might have been otherwise, but, which, once seen, suits us as valid, is something that can be communicated. It may also always be shifted, contested, come to be seen as conventional, complex, or, perhaps, false. Simplicity is tied to taste. But it is not merely a matter of taste. Rather, it reflects an ideal of intersubjective harmony.

Yet Kant was not saying that simplicity is simple. He was not positing at the basis of all knowledge a wholly "aestheticized" notion of experience. The term "aesthetic," with its long history, has always been connected with the structure of human sensation and perception, feeling and emotion. Since Kant's rejection of Pythagorean and other forms of "uncritical" metaphysics, aesthetics has tended to be placed on the side of the "subjective." But Kant did not want to see knowledge as the perfection of aesthetics, or sensation. Instead, he wanted to transform the opposition between "subjective" and "objective" by everywhere embedding it in the notion of judgment. This capacity of ours belongs to logic, not merely to sensation or psychology.

Simplicity and aesthetic experience are different. They are not to be equated, even if both belong to our powers of reflection and judgment, and not merely to our psychological or causally determined modes of response.

Thus crucially Kant's perspective is not reductive. He denied explicitly that all judgment has an aesthetic basis, is sensory with respect to form. Mathematics, he insisted, does not contain "beautiful" proofs, does not generate truly aesthetic response. For it does determine its results by means of concepts and intuitions that reflect fixed forms [22, 5:241f., 362f]. Numbers, we recall, are not in any clear way material, and they seem to be impervious to how we react to them.

Simplicity as an aesthetic ideal must not be assumed to be instrumentally or cognitively valuable by the standards of any one discipline. First, the relation of "aesthetic" experiences of simplicity to cognitive content may be neither direct nor even systematic, for, as we have already suggested, they shift with history and situation. Second, in cognitive activities simplicity may operate as nothing more than a criterion or label we attach to a preferred or rejected rival, and so be a notion in need of serious analysis. Third, simplicity is a value, not merely a fact. It is part of a method or process, not merely a result.

It is true that mathematicians develop strong feelings about mathematical structures and proofs in particular contexts, and the pleasures of understanding and seeing are, for some, central to the ultimate value of pursuing their subject. And yet people's associations of pleasure and delight with particular proofs and objects seem to be no more than that: experiences on the margins of something stronger and more rigid. They are responses to cognitive achievement, and derivative and unnecessary ones at that. Mastery of the procedure of proof requires the imposition of step-by-step procedure, not feeling.

In mathematical practice, arguably what is called "aesthetic"—a theorem's resolving an old question, or going in its applications far beyond the range of originally expected areas of application, or the beautiful simplicity of a proof or concept or a novel application of an abstract theory to something concrete— these are phenomena that are not properly aesthetic at all, but instead matters of mathematics. That which works mathematically can be explicated without irreducibly aesthetic terms, even if "ah ha!" moments are commonly experienced. Moreover, after awhile, what is beautiful comes to be seen, eventually, as jejune or trivial [33, p. 118].

These points may be marshalled against the view, defended at length by the great number theorist G. H. Hardy, that the true value and object of mathematical appreciation is something "aesthetic" [19]. On Hardy's aestheticized view, the aim of pure mathematics is not in any way instrumental, for it is directed at pure propositions themselves. Proofs are pointers toward mountaintops one hopes another mathematician will get into view, but in the end are really just a matter of *mere* decoration [18].[4]

Hardy labelled all the pictures, intuitive metaphors, conversations, and even the proofs given by mathematics mere "gas," i.e., something inessential, a fading atmosphere around the hard realities of mathematics [18]. On this view, the metaphors and procedures of conversation familiar to the "mathematician-in-the-street" are something destined to disperse and evaporate like clouds, leaving nothing meaningful behind.

And yet this relegation of our discussions of mathematical theorems and concepts to the ineffable and the "merely" decorative falsifies the importance and nature of simplicity. This point was made by Wittgenstein in several of his courses for mathematics students at Cambridge, including the ones that Turing attended.[5] "Gas" is a notion making our communal discussions irrelevant dross. But we want our decorations too to do real work. "Gas" must be gotten rid of, and replaced by meaningful, working talk within our common, everyday lives.

The way to refashion the idea of "gas" is to insist that which we share in conversation, in judgment, matters in a fundamental way to logic, as well as to experience.

The Fluidity of Simplicity

Kant's problematic of how it is that we are able to follow rules at all, the problem of our capacity for judgment, belongs to the foundations of logic. Wittgenstein and Turing would later rework this idea in a profound way. In Wittgenstein's mature rendition of the idea, the "universal voice," like Turing's universal machine, must

[4]Cf. the discussion between Wittgenstein and Turing in the very first lecture of [43].
[5]On this see [16].

aim at doing work for all routinization without itself being able to determine in advance final stopping points, either of specific routines or of the whole activity in general.

For Wittgenstein and for Turing, the idea of "form" is operationalized, while simultaneously remaining irreducible to any one series of operations. They took as given our capacity to follow a rule or procedure, conceiving this as part of our capacity to put together a collection of rule-expressions into a pattern and then act upon it, correctly or not, by demanding agreement from others.

This is why both Wittgenstein and Turing both praised ordinary "phraseology" as a locus and touchstone of simplicity, as well as a necessary backdrop and medium for philosophy. The idea is that we should ideally all be able to profit from symbolic logic, without everyone having to learn and apply it.

Turing explicitly held that the idea of a "cast-iron" notation, formalized "reason" unguided, is not only undemocratic and unscientific, but in the end a will o' the wisp [39] (cf. my commentary [14]). Incompleteness and undecidability in the foundations revealed, to him, the need for what he called "common sense," in other words, simplicity—not necessarily formal simplicity, but end user simplicity—as fundamental to the development and application of logic [38] (cf. [16]).

What does this approach make of our experiences of what we call "simplicity"? Wittgenstein argued that to experience an individual, or a simple, is to become *acquainted* with it. But not in Russell's sense of "acquaintance"—the immediate mental act of attention involved in contact between mind and thing. Rather, we are acquainted with simplicity in the everyday sense in which we acquaint ourselves with a person, a neighborhood, a face, a culture, a proof or area of mathematics, a work of art, a musical piece [15].

This requires that we exercise judgment: action and passion, looking and listening, conversing, mimicry and improvisation, responding and allowing the object to respond back to us. It involves a certain kind of rigor, in the sense in which we are urging it. Acquaintance with simplicity is, like acquaintance with a person or a face or a philosophy or an artwork, complex.

This does not imply an "aestheticized" view of mathematics or of philosophy. But it does involve an insistence that acquaintance with simplicity is complex. Wittgenstein insisted, like Kant and like Russell, that "acquaintance" belongs to the foundations of logic. But he did not say that it does so "subjectively," much less "formally." Where Kant embraced an ideal of form, systematicity as rigor, Wittgenstein transformed the role of simplicity, the whole idea of rigor, itself.

Wittgenstein and Turing embraced an ideal of the "fluidity" of simplicity. What does this mean? We may begin from the idea that simplicity is constructed as we proceed: it is a journey with occasional rest stops, but no final destination, not even—as in Kant—as a fixed regulative ideal. But there is more to the idea of the fluidity of simplicity than that: what we call "simple" evolves, is corrigible, or is relative.

Pallasmaa's masterful contribution to this volume, "The Complexity of Simplicity" argues that simplicity in art, and specifically architecture, emerges out of

a struggle or dialectic and is always a compromise, a shaping and balancing of tensions within a space within which life will be lived. Simplicity is constructed for and by us, and it involves, always, tradeoffs.

Contexts, like architectural spaces and media generally, are not inert boxes into which words and diagrams are placed without potentials for drift and shift. They are fields and modes of possibility and necessity, modalities of creativity placed in structures, including those of discourse, and shaped in moments of dialectical tension where we draw out simplicity even as we hide newly produced complexity with words and procedures and objects, under rugs and floors and behind walls.

In his mature book, *Philosophical Investigations*, Wittgenstein embraced this point of view. He used a dialectical motif to present his remarks on "simple" and "complex" [47, §§46–64].[6] Thereby he came to answer the grandest question embedded in his philosophical life, "What is the nature of the logical?"

In 1937, when he drafted his manuscript of the *Investigations*, he had come to see the point. He saw that he should present his new thoughts about simplicity and complexity against the backdrop of his old ways of thinking. In proceeding this way, he won through to just that dialectical tension of which Pallasmaa spoke in juxtaposing simplicity with complexity in architecture.

The form Wittgenstein's writing assumed was altered in order to express his newly found understanding of simplicity's role. At this time, and for the first time, he surrendered the mode of proceeding in his writing step-by-step, in a linear manner, beginning from a single starting point. He realized that he could continually detach, move, rearrange, amalgamate, and reconfigure motifs and pieces of procedure and thought within one another without end, erasing and revising starting parts of thoughts once written down, shifting their force, revisiting themes and drawing out variations in a multitude of dimensions at differing scales, endlessly.

This technique for writing philosophy reflected his new embrace of a position that he had to evolve into over a long period of time. To see this, let us consider a remark drawn from his "middle," intermediate period (1929–1934), before he had won through to the ideal of the fluidity of simplicity [45, Sect. 2]:

> Why is philosophy so complicated? It ought, after all, to be completely simple. Philosophy unties the knots in our thinking, which we have tangled up in an absurd way; but to do that, it must make movements which are just as complicated as the knots. Although the result of philosophy is simple, its methods for arriving there cannot be so. The complexity of philosophy is not in its matter, but in our tangled understanding.

[6] As it happens, he only drafted these particular passages relatively late in the game, beginning in November 1936. They emerged from a crisis he experienced after realizing that he would not be able to directly transform his dictation to his (mathematics) students, *The Brown Book* [41], into a book. As he explained to Moore in the summer of 1937, *The Brown Book* had stymied his efforts to revise it because there he had followed a "false method." Now, with his new remarks on "simple" and "complex," he had found a way to apply the "right" method. Moore said, when asked a year later, that he did not know what Wittgenstein meant by "the right method" (see Rhees's Preface to [42, pp. 12–13]). But we can guess. Wittgenstein had come to appreciate that *The Brown Book* was not only "boring" and "artificial," but misleading. It begins from a single starting point, and moves too sequentially, orchestrated in too linear a manner. Cf. [8].

This is a well-known quote, written soon after Wittgenstein's post-*Tractatus* return to philosophy in 1929. The idea here is that when you unravel a knot, it's gone: there's no particular thing that remains, just emptiness, so to speak. You are left with the absolutely simple, or clear: the wholly unknotted.

Wittgenstein's view at this point was that all the complexity lies with our confusions. For, underneath all our talk and conceptual articulation, there must be a definite point at which ultimate simplification is always possible. There might be—as he granted in 1929—a multitude of different logical spaces, or *Satzsysteme*. But within each framework of thought and talk, analysis must always bottom out in simples.

This intermediate view treats simplicity as relative. But such a picture veers too closely toward the idea of philosophy as mere "gas," inarticulate decoration, an empty gesture. Instead, Wittgenstein came to see the inadequacies in his metaphor of simplicity as knot-untying.

First, his idea of escape from all confusion is a poor one for portraying the heart of mathematical understanding. Because even if you unravel something in a mathematical context in the end you still have a concrete result, a collection of aspects, features, and procedures. Mathematics may be as it may be: there may be truths that are there to be seen, quite apart from our seeing them. There are proofs about what we can and what we cannot prove, given certain methods. But getting to simplicity: that requires *us*. So Wittgenstein rejected his own metaphor, even while, at the same time, the ideal of philosophy as an activity of clarification and simplification remained very central to his work.

Second, by early 1937 he encountered Turing's epochal analysis of logic in "On Computable Numbers" [37]. That summer he discussed his evolving ideas with Turing, who had become excited about redoing the foundations of mathematics in light of the paper. Immediately after this discussion, Wittgenstein returned to Norway and composed during that autumn and subsequent year the first full length draft of the *Investigations* (the so-called *Frühfassung*, or "Early Version"), a book with significantly different literary mechanisms, variations, and philosophical methods than anything he had written before [46]. Its second part was an application of the first part to logic and the foundations of mathematics.[7] The whole is shaped by his reactions to Turing's analysis, applying the "right" method of philosophy.

The literary result is an "album," a landscape of shots of voices and variations and renewed starting and stopping points, echoing and canceling one another with modulations, self-confessions, re-phrasings, and artificial and natural snapshots of philosophical activity [47, Preface, p. 4]. It is dialecticity with precision and without loss, rigorous in its own way. It offers a way of thinking about what it is to think through to the simple, the unvarnished and natural, which is, at the same time, a rich field of unending depth and sophistication, a series of arguments about what is to count as simple, straightforward, obvious, or given.

[7]This second part was first published as Part I of [44]; for discussion of the composition of the *Investigations*, see [47, pp. x–xxiii], and [10].

In §§46–64, where he explicitly confronts "simple" and "complex," Wittgenstein frames and motivates his earlier point of view so as to present his later, more mature way of proceeding. He undermines and shifts the idea of an ultimate simple, conceived as a point or ideal of departure—his own earlier, erroneous ideal. At first, in his *Tractatus* [40], he had argued that a complex soul could not be a soul; that objects are simple; that philosophical analysis must bottom out in a particular place. Now he transposes such ideals of simplicity into a very different key. Simplicity is made into a journey, not a destination, and part of procedure as such, not one procedure.

The point is not merely that simplicity is relative to a choice of system, and not absolute. Rather, as he stressed from hundreds of angles in the mature writings, our needs and demands for simplicity are ubiquitous and unending. For we always *require* a first step when we analyze or voice a thought, we always *require* something simple, and we must learn to acknowledge that any such starting point is always taken from a particular place, one that we can share, break off from, pass off to the next person, reject, discuss, and contest.

This perfectly echoes, and philosophically deepens, Turing's mathematical analysis of logic. In "On Computable Numbers" [37], Turing had compared the taking of a "step" in a formal system to the everyday use by a human being of a routine of calculation with pencil and paper: a step-by-step procedure, beginning at some point or other, using circumscribed sets of symbols, states, and movements, and then "followed" in a step-by-step routine. It is crucial to this comparison that any such procedure can be broken off at any point and passed off to, copied by, shared with, another.

Turing's universal machine demonstrates—mathematically, philosophically, and logically—both the ubiquity and the robustness of this idea. Abstractly, it shows that one Universal Machine may code up and do all the work of all the others. Concretely, this implies both that the notion of a "logical step" is absolute, impervious to its representation in a particular formal system, and also that there is no overarching decision procedure for logic as such. Stressing "common sense," Turing showed this by producing, rather than a contradiction, an *empty* command, one that cannot be *followed* [12, 16].

Philosophically this provided a logical demonstration, as he would put it, of the ineradicable foundational role played by "common sense." The totality of computable functions is closed off against diagonalization arguments that lead outside of it. Yet the Universal Machine implies, ultimately, that there is in principle no separation, but instead a *fluidity*, between hardware and software, user and data [7]. Beyond this, there is in principle no dichotomy between the individual and the social, or the spontaneous and the routine.[8]

What is simple is fluid: it is as if we are swimming and must try to grab onto something, to shape the flow around us, to work for us. What is taken as simple

[8]On the importance of cultural integration of human and machine intelligence in a cultural setting of searching, see [35].

within one procedure or way of looking at things may by itself unwind as complex; what is complex may wind up being simple; what is a touchstone of simplicity or identity may come to look like a possible step, rather than an object. There are different ways of looking and characterizing procedures that reveal different necessities and simplicities.

Logic and philosophy themselves require no less. As the later Wittgenstein had it, simplicity is an artifact of this or that representational or logical system, designed with the user and our needs and other necessities in mind. If we draw it out, it is there to be seen, revealing new aspects of things and situations. Simplicity, as an ideal, is also a kind of necessity, an always standing, never uncontestable, robust and evolving practical prospect in our everyday procedures.

The point is ancient and primordial, as Wittgenstein indicates in the *Investigations* by initiating his remarks on "simple" and "complex" with a quote from Plato's account of Socrates's dream in the *Theaetetus* [47, Sect.46]. At stake in the dialogue is the question of whether knowledge is to be analyzed as *justified true belief*. Socrates reduces this to the question: in the name "Socrates" is the syllable "So" or are the letters "S" and "O" the basic units? What justifies or accounts for what? How can this be perceived, if knowledge is something different from perception?

In *Philosophical Investigations* Wittgenstein models this dream sequence with a language-game of colored squares, labelled with a series of letters. What is simple? And what complex? And why? The colors, the squares, the arrangements of squares? We are to see the problem inscribed in the ordinariness of counting.

The point exhibits and produces the need for us to attend to standpoint and use naturally, in motion, yet also as a static balancing act. It is "common sense"— i.e., something we share in conversation and inculcate in one another through education—that signs must be able to be seen to be "the same," recognized again. But it is also "common sense" that the same sign may be seen, used, projected, differently. Are the first and last signs in "212" to be taken as the same, or is the same to be seen as different?

When the simples are reached, they are perceived, understood, seen and taken up as simple in our proceeding. They are *given*, presented by us for us. "What is seen" is for Wittgenstein not an ultimate object of self-evident cognition, it is instead an achievement of *acquaintance*: shared understanding, a moment in a conversation, an arrangement of simples into a surveyable whole which may be copied, communicated, offloaded, shared, transposed, misunderstood, rejected, or contested.

Simplicity as Artistry

This ideal of simplicity as fluidity, an ideal embedded in ubiquity, communicability, and system, is illustrated in the works of two artists we shall next consider, Mel Bochner and Fred Sandback. Since both are implicated in the turn toward "conceptual art" in the 1970s, they afford us the opportunity of arguing against

an ideal of simplicity as formality and abstraction, pure conceptualization and dematerialization. Instead, the drives to simplicity, concreteness, everydayness, and communicability are dominant motifs in their works.

Mel Bochner

In 1966 at Cooper Union School of Visual Arts Mel Bochner mounted what art historians consider to be the first exhibition of so-called "conceptual art." He was at that time an instructor, and was asked to assemble a Christmas show of drawings. So he went out and collected Xerox copies of work by people he knew and liked (Donald Judd, Dan Flavin, Sol LeWitt, Eva Hesse, and others, including some proof notes of mathematician Ararat Babakhanian). He then presented these to the gallery director. She refused to pay to frame and mount them.

So Bochner went to the Art History department's Xerox machine—to which he had unlimited access as an instructor—and put on an exhibition consisting of four identical looseleaf notebooks, each with 100 Xerox copies of these studio notes, including working drawings, pages from *Scientific American*, proof sketches, and diagrams he had collected. He titled the exhibition *Working Drawings and Other Visible Things on Paper Not Necessarily Meant to Be Viewed as Art*.

In 1966 there was no precedent for presenting photocopies within a gallery setting. Bochner had made a move to simplicity, and to rigor, of a certain kind. From this point onward the trajectory of art became bound up, quite explicitly, with the attempt to make thinking visible and shareable.

This was taken by some critics and artists to necessitate a dematerialization of art: the theory demanded that art be "purely conceptual," reduced to idea shown, or perhaps even to tautology, or gesture made.[9] Only this, it was argued, would allow us to overcome the idea of a work of art as a specialized object. The aim was to reject a fetishization of the idea of an artist's genius of skill or mastery, or the critic's power, and instead take the audience's responses seriously, expanding the context or space in which art is viewed.

But the theory tended to treat simplicity as something absolute, and philosophy and art as mere "gas." It ended, as Buchloh has argued, in a "totally administered," wholly commodified world, one which failed to eradicate memory, tradition, and vision [4].

We should see Bochner's work as a response to this theory, an illustration and exemplification of our ideal of the fluidity of simplicity defended above. Bochner's 1966 exhibit was aimed at reconfiguring and recovering certain concrete aspects of simple ideas: of art as opposed to copy, of a boundary between artist and viewer, of the material and conceptual, of gallery space and magazine page, of everyday

[9]See, e.g., [24].

process and artwork, of mechanical reproduction and creation. The rigor of his exhibition lay in its pressing beyond traditional assumptions about how art and art galleries have to be, laying them bare.

Unlike those in his cohort who saw the early Wittgenstein as a mystic of the ineffable and the tautologous, Bochner, who worked with engineers, took Wittgenstein's maturer idea of the fluidity of simplicity and seriality as a concrete directive. Like Wittgenstein, he was avoiding the reduction of artworks and philosophy to "gas."

By 1964 Bochner had struggled to find something to paint that would go beyond the terms of the 1950s abstract expressionism and formalism that at that time dominated art schools.[10] His earliest abstractionist paintings are just solid grey, with paint heaped on the canvas. These culminated in a dead end for the artist [25]. He was hired to write reviews, and in a series of exhibition descriptions published in *Arts Magazine*, he began to find terms for the work of Dan Flavin, Sol LeWitt, Joseph Kosuth, and others that allowed people to begin to imagine that there was something in art that lay beyond abstract expressionism, formalism, and minimalism. See [2]. Yet, uncomfortable with the role of a critic, he turned to mathematics.

His earliest works from this time are number works on graph paper. He played with magic squares and Latin squares, partly inspired by an interest in Islamic tiling and the work of Jasper Johns, but also following the everyday calculative rules of and with numbers he knew and enjoyed.[11] Gradually it dawned on him that these too were works of language and experience, the eye and the hand and the mind, and that the project of making thought visible with these means was in itself something of artistic value.

Critics like Greenberg and Fried had argued, following Kant, that art should concern itself with structures of appearance and sensation and feeling—with form— thereby implying that art criticism would bring the art object to life, providing communicable standards and justifications to help distinguish genuine aesthetic value and experience from nongenuine, or more purely theatrical work. Bochner wanted to democratize and make directly available both art and the experience of criticism, and so he returned, not to theory, but to everyday work.

His illustrations to a collector's edition of the volume of Wittgenstein's final philosophical remarks, *On Certainty*, are based on drawings he made in 1971 inspired by Wittgenstein's ideas [48], one of which is reproduced on page 153. A foreword to the edition was written by the philosopher Arthur Danto, a critic fascinated by the inability of mere sensation to detect what is and is not art and by ways in which contemporary art draws purely philosophical questions into the everyday [6].

[10] See Field's introduction to [9].

[11] See [3, p. 463] on Bochner's 1968 work at Singer Corporation's research and development lab; see [13] on magic squares, surprise, and Wittgenstein on mathematics.

In this context, in surrounding Wittgenstein's final philosophical words with his own artistry, Bochner is investigating how the dialectic of skepticism and simplicity, the very difficulty of making rigorously concrete Wittgenstein's mature ideas about rigor, might be thematized and put to use in art.

Bochner's father was a sign painter, and Bochner himself is emphatic that "depiction" has nothing to do with this art. Yet the representational forms he uses belie any ideal of emptiness. The numbers are, the artist writes, "handwritten, not drawn," overlain on the "classical model of the square" taken from Leonardo and Dürer, a motif of shifting bedrock in relation to the artistry placed upon it [48, Artist's Statement]. They are designed to light up Wittgenstein's text, like a medieval Celtic illumination. Bocher insists that this is an investigation of the notions of *number* and *certainty*, writing that for him "only a series of images could show how doubt is embedded in method" [48, Artist's Statement].

There are clear plays here on various distinctions: between drawing and hand-writing, sequencing and brainstorming, mechanical aspects of calculation and human spontaneity, foreground and background, rigor and false rigor, framework and element. Bochner insists in his Preface that these are not drawings, but of course this only means we are to question this insistence. You can spot patterns here—or maybe not. Often you are not sure. Intention is not the point, nor simply being able to formulate a rule for a portion of the field at issue, though one can explore and find patterns within the whole. As Wittgenstein observed [48, Sect. 139], "Not only rules, but also examples are needed for establishing a practice. Our rules leave loop-holes open, and then the practice has to speak for itself."

Fred Sandback

And yet Bochner's work remains entangled with representational elements, numeri-cal figures that partake of seriality and procedure. Simplicity's relation to the notion of a communicable system remains overt: enacted, yet represented. As we have argued, every simplification is a step on a longer journey, and every starting point may be the focus of further simplification. In closing I want to show how this is enacted artistically in the work of Fred Sandback, whose work instantiates the ideal of simplicity we have characterized above.

Sandback's "Broadway Boogie Woogie" is an artwork constructed from colored yarn stretched in different configurations to create the partial delineation of volumes and planes in space. It was shown in 2007 in an exhibition at the Mondriaanhaus organized by Juliette Kennedy. This work alludes to Mondrian's penultimate painting from 1942–1943, now at the Museum of Modern Art in New York. In this installation it recovers an echo of that work by returning to Europe, to Mondrian's own home, drilling down through the floor, rooted, but light as air. Mondrian had been fascinated by the improvisational aspects of jazz, its dynamic rhythm, as well as the energies and lights of New York. Here, in a construction made of fibers, the fluidity and the robustness of simplicity are enacted, this time in a peaceful

balance of light tensions and lines of color. The response is peaceful contemplation, sharpness and rigor of system, invitation to walk in and through, an extraction, from a distance, of the hurly burly of Broadway. We have here what is truly a composition.

Sandback's works of this type, beginning with a little wire outline of a rectangular solid in 1966, are extremely moving works. They are, in a sense, unphotographable. For they are sculptures, but ones in motion. They are not exactly drawings, and yet are not to be regarded as schematic. Their soundness and rigor are complete, yet open-ended. They do not saturate or theatricalize the space, they unclutter it. The simplicity of their elements and materials and their openness to the viewer make Bochner's work, by comparison, something entangled and baroque. See page 37 for a photograph of Sandback's *Untitled (Sculptural Study, Six-part Construction)*, from 1977/2008.

The simplicity, the sophistication, and the rigor of such an installation is enormous. Sandback's works in yarn echo and shift the space at hand because they have no center. They have no inside and no outside. Here, at least, simplicity is something unknotted—just as Wittgenstein's metaphor of simplicity said—but we see that there remains an artwork, an object, a process, an invitation, one without end. We are to acquaint ourselves with the artwork, in an everyday sense. It is ephemeral—gone when it is gone—but robust and absolute, re-erectable, with care, in another place, and fully portable, as well as kind to the environment, the tapestry of life. As Wittgenstein said of his own work, nothing is hidden. Though they are light and fragile, like life itself, these do not evaporate into mere "gas."

We should not consider this achievement of simplicity to be dematerialized at all; it is neither "minimal" or "purely formal." Sandback's works are not only materialized, they are maximal: they bring human life back into art. As Sandback articulately wrote [34]:

> My work isn't environmental. It's present in pedestrian space, but is not so strong or elaborate that it obscures its own context. It doesn't take over a space, but rather coexists with it...
>
> I'd rather be in the middle of a situation than over on one side either looking in or looking out. Surfaces seem to imply that what's interesting is either in front of them or behind them. Interiors are elusive. You can't ever see an interior. Like eating an artichoke, you keep peeling away exteriors until there's nothing left, looking for the essence of something. The interior is something you can only believe in, which holds all the parts together as a whole, you hope. The use of numbers or systems in what I do is very casual and incidental. Sometimes pieces have even-numbered sets of measurements if size isn't critical within general limits. More often, though, pieces are only measured after they're completed. What I'm doing really doesn't have anything to do with geometry, and it doesn't have anything to do with deductive reasoning.

Here is logic unfettered, just as the title of the 2007 Mondriaanhaus exhibit said. Logic is now dynamic, but beyond seriality; it is purely reflective and spatial. Simplicity is simplification, a process, not a thing. Sandback shows us simplicity, without trying to say it, in works reflective through and through. These allow rigor and simplicity to show themselves. This artist is not illustrating an idea, his artwork is not didactic. And it is not at all haphazard. Nor is it a mere gesture, a mere performance. Instead, it is *given*, by him to us, by us to one another, by the space and our use of it in its surroundings.

With the help of Turing's analysis of logic, Wittgenstein reached the idea of the fluidity of simplicity. Yet he and Turing, though they had glimpsed and stressed the importance of the everyday, still were pondering the uses of signs, linear processes, step-by-step procedures. Here we see a generalization of the point, drawing simplicity toward, not only commonality and common sense in step-by-step shareable routines, but also toward potentials for the ubiquity of art in life.

These works realize the ideal of simplicity defended above. The circularity of reflecting judgment allows for an endless, though structured play of light, color, surrounding context, and artwork. The works generate simple freedom in motion, spanning division—just as simplicity does—between "objective" and "subjective," action and passion, representation and thing, appearance and reality.

As we have said, simplicity is not simple. It is a journey, not a destination. But for all that, it is.

Acknowledgements This paper would not have come to be without numerous conversations, exhibitions, and lecture opportunities afforded me, above all by Juliette Kennedy. In addition, I thank the participants and audience at the CUNY Graduate Center Conference on "Simplicity: Ideals of Practice in Mathematics & the Arts," April 4, 2013, as well as the co-organizers with Juliette, Roman Kossak, and Philip Ording. Early versions of this paper were given at the symposium "Aesthetics and Mathematics," organized by Juliette Kennedy, Rosalie Iemhoff, and Albert Visser at Utrecht University, 10 November 2007 in conjunction with the exhibition at the Mondriaanhuis, *Logic Unfettered—European and American Abstraction Now*; at the American Academy of Berlin, October 27, 2008; at the PhiMSAMP conference "Is Mathematics Special?" held at the University of Vienna, May 17, 2008; at the Paris VIII seminar of Antonia Soulez, "Intentionnel/Intentionnel devant les régles," May 13, 2009; and at the Annual Nordic Wittgenstein Society Meeting, Stavanger, Norway May 30, 2015. I am grateful to the members of the audiences on these occasions for their comments, as well as to the students in my spring 2016 Wittgenstein seminar at Boston University. Helpful comments on a late draft were provided by Ubaldo Di Benedetto, Akihiro Kanamori, Roman Kossak, Andrea MacGown, and an anonymous referee. I am grateful to Caroline Jones and Scott Rothkopf for their suggestions about Bochner's work.

References

1. Anscombe, G. E. M. "The Intentionality of Sensation: A Grammatical Feature." In *Metaphysics and the Philosophy of Mind: Collected Philosophical Papers Volume II*. Minneapolis, MN: University of Minnesota Press, 1981. Originally published in Butler, R.J. ed., *Analytical Philosophy*, second series (Oxford: Oxford 1965.)
2. Bochner, Mel. *Solar System and Rest Rooms: Writings and Interviews 1965–2007*. Writing Art Series. Cambridge, MA: MIT Press, 2008.
3. ———. "Media Study." *Artforum International* 51 no. 1 (2012): 463.
4. Buchloh, Benjamin. "Conceptual Art 1962–1969: From the Aesthetic of Administration to the Critique of Institutions." *October* 55 (1990): 105–143.
5. Cooper, S. Barry and Jan van Leeuwen, editors. *The Selected Works of A.M. Turing: His Work and Impact*. Amsterdam: North-Holland / Elsevier Science, 2013.
6. Danto, Arthur. *The Transfiguration of the Commonplace: A Philosophy of Art*. Cambridge, MA: Harvard University Press, 1981.
7. Davis, Martin. "Universality is Ubiquitous." In [17].

8. Engelmann, Mauro Luiz. *Wittgenstein's Philosophical Development: Phenomenology, Grammar, Method, and the Anthropological View*. Palgrave History of Analytic Philosophy. Basingstoke, UK: Palgrave Macmillan, 2013.

9. Field, Richard S. *Mel Bochner: Thought Made Visible 1966–1973*. New Haven, CT: Yale University Art Gallery, 1996.

10. Floyd, Juliet. "Wittgenstein on 2,2,2... : On the Opening of *Remarks on the Foundations of Mathematics*." *Synthese* 87, no. 1 (1991): 143–180.

11. ———. "Heautonomy and the Critique of Sound Judgment: Kant on Reflective Judgment and Systematicity." In *Kant's Aesthetics*, edited by Herman Parrett. Berlin: Walter de Gruyter Verlag, 1998.

12. ———. "Wittgenstein's Diagonal Argument: A Variation on Cantor and Turing." In *Epistemology versus Ontology, Logic, Epistemology*, edited by P. Dybjer et al. Logic, Epistemology, and the Unity of Science. Dordrecht: Springer Science+Business Media, 2012.

13. ———. "*Das Überraschende*: Wittgenstein on the Surprising in Mathematics." In *Wittgenstein and the Philosophy of Mind*, edited by Jonathan Ellis and Daniel Guevara. Oxford: Oxford University Press, 2012.

14. ———. "Turing, Wittgenstein and Types: Philosophical Aspects of Turing's "The Reform of Mathematical Notation" [1944–5]." In *Alan Turing: His Work and Impact*, edited by S. Barry Cooper and Jan van Leeuwen. Amsterdam: Elsevier, 2013.

15. ———. "Aspects of Aspects." In *The Cambridge Companion to Wittgenstein*, edited by Hans Sluga and David Stern, 2nd revised ed. Cambridge: Cambridge University Press, 2017.

16. ———. "Turing on "Common Sense": Cambridge Resonances." In [17].

17. Floyd, Juliet and Alisa Bokulich, editors. *Philosophical Explorations of the Legacy of Alan Turing: Turing 100*. Boston Studies in the Philosophy and History of Science. New York: Springer Science+Business Media, 2017.

18. Hardy, G. H. "Mathematical Proof." *Mind* 38, no. 149 (1929): 1–25.

19. ———. *A Mathematician's Apology*. Cambridge, UK: Cambridge University Press, 1940.

20. Hilbert, David. "Logic and the Knowledge of Nature." In *From Kant to Hilbert: A Source Book in the Foundations of Mathematics*, edited by William Ewald. Oxford: Oxford University Press, 1996.

21. Kanamori, Akihiro. "Mathematical Knowledge: Motley and Complexity of Proof." *Annals of the Japan Association for Philosophy of Science* 21 (2012): 21–35.

22. Kant, Immanuel. *Critique of the Power of Judgment [1790]*. The Cambridge Edition of the Works of Immanuel Kant. Cambridge, UK: Cambridge University Press, 2000.

23. ———. "Metaphysical Foundations of Natural Science [1786]." In *Theoretical Philosophy after 1781*, The Cambridge Edition of the Works of Immanuel Kant. Cambridge, UK: Cambridge University Press, 2002.

24. Kosuth, Joseph. "Art After Philosophy." *Studio International 178* nos. 915–917 (1969): 134–137, 160–161, 212–213.

25. Meyer, James and Mel Bochner. "Mel Bochner in Conversation with James Meyer." In [9].

26. Putnam, Hilary. "Rethinking Mathematical Necessity." In *Words and Life*. Cambridge, MA: Harvard University Press, 1994.

27. ———. *The Collapse of the Fact / Value Dichotomy and Other Essays*. Cambridge, MA: Harvard University Press, 2002.

28. ———. *Philosophy of Logic*. London: Routledge, Taylor and Francis Group, 2010.

29. Quine, W. V. *Ontological Relativity, and Other Essays*. The John Dewey essays in philosophy. New York: Columbia University Press, 1969.

30. ———. "The Scope and Language of Science [1954]." In *The Ways of Paradox and Other Essays*. Cambridge, MA: Belknap / Harvard University Press, 1976.

31. ———. *Quiddities: An Intermittently Philosophical Dictionary*. Cambridge, MA: Belknap / Harvard University Press, 1987.

32. ———. *Word and Object*. Cambridge, MA: MIT Press, 2013.

33. Rota, Gian-Carlo. "The Phenomenology of Mathematical Beauty." In *Indiscrete Thoughts*. Boston: Birkhaüser, 1997.

34. Sandback, Fred. "1975 Notes." Accessed July 15, 2016. http://fredsandbackarchive.org/texts. html.
35. Sterrett, Susan G. "Turing and the Integration of Human and Machine Intelligence." In [17].
36. Thiele, Rüdiger. "Hilbert's Twenty-Fourth Problem." *American Mathematical Monthly* 110 (2003): 1–24.
37. Turing, Alan M. "On Computable Numbers, with an Application to the *Entscheidungsproblem.*" *Proceedings of the London Mathematical Society* 2, no. 42 (1936): 230–265. Reprinted with commentary in [5].
38. ———. "Solvable and Unsolvable Problems." In *Science News*, edited by A. W. Haslett. London: Penguin Books, 1954. Reprinted with commentary in [5].
39. ———. "The Reform of Mathematical Notation and Phraseology [1944–45]." In *Collected Works of A.M. Turing: Mathematical Logic*, edited by R. O. Gandy and C. E. M. Yates. Amsterdam: Elsevier, 2000. Reprinted with commentary in [5].
40. Wittgenstein, Ludwig. *Tractatus Logico-Philosophicus.* International Library of Psychology, Philosophy, and Scientific Method. London: Routledge and Kegan Paul, 1922.
41. ———. *Preliminary Studies for the "Philosophical Investigations": Generally Known as The Blue and Brown Books.* New York: Harper and Row, 1965.
42. ———. "Eine Philosophische Betrachtung." In *Das Blaue Buch, Eine Philosophische Betrachtung (Das Braune Buch). Wittgenstein Werkausgabe*, vol. 5. Frankfurt am Main: Suhrkamp / Basil Blackwell, 1969.
43. ———. *Wittgenstein's Lectures on the Foundations of Mathematics: Cambridge, 1939, from the Notes of R.G. Bosanquet, Norman Malcolm, Rush Rhees and Yorick Smythies.* Edited by Cora Diamond. Hassocks, Sussex: The Harvester Press, Ltd., 1976.
44. ———. *Remarks on the Foundations of Mathematics.* Revised, from 1956 edition. Cambridge, MA: MIT Press, 1978.
45. ———. *Philosophical Remarks.* Translated by Rhees Rush. Chicago: University of Chicago Press, 1980.
46. ———. *Philosophische Untersuchungen Kritisch-genetische Edition.* Frankfurt am Main: Suhrkamp, 2001.
47. ———. *Philosophische Untersuchungen = Philosophical Investigations*, revised 4th edition. Chichester, West Sussex, UK: Wiley-Blackwell, 2009.
48. Wittgenstein, Ludwig and Mel Bochner. *On Certainty = Über Gewissheit.* Arion Press Collector's Edition. San Francisco: Arion Press, 1991.

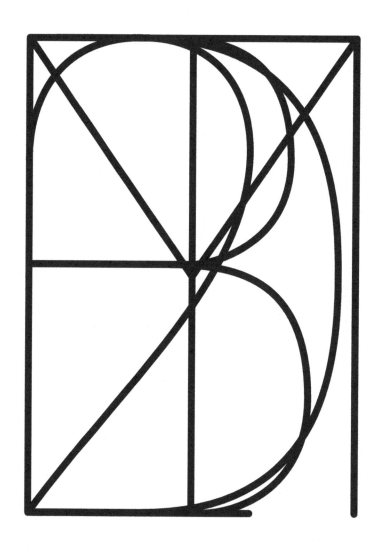

Dexter Sinister
Composite glyph (MTDBT2F), 2012

"Mathematical Typography"
(After Donald Knuth, 1978)

Dexter Sinister

The type you are reading right *now* is called Meta-the-difference-between-the-two-font. It was designed by Dexter Sinister in 2010, and derived using MetaFont, the now-thirty-five-year-old computer typography system programmed by Donald Knuth in 1979.

MetaFont is both a programming language and its own interpreter, a swift trick where it first provides a vocabulary and then decodes its syntax back to the native binary machine language of 1s and 0s. Knuth originally intended MetaFont as a helper application for TeX, the computer typesetting system he created to facilitate high-quality typography directly by authors. A Stanford professor and author of the multi-volume computer science "Bible" *The Art of Computer Programming* [2], Knuth was dismayed on receiving galley proofs for the second edition of this book. The publisher had just switched from traditional hot metal typesetting to a digital system and the typographic quality was far worse than the original 1971 edition. Knuth figured that setting letters on a page was simply a matter of ink or no-ink, on or off, 1 or 0, and therefore a perfect problem for the computer. He planned on spending a 6-month sabbatical writing a typesetting program and produced (almost 10 years later) the near-ubiquitous (in mathematics and science publishing, anyway) computer typesetting program, TeX. MetaFont was designed from the start as TeX's manual assistant and faithful servant, producing as required the high-quality fonts at whatever size and shape on command.

*This paper originates in two texts: "A Note on the Type," (2010) first published in *The Curse of Bigness*, Queens Museum (see also [8]) and "Letter & Spirit" (2011), *Bulletins of the Serving Library* [9].

D. Reinfurt (✉)
Department of Visual Arts, Princeton University, Princeton, NJ, USA
e-mail: reinfurt@princeton.edu

S. Bailey
Haute École d'Art et de Design, Geneva, Switzerland

© Springer International Publishing AG 2017
R. Kossak, P. Ording (eds.), *Simplicity: Ideals of Practice in Mathematics and the Arts*,
Mathematics, Culture, and the Arts, DOI 10.1007/978-3-319-53385-8_14

MetaFont was also intended as a tool for designing new typefaces on its own. As MetaFont was programmed by Knuth, a mathematician, the resulting typographic design method relies on equations (multi-variable algebra and a bit of vector arithmetic) to specify letterforms and computer code to compile these instructions into a usable font—all of which is more the native province of mathematicians than type designers.

In the American Mathematical Society's prestigious Josiah Willard Gibbs Lecture of July 4, 1978, Knuth gave a talk titled "Mathematical Typography," and suggested that, "We may conclude that a mathematical approach to the design of alphabets does not eliminate the artists who have been doing the job for so many years" [3]. True enough, but the relatively steep technical slope of using MetaFont for type designers combined with the limited interest in making typefaces by mathematicians has resulted in only several handfuls of MetaFonts being produced over the last thirty years. As such, scant documentation and support exists for someone trying to create a MetaFont today.

Unlike more common computer outline font formats such as TrueType or Postscript Type 1, a MetaFont font is constructed of strokes drawn with set-width pens. Instead of describing the outline of the character directly by drawing each letter shape inside and outside, counter and letterform, a MetaFont file describes only the basic pen path or skeleton letter. Perhaps better imagined as the ghost that comes in advance of a particular lettershape, a MetaFont character is defined only by a set of equations rather than hard-coded coordinates and outline shapes. So it is then possible to treat parameters such as aspect ratio, slant, stroke width, serif size, (curlyness!?) and so on as abstracted input values that can change in each glyph definition, creating not a set of set letters, but instead a set of set parameters, any of which can be changed each time the font is rendered. By changing the value at one location in the MetaFont file, a consistent change is produced throughout the entire font. The resulting collection of glyph definitions and input parameters is not then a single font, but instead, a meta-font.

"Font" is a word whose current common usage (particularly in the context of personal computers) has twisted its exact definition. Returning to its roots, a "font" is simply a collection of characters of one particular design, or precisely, typeface. More specifically a "font" is the particular realization of a certain typeface in a certain medium, according to certain parameters such as size, width, weight, style, contrast, and shape—for example, a font of William Caslon's letters cast in hot lead at 14 points or a font of Standard Grotesque at 96 points carved from oak or even a full font of 12 pixel letters stretched 150% and rendered on a 72-dpi screen from the Arial typeface. However, this collection of parameters (size, width, weight, etc.) according to which a font is rendered from a particular typeface are not fixed. New parameters can be added at will, and this is where the "Meta" of MetaFont begins.

"Meta-" is a prefix of Greek origin that originally simply meant "after," but due to a strange turn of events came to mean "of a higher order, beyond" in Latin and later modern languages (excluding Greek, where it retains its original meaning). Its current use as "of a higher order" is from Aristotle's book on the Metaphysics, but he would never have called it that. Aristotle referred to the subject of that book as First Philosophy or Theology. The title "Metaphysics" comes from Andronicus of Rhodes (first century BC), who was the first

editor of Aristotle and placed the book on the Metaphysics after the book on the Physics in his compilation (so, it was literally "after" the Physics). So then you have metalanguages (languages used to describe languages), metahistory (the study of how people view and study history), metatheorems (theorems about theorems), metarules (rules about rules) etc. Indeed you can "meta" just about anything.

In 2009, The New Yorker ran "The Unfinished," a piece about American writer David Foster Wallace following his death 6 months earlier. Midway through the tribute, D.T. Max quotes from an early letter that Wallace sent to Gerald Howard of Penguin Books, in which he explains that his work is neither primarily "realism" nor "metafiction," but rather, "if it's anything, it's meta-the-difference-between-the-two" [5].

Typically, it's a throwaway line that returns, then stays with you. Does the "difference" here refer to a mathematical distinction in quantity, or to a more common sense of distinction or dissimilarity (or even disagreement)? Or both? Wallace's chain-of-words is as slippery as the logically-recursive sentence "The first rule is: there are no rules," but with a difference. Instead of simply setting up an endless loop between two poles, it observes that loop from a higher point of concentrated disinterest. There's no simple way out of this one, and yet there seems to be just enough there to keep trying.

Author Zadie Smith makes a case for this in an essay on Foster Wallace, using his short story "The Depressed Person" from *Brief Interviews with Hideous Men* as an arch example: "The effect on the reader is powerful, unpleasant. Quite apart from being forced to share one's own mental space with the depressed person's infinitely dismal consciousness, to read those spiral sentences is to experience that dread of circularity embedded in the old joke about recursion (to understand recursion you must first understand recursion)" [10].

Exporting Wallace's chain from literature to a more general use, we could plug other values into the equation. For "realism" we could insert "practice" and for "metafiction" perhaps "theory." (These poles can be endlessly swapped with similarly productive confusion—try "concrete"/"abstract" or "modernism"/"postmodernism.") And yet the "meta-the-difference-between-the-two" between any of these two isn't simply resolved by some alchemical fusion, as in "practice"+"theory"="praxis," practice informed by theory and vice versa. Less of a compound than an extraction, more a subtraction than an addition, Meta-the-difference-between-the-two-font is then a skeleton, a script, or a good idea in advance of its realization.

Knuth began his Gibbs lecture, "Mathematical Typography" with an apology of sorts, saying: "I will be speaking today about work in progress, instead of completed research; this was not my original intention when I chose the subject of this lecture, but the fact is I couldn't get my computer programs working in time." And he continues, "Fortunately it is just as well that I don't have a finished product to describe to you today, because research in mathematics is generally much more interesting while you're doing it than after it's all done" [3].

Meta-the-difference-between-the-two-font has a similarly incomplete character. As a set of simple letterforms and a collection of meta-design parameters, MTDBT2F will create unending numbers of different fonts from now onwards, always only moving forward and compiling a collection of surface effects onto its essential skeleton to produce a growing family of "hollow" fonts whose forms have more in common with handwriting than they do

with hot metal counterpunches (not to mention modern digital fonts). The clumsy result, with its chewy name Meta-the-difference-between-the-two-font, arrives before the effect that is applied to it, returning to a moment before fonts, just before Gutenberg's first black-letter Gothic types attempted to match the scribe's penmanship. At this point, to computer-automate the production of handwritten calligraphy, and to more or less ignore 400 years of typographic tradition, is essentially absurd.

Meta-the-difference-between-the-two-font picked up where Knuth's MetaFont left off. In fact, the only OSTENSIBLE difference between the two is that the new version was re-scripted in contemporary code to run on current computers. When typefaces are reduced to on/off bits of information, the typographic norms established by metal type (and carried over into photocomposition) are no longer bound to material necessity—they can be ignored and modified, and this is precisely what Knuth did. However, it was only with the advent and proliferation of PostScript in the early 1980s that typefaces became "device independent," freed from their association with particular composing machines and their controlling companies. But beyond this nominal "language difference," MTDBT2F remained more or less faithful to MetaFont's founding principles—not least its wacko parameters borrowed from Knuth's Computer Modern font, which include "SUPERNESS," "CURLINESS," and so on.

In the early 1980s, on the pages of academic design journal *Visible Language*, a classic thesis-antithesis-synthesis played out around the technological and philosophical fine points of computer-assisted type design. Knuth begins with his article, "The Concept of a Meta-font" [4]. Two years prior, he had conceived and programmed the software he was writing about. This article is a performative account of his intervening attempts of using MetaFont to harness the essential "intelligence" of letterforms. In his view, the way a single letter is drawn—an a priori A, say—presupposes and informs all other letters in the same font. This information can be isolated, turned into a set of instructions, and put to work computer-automating the generation of new characters by filling in the features between two or more variables such as weight or slant.

Such intelligence is (and has always been) implicit in any typeface, but Knuth is out to omit all ambiguity and install a more definite system. He acknowledges that this preoccupation with designing meta-level instructions rather than the fonts themselves is typical of the contemporary inclination to view things "from the outside, at a more abstract level, with what we feel is a more mature understanding." From this elevated vantage, MetaFont was set up to oversee "how the letters would change in different circumstances."

A year later, cognitive scientist Douglas Hofstadter responded with his "MetaFont, Metamathematics, and Metaphysics" [1]. While "charmed" by Knuth's thesis and admitting the bias of his own interests in artificial intelligence and aesthetic theory, Hofstadter proceeds to shoot down his colleague's apparent claim that the shape of any given letterform is "mathematically containable." To support his case, he invokes mathematician Kurt Gödel's Incompleteness Theorems, which assert that any account of a logically coherent system always contains one root-level instance that cannot itself be contained by that account. Hofstadter's antithesis then usefully couches the debate in terms of "the letter of the law" versus "the spirit of the law," a familiar antinomy that posits an absolute deference to a set of set rules against a consistent-yet-fluid set of principles. Our prevailing legal system is, of course, based on both: judges base their decisions on firmly established precedent,

Fig. 1 Two letters vying for the same "typographic niche," from Hofstadter [1]

but also map uncharted territory by bringing the full range of their experience to bear on specific cases "in a remarkably fluid way." In this manner, the law itself adapts.

Hofstadter argues that an accordingly *spirited* conception of type design would therefore renounce Knuth's ur-A-FORM in favor of a yet-higher-level abstraction, an ur-A-ESSENCE, the fundamental difference being that Hofstadter's notion of "intelligence" extends beyond a Platonic shape, allowing for the concept of *what constitutes an A* to change, too—beyond what we can reasonably conceive of this possibly being in the future. Each new instance of an A adds to our general understanding of this idea (and ideal), which is necessarily assembled backwards over time. Hofstadter includes this illustration of two letters vying for the same "typographic niche," to make himself clear (see Fig. 1).

Neatly enough, the following year linguistics professor Geoffrey Sampson drafted a brief response to Hofstadter's response to Knuth, titled "Is Roman Type an Open-Ended Question?" [7], which, it turns out, is decidedly rhetorical. Sampson argues that Hofstadter's hairsplitting unfairly and unnecessarily exaggerates Knuth's claims to the point of warping both his meaning and intentions. There is enough metaphysical latitude, the linguist referees, to accommodate both points of view without recourse to the misery of analytical one-upmanship. Sampson's synthesis of letter and spirit contends that it is perfectly reasonable to conceive of letterforms as both a closed system (Knuth's A-shape) AND as an open-ended system (Hofstadter's A-ness).

The history of typography is marked by a persistent drive to rationalize. Following the invention of movable type in the mid-fifteenth century, the Renaissance saw several attempts to prescribe the construction of the Roman alphabet: Fra Luca Pacioli's alphabet of perfect relations, Albrecht Dürer's letters of mathematical instructions, and Geoffroy Tory's humanistic rationalizations. These attempts were, however, essentially calligraphic exercises in determining "divine proportions"; the first to apply Enlightenment rationality to properly technical ends was the so-called Romain du Roi, or the "King's Roman." Commissioned by Louis XIV in Paris at the end of the seventeenth century, it was a typical Age of Reason project—the imposition of a mathematically-rigorous structure on forms that had, until now, developed organically, initially shaped by the human hand (calligraphy, inscriptions, woodcuts) and adapted according to the various demands and opportunities of the printing press and its attendant technologies. Designed by a committee of scholars from the Academy of Sciences led by mathematician Nicolas Jaugeon, the Romain du Roi was initially plotted on an orthogonal 48 x 48 grid, and a corollary "sloped Roman" italic variant derived by skewing the upright version. (See Fig. 2.)

The coordinates were first engraved as a set of instructions, then cut into punches to make metal type, which were to be used exclusively on official or state-approved materials. In this way, the King's letters exerted state power like a great seal or particular signature.

Fig. 2 Romain du Roi

Fig. 3 Herbert Bayer's 1925
Universal Alphabet, condensed
bold version. ©2012 Artists
Rights Society (ARS), New
York/ VG Bild-Kunst, Bonn

abcdefghijkl
mnpqrstuvw
xyzag dd

Such ratiocination was revived at the Bauhaus in the 1920s, in line with two of the school's foundational principles set up to meet the demands of industrialization: the omission of ornament and the reduction to geometric elements. The most celebrated outcome was Herbert Bayer's 1925 Universal Alphabet, a pared-down sans-serif comprised exclusively of lowercase characters. Bayer adapted the basic glyphs for typewriter and handwriting, experimented with phonetic alternatives, and proposed a wide family of variants, such as the condensed bold version drawn on the panel in Fig. 3.

Alongside the basic character set (minus a presumably redundant "o," but with alternatives to "a" and "g," as well as two "d"'s that anticipate lighter weights), Bayer has further abstracted the tools he used to draw it: ruler, T-square, set square, compass and protractor. As such, the drawing captions itself, pointing to its point—that this is a project *intrinsically concerned with a particular mode of construction.* Around the same time, fellow Bauhausler Josef Albers followed similar principles to slightly different ends with his Stencil Alphabet. This, too, was a single-case font, now entirely configured from ten rudimentary shapes, also typically isolated and presented alongside the assembled letters. Drawn and photographed for exclusive use in the school's own publications and publicity, these elemental Bauhaus fonts remained closeted explorations rather than properly industrial

products. Neither was properly developed into a "working" typeface, mass-manufactured in metal for wider use. Outside the school, though, prominent Werkbunder Paul Renner toned down the hard geometry with gentler, "humanist" sensibilities—more modulation, less harsh on the eye—to yield his commercially successful Futura. When it was issued in 1927, godfather of the nascent "New Typography," Jan Tschichold, wrote that [11]

> it cannot be open to one person to create the letterform of our age, which is something that must be free of personal traces. It will be the work of several people, among whom one will probably find an engineer.

During the 1930s, British type designer Stanley Morison was in charge of Monotype, the most significant type foundry of the day. Morison was solicited by *The Times*, London's principal newspaper, to take out a $1,000 full-page ad. Morison responded yes, as long he could typeset the page himself, because the newspaper's existing design was in such a dire state. This conversation reportedly carried itself up the *Times'* chain of command, prompting its director to invite Morison to oversee a complete overhaul of the paper's typography. Morison accepted, again on one condition—that the paper abolish the use of full points after isolated proper nouns, which he (rightly) considered superfluous and a prime example of the sort of typographic depravity he intended to stamp out. The paper removed the offending punctuation, and Morison climbed aboard.

Newspaper typography is a particularly sensitive art. Minute adjustments have critical knock-on effects for the amount of news that can be issued—especially when multiplied by the massive circulation figures of *The Times*. In a 25-page memorandum, Morison concluded that the house typeface needed to be updated. What became Times New Roman, however, was neither redrawn from scratch nor merely an amendment of the existing version, but rather *amalgamated* from a number of different typefaces made at various points over the previous 400 years. The mongrel result was effectively collaged from past forms, so the lowercase "e" doesn't exactly "match" the lowercase "a"—at least not according to the usual standards of typographic consistency. Up close, Times New Roman is full of such quirks (Fig. 4).

The design of letterforms usually manifests an individual designer's aesthetic impulse at a given point in time, but Times New Roman was the bastard offspring of MANY designers working ACROSS time, with Morison's role something like that of producer, editor, or

Fig. 4 *The Times of London*, 1932

arranger. The most frequently repeated account of the type's development suggests that Morison gave an existing type sample and some rough sketches to an assistant in the paper's advertising department, who duly cobbled together the new font. Whatever the story, in a note on HIS type, Morison concluded, auspiciously enough: "Ordinary readers, for whom a type is what it does, will be pleased to leave them to analyze the spirit of the letter" [6].

French type designer Adrian Frutiger took the rational mapping of the Romain du Roi to another plateau with Univers, released by the foundry Deberny & Peignot in 1957. In line with the all-encompassing aspirations of mid-twentieth century Swiss design—locus of the so-called International Style—Univers was conceived as an unusually extended family of fonts. The standard palette of variants, traditionally limited to regular, italic, bold, and sometimes bold italic, was expanded sevenfold, yielding a total of 21 fonts to be cut at any given size. In the foundry's publicity, the family was usually housed in a two-dimensional matrix: an X-axis charts relative WIDTH interspersed with POSITION (Frutiger's term for slant), while the Y-axis charts relative WEIGHT. The family DNA is manifest in a few eccentricities, such as a square dot over the "i" and a double-barred lowercase "a," while individual character sets are named according to their position in the matrix—55 for standard roman, 56 for standard oblique, 65 for medium roman, 66 for medium oblique, and so on (Fig. 5).

Univers' matrix implies that the family could potentially procreate in any direction ad in nitum, and, in fact, the project has remained notably open since its inception. Frutiger himself reworked the typeface for digital release by Linotype in 1997, raising the total number of distinct character sets from the original 21 to 63. These included additions to both ends of the chart (Ultra Light and Extended Heavy), along with new monospace variants, requiring a third number to be added to the identifying code. In the wake of Univers' popularity, further dimensions have since been introduced, including extended character sets such as Central European, and non-Latin alphabets such as Greek, Cyrillic, Arabic, and Japanese.

Fig. 5 French type designer
Adrian Frutiger's Univers

This globalization culminated in 2011 with Linotype rechristening the entire design "Univers Next."

Towards the end of "The Concept of a Meta-font," an admirably frank Knuth wonders: "The idea of a meta-font should now be clear. But what good is it?" Hofstadter, for one, had an idea: "Never has an author had anything remotely like this power to control the final appearance of his or her work." Indeed, seeing his own writing in print years earlier, Knuth had been so upset by the shoddy standards of early digital typesetting that he resolved to do it himself—not unlike Morison with his Times ad. It took longer than expected, but a decade later, Knuth had designed TeX, an automated typesetting system still in wide use today within academic publishing. MetaFont was initially developed as handmaiden to TeX, to generate the fonts to be used within the broader tasks of document markup and page assembly. However, as MetaFont developed as a project in its own right, its purpose was less immediately apparent. At the time of his *Visible Language* article at least, MetaFont appears to be more a case of hobbyist tinkering in search of an eventual application.

To be fair, Knuth does propose a few uses, all of which were already possible but certainly enhanced by the speed of computer processing. One is the ability to adjust the details of a particular font in line with the limits of a given output device—to make letters thinner or less intricate, for instance, so as to resist type "filling in" with either ink (on paper) or pixels (on low-resolution monitors). A second is the possibility of generating countless iterations of the same basic design with slight differences in order to compare and contrast. But a more surprising (and most emphatically stated) third function of MetaFont, according to its creator, is to meet the "real need" of "mankind's need for variety." In other words, to create difference for the sake of difference.

And so the notion of developing MetaFont as an autonomous project rather than as one of TeX's machine-parts appears to aim foremost at expanding the possibilities of literary expression—anticipating "greater freedom," a "typeface of one's own," "multiple fonts to articulate multiple voices," and so on. It's worth recalling, though, that when Knuth invented TeX in order to better typeset his own pages or Morison refurbished *The Times*, their impetus was fundamentally reactive, not constructive. They weren't out to expand the possibilities for expression per se, only to reinstate standards that had been eroded—ones that had been established in the first place to articulate written language as clearly as possible, not to pile on the effects. As Knuth himself states, typefaces are more medium than message, to the extent that "A font should be sublime in its appearance but subliminal in its effect."

References

1. Hofstadter, Douglas R. "Metafont, Metamathematics, and Metaphysics: Comments on Donald Knuth's Article (16:1)" *Visible Language* 16, no. 4 (1982): 309--338.
2. Knuth, Donald Ervin. *The Art of Computer Programming, Vol. 1--4A Boxed Set*. Reading, MA: Addison-Wesley, 2011.
3. ———. "Mathematical Typography." *Bulletin of the American Mathematical Society* 1, no. 2 (1979).

4. ———. "The Concept of a Meta-font." *Visible Language* 16, no. 1 (1982): 3--27.
5. Max, D. T. "The Unfinished." *The New Yorker* 9 (2009): 48--61.
6. Morison, Stanley. *Letter Forms: Typographic and Scriptorial*. Point Roberts, WA: Hartley & Marks Publishers, 1997.
7. Sampson, Geoffrey. "Is Roman Type an Open-Ended System? A Response to Douglas Hofstadter." *Visible Language* 17, no. 4 (1983): 410.
8. Sinister, Dexter. "A Note on the Type." *Bulletins of the Serving Library* 1, 2011.
9. ———. "Letter & Spirit." *Bulletins of the Serving Library* 3, 2012.
10. Smith, Zadie. "Brief Interviews with Hideous Men: The Difficult Gifts of David Foster Wallace." In *Changing My Mind: Occasional Essays*, 257--300. London: Penguin UK, 2009.
11. Tschichold, Jan. *The New Typography*. Berkeley: University of California Press, 2006.

Óscar Muñoz
Re/trato, 2003
Digital video, silent
Duration: 28 minutes, 47 seconds
Courtesy the artist

Simplicity via Complexity: Sandboxes, Reading Novalis

Andrés Villaveces

Dual Motion, Sandboxes

> *If you think it is hard to type with frog feet, you should try typing with wings. But don't worry about the capitals. A couple of centuries ago, the ffrench used doubled lowercase letters rather than capitals. So frog could be made to look more important by spelling it ffrog. And ffrog is ffrench, right? Thing is, the ffrench only did it with consonants. It won't work with aalbatross. Maybe that's why albatross has two esses at the end, to make up for not having two a's at the beginning.*
> —Jan Zwicky, *The Book of Frog*

When the invitation to a meeting on simplicity arrived, I initially had a sense that the "simplicity question" seemed unidirectional and perhaps all too well posed. It seemed initially to play *too well* with my own experience. (As a mathematician, one of my most sustained, energy-draining, and time-consuming struggles often seems to be with various forms of simplification.) The philosophical issue seemed almost flat. Yet lurking beneath the surface of this seemingly relentless simplification there is an opposite movement, a dual force. Looking more carefully underneath that unidirectional move toward simplification, I started finding strong elements of a move in the *opposite* direction, perhaps aptly called "complexification." This paper centers on the spiraling, back-and-forth movement between simplification and complexification, and on the central role of complexification as part of the simplification process.

A. Villaveces (✉)
Mathematics Department, Universidad Nacional de Colombia, Bogotá, Colombia
e-mail: avillavecesn@unal.edu.co

© Springer International Publishing AG 2017
R. Kossak, P. Ording (eds.), *Simplicity: Ideals of Practice in Mathematics and the Arts*,
Mathematics, Culture, and the Arts, DOI 10.1007/978-3-319-53385-8_15

The problem had been raised by Hilbert, and later expanded by other authors in very thorough accounts; there seemed therefore to be a high risk of falling into the trap of "descriptive philosophy," limited to an account of *how* simplicity arises and how it works. Somehow this didn't feel satisfactory to me; I felt more attuned to studying and proposing an *opposition* between complexification and simplification, and then simplification through complexification—complexification as a "vector" of simplification, as an essential part of the simplification of mathematical proofs. Three examples of this phenomenon ended up being the backbone of the lecture, and along the way the "sandboxes" for this process appeared, as devices where the (perhaps an infinite regress?) process of *simplification through complexification through simplification through...* dwells: devices that enable this back-and-forth process.

Excerpts from Novalis' enormous encyclopedia project, usually known as the *Allgemeine Brouillon* [10], can enlighten this path toward disentangling the puzzle of why apparently we so often do need to complexify in order to achieve simplification: Novalis was many things, among them a romantic poet, but he was also a pioneer geologist two centuries ago, as well as one of those unclassifiable philosophers (along with his contemporary, poet and philosopher Leopardi, and not too distant in time from Schopenhauer, whose magnum opus on the problem of representation also could have repercussions here—I chose however Novalis for the strength of his poetic images).

During the lecture, I engaged in a dialogue of sorts with a few artworks. A little of that dialogue remains here—as this is also an account of the lecture given. This dialogue is mostly of a metaphoric kind: the ideas discussed here are of course independent from the artworks, but there is also an unformalized exchange between the artworks and the mathematics—I engage in this kind of back-and-forth more as an invitation to the reader to continue.

Simplicity and Complexity, Spiraling

> Initially, *there are no simple definitions—the more we* simultaneously define—*the more correct every single definition becomes.* Defining en masse-science. *The definition is the formula for the construction of concepts, etc.*
> —Novalis, *Allgemeine Brouillon*

The *simplicity question*—the quest for the simplest proof or the simplest design, line, or resolution of architectural space or rhyme or melody—when described in such an ambiguous way, draws a tenuous but intriguing connection between mathematics and various other disciplines (architecture, physics, design, chemistry, music, etc.). The problem of finding the "simplest proof" of a mathematical theorem,

a question that has been called "Hilbert's 24th problem,"[1] is both intrinsically philosophical and purely mathematical. The notion itself of a *simplest* proof is the first and perhaps trickiest problem; the *existence* of such a simplest proof is a second, independent issue; finally, the question of *how to provide* such a simplest proof— provided it exists—is a third problem. The question feels resolutely vague when posed in an inadvertent, context-free way; a first approach could consist of looking for many contrasting examples of *how* simplification is approached, and indeed this was a dominant rationale of several approaches presented during the meeting.

In this paper I illustrate the contrasting view that *complexification* sometimes not only helps to achieve simplification but often even seems to be a *necessary* feature of it, how at some points apparent compromises of the simplifying process, apparent turns to complexity, may be needed in order to actually complete the move to simplicity. These apparent opposites indeed create a back-and-forth movement between simplification and complexification. In mathematics these movements have often created controversial situations—the movement to simplification is rarely unanimously absorbed—natural resistance to the first (necessary) complexification generates divisions inside the community of mathematicians. Sometimes these divisions even reach the point of becoming a ramification of mathematics: one team embraces the complexification, their opponent team doesn't. These ramifications are sometimes temporary—they evaporate. Yet sometimes they create actual subdisciplines.

Although the one-way path to simplification seems to signal a strong marker of *successful process* in mathematics,[2] at least judging by many descriptions and by the striking examples that were also given during the conference,[3] the path to simplification is not necessarily as linear as those examples purport.

Along this zigzagging path to simplification several "sandboxes" have been built and used by mathematicians. So, what are sandboxes, and why do I bring them up in this context? The terminology has been used in other domains—for example, in software development, Wikipedia states "A sandbox is a testing environment that isolates untested code changes and outright experimentation from the production environment or repository, in the context of software development including Web development and revision control." Sandboxes are therefore "testing terrains." An example of a sandbox is the use of a model of set theory (we are using here

[1]Although removed from the original list of 23 problems, the problem of *finding criteria for simplicity* for mathematics was in Hilbert's notes; Thiele [11] has written a detailed exposition of the rediscovery of this problem in 2000.

[2]Rota has described how a proof indeed is "distilled," simplified, through many iterations, by many different people [12].

[3]An extreme example of the impact of simplification in *revealing structure* was given by Dennis Sullivan during his lecture *Simplicity Is the Point*, which is transcribed in this volume. He spoke on the early emergence of Feynman diagrams, on how Feynman through what he described as his "little system of diagrams"—itself apparently a strong simplification of previous attempts—was able to capture the way to compute path integrals that had until then been "too complex" to even be computed before Feynman came up with his diagrams.

a technical term; a model of set theory is a collection of objects together with an abstract "membership" relation) obtained by extending the original universe of sets via the technique called forcing (typically) for a question that should be ideally resolved in ZFC, a question that would not seem to appeal to such antics. "Forcing the answer"—extending the universe of sets to find a place where the answer exists, and then, in a second stage, showing that the result proved did not actually essentially *depend* on such a change of universe (in set theory the technical expression used for this situation is "absolute" between the universe and its extension) provides a "twisted," indirect proof—quite far from the initial ideal of simplicity (unless one has been trained to use forcing or large cardinals) as a way to "test possibility." The sandbox in this case can be regarded as the forced universe, or the universe with large cardinals.

During the "Simplicity" meeting, there was a wide palette illustrating *how* simplification unfolds in different disciplines: the participants sketched many of these connections or formulations in architecture, in art theory and art practice, in design, in poetry, in the philosophy of language, in the philosophy of mathematics, and of course in mathematics proper. Mathematics would initially appear to be full of examples of the movement from complex to simple.

Finally, I develop the idea of "simplicity sandboxes:" testing devices for simplifications (through complexifications), creating special conditions (in principle more complex than the original statement of the problem) under which a simpler "answer" may be *tested* (in the absence of a proof) and thereafter transferred to situations freed of the special conditions. In ideal situations, the first proof may seem much simpler than later proofs (apparently reversing a naïve one-way direction toward simplification) but also works as a proof under "rarefied conditions."

Gian-Carlo Rota describes quite vividly some of the ways in which proofs are simplified, and the importance of this (sometimes decades-long, or even centuries-long) striving for reexplanation, redefinition, reproving, and in general simplifying [12].

However, I take a turn here and focus on the way the "opposite" move, the complexification of concepts and especially in some cases their framing in seemingly much more complicated worlds, seems to be a necessary aspect on the way to simplification. I stress: complexification is part of the dynamics of the simplification process.

The back-and-forth motion that emerges takes the form of mathematical adjoint pairs[4] $C \xleftrightarrow{U,V} D$: informally, spiral motions where one direction ellicits a response "in the opposite" that may build up *more* information on the original. Adjoint pairs are weaker (but gather more meaning) than inverses: as you go back and forth you do not quite return to the original position but seem to collect more information from the seeming return to the original place. This spiraling suggests a compelling

[4]Technically, our back-and-forth processes are really *category-theoretical adjoint pairs inside a category C*, i.e. pairs of functors $\xleftrightarrow{U,V}$ and a correspondence giving $Hom(F(X), Y) = Hom(X, G(Y))$, for every pair of objects X, Y in the category C.

line of thought: the evolution of the notion of infinitesimals versus a strict "ε-δ formulation" of limits and continuity, spiraling historically and conceptually from Leibniz and Newton, through Fourier and Weierstrass, back to infinitesimals (but formulated using nonstandard analysis) with Robinson!

These spiraling movements also can be seen as encapsulating Novalis' intriguing description of the simultaneity of definition ("*the more we simultaneously define, the more correct the definition becomes*").

$$\cdots S_1 \hookrightarrow C_1 \hookrightarrow S_2 \hookrightarrow C_2 \cdots$$

Simplicity from Complexity in Mathematics

> *85. THEORY OF ART: Are technical definitions and formulae for constructions—the same as prescriptions?*
> *86. NATURAL THEORY OF ART: An element is a product of art. There are as yet no elements—however, ones of this kind should be made. Should art be a differentiation (and integration) of the spirit?*
> —Novalis, *Allgemeine Brouillon*

Here is Novalis, again, on the extraction of elements as "products of art." The *extraction* of elements (the ultimate simplification in geology—as in Novalis' own work—or in chemistry, physics, and ultimately mathematics) is seen by Novalis as a product of art. Notice the nuance on the word *product* implying a potentially complex process; art as a differentiation and integration (the two dual movements of simplification and complexification) of the spirit seems to be for him in this passage the key to its role as the ultimate vector of simplicity. This is strongly suggestive of what happens in the examples that follow.

Incompleteness, on the Way to Completeness

Our first mathematical example is the classical story of Gödel's Completeness and Incompleteness theorems, but with an inverted narrative.

The typical vision of the role of Gödel's Incompleteness theorem is focused on the "mortal blow" it gave to Hilbert's program. The standard narrative of the unfolding of ideas seems to follow the chronological order of publication: first Completeness, and about a year later, Incompleteness.

Taking chronology at face value, completeness would therefore seem to be a logical predecessor to incompleteness. However, taking into account the small difference in time of publication (one year) one could *invert* the chronological

narrative order[5] and regard incompleteness as *philosophically prior* to completeness. In this respect, the oscillation between completeness and incompleteness is a first (emblematic) example of the back-and-forth of simplicity.

The initial purpose had been to provide a complete, categorical description of the natural numbers. This may easily be done in second-order logic, but if one tries to do the same in first-order logic—and insists on doing it in a computable way—one enters the terrain of incompleteness: the existence of sentences about the natural numbers that are true yet impossible to deduce from the axiom system, from the description that was supposed to be complete in the first place.

Three of the most important variations of the Incompleteness theorem,[6] one of them with the negative prefix "In-," the others with the negative prefix "Un-," bear witness to additional limitations of first-order logic: defining definability and defining a global notion of truth.[7]

Tangentially perhaps, Isaiah Berlin [4] singled out the romantic revolution as having launched the first *attack* on three principles, "three legs upon which the whole Western tradition rested." These principles are (roughly):

- any real question can be answered (and our lack of an answer is due perhaps to our ignorance) or if something cannot be answered, it is not a question;
- any real concept can be transmitted, can be taught (contrary to beliefs in other cultures that there are concepts that cannot be transmitted, or taught, unless you are illuminated or blessed or "chosen"); and
- all the answers must be compatible with one another.

It is interesting to compare what Berlin used as his first approach to the problem of defining *operationally* the concept of romanticism with the three "In/Un" theorems derived from Gödel's and Hilbert's own famous *Wir müssen wissen—wir werden wissen!*

[5] Juliette Kennedy studies in detail Gödel's work toward his doctoral dissertation; she points at how the three concepts of Completeness, Incompleteness, and Categoricity were initially less separated from one another than they later became [8]. Curtis Franks also discusses at length the import on Hilbert's program [6].

[6] Often stated as follows:

Theorem 13.1 (Undefinability of Definability—Tarski) *There is no formula in arithmetic that encodes the predicate "being (the Gödel number of) a formula true in the natural numbers." That is, there is no arithmetic formula Tr such that for every formula φ we have that $Tr(\varphi_g) \leftrightarrow \varphi$ holds.*

Theorem 13.2 (Undefinability of Truth—Tarski) *The set of Gödel numbers of true sentences in arithmetic (this is, in the language with $+$ and \times) is not itself definable in arithmetic.*

Theorem 13.3 (First Incompleteness Theorem—Gödel) *If an axiomatic system \mathscr{A} designed to axiomatize arithmetic is free from contradiction and recursive, then there exists a sentence $\varphi_{g\ddot{o}del}^{\mathscr{A}}$ that is true in the natural numbers but not an \mathscr{A}-theorem.*

[7] Of course, the key point of the three "In-/Un-" theorems is the construction of a Gödel sentence $\varphi_{g\ddot{o}del}^{A}$ that can neither be inside or outside $Tr = \{\ulcorner \varphi \urcorner | \mathbb{N} \models \varphi\} \subset \mathbb{N}$. This sentence is a sophisticated generalization of Epimenides' Paradox (the liar) that takes huge advantage of the coding power of $(\mathbb{N}, +, \cdot, 0, 1, <)$.

Therapeutic Completeness? Many Possible Worlds

The simplification here is now available to us, with this temporally inverted (but logically more interesting) alternative narrative: after hitting a wall by insisting on obtaining a full coincidence between sentences that are true in the standard model of arithmetic and provable sentences in Peano's arithmetic, the sandbox of *looking at many different models* of Peano's arithmetic, looking (so to speak) *simultaneously* at all possible variations of the standard model, at all possible manifestations (in all possible infinite cardinalities, with all sorts of nonstandard behaviors), we do recover completeness! This is the exact sense in which we recover (in an almost therapeutic sense of the word) the completeness (in the sense of coincidence between being a syntactic consequence and being semantically valid, now in *all* models of the given theory) that had been lost by the insistence on focusing on the standard model of arithmetic!

There is some sense in which the strong complexification move (natural in model theory for the past sixty years, but unusual even for mathematicians far away from mathematical logic) of looking simultaneously at many, indeed at all, models of a theory is the only way in which completeness is regained. The theorem says that a first-order theory T entails syntactically a sentence σ if and only if σ is true in *all* models of T. Looking at the standard model (or at any specific model) is not enough![8]

Landscape (*Maisema* in Finnish) by Irma Laukkanen provides an apt metaphor of the phenomenon "only by looking simultaneously at many worlds can one simplify, grasp the theory... and avoid incompleteness." To describe this in a more direct way: if you keep your eyes forever focused on only one manifestation (model, glass) of your problem or your theory, you are bound to miss something, perhaps crucial. A profusion of models (the complexity of having to consider them *all*) ultimately precipitates a simplicity of interpretation!

Of course, all the previous considerations suggest naturally the possibility of iterating the back-and-forth between simplification and complexification, and even start the path toward this. A succinct way of describing such an iteration, suggesting an infinite chain, is represented by the following (infinite) formula.

$$\cdots \to \text{SIMPL}_{n+1} \to \text{COMPL}_n \to \text{SIMPL}_n \to \cdots$$

At least one basic textbook in mathematical logic [14] and the forthcoming book by Jouko Väänänen and myself [16] take this approach and invert the usual order: the Incompleteness theorem is proved (after the necessary computability theory); then, almost as a "solution" to the incompleteness problem, the class of *arbitrary*

[8]Although Peano's arithmetic may be regarded as a tool to analyze the *standard model* $(\mathbb{N}, +, \cdot, 0, 1, <)$, if you insist on getting a SIMPL_n equivalence between syntax and semantics, you will be *forced* to accept the added COMPL_n of having to consider "all possible worlds" (all models of the theory)—as in a sort of latter-day take on Leibniz. Here, SIMPL_n, COMPL_n refer to the sequence on page 195.

models of arithmetic is introduced; then come arbitrary elementary classes (of the form $Mod(T)$ for arbitrary theories T); and finally the Completeness theorem is proved.

Logic, Geometrizing Away from Language?

> *89. PHYSICAL THEORY OF ART: How few people have a* genius *for experimenting. The true experimenter must have a* dim feeling for Nature *within himself, which—depending on the perfection of his faculties—guides him with unfailing surety along his path, allowing him to discover and determine with much* greater precision, *the hidden and decisive phenomenon. Thus the true lover of Nature distinguishes himself by his skill in* multiplying and simplifying, *combining and analyzing, romanticizing and popularizing the experiments, by his ability in inventing new experiments.*[9]
> — Novalis, *Allgemeine Brouillon*

Novalis alludes to the original problem of representation with words that we may take just as precisely as we want. In his Physical Theory of Art, Novalis appears to address "Art" as a kind of scientific knowledge of the world, of Nature. "Multiplying and simplifying" are two poles of tension, as are "combining and analyzing" from the same sentence.

At least three moves in model theory can be read off as part of this more general framework: Shelah's shift of focus from the truth of formal sentences to Abstract Elementary Classes, Zilber's model theoretical analysis of pseudo-exponentiation, now extended to larger families of "pseudo-analytical" functions, and even the examples from our previous section, the classical Gödel Completeness and Incompleteness theorems.

Model theory's rootedness in the syntax of mathematical logic has been a problem since its beginnings (a forthcoming book by John Baldwin explores in detail this and many other philosophical questions pertaining to model theory [1]). For several decades the focus of mathematical logic had been, variously, the development of semantics for first order logic, various fragments of second-order logic, various kinds of infinitary logics, generalized quantifiers, etc. Although these developments are extremely varied, they all share some variant of the word "logic": the control of the resulting classes of models is strongly syntactic and depends on internal properties of the logic where the axiomatization is written. The rooting of model theory in the syntax was, however, at odds with both

[9]My underlining. The presence of Gestalt thinking in science (and in particular in mathematics) is implicitly described here, more than a century before the actual theory of Gestalt was fully organized and developed. In personal communication, Zwicky remarks on the parallel between this passage of Novalis and Konrad Lorenz's description of the "hunch" necessary to the experimentalist to actually start working, to actually start gestalting a field of perception.

mathematical practice (where classes of structures—for example, classes of local rings or classes of specific kinds of groups—seem to be treated with more emphasis on semantic than syntactic aspects) and with the fact that among the usual branches of mathematical logic, model theory is closest to semantics. In the late 1970s Saharon Shelah started developing classification theory for *Abstract Elementary Classes* (AECs)[10]—classes of models whose definition *a priori* is not provided by an axiomatic system (internally) satisfied by each model, but rather by *external* relationships between the models (the dependence on satisfying sets of sentences in a language is replaced by an abstract notion of "strong" embedding—a description of *how* a model N is "encased" into an extension M). The classes need of course to satisfy various closure relations (under isomorphism, under limits) and provide enough tools for construction (but these are really restricted to the Löwenheim Skolem theorem, now a property of the strong embeddings of the class, as well as a coherence notion providing criteria for producing strong embeddings).

The main reason for the development of these classes and their model theory, ultimately extending stability theory way beyond its original first-order scope, was originally connected to developing model theory for various strong logics; this was later connected with the quest for a proof of *categoricity transfer* for sentences in the "first" infinitary logic beyond first order, $L_{\omega_1,\omega}$. (Of course, there is much more— in 1975, Shelah described his goal of building an "algebraically minded model theory" [13] and an important aspect of the model theory of the past twenty years seems to have started actually fulfilling that role, both in first order and beyond first order.) In many ways the break-up of syntax dependence may initially have seemed to have been a complication, a move away from simplicity. The development of stability theory for AECs did not have a very quick start, and this may be due to the fact that the setting required a whole new way of organizing the material, not dependent on definability, formulas, or compactness but rather on more abstract versions of the same phenomena. The theory is still in development, with very significant progress in the past few years.

From Geometry to Logic, Breaking the Language

The dual move, away from very strict control by language (the class of models studied is not necessarily given as *the* class of models of a theory, and the techniques of comparison and construction of models do not necessarily rely on formulas, types as sets of formulas, compactness, etc.) and toward inner semantic properties

[10] An Abstract Elementary Class (AEC) is a class \mathscr{K} of L-structures (for a fixed vocabulary L) closed under isomorphisms, together with a partial order $\prec_{\mathscr{K}}$ refining L-substructure, and with three additional axioms allowing meaningful model theory: a "Löwenheim-Skolem axiom," a form of closure under direct limits (for $\prec_{\mathscr{K}}$), and a "coherence" axiom.

of models in the classes under scrutiny, marks a serious conceptual rupture in the history of model theory.[11]

Recall that in AECs the emphasis seems to have been taken away from "language" or logic, and is now placed apparently on the way models are embedded into one another. There is however quite strong *implicit* linguistic control via Shelah's *Presentation theorem*. This provides us a case of a first step of rather strong complexification (the model theory of AECs does indeed start much harder, much more grounded in set theory, than first-order model theory) followed by later structural grasp on proofs of categoricity transfer, stability theoretic phenomena (orbital types—called Galois types), and inclusion of classes of models usually axiomatized by using infinitary languages.[12]

The driving problem in the area has been a family of *"categoricity conjectures"*: roughly, categoricity[13] in a high enough cardinal κ implying categoricity at all cardinals above κ (or variants of this phenomenon). Strong *geometric* structural features have emerged. Boris Zilber has even claimed (in personal conversations and lectures) that categoricity may be regarded as *the new analyticity*. In forthcoming work, I develop further this idea [15].

[11]This rupture is explored in Juliette Kennedy's *Formalism Freeness* paper [9] and also by Fernando Zalamea [17]. Kennedy systematically studies the drift away from linguistic control, the "symbiotic" relationship between second-order logic and set theory, and ultimately the *entanglement* present between language and formalism free presentations of our theories. Zalamea compares Shelah's work to that of Grothendieck and about a dozen other mathematicians of the past fifty years. He proposes a "sheaf-theoretical" understanding of the ruptures, surgeries, local mappings between a wild array of theories.

[12]More recently, we have seen new steps toward the geometrization of model theory, generalizing earlier work due to Hrushovski and Zilber: the emergence of Zariski-like (extremely geometric) structures in the context of (extremely remote, apparently) quasiminimal abstract elementary classes [7], the construction of model theoretical *sheaves* for mathematical physics [5], among other directions [18]. Along with this geometrization, several other gains in expressive power, in connection to analytical questions, have appeared: Stronger languages (Infinitary Languages, Second-Order languages), stronger quantifiers (measure quantifiers, game quantifiers, game semantics), sometimes weaker languages (even toward computer science), intention of suppression or strong reduction of language, embeddings between models and closure properties, embedding convergence, continuity (measures, etc.) into the language, taking seriously Grothendieck's "scheme revolution," Model Theory on sheaves and schemes and foliations. All of this is very much work in progress.

[13]The "eventual categoricity conjecture" has not been proved in full generality yet, but the work of Shelah, Grossberg, VanDieren , Lessmann, and more recently Boney and Vasey has brought about steps toward a comprehension of the difficulty of the problem. John Baldwin has written an exposition of some aspects of the problems around categoricity transfer [2].

The Price: Loss of Compactness

There is a price to pay for doing away with linguistic control: the loss of *compactness* when stepping aside from first-order logic.[14] (Other logics have compactness, but they usually require quite strong large cardinal hypotheses—our logic $L_{\omega_1,\omega}$ and AECs notoriously lack the compactness theorem.) This implies that the model theory is developed along different lines, emphasizing structure through less logic and perhaps more geometry.

There are however caveats: first of all, compactness is seldom completely lost— traces of compactness often remain and are heavily used.[15] Those "residues" of compactness tend to have strong structural flavor. Notoriously, although the analysis of definability seems to disappear in these forms of model theory—there are no formulas!—the analysis can be carried in terms of "types."[16] *Ad augusta per angusta.*

This effacement of compactness and the dependence on diagrams, towers of models, types as orbits under actions of groups, etc. has serious complications, and in many cases the thriftiness of the proofs using formulas and compactness is missing and has to be replaced by complicated diagrams. What is emerging, however, is a way of doing model theory in which entanglements with the more classical first order enriches both.[17] First-order logic *reflects* several non-first-order phenomena. The complication/simplification added by all these considerations has opened up many lines—several of them away from first order, some of them back in first order.

[14]The Compactness theorem of first order logic is extremely useful in that context and overshines further developments of model theory in the *non-elementary* context, where full compactness fails. The Compactness theorem is a strong "local/global" property that enables many constructions: if a theory T is locally satisfiable, then it is globally satisfiable—if every finite subset of T has a model then the whole of T does as well.

[15]Variously, the nonexistence of maximal models, various forms of the amalgamation property, Ehrenfeucht-Mostowski models, etc. have been described, on occasions very formally, as remnants or weak forms of compactness.

[16]Types in model theory appear under many different avatars—namely as *sets of formulas*, *Zariski-closed sets*, *orbits under automorphisms* of large models, and more recently *measures/states* or *distributions*.

[17]The work of Bays, Hart and Pillay [3] on the model theory of Kummer extensions, of covers, done *in first order* and replacing part of Zilber's work in a first-order context is a good example of this entanglement.

Sandboxes for Simplicity: A Dynamics of Adjunction?

Back to our sandboxes: whither? why? what?

Sandboxes were just a part of the title of the lecture—the rest was to put emphasis on the dynamics of complexification toward simplification. Along the way I realized that we mathematicians build "sandboxes" (forcing universes, infinitary logics, etc.) along the way, in order to form a conceptual image or just to test a conjecture under perhaps favorable conditions. This process may simplify the life of the mathematician who invents it, at least for a while, but it makes everyone else's life more complex. Why go to AECs when you have first order? Why go to forcing extensions? Why make life even more complex?

There are at least two answers: plausibility and imaging (Gestalt, perhaps).

Plausibility—testing in a mathematical sandbox shows that at least the conjecture is plausible, that it is not completely far-fetched, that at least in *some* universe, in some "sandbox" there is an answer. In many cases this answer will have to be taken out of the sandbox—sometimes by the author, sometimes by someone else—and this process may be lengthy, painful, and arid.

But perhaps the most important point is the formation of an image of the solution, to induce in the author of the proof (or the readers) an image of a solution, even if it only happens in the (initially) strange realm of the sandbox.

Anecdotally, during the lecture something happened: because of time constraints, I was not able to explain what sandboxes *are*—and this was perhaps not the intention of my lecture—for me, "sandboxes" are an almost self-evident part of the back-and-forth process. However, the word *sandbox* attracted the attention of some of the artists in the audience. Just after my lecture, and during the ensuing months, I received requests by several people who saw the title (and perhaps went to the lecture) to explain what the sandboxes are. The mathematicians themselves never asked that question. There is, to me, something deeply intriguing in the communication between mathematicians and artists—how we often seem to be attuned to similar sensibilities, but *express* them in such different ways. In this case, their sensitivity to the word *sandbox*, the pressing questioning, was a surprise to me.

Coda: Endless Loop?

Of course in mathematics an implicit core belief guiding our practice seems to be the *finiteness*, the boundedness of the simplification process; although simplification may sometimes occur along centuries, the core belief that we get to the bottom of issues, so to speak, seems to be a strong guide. But we have seen in our examples how the adjunction between complexification and simplification seems to start loops that go on beyond the original aim: the loops between completeness and incompleteness (and their more recent versions in higher order logics), the loops between language-controlled model theory and its free semantical variants, etc.

Let us close (inconclusively) with Óscar Muñoz's *Re-trato* (see page 189)—a pun on the word "portrait," with emphasis on the repetition, a self-portrait drawing *with water* almost immediately evaporating on the hot stone surface, forcing the artist to go on a seemingly endless loop of redrawing his own face—is a strong emblematic example of this movement in and out of simplicity through complexity.

Acknowledgements I wish to thank the organizers of the meeting "Simplicity: Ideals of Practice in Mathematics & the Arts" (Juliette Kennedy, Roman Kossak, and Philip Ording) for the invitation to a wonderful event. I also thank the referee for a very insightful reading that resulted in sharper formulations and the proofreader for very useful suggestions. I am also in debt to Jan Zwicky for her extremely insightful comments on an earlier version of this essay, on both the content and the writing. In many ways her amazing way of reading made me see with a different *contrast* some of my own assertions. Finally, I also want to mention many fruitful conversations with John Baldwin, Alex Cruz, Juliette Kennedy, Alejandro Martín, Jouko Väänänen, and Fernando Zalamea on subjects ultimately connected with these musings.

References

1. Baldwin, John T. *Formalism without Foundationalism—Model Theory and the Philosophy of Mathematical Practice*, forthcoming.
2. ———. *Categoricity*. University Lecture Series, vol. 50, *American Mathematical Society*, 2009.
3. Bays, Martin, Bradd Hart, and Anand Pillay, "Universal covers of commutative finite Morley rank groups." Preprint, 2014. arXiv:1403.4883.
4. Berlin, Isaiah. *The Roots of Romanticism*, The 1965 A. W. Mellon Lectures in the Fine Arts, The National Gallery of Art, Washington. Edited by D.C., Henry Hardy. Princeton: Princeton University Press, 1999.
5. Cruz Morales John Alexander and Boris Zilber. "The geometric semantics of algebraic quantum mechanics." *Philosophical Transactions of the Royal Society A* 373 (2015).
6. Franks, Curtis. *The Autonomy of Mathematical Knowledge: Hilbert's Program Revisited*, New York: Cambridge University Press, 2010.
7. Kaisa Kangas. "Finding a Field in a Zariski-like Structure." PhD diss.,University of Helsinki, 2015.
8. Kennedy, Juliette . "Gödel's Thesis: An Appreciation." In *Kurt Gödel and the Foundations of Mathematics. Horizons of Truth*. Edited by M. Baaz et al. New York: Cambridge University Press, 2011.
9. ———. "On Formalism Freeness: Implementing Gödel's 1946 Princeton Bicentennial Lecture." *The Bulletin of Symbolic Logic* 19, no.3 (2013): 351–393.
10. Novalis. *Notes for a Romantic Encyclopaedia: Das Allgemeine Brouillon*. Edited and translated by David Wood. Albany: State University of New York Press, 2007.
11. Thiele, Rüdiger. "Hilbert's 24th Problem." *American Mathematical Monthly* 110, no. 1 (2003): 1–24.
12. Rota, Gian-Carlo. *Indiscrete Thoughts*. Edited by F. Palombi. Boston: Birkhäuser, 1997.
13. Saharon Shelah. "The Lazy Model-Theoretician's Guide to Stability." *Logique et Analyse* 18, nos. 71–72 (1975): 241–308.
14. Väänänen, Jouko. *Matemaattinen Logiikka*. In Finnish. Helsinki: Gaudeamus, 1987.
15. Villaveces, Andrés. "Grasping Smoothly and Letting Go: Categoricity and Location." Lecture presented at "Getting There and Falling Short: An Interdisciplinary Symposium on Complex Content," Helsinki, 2015.

16. Villaveces, Andrés and Jouko Väänänen. *Lógica Matemática—De incompletitud a categoricidad*, forthcoming.
17. Zalamea, Fernando. *Synthetic Philosophy of Contemporary Mathematics*. Falmouth, UK: Sequence Press, Urbanomic, 2012.
18. Zilber, Boris. "The Semantics of the Canonical Commutation Relation." Preprint https://people.maths.ox.ac.uk/zilber/publ.html

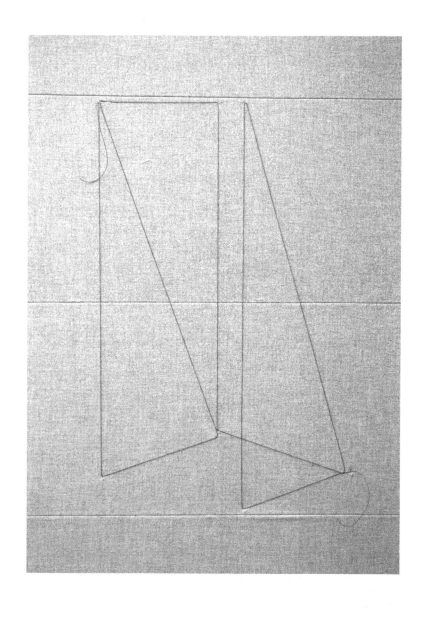

On the Alleged Simplicity of Impure Proof

Andrew Arana

Roughly, a proof of a theorem, is "pure" if it draws *only* on what is "close" or "intrinsic" to that theorem. Mathematicians employ a variety of terms to identify pure proofs, saying that a pure proof is one that avoids what is "extrinsic," "extraneous," "distant," "remote," "alien," or "foreign" to the problem or theorem under investigation. In the background of these attributions is the view that there is a distance measure (or a variety of such measures) between mathematical statements and proofs. Mathematicians have paid little attention to specifying such distance measures precisely because in practice certain methods of proof have seemed self-evidently impure by design: think for instance of analytic geometry and analytic number theory. By contrast, mathematicians have paid considerable attention to whether such impurities are a good thing or to be avoided, and some have claimed that they are valuable because generally impure proofs are *simpler* than pure proofs. This article is an investigation of this claim, formulated more precisely by proof-theoretic means. After assembling evidence from proof theory that may be thought to support this claim, we will argue that on the contrary this evidence does not support the claim.

The Purity Debate in Overview

A purity constraint, restricting proofs of theorems to what is "close" or "intrinsic" to that theorem, requires an account of how the distance between proof and theorem is to be measured. Two such measures of distance are what we have called "elemental" and "topical," distance. A proof is *elementally close* to a theorem if the proof draws

A. Arana (✉)

Unité de Formation et de Recherche de Philosophie, Université de Paris-Sorbonne and Institut d'Histoire et de Philosophie des Sciences et des Techniques, Paris, France

e-mail: andrew.arana@univ-paris1.fr

© Springer International Publishing AG 2017

R. Kossak, P. Ording (eds.), *Simplicity: Ideals of Practice in Mathematics and the Arts*, Mathematics, Culture, and the Arts, DOI 10.1007/978-3-319-53385-8_16

only on what is more elementary or simpler than the theorem [4]. A proof is *topically close* to a theorem if the proof draws only on what belongs to the content of the theorem, or what we have called the *topic* of the theorem [5, 17]. Each of these distance metrics induces a purity constraint, viz. elemental purity and topical purity. In these articles cases from mathematics have been presented that make evident the importance of these constraints in the history of mathematics through the present.

Once a purity constraint has been identified, we can ask why mathematicians value proofs that obey such a constraint. The basic case for preferring elementally pure proofs over elementally impure proofs, made in [4], is that elementarily pure proofs make the most efficient use of the information at the disposal of a given investigator (e.g. a student who knows little more than what a problem asks to be done). By contrast, in [17] the case is made that pure proofs give better reason to believe that *the* statement whose proof is sought has been proved, rather than some other, perhaps closely related, statement. This analysis takes a "vectorial" conception of mathematical investigation, in which the success of a proof is determined by the extent to which it is directed at exactly the intended statement. A proof may succeed as a proof of some different statement while failing as a proof of the statement towards which it was intended to be directed.

By contrast, impure proofs have been judged valuable on account of their illuminating previously unseen connections. For example, Kreisel has written [38, p. 167]:

> But also there is the void created by simply not saying out loud what (knowledge) is gained by impure proofs, for example by analytic proofs in number theory: knowledge of *relations between the natural numbers and the complex plane* or, more fully, between arithmetic and geometric properties. It is precisely this knowledge which provides effective new means of checking proofs: if this conflicts with some ideal of rigour, so much the worse for the ideal (which is being tested).

Additionally, it is a technical feat to use evidently "distant" methods to solve a problem at hand. In a way that is what is so impressive about them. We wonder how it is that, for instance, complex analysis can be brought to bear on arithmetic. and we are struck that this is possible. Whereas when seeking a pure proof, the search space is constrained, and so the strikingly distant connections characteristic of impurity cannot arise.

This constraint of the search space can be thought to be an advantage in proof, since the variety of considerations that can be brought to bear on the directing problem or theorem includes only a fraction of all the possible considerations that might otherwise be tried. Additionally, one might think that the "closeness" of proof to theorem would engender other justificatory efficiencies, since such proofs will avoid what would seem from outside the practice to be extraneous or "roundabout".

However, there is a strand of theorizing on mathematics that emphasizes the opposite, stressing the *simplicity* of impure proof in comparison with pure proof. Such claims have been made, for instance, on behalf of analytic geometry and of complex analysis in real arithmetic and analysis. Let us consider these claims in further detail now, so that we can more precisely *formulate* and *evaluate* theses concerning the simplicity of impure proof relative to pure proof.

Simplicity and Impurity in Mathematical Practice

Since the seventeenth century analytic methods have been viewed by many as a source of impurity in geometry, in contrast to the coordinate-free "synthetic" methods typified by Euclidean geometry. Descartes canonized a procedure for solving geometrical problems as follows: first express the problem by algebraic equations, then solve these equations by algebraic manipulations, and finish by translating these algebraic solutions back into geometrical terms. He lauded this method for making it "easy" [aisé] to find constructions, though he noted that sometimes the method requires "dexterity" [adresse] in order to find "short and simple" [courtes et simples] constructions.[1] Note that this Descartes here distinguishes two types of simplicity: the simplicity of *discovering* a solution to a problem, and the simplicity of the construction itself. This distinction will recur and we will return to it shortly.

In contrast with Descartes, some mathematicians have judged such use of algebra in geometry to be "rather far" from the problems at hand, and thus impure. Consider for example the following passage of Newton [44, pp. 119–20]:

> Equations are Expressions of Arithmetical Computation, and properly have no Place in Geometry, except as far as Quantities truly Geometrical (that is, Lines, Surfaces, Solids, and Propositions) may be said to be some equal to others. Multiplications, Divisions, and such sort of Computations, are newly received into Geometry, and that unwarily, and contrary to the first Design of this Science.... Therefore these two Sciences ought not to be confounded. The Antients did so industriously distinguish them from one another, that they never introduced Arithmetical Terms into Geometry. And the moderns, by confounding both, have lost the Simplicity in which all the Elegancy of Geometry consists.

Newton spelled out the type of geometric simplicity he sought in the following passage [45, p. 421] (translation from [25, p. 77]):

> Men of recent times, eager to add to the discoveries of the ancients, have united specious arithmetic [i.e., algebra] with geometry. Benefitting from that, progress has been broad and far-reaching if your eye is on the profuseness of output but the advance is less of a blessing if you look at the complexity of its conclusions. For these computations, progressing by means of arithmetical operations alone, very often express in an intolerably roundabout way quantities which in geometry are designated by the drawing of a single line.

Thus Newton identified the impurity of algebra in geometry as detracting from the simplicity of geometrical reasoning that ancient works had exemplified.

Newton's views would come to seem rather peculiar, as the power of the Cartesian method became increasingly evident [25, 50]. This power was characterized by Colin MacLaurin, a contemporary and expositor of Newton, as follows [40, Book 2, p. 163]:

> The improvements that have been made by [analytic methods], either in geometry or in philosophy, are in great measure owing to the facility, conciseness, and great extent of the method of computation, or algebraic part.

[1]Cf. [14, p. 351], though statements of this sort are found throughout *La géométrie*. For more on the simplicity of the Cartesian method in geometry [3, Sect. 2], [41].

Similarly, Lagrange and Klein emphasized the utility of algebraic methods in geometry. Lagrange wrote [22]:

> As long as algebra and geometry have been separated, their progress has been slow and their usage limited; but when these two sciences are reunited, they lend each other strength and march onward together at a rapid pace toward perfection.[2]

Along the same lines, Klein wrote [37, p. 160]:

> As a matter of principle, we have always availed ourselves of the aids of analysis, and in particular of the methods of analytic geometry. Hence we shall here again assume a knowledge of analysis, and we shall inquire *how we can go, in the shortest way, from a given system of axioms to the theorems of analytic geometry*. This simple formulation is, unfortunately, rarely employed, because geometricians often have a certain aversion to the use of analysis, and desire, insofar as possible, to get along without the use of numbers.

While MacLaurin, Lagrange and Klein were clearly promoting the gain in simplicity afforded by algebra in geometry, these passages leave it unclear whether they intended to promote the gain it affords in producing work that is simple to verify once located, or in the discovery of geometric results in the first place. Detlefsen has drawn attention to this distinction, identifying the former type of simplicity as *verificational* simplicity and the latter as *inventional* simplicity [15, p. 376], [16, p. 87]. Verificational simplicity measures the simplicity of determining whether a given proof is a proof at all; thus it measures the simplicity of confirming the validity of the deductions of a given proof. By contrast, inventional simplicity measures the simplicity of discovering a proof of a given statement. MacLaurin's remarks on the simplicity of algebraic methods in geometry do not seem to be sensitive to this distinction.

By contrast with MacLaurin, Lagrange and Klein, d'Alembert claimed explicitly that algebraic methods in geometry afford both types of simplicity. Firstly, he remarked of ancient geometrical works "that almost no one reads them with the ease [*facilité*] given by algebra in reducing their demonstrations to a few lines of calculation" [12, p. 551]. He thus stressed the gain in verificational simplicity that algebraic considerations can bring to geometrical proof. He went on to remark, though, that these considerations enable us to "arrive nearly automatically at results giving the theorem or the problem that we sought, which otherwise we would not have gotten or would only have gotten with much effort." (*Ibid.*) That is, he also stressed that our ability to discover results in geometry is improved when we make use of algebraic methods (though he also noted exceptions to this, in particular when trigonometric expressions were involved).

We find such claims regarding the simplicity of impure methods also in discussion of the application of complex analysis to real analysis, algebra and arithmetic. One prominent example of such application was in the theory of equations. Algebraists since Cardano had sought exact solutions in finite terms to cubic polynomial equations with rational coefficients having three *real* roots, and

[2]Cf. [39, p. 271]. For a detailed historical investigation of Lagrange's views on purity in his algebraic work.

were dismayed to discover that this seemed to require using imaginary numbers. This is an apparent impurity for a problem concerning just real algebra. The *casus irreducibilis*, as this is known, spurred numerous, unsuccessful attempts to avoid imaginary numbers, even leading to a prize question in 1781 from the scientific academy in Padua.[3]

Another such example is the prime number theorem, a result concerning the distribution of prime numbers among the natural numbers that gives a precise estimate of the number of primes less than a given natural number.[4] It was proved by Hadamard [26] and, independently, de la Vallée Poussin [18] using complex analysis in 1896. Their use of imaginary numbers to solve a number-theoretic problem was judged impure by many , spurring work that led to the "elementary" proofs of Selberg and Erdős in 1949 that avoid reference to imaginary numbers [20, 52]. The elementary proofs have been viewed as more pure than the complex analytic proofs; as Granville recently put it, "A simple question like 'How many primes are there up to x?' deserves a simple answer, one that uses elementary methods rather than all of these methods of complex analysis, which seem rather far from the question at hand."[5]

As with the application of algebra to geometry, these allegedly impure solutions have been promoted for their alleged efficiency. In a famous remark, Hadamard observed that "the shortest and best way between two truths of the real domain often passes through the imaginary one" [27, p. 123]. Palle Jorgensen [35] has observed that Hadamard, who prefixes this passage by saying that "it has been written", is referring to the following passage of Painlevé's [46, pp. 72–73]:

> The natural development of this study soon led geometers to embrace in their research imaginary values of variables as well as real values. The theory of Taylor series, of elliptic functions, the vast doctrine of Cauchy made the fecundity of this generalization erupt. It appeared that between two truths in the real domain, the easiest and shortest path often passes through the complex domain.

Hadamard and Painlevé presumably had in mind applications of complex analysis in the solution of differential equations, in the evaluation of real integrals using residue theory, and in the solution to arithmetic problems by analytic number theory. Once again, though, there is ambiguity concerning whether they meant that the "easiest" or "shortest" paths engendered by complex analysis are easy or short when it comes to verifying proofs or to discovering them.

None of the authors just surveyed seem to have had sharp measures of the type of simplicity to which they were appealing. Because of their expertise the anecdotal evidence they offer ought to be taken seriously. However, claims of the sort quoted

[3]The prize question is described in [51, p. 4]. Otto Hölder showed in 1892 that there is no exact solution in finite terms to cubics in the casus irreducibilis that avoids imaginary numbers [32]. For a more thorough discussion of the casus irreducibilis in relation to purity [1].

[4]More precisely, the prime number theorem states that $\frac{\pi(x)}{x/\log(x)}$ approaches 1 in the limit, where $\pi(x)$ is the number of primes less than or equal to x.

[5]Cf. [24, p. 338]. For more on purity in arithmetic [2, 4].

here are typically given as part of a broader polemic in which the author is promoting his or her own favored approach to the topic in question. We thus ought to take their *evidence* with a grain of salt.

However, we should take their *claims* very seriously. If true, they would undermine the value purity has been taken to have by many mathematicians. More precisely, the value of pure proof would be countered by disadvantages if impure proof is *generally* or *systematically* simpler than pure proof. Toward determining if this is so, the tradeoff between the difficulty of discovering impure proofs, and the simplicity impurity allegedly confers, warrants further investigation.

It is thus urgent to formulate claims regarding the simplicity of impure proof relative to pure proof so that the theses in question can be better evaluated. We have identified the following two theses in the reflections we have surveyed:

Thesis 1: Impure proofs are generally simpler to *verify* than pure proofs of the same statement.

Thesis 2: Impure proofs are generally simpler to *discover* than pure proofs of the same statement.

One way to evaluate these theses would be to undertake a detailed case study of a mathematical sub-discipline, as Avigad does for number theory in [8], and to evaluate simplicity claims on the basis of this investigation. An alternate way would be to consider the theses in light of work in proof theory.[6] In this paper we will undertake the latter kind of evaluation. Each approach brings different information and is valuable for different reasons. The chief advantage of the formal approach is that it permits the theses to be formulated exactly and for those theses to be evaluated systematically. Its chief disadvantage is that proof-theoretic formulations may distort the phenomena being measured. We will address this disadvantage as they come to light in the ensuing discussion. In general we believe that this investigation should be carried out side-by-side with case study investigations; such investigations may lead to new formal measures of proof complexity.

As we have explained, these theses, if true, would give reason to discount the value of purity. This would not be the case if *some* impure proofs are simpler than pure proofs of the same theorems; rather, what needs to be investigated is whether there is a *general* pattern of improvement of simplicity when moving from pure to impure proof. This article focuses on Thesis 1; Thesis 2 will be addressed in another article. Our main finding in this article is that work in proof theory provides little evidence for thinking that there is a general pattern of improvement of verificational simplicity when moving from pure to impure proof.

[6]Note that in [8] Avigad draws on work from automated reasoning, which is closely allied with proof theory; thus these approaches are not exclusive.

A Formal Evaluation of Simplicity of Impure Proof

In order to investigate Thesis 1, we will focus on the verificational simplicity of theorems in these theories. We will use as a measure of verificational simplicity the length of proofs in formal theories. This measure is well-known in proof theory, and accordingly we will be able to employ theorems of proof theory to evaluate Thesis 1.

Our approach will be to investigate extensions of a given formal theory (which we will call the "base theory") by elements that yield, we will argue, *impure* proofs for theorems of that base theory. We will consider extensions that are "conservative" in the following rough sense: anything provable in the extended theory that can be expressed in the language of the base theory is already provable in the base theory. Thus we can compare the verificational simplicity of proofs of theorems of the base theory with proofs of those same theorems in an extended theory. We can thus compare the verificational simplicity of pure and impure proofs of theorems of the base theory.

Our strategy for this evaluation is as follows. In section "The Theories", we will introduce the formal theories to be studied here. In section "Impurity", we will argue that the extensions of the base theory permit impure proofs of theorems of the base theory. In section "Conservativity", we will state what is known concerning the conservativity of these extensions over the base theory. In section "Speed-Up" we will introduce the aforementioned measure of verificational simplicity, proof length, and an apparatus for comparing the verificational simplicity of proofs known as "speed-up". In section "The Evidence" we will state what is known concerning the speed-up of proofs in the extended theory over proofs of the same theorems in the base theory. Finally, in section "Evaluating the Evidence", we will explain how this evidence bears on Thesis 1. Since proofs in the extended theories will be seen to be impure in general for theorems in the base theory, our case will be that the evidence tells against Thesis 1.

The Theories

Our investigations will focus on formal theories of arithmetic. For starters, first-order Peano Arithmetic (PA) has axioms that define addition, multiplication, and an ordering of integers, as well as induction axioms given by the familiar induction schema. Its language \mathscr{L}_{PA} consists of constants 0, 1, function symbols $+$, \times, and relation symbol $<$. At the center of our investigations here, however, is the first-order arithmetic theory known as Primitive Recursive Arithmetic (PRA). PRA is obtained from first-order PA by adding to PA symbols and defining equations for all primitive recursive functions, and restricting the induction scheme to quantifier-free formulas.

PRA will serve as our "base theory" in the sense described above: our proof-theoretic observations will compare proofs of theorems in PRA with proofs of the

same theorems in extensions of PRA. We will consider extensions of PRA of two different types, adopting a helpful classificatory scheme due to Ignjatović [10, 34]: "arithmetical" and "conceptual" extensions. These types of theories give proofs of theorems of PRA that are, as we will argue, *impure*.

Arithmetical extensions of PRA add new arithmetical principles, specifically induction schemas for more inclusive classes of arithmetical formulas. We will focus on the arithmetical extension $I\Sigma_1$ of PRA, which is obtained from PA by restricting the induction schema to Σ_1^0-formulas. It is not obvious that $I\Sigma_1$ is an extension of PRA, since PRA contains function symbols and defining equations for all the primitive recursive functions, and $I\Sigma_1$ doesn't. But it can be shown that PRA is "essentially" included in $I\Sigma_1$, as follows (see [54, pp. 374–375], for the details). The language of $I\Sigma_1$ (i.e. \mathscr{L}_{PA}) can be interpreted in the language of PRA by what Simpson calls the "canonical interpretation," which (a) interprets 0 and 1 as 0 and 1 in the language of PRA; (b) interprets addition and multiplication as primitive recursive functions defined in the expected way; and (c) interprets $<$ by defining predecessor and truncated subtraction as primitive recursive functions from which $<$ can be straightforwardly defined. It can then be shown that any first-order formula that is provable in PRA is provable in $I\Sigma_1$ when given the canonical interpretation. Moreover, any model of $I\Sigma_1$ can be expanded to a model of PRA by interpreting the symbols for the primitive recursive functions according the their definitions. Since Σ_1^0 induction suffices to prove the totality of these functions, the language \mathscr{L}_{PA} can be extended to include these extra symbols while remaining conservative over $I\Sigma_1$ [54, Sect. II.3, pp. 69–73], [36, Chap. 4]).

By contrast, *conceptual* extensions add to PRA a new type of element, sets, and principles for using sets. We will focus on three conceptual extensions of PRA: RCA_0, WKL_0 and WKL_0^+, each a subsystem of second-order arithmetic. Firstly, the theory RCA_0 is obtained by adding to PRA a comprehension schema for Δ_1^0-definable sets of numbers—that is, a *recursive* comprehension schema, hence the name—and replacing PRA's induction scheme with an induction schema for Σ_1^0 formulas, possibly with set parameters.[7] Secondly, WKL_0 is the theory RCA_0 augmented by weak König's lemma, which yields paths through infinite $\{0, 1\}$-trees. Thirdly, WKL_0^+ is the theory WKL_0 augmented by a form of the Baire category theorem saying that every arithmetically defined sequence of dense open sets of Cantor space has non-empty intersection.

[7]In [54], Simpson defines RCA_0 (on p. 24) in a slightly different but equivalent way, using Σ_1^0-induction (with set parameters) but not primitive recursion. As he notes on p. 73, Friedman originally defined RCA_0 in the way we have done here [23, pp. 557–558].

Impurity

Next, we will argue that each of these extensions of PRA yields impure proofs of theorems of PRA. Firstly, proofs of theorems of PRA in conceptual extensions of PRA are, in general, *topically* impure, because they draw on set-theoretic resources rather than just resources concerning natural numbers. Theorems of PRA, a first-order theory of arithmetic, are theorems about natural numbers and not sets: in particular, its quantifiers range over objects of arithmetic rather than set-theoretic type. While PRA also uses functions and relations on numbers, these functions can be understood algorithmically, without appeal to set theory. We see no good reason to think that a set-theoretic understanding of functions takes precedence, particularly in the case of PRA where the functions are merely used for computations on natural numbers.

One might object to this on the following grounds, following a suggestion of Sean Walsh. By the same reasoning, proofs of theorems of $I\Sigma_1$ in RCA_0 are also topically impure, since they too deploy set-theoretic resources for proving arithmetic theorems. But $I\Sigma_1$ and RCA_0 are mutually interpretable. Thus, we can translate any proof in RCA_0 into a proof in $I\Sigma_1$, and thus into a proof that avoids set-theoretic resources; and this translations is line-by-line, as straightforward as it gets. Thus, one might maintain, the impurity of proofs in RCA_0 of theorems of $I\Sigma_1$ is a mirage; proofs in RCA_0 use set-theoretic resources only in a superficial way, that can easily be expressed in non-set-theoretic ways, without any significant gain in length of proof.

This objection can be expressed more sharply, taking a cue from Wright in a slightly-different context [57, pp. 17–18], [33, p. 322]:

> Well, I imagine it will be granted that to define the distinctively arithmetical concepts is so to define a range of expressions that the use thereby laid down for those expressions is indistinguishable from that of expressions which do indeed express those concepts. The interpretability of Peano arithmetic within Fregean arithmetic ensures that has already been accomplished as far as all pure arithmetical uses are concerned.

A topically pure proof of a theorem draws only on what belongs to the content of the theorem; following Wright, one could maintain that this includes concepts whose use is *indistinguishable* from that of concepts that feature in the statement of the theorem. Since the mutual interpretability of $I\Sigma_1$ and RCA_0 entails that the use of set-theoretic concepts in an RCA_0-proof of a $I\Sigma_1$-theorem is indistinguishable, in a precise sense, from the use of purely arithmetical resources, the objection asserts that an RCA_0-proof of a $I\Sigma_1$-theorem is in fact topically pure.

In reply, let's consider an agent P, a relative logical novice who is familiar with $I\Sigma_1$ but not RCA_0, because she does not know any set theory. She can understand theorems of $I\Sigma_1$ and $I\Sigma_1$-proofs of these theorems, but not RCA_0-proofs of them. The objector maintains that he can translate any $I\Sigma_1$-proof into an RCA_0-proof, but P does not understand the translated versions. The objector may reply that P "implicitly" understands the parts (terms, sentences) of the RCA_0-proof she purports not to understand, since she understands the parts of the $I\Sigma_1$-proof from

which they have been translated. But P does not understand this translatability, since she does not know RCA_0. The objector may then reply that the type of "implicit" understanding of RCA_0-proofs intended here is not psychological, but rather *semantic*: that the meanings of the parts of RCA_0-proofs are the same as the meanings of the parts of $I\Sigma_1$-proofs. By virtue of mutual interpretability, parts of RCA_0-proofs play the same inferential role in proofs of $I\Sigma_1$-theorems as parts of $I\Sigma_1$-proofs. They thus have the same use, and hence the same meaning. Call this *Wright's thesis*. It follows, the objection goes, that agent P does in fact understand the parts of RCA_0-proofs she purports not to understand, since she understands their translations into $I\Sigma_1$.

Whatever the virtues of Wright's thesis otherwise, its application to mathematics dissolves important aspects of mathematical practice, and thus impairs our ability to understand this practice. For suppose we admit Wright's thesis, maintaining that if two theories T_1 and T_2 are mutually interpretable, then their semantic parts (terms, statements) have identical meanings. Hilbert showed that the theory of fields is mutually interpretable (with parameters) with the theory of Pappian projective planes [30]. Thus purely geometric talk of projective planes can be term-by-term translated back and forth with purely algebraic talk of fields. Wright's thesis entails that this purely geometric talk and this purely algebraic talk have the same meaning. This goes against 500 years of thinking in mathematics, where algebraic thinking and geometric thinking have been thought to be distinct (as discussed in section "Simplicity and Impurity in Mathematical Practice"). If the semantic boundary between algebra and geometry is dissolved, then topical purity for algebra and geometry is also dissolved, since topical purity is a semantic view as well. But topical purity has been and remains today important to mathematical practice, as we explained earlier and in several other referenced articles as well. Dissolving the semantic boundary between algebra and geometry would dissolve topical purity as a genuine constraint of mathematical practice, and would thus impair our ability to understand mathematical practice. That is too high a price to pay for a controversial semantic view like Wright's thesis. Thus we reject Wright's thesis and maintain, against the objection, that RCA_0-proofs of $I\Sigma_1$-theorem are in general topically impure.

We next turn to the impurity of arithmetical extensions of PRA. This case is different than for conceptual extensions of PRA, because arithmetical extensions do not add set-theoretic resources to PRA. Thus they do not engender proofs that are obviously topically impure for PRA. Instead, these extensions add stronger induction principles than PRA. These principles are, as we will argue, less elementary than the quantifier-free induction of PRA, and thus proofs of theorems of PRA in conceptual extensions of PRA are, in general, *elementally* impure.

We focus on proofs of theorems of PRA using Σ_1-induction rather than just PRA's quantifier-free induction; that's to say, proofs that may apply the induction schema of PRA to Σ_1^0-formulas rather than just to quantifier-free formulas. Tait has argued that the finitist accepts quantifier-free induction, on constructive grounds, while not accepting Σ_1-induction [56]. That's because there need be no way of constructing the existential witness of the conclusion of Σ_1-induction from the witnesses for the existential formulas in the antecedent clauses.

As a result, the finitist maintains that proofs using quantifier-free induction are (all else being equal) more *secure* than proofs using Σ_1-induction. Taking epistemic security as a criterion of elementarity, it follows that Σ_1-inductive proofs of theorems of PRA are elementally impure. Proofs of theorems of PRA using Σ_1-induction involve a redeployment of PRA's conceptual resources that does not meet the epistemic standards that the principles of PRA are taken to meet, and hence are elementally impure.

As the reference to finitism suggests, Hilbert arguably held a view of purity like this, at least in his later years (for discussions of Hilbert's earlier views on purity, see [5, 29] and [1]). As Kreisel described it, Hilbert's "famous consistency programme is also a particular case of this search for pure methods: so-called finitist theorems should have finitist proofs" [38, p. 163]. Hilbert characterized the "real" propositions of "ordinary finite number theory" as those that can be "developed through the construction of numbers by means solely of intuitive contentual considerations" that are basic "for mathematics and, in general, for all scientific thinking, understanding, and communication" [31, p. 376]. As he saw it, such "real" propositions, being "immediately intuitive and directly intelligible", were more securely knowable than "ideal" propositions which are non-contentual and are "merely things that are governed by our rules" [31, p. 380]. Hence, he judged, real propositions are best proved by real rather than ideal methods. Thus, we agree with Kreisel that Hilbert's program is a program for purity, in particular for elemental purity.[8]

Here too one could raise an objection. Friedman has conjectured that every arithmetical theorem already proved in the *Annals of Mathematics* can be proved in the theory known as elementary function arithmetic (EFA), which is proof-theoretically weaker than PRA [7]. If true, one might infer that elemental purity is a trivial constraint: every arithmetic theorem has an elementally pure proof, indeed a *very* elementally pure proof. In reply, we observe firstly that Friedman's "grand" conjecture is far from certain. At the moment an active research program is aimed at showing that Fermat's Last Theorem is provable in EFA [43], but even this modest step toward Friedman's conjecture is a long way from being settled. Secondly, even if true, the conjecture says nothing about the length of proofs of arithmetic theorems in EFA. One would expect them to be much longer in general. There are thus two notions of elementarity at play here: on the one hand, inductive strength, and on the other hand, length of proof. These seem to be in conflict with one another: if the conjecture is correct, then every arithmetic theorem has an elementally pure proof in the sense of inductive strength, but not necessarily in the sense of length of proof. Thus the conjecture, if true, would lead to an investigation of the length of proof

[8]A significant remaining question is whether $I\Sigma_1$ is especially significant, as an arithmetical extension of PRA, for the thesis that impurity generally offers gains of efficiency; or whether a study of $I\Sigma_2$, for instance, would offer key additional insights. Toward this, Ignjatović has conjectured that further inductive strengthenings of PRA with respect to the quantifier-free theorems of PRA will yield a *significant* gain of efficiency, but to the best of our knowledge this is still open.

of arithmetic theorems in EFA versus in inductively stronger arithmetic theories. This is precisely the sort of investigation to be carried out in this article for other theories, so the conjecture would simply necessitate a sequel to this article, rather than refuting its points.

Conservativity

Having argued that arithmetic and conceptual extensions of PRA are in general impure, we now turn to the question of their conservativity over PRA. Recall that a theory T_2 is *conservative* over a theory T_1 iff for every sentence φ in the language of T_1 that is provable in T_2, φ is also provable in T_1. Each of these extensions of PRA are conservative over PRA. The arithmetic extension $I\Sigma_1$ is conservative over PRA for Π_2^0 sentences, as shown by Parsons [47]. Since RCA_0 and $I\Sigma_1$ prove the same first-order sentences [54, pp. 25, 369], it follows again from Parsons' result that RCA_0 is conservative over PRA for Π_2^0 sentences. Friedman observed that WKL_0 is conservative over PRA for Π_2^0 sentences, and Harrington has shown that WKL_0 is conservative over RCA_0 for Π_1^1 sentences, and hence for all arithmetical sentences [54, pp. 369–372]. Finally, Brown and Simpson have shown that WKL_0^+ is conservative over RCA_0 for Π_1^1 sentences [9].

Speed-Up

To compare the efficiency of proofs of theorems of PRA with proofs of these *same* theorems in conservative extensions of PRA, we consider the "speed-up" of proofs in extensions of PRA. Proof theorists measure the complexity of a system of proof by the "speed-up" that one system of proof offers over another. By calling a theory T_2 a "speed-up" of a theory T_1, we mean that all the theorems of T_1, perhaps restricted to those of a given type, have significantly more efficient proofs in T_2, measured in terms of length of proof.

Proof theorists distinguish between two types of speed-ups—*polynomial* and *super-polynomial*—the former being regarded as relatively insignificant, the latter as relatively significant. Suppose T_1, T_2 are two theories such that $T_2 \subset T_1$. We say that T_1 is at most a *polynomial speed-up* of T_2 when for every φ provable in T_2, the length of the shortest proof (measured in terms of total number of symbol occurrences) of φ in T_2 is less than some fixed polynomial multiple of the length of the shortest proof of φ in T_1. This notion can be relativized as follows. Let Φ be a set of formulas provable in T_2. We say that T_1 is at most a polynomial speed-up of T_2 *with respect to* Φ when for every $\varphi \in \Phi$, the length of the shortest proof of φ in T_2 is less than some fixed polynomial multiple of the length of the shortest proof of φ in T_1.[9]

[9]Polynomial speed-up may be more carefully defined as follows [10, pp. 4–5]. Let the *length* $\ell(\pi)$ of a proof π be the number of symbol occurrences in π. For any formula φ, let $\pi_{T_i}^{<}(\varphi)$ be the

Polynomial speed-up is distinguished from a particular type of non-polynomial speed-up called *roughly super-exponential speed-up*. This is speed-up by a function that grows much more rapidly than a polynomial function.[10] T_1 is said to have a *roughly super-exponential speed-up* over T_2 when for every φ provable in T_2, the length of the shortest proof in T_2 of φ is a "roughly super-exponential multiple" of the length of the shortest proof of φ in T_1. This notion can also be relativized as follows. For a set Φ of formulas provable in T_2, T_1 is a super-exponential speed-up of T_2 *with respect to* Φ when the lengths of the shortest T_2-proofs of the various φ_i in Φ are "roughly super-exponential multiples" of the shortest T_1-proofs of those same φ_i.[11]

This distinction between types of speed-ups is important because, as we said earlier, polynomial speed-up is generally regarded as relatively insignificant, while super-exponential speed-up is regarded as relatively significant. The case for the significance of polynomial-time computability as a measure of efficiency seems to have been first made by Edmonds in [19], and was quickly adopted as the standard view in computer science and proof theory [21], [13, Sect.2.2]. Edmonds writes that its significance is clear in practice; he cites the graph-theoretic work of organic

shortest proof (in terms of number of symbol occurrences) of φ in T_i. We say that T_1 is *at most a polynomial speed-up of* T_2 with respect to Φ if there is a polynomial $p(x)$ with natural number coefficients such that for every φ provable in T_2

$$\ell(\pi_{T_2}^<(\varphi)) < p(\ell(\pi_{T_1}^<(\varphi))).$$

[10] This can be defined precisely as follows. Firstly, a function $f(x)$ *eventually dominates* a function $g(x)$ if there is an m such that for all $n > m$, $f(n) \geq g(n)$. Secondly, let 2_m^x be the function defined by: $2_0^n = n, 2_{m+1}^n = 2^{2_m^n}$. For example, $2_1^n = 2^{2_0^n} = 2^n, 2_2^n = 2^{2_1^n} = 2^{2^n}, 2_3^n = 2^{2_2^n} = 2^{2^{2^n}}$, and so on. A function $f(x)$ has *Kalmar elementary growth rate* if there is an m such that 2_m^x eventually dominates $f(x)$. It turns out that 2_x^x is the first function that dominates all Kalmar elementary functions. A function $f(x)$ has *roughly super-exponential growth rate* if and only if (i) it does not have Kalmar elementary growth rate, but (ii) there is a polynomial $p(x)$ with natural number coefficients such that $p(2_x^x)$ eventually dominates it.

[11] Roughly super-exponential speed-up may be more carefully defined as follows [10, pp. 4–5]. T_1 has *roughly super-exponential speed-up over* T_2 if and only if

1. there is no function $f(x)$ with Kalmar elementary growth rate such that for every φ provable in T_2, $\ell(\pi_{T_2}^<(\varphi)) < f(\ell(\pi_{T_1}^<(\varphi)))$; and
2. there is a function $g(x)$ with roughly super-exponential growth rate such that for every φ provable in T_2, $\ell(\pi_{T_2}^<(\varphi)) < g(\ell(\pi_{T_1}^<(\varphi)))$.

For Φ a set of formulas provable in T_2, T_1 has roughly super-exponential speed-up over T_2 *with respect to* Φ if and only if there is a sequence $\{\varphi_i : i \in \omega\}$ of formulas from Φ such that

1. there is no function $f(x)$ with Kalmar elementary growth rate such that for every $\varphi_n \in \Phi$, $\ell(\pi_{T_2}^<(\varphi_n)) < f(\ell(\pi_{T_1}^<(\varphi_n)))$; and
2. there is a function $g(x)$ with roughly super-exponential growth rate such that for every $\varphi_n \in \Phi$, $\ell(\pi_{T_2}^<(\varphi_n)) < g(\ell(\pi_{T_1}^<(\varphi_n)))$.

chemists as a case where polynomial-time complexity is obviously superior to super-polynomial-time complexity (p. 451). Similarly, Parikh writes of "feasible" proofs and proofs of "reasonable length" as being intuitive notions that he identifies with non-super-polynomial complexity, appealing to "common sense" [48, p. 494]. We follow this practice here.

The Evidence

The following is known regarding speed-up with respect to the theories we have considered.

1. $I\Sigma_1$ has a roughly super-exponential speed-up over PRA with respect to the Π_1^0 theorems of PRA. This was shown by Ignjatović [10].
2. RCA_0 has at most a polynomial speed-up over $I\Sigma_1$ with respect to first-order arithmetical formulas. This is folklore, following from the existence of the "canonical interpretation" of RCA_0 into $I\Sigma_1$ that we gave earlier.
3. WKL_0 has at most a polynomial speed-up over RCA_0 with respect to Π_1^1 sentences, and hence for first-order arithmetical formulas. This was shown by Hájek [28] and, by other means, Avigad [6].
4. WKL_0^+ has at most a polynomial speed-up over WKL_0 with respect to Π_1^1 sentences, and hence for first-order arithmetical formulas. This was shown by Avigad [6].

Thus the arithmetic extension $I\Sigma_1$ has significant speed-up over PRA, but the conceptual extensions RCA_0, WKL_0 and WKL_0^+ do not yield further significant speed-up.

It is reasonable to wonder whether, as we move further up this chain of theories from RCA_0 through WKL_0^+ and beyond, we will find another conceptual extension of PRA that yields a significant speed-up. Yokoyama has proved that there is a maximal such conceptual extension of RCA_0 [58], though his proof does not yield the identity of this theory, only its existence[12]; and has conjectured that no such conceptual extension of RCA_0 offers more than polynomial speed-up. By "such" a conceptual extension of RCA_0, and by "this chain of theories", we mean Π_2^1-axiomatizable theories, like WKL_0 and WKL_0^+.[13] By a "maximal" such theory, we

[12]He suggests as a possibility $WKL_0^+ + COH$, where COH asserts the existence of a cohesive set, having shown that $WKL_0^+ + COH$ is a Π_2^1-axiomatizable Π_1^1-conservative extension of RCA_0 (Corollary 2.5).

[13]That WKL_0 and WKL_0^+ are Π_2^1-axiomatizable can be seen by inspecting the logical form of their axioms. That they are *not* Π_1^1-axiomatizable follows, respectively, from Harrington's result that WKL_0 is Π_1^1-conservative over RCA_0 and from Brown and Simpson's result that WKL_0^+ is Π_1^1-conservative over RCA_0. To see why for the case of WKL_0, note that we can write WKL_0 as $RCA_0 + \varphi$. If WKL_0 were Π_1^1-axiomatizable, then there would be a Π_1^1 theory T such that T is equivalent to WKL_0. Since RCA_0 is finitely axiomatizable, $RCA_0 + \varphi$ is equivalent to a single

mean a theory that logically implies any other Π_2^1-axiomatizable Π_1^1-conservative extension of RCA$_0$. At present, all our known methods of producing conservative extensions of RCA$_0$ rely on the Π_2^1-axiomatizability of the extension. Unless new methods of finding conservative extensions of RCA$_0$ were to be located, a positive answer to Yokoyama's conjecture would indicate that no other conceptual extension of PRA should be expected to yield significant gains in efficiency of proof length.

Evaluating the Evidence

What, if anything, do these findings mean concerning the relative advantages of pure and impure proof? The only clear message is that they do *not* provide evidence of a general pattern of improvement in efficiency in moving from pure to impure proof. The move from IΣ_1 to RCA$_0$, for example, is a move in the direction of topical impurity, we have argued. It does not correspond, however, to significant shortenings of proofs.

This is neither to deny nor to ignore IΣ_1's roughly super-exponential speed-up over PRA. Rather, it is to say, firstly, that the impurity of proofs in IΣ_1 of theorems of PRA is a matter of elemental impurity rather than topical impurity; and secondly, that it does not imply a *general pattern* of speed-up in moving from pure to impure proof.

Furthermore, one may reasonably question the relevance of these formal results to the types of gains of simplicity described by MacLaurin, d'Alembert and Painlevé, as discussed in section "Simplicity and Impurity in Mathematical Practice". No one has ever said, "Proving things in PRA is hard, but is made so much easier by working in IΣ_1." But the claims about purity and simplicity from mathematical practice do make claims like this. Thus, whatever kinds of gains in simplicity may be afforded by moving from purity to impurity, the speed-up of proofs in IΣ_1 for theorems of PRA does not seem to shed light on those gains.

Conclusions

Length of proof is a familiar measure of simplicity in proof theory, though one must be sensitive to what exactly this measure *is not* measuring. As has been frequently observed, proof length is a crude and possibly misleading measure of

sentence that, by compactness, is provable in a finite subtheory of T that can be conjoined into a single sentence ψ. Hence RCA$_0$ proves the equivalence of ψ and φ. Since WKL$_0$ proves ψ, it follows by Harrington's conservation result that RCA$_0$ proves ψ, and thus that RCA$_0$ proves φ, contradicting the fact that WKL$_0$ is properly stronger than RCA$_0$. For WKL$_0^+$ the argument is similar, using Brown and Simpson's result instead.

proof complexity. For instance, Potter has pointed out that proof length is highly dependent on choices of means of expression [49, pp. 234–236]. He notes a recent result showing that the term expressing the cardinal number 1 in Bourbaki's 1954 formal system has approximately 10^{12} characters, when fully expanded; and that when in the fourth edition of the same book ordered pairs (a, b) are defined in Kuratowski's way as $\{\{a\}, \{a, b\}\}$, instead of taken as a primitive as in the earlier editions, the term for 1 has approximately 10^{54} characters [42]. Intuitively, the introduction of a single instance of an ordered pair should not make a proof significantly more complex, but this result suggests that it may. As a result Potter councils caution in using proof length as a measure of proof complexity. He recommends using, in addition to length, "elegance and perspicuity" to judge the improvement in complexity of a proof using higher-order methods, noting that these "are of course much less objective than mere length and hence less amenable to formal study."

Avigad remarks, similarly [7, p. 276n18]:

> [L]ength has something to do with explaining how infinitary methods can make a proof simpler and more comprehensible. But the advantages of working in a conservative extension seem to have as much to do with the perspicuity and naturality of the notions involved, and using the number of symbols in an uninterpreted derivation as the sole measure of complexity is unlikely to provide useful insight.

Relevant to this is Caldon and Ignjatović's suggestion that moving up the chain of theories we have been discussing, from PRA through RCA_0 to WKL_0 and WKL_0^+, may result in what he calls "conceptual speed-up". That is, it may produce proofs that are generally clearer and easier to grasp than those of their predecessors. If this were correct (and though it may be plausible, Caldon and Ignjatović provide no reason to think it is), then this hierarchy of theories would be a reasonable basis for a formal investigation of perspicuity in mathematical proof. On the other hand, proofs in these formal systems are not necessarily all that simple. As Simpson has remarked [53, p. 361], proofs in WKL_0, or WKL_0^+ are "sometimes much more complicated than the standard proof."

Avigad also stresses a different but closely related matter. In [7] he notes that a great deal of mathematics can be formalized in the theories $I\Sigma_1$, PRA, RCA_0, etc. that we have been discussing, as well as in yet weaker theories. Avigad notes that Takeuti was able to formalize enough complex analysis in a conservative extension of PA to permit the formalization of the complex-analytic proofs of the prime number theorem of Hadamard and de la Vallée Poussin. Indeed it was later shown that $I\Sigma_1$ suffices for this [55]. Also, Cornaros and Dimitracopoulos were able to formalize Selberg's "elementary" proof in a subtheory of $I\Sigma_1$ [11].

Yet, as Avigad notes, both the classical and the elementary proofs are formalizable in the same weak theory, $I\Sigma_1$. This indicates, he suggests, that whatever difference in complexity there is between the two proofs is not detectable merely by determining how much logical strength is needed to prove it. As he puts it (p. 274), "it is a mistake to confuse mathematical difficulty with logical strength; in other words... there is a difference between saying that a proof is hard, and saying that it requires strong axioms."

We agree with this point, though it runs somewhat orthogonally to our narrative in this paper. Our formal investigation has centered on the gains of general proof efficiency, measured in terms of length, in moving from logically weaker to stronger formal theories of arithmetic. Avigad's point is that the weaker/stronger distinction does not map very well onto the pure/impure distinction as realized in ordinary mathematics. We agree, but our goal in this paper has been to see how far we can get in our investigation of purity and complexity using just the means available in proof theory as it presently exists. Hence, we have considered various set-theoretic extensions of PRA that can be viewed as having added some additional impurity, and tried to say to what extent that additional impurity purchases a gain of simplicity. Our conclusion has been that there is no *general* gain in simplicity purchased by this move, at least for simplicity measured in terms of proof length.

Returning, finally, to the issues raised in section "Simplicity and Impurity in Mathematical Practice", our conclusion concerns only what we have called Thesis 1, that impure proofs are generally simpler to *verify* than pure proofs of the same statement. The results from proof theory discussed here do not bear on Thesis 2, that impure proofs are generally simpler to *discover* than pure proofs of the same statement. Thesis 2 may seem to be more pertinent to understanding mathematical practice than Thesis 1; it is arguably a better expression of the types of gains of simplicity described earlier by MacLaurin, d'Alembert and Painlevé. We agree with this point. Proof theory is a flawed measure of proof complexity, particularly so for analyzing proofs in mathematical practice. However, at the moment it is the best we have, and these results at least give us *some* data for philosophical reflexion. A measure of *inventional simplicity* would be great to have, in order to analyze more fully the simplicity of impurity in practice, but at the moment we do not have such a measure. Thus, the results of this article are but a start, and we hope they may stimulate further work.

Acknowledgements Thanks to Walter Dean, Michael Detlefsen, Sébastien Maronne, Mitsuhiro Okada, Marco Panza, and Sean Walsh for helpful discussions on these subjects.

References

1. Arana, Andrew. "Logical and semantic purity." *Protosociology*, 25 (2008): 36–48. Reprinted in *Philosophy of Mathematics: Set Theory, Measuring Theories, and Nominalism*. Edited by Gerhard Preyer and Georg Peter. Frankfurt: Ontos, 2008.
2. ———. "Purity in arithmetic: Some formal and informal issues." In *Formalism and Beyond. On the Nature of Mathematical Discourse*, edited by Godehard Link, 315–335. Boston: de Gryuter, 2014.
3. ———. "Imagination in mathematics." In *The Routledge Handbook of Philosophy of Imagination*, edited by Amy Kind, chapter 34, pages 463–477. London: Routledge, 2016.
4. ———. "Elementarity and purity." In *Analytic Philosophy and the Foundations of Mathematics*. Edited by Andrew Arana and Carlos Alvarez. Palgrave/Macmillan, Forthcoming.
5. Arana, Andrew, and Paolo Mancosu. "On the relationship between plane and solid geometry." *Review of Symbolic Logic* 5, no. 2 (2012): 294–353.

6. Jeremy Avigad. "Formalizing forcing arguments in subsystems of second-order arithmetic." *Annals of Pure and Applied Logic* 82 (1996): 165–191.

7. ———. "Number theory and elementary arithmetic." *Philosophia Mathematica* 11 (2003): 257–284.

8. ———. "Mathematical method and proof." *Synthese* 153, no. 1 (2006): 105–159.

9. Brown, Douglas K. and Stephen G. Simpson. "The Baire category theorem in weak subsystems of second-order arithmetic." *Journal of Symbolic Logic* 58, no. 2 (1993): 557–578.

10. Caldon, Patrick, and Aleksandar Ignjatovic. "On mathematical instrumentalism." *Journal of Symbolic Logic* 70, no. 3 (2005): 778–794.

11. Cornaros, Charalampos, and Costas Dimitracopoulos. "The prime number theorem and fragments of PA." *Archive for Mathematical Logic* 33, no. 4 (1994): 265–281.

12. d'Alembert, Jean Le Rond. "Application de l'algebre ou de l'analyse à la géométrie." In editors, *Encyclopédie ou Dictionnaire raisonné des sciences, des arts et des métiers*, volume 1. Edited by Denis Diderot and Jean Le Rond d'Alembert. Paris: Briasson, David, Le Breton, and Durand, 1751.

13. Dean, Walter. "Computational Complexity Theory." In *The Stanford Encyclopedia of Philosophy*. Edited by Edward N. Zalta. Fall 2015 edition, 2015.

14. Descartes, René . "La géométrie." In *Discours de la méthode pour bien conduire sa raison et chercher la vérité dans les sciences*, 297–413. Leiden: Jan Maire, 1637.

15. Detlefsen, Michael. "On an alleged refutation of Hilbert's program using Gödel's first incompleteness theorem." *Journal of Philosophical Logic* 19, no. 4 (1990): 343–377.

16. ———. "Philosophy of mathematics in the twentieth century." In *Philosophy of Science, Logic, and Mathematics*, volume 9 of *Routledge History of Philosophy*, 50–123. Edited by Stuart G. Shanker. London: Routledge, 1996.

17. Detlefsen, Michael, and Andrew Arana. "Purity of methods." *Philosophers' Imprint* 11, no. 2 (2011): 1–20.

18. de la Vallée Poussin, Charles. "Recherches analytiques sur la théorie des nombres premiers." *Annales de la Socièté Scientifique de Bruxelles* 20 (1896): 183–256. Reprinted in Collected Works Volume 1. Edited by P. Butzer, J. Mawhin, and P. Vetro, Académie Royale de Belgique and Circolo Matematico di Palermo, 2000.

19. Edmonds, Jack. "Paths, trees, and flowers." *Canadian Journal of Mathematics* 17 (1965): 449–467.

20. Erdős, Paul. "On a new method in elementary number theory which leads to an elementary proof of the prime number theorem." *Proceedings of the National Academy of Sciences, USA* 35 (1949): 374–384.

21. Fortnow, Lance, and Steve Homer. "A short history of computational complexity." *Bulletin of the European Association for Theoretical Computer Science* 80 (2003): 95–133.

22. Ferraro, Giovanni, and Marco Panza. "Lagrange's theory of analytical functions and his ideal of purity of method." *Archive for History of Exact Sciences* 66, no. 2 (2011): 95–197.

23. Friedman, Harvey M. "Systems of second order arithmetic with restricted induction. I." *Journal of Symbolic Logic*, 41, no. 2 (1976): 557–8.

24. Granville, Andrew. "Analytic Number Theory." In *The Princeton Companion to Mathematics*. Edited by Timothy Gowers, June Barrow-Green, and Imre Leader. Princeton: Princeton University Press, 2008.

25. Guicciardini, Niccolò. *Isaac Newton on Mathematical Certainty and Method*. Cambridge, MA: MIT Press, 2009.

26. Hadamard, Jacques. "Sur la distribution des zéros de la fonction $\zeta(s)$ et ses conséquences arithmétiques." *Bulletin de la Société Mathématique de France*. 24 (1896):199–220.

27. ———. *The Psychology of Invention in the Mathematical Field*. Princeton: Princeton University Press,1945.

28. Hájek, Petr. "Interpretability and fragments of arithmetic." In *Arithmetic, proof theory, and computational complexity*. Edited by Peter Clote and Jan Krajícek. 185–196. New York: Oxford University Press, 1993.

29. Hallett, Michael. "Reflections on the purity of method in Hilbert's *Grundlagen der Geometrie.*" In *The Philosophy of Mathematical Practice.* Edited by Paolo Mancosu. 198–255. New York: Oxford University Press, 2008.

30. Hilbert, David. *Grundlagen der Geometrie.* Leipzig: B.G. Teubner, 1899.

31. ———. "On the infinite." In *From Frege to Gödel: A Source Book in Mathematical Logic, 1879–1931.* Edited by Jean van Heijenoort. 367–392. Cambridge, MA: Harvard University Press, 1967.

32. Hölder, Otto. "Über den Casus Irreducibilis bei der Gleichung dritten Grades." *Mathematische Annalen* 38 (1892): 307–312.

33. Hale, Bob, and Crispin Wright. *The Reason's Proper Study: Essays towards a Neo-Fregean Philosophy of Mathematics.* Oxford: Clarendon Press, 2001.

34. Ignjatovic, Aleksandar. "Fragments of First and Second Order Arithmetic and Length of Proofs." PhD diss., University of California, Berkeley, 1990.

35. Jorgensen, Palle. "Source of Jacques Hadamard quote." http://www.cs.uiowa.edu/~jorgen/hadamardquotesource.html, December 2015.

36. Kaye, Richard. *Models of Peano Arithmetic.* New York: Oxford University Press, 1991.

37. Klein, Felix. *Elementary Mathematics from an Advanced Standpoint. Geometry.* New York: Dover, 1953. Translated from the third German edition by E. R. Hedrick and C. A. Noble, New York: Macmillan, 1939.

38. Kreisel, Georg. "Kurt Gödel." *Biographical Memoirs of Fellows of the Royal Society* 26 (1980): 149–224.

39. Lagrange, Joseph-Louis. "Leçons sur mathematiques elementaires." In *Oeuvres de Lagrange,* volume VII. Edited by Joseph-Alfred Serret. Paris: Gauthier-Villars, 1876.

40. MacLaurin, Colin. *A Treatise of Fluxions.* Edinburgh: Ruddimans, 1742.

41. Maronne, Sébastien. "Pascal versus Descartes on geometrical problem solving and the Sluse-Pascal correspondence." *Early Science and Medicine* 15 (2010): 537–565.

42. Mathias, A. R. D. "A term of length 4,523,659,424,929. *Synthese* 133, no. 1–2 (2002): 75–86.

43. McLarty, Colin. "What Does It Take To Prove Fermat's Last Theorem? Grothendieck and the Logic of Number Theory." *The Bulletin of Symbolic Logic* 16, no. 3 (2010): 359–377.

44. Newton, Isaac. *Universal arithmetick.* London: J. Senex, W. Taylor, T. Warner, and J. Osborn, London, 1720. Reprinted in *The mathematical works of Isaac Newton,* Vol. II, edited by Derek T. Whiteside, Johnson, New York: Reprint Corp., 1967.

45. ———. "Geometria curvilinea." In *The Mathematical Papers of Isaac Newton. Vol. IV: 1664–1666,* edited by D.T. Whiteside, 420–484. Cambridge, UK: Cambridge University Press, 1971.

46. Painlevé, Paul. "Analyse des travaux scientifiques." In *Oeuvres de Paul Painlevé,* volume 1. Paris: CNRS, 1972. Originally published by Gauthier-Villars, 1900.

47. Parsons, Charles. "On a number-theoretic choice scheme and its relation to induction." In *Intuitionism and Proof Theory,* edited by A. Kino, John Myhill, and Richard Eugene Vesley, 459–473. Amsterdam: North-Holland, 1970.

48. Parikh, Rohit . "Existence and feasibility in arithmetic." *Journal of Symbolic Logic* 36 (1971): 494–508.

49. Michael Potter, Michael. *Set theory and its philosophy.* Oxford: Oxford University Press, 2004.

50. Pycior, Helena M. *Symbols, impossible numbers, and geometric entanglements.* Cambridge: Cambridge University Press, 1997.

51. Rider Robin E. *A Bibliography of Early Modern Algebra, 1500–1800,* volume VII of *Berkeley Papers in History of Science.* Berkeley: Office for History of Science and Technology, University of California, 1982.

52. Selberg, Atle. "An elementary proof of the prime-number theorem." *Annals of Mathematics* 50 (1949): 305–313.

53. Simpson, Stephen G. "Partial realizations of Hilbert's Program." *The Journal of Symbolic Logic* 53, no. 2 (1988): 349–363.

54. ———. *Subsystems of Second Order Arithmetic.* Perspectives in Mathematical Logic. Berlin: Springer, 1999.

55. Sudac, Olivier. "The prime number theorem is PRA-provable." *Theoretical Computer Science* 257 (2001): 185–239.
56. Tait, William W. "Finitism." *The Journal of Philosophy* 78, no. 9 (1981): 524–546.
57. Wright, Crispin. "Is Hume's Principle Analytic?" *Notre Dame Journal of Formal Logic* 40, no. 1 (1999): 6–30.
58. Yokoyama, Keita. "On Π_1^1 conservativity for Π_2^1 theories in second order arithmetic." In *Proceedings of the 10th Asian logic conference, Kobe, Japan, September 1–6, 2008*, edited by Toshiyasu Arai et. al., 375–386. Hackensack, NJ: World Scientific, 2010.

Henry Flynt
Illusion-Ratios (6/19/61)

An "element" is the facing page (with the figure on it) so long as the apparent, perceived, ratio of the length of the vertical line to that of the horizontal line (the element's "associated ratio") does not change.

A "selection sequence" is a sequence of elements of which the first is the one having the greatest associated ratio, and each of the others has the associated ratio next smaller than that of the preceding one. (To decrease the ratio, come to see the vertical line as shorter, relative to the horizontal line, one might try measuring the lines with a ruler to convince oneself that the vertical one is not longer than the other, and then trying to see the lines as equal in length; constructing similar figures with a variety of real (measured) ratios and practicing judging these ratios; and so forth.) [Observe that the order of elements in a selection sequence may not be the order in which one sees them.]

First published as *Concept Art Version of Mathematics System 3/26/61* in the essay "Concept Art," which appeared in *An Anthology of Chance Operations* edited by La Monte Young, 1963.
Courtesy the artist

Minimalism and Foundations

Spencer Gerhardt

In *The Continuum*, Hermann Weyl notes [16, p. 17]:

> The states of affairs with which mathematics deals are, apart from the very simplest ones, so complicated that it is practically impossible to bring them into full givenness in consciousness, and in this way to grasp them completely.

While a gap between the conceptual world of mathematics and its "givenness in consciousness" is often assumed, from time to time this distance has proven a source of mathematical interest. For instance, Weyl and Brouwer, unsettled by the disparity between the classical line and intuition, sought out mathematical machinery to model the experienced continuum. More generally, Brouwer's intuitionism of the 1910s and 1920s introduced an entire mathematical framework that was both time and subject dependent.

Although not widely adopted, Brouwer's reorientation of mathematics to include an idealized subject and his critique of formalism have intriguing, and in some cases explicit, connections to music and art of the 1960s and '70s. In particular, the time and subject dependent form of Minimalist composition developed by the composer La Monte Young was later reinterpreted in light of such foundational concerns. This paper discusses the origins of Young's distinctive style, and considers its foundational turn in works by two artists of his milieu, Henry Flynt and Catherine C. Hennix. Flynt's Concept Art introduces time and subject dependent proof systems as a critique of formalism in art and mathematics, where Hennix's Minimalist compositions of the 1970s theorize compositional practices in Young's music in terms of Brouwer's construction of intuitionistic sets.

S. Gerhardt (✉)

Department of Mathematics, University of Southern California, Los Angeles, CA, USA

e-mail: sgerhard@usc.edu

© Springer International Publishing AG 2017

R. Kossak, P. Ording (eds.), *Simplicity: Ideals of Practice in Mathematics and the Arts*,

Mathematics, Culture, and the Arts, DOI 10.1007/978-3-319-53385-8_17

I

In the summer of 1958, La Monte Young composed *Trio for Strings* on the Royce Hall organ at UCLA. Notable for its focus on harmony to the exclusion of melodic considerations, the over fifty minute composition is made up entirely of sustained harmonic groupings and silences.

Often regarded as the first piece of Minimalism, *Trio* is also a strict twelve-tone composition.[1] While the twelve-tone technique is perhaps best understood as method of successive variation, the key concept Young draws upon from this process of transformation is *invariance*. Hence the twelve notes in the row are subdivided into four pitch sets, and transformations are selected in the *unique* way so that as few harmonic groupings as possible occur.[2] In addition, each of the four pitch sets are subsets of the same four-note chord: a fifth with a nested fourth, and semitone in between. The logical framework of the composition rests on a single harmonic grouping, later referred to as a "Dream Chord."

Trio achieves a focus on harmonic identity through elegant and "simple" formal means. While Minimalism is sometimes associated with such logical reductions of form, this is not the approach Young himself comes to favor. Hence the external relations of time and "musical space"[3] present in *Trio*, such as mirror symmetries along time axes and reciprocal relations between silences and chord groupings under row transformations, no longer appear in Young's music after this piece, while the same harmonic material is continually refigured. Even in *Trio*, one can sense Young moving towards a more subject-dependent approach to time and form. The lengthy silences, sustained harmonic groupings, and use of invariance all diminish the sense of a global musical space and an external process of transformation.

In 1960, Young moves to New York and begins writing short word pieces, many of which are published together as *Compositions 1960*.[4] In these pieces, the notion

[1] In twelve-tone music, the underlying structural unit is an ordering of the twelve notes in the scale (the "tone row"), which is acted on by a permutation group (the "tone group," generated by inversion, transposition and retrograde).

[2] The row is subdivided into sets $\{C^\sharp, E\flat, D\}, \{B, F^\sharp, F, E\}, \{B\flat, A\flat, A\}, \{G, C\}$. The overall form is $P_0 \rightarrow I_9 \rightarrow RI_9 \rightarrow I_4 \rightarrow RI_4 \rightarrow P_0 \rightarrow Coda$. I_9 and RI_9 are the only row operations that preserve two blocks ($\{C^\sharp, E\flat, D\}$ and $\{B\flat, A\flat, A\}$) from the initial partition, and I_4, RI_4 are the only operations that preserve a single block ($\{B\flat, A\flat, A\}$) common to I_9 and RI_9. This method of dividing the row into pitch sets and looking for invariance under row operations is characteristic of late Webern, though it was never employed in such a logically reductive manner.

[3] Schoenberg, who developed the twelve-tone method in the 1920s, sometimes describes twelve-tone music as an undirected space of relations, untethered from the tonal notion of a root. In *Style and Idea*, he writes "All that happens at any point of this musical space has more than a local effect. It functions not only in its own plane, but also in all other directions and planes, and is not without influence even at remote points... there is no absolute down, no right or left, forward or backward. Every musical configuration, every movement of tones has to be comprehended primarily as a mutual relation of sounds" [15, p. 109].

[4] These are collected in *An Anthology*, a classic document of the early 1960s New York avant-garde edited by Young.

of a composition as a completed form is superseded by questions of existence, performance ritual, and extra-musical activity specified within a performance context. Several pieces suggest potentially incompletable constructions of the most basic elements of music, geometry and arithmetic. For instance, *Composition 1960 #7* notates a perfect fifth to be held "for a long time," and *Arabic Numeral (Any Integer) to H.F.* describes a loud piano cluster to be repeated some given number of times with as little change as possible. Here the notion of invariance under transformation is reoriented explicitly within a given perceptual sphere.

Perhaps most suggestive, *Composition 1960 #10 to Bob Morris* provides the instructions "draw a straight line and follow it." While this could easily be taken as a conceptual exercise, it is reflective of Young's compositional process that the piece is not only performed, but carried out in a highly constructive manner. In the initial 1961 performances at Harvard and Yoko Ono's loft, a sight (in this case, a vertical string tied from the floor to the ceiling) is determined, along with a point in the vicinity of where the line should end. Every few feet a plumb-bob is aligned visually with the sight, with Young providing verbal directions on how to adjust the plumb. Chalk markings are made on the floor, and later all markings are connected with a yardstick.[5] As in the process of tuning, the line is only built up over time through successive perceptual adjustment. While an elementary form is investigated, it is not treated as an external reality referred to by performance, but rather something constructed in time through the subject's perspective.

In 1962, Young encounters just intonation, a system of tuning where musical intervals are understood in terms of whole number ratios.[6] From this point on the audible structure of the harmonic series becomes a central principle of organization in Young's music. The addition of tuning suggests an important refinement in Young's approach: not only are forms of music unfinished, but the *elements themselves* are incomplete. Comparing tuning to the astronomical observation of planets in orbit, Young notes [17, p. 7]:

> Tuning is a function of time. Since tuning an interval establishes the relationship of two frequencies in time, the degree of precision is proportional to the duration of the analysis, i.e. to the duration of tuning. Therefore, it is necessary to sustain the intervals for longer periods if higher standards of precision are to be achieved.

Young goes on to argue that the accuracy of a tuned interval corresponds to the observed number of cycles of its periodic composite waveform.[7] The longer an interval is observed, the more developed it becomes. Intervals are not treated as completed points in "musical space," but rather subject-dependent constructions,

[5]The initial Harvard performance was organized by Henry Flynt, and carried out by Young and Robert Morris. See Curtis [3, p. 89].

[6]For instance, an octave is assigned the frequency ratio 2:1, a fifth 3:2, a fourth 4:3. Less familiar intervals such as 28:27, 49:48, and 64:63, which are normally heard only as overtones of a fundamental, also play an important role in Young's music.

[7]Young draws a number of interesting conclusions from this view, for instance the impossibility of tuning an equal-tempered tritone, whose frequency ratio is $\sqrt{2} : 1$.

developing in time and essentially incompletable. Viewed in this light, the sustained harmonic groupings present in *Trio* could be seen as further elaborations of intervals, rather than suspensions of preexisting forms. This notion of elements and forms developing in time is broadly applicable to Young's compositional process.

Reflecting this idea, the basic harmonic material of *Trio* is continually reexamined in Young's music.[8] In *Four Dreams Of China* (1962), different voicings of the Dream Chord are sustained in the manner of *Composition 1960 #7*. In *The Melodic Version* of *The Second Dream* (1984) (and further elaborations of *The Second Dream*), a Dream Chord and its subsets are again sustained, but are now represented by the ratio 18:17:16:12, and given in a form that is developing in time. At each moment, the performer may choose to hold their current note in the Dream Chord, or pause, or possibly move to another note, with a set of rules determining the available choices at each moment given through the configurations occurring up to present. Like a branching tree, any individual performance is a single path of a much larger compositional framework. As we shall see in the final section, this method of composition, roughly in place by Young's mid-'60s *Theater of Eternal Music* pieces, resembles Brouwer's notion of a choice sequence. In addition, Young's notion of tuning as a function of time bears a likeness to Brouwer's intuitive continuum, where the elements are not completed atomistic points but unfinished *sequences* of observation.

II

In the fall of 1960, Young meets the twenty year old Harvard mathematics student Henry Flynt (the "H.F." in Young's *Arabic Numeral (Any Integer) to H.F.*). Inspired by Young's *Compositions 1960*, Flynt himself begins to write word pieces, which evolve into his Concept Art of 1961.[9] In these and later pieces, Flynt interprets the time and subject dependent constructions present in Young's music in terms of the foundations of mathematics.[10]

[8] In fact, there have been five different versions of *Trio*. The 1958 version, three just intonation versions (1984, 2001, 2005), and most recently (2015) a three hour tuned version based on Young's original sketches for the piece.

[9] Although distinct from Conceptual Art of the later 1960s, it is interesting to note Flynt's connection to the genre. Flynt is part of the artistic circle of Robert Morris and Walter de Maria at this time, and each contribute to *An Anthology* (Flynt's contribution is *Concept Art*). Flynt notes "there was a milieu which may have consisted only of Young, Morris, myself, and one or two others, which was never chronicled in art history" [5, p. 2].

[10] For instance, Flynt's *Each Point On This Line Is A Composition* (1961) appears to be a specifically foundational interpretation of Young's *Composition #9 1960*, in which a line is printed on a notecard.

Proceeding from Carnap's declaration that "In logic, there is no moral. Anyone may construct his logic, i.e., his language form, as he wishes," [2] Flynt proposes new logical systems based on colored pencil "action drawings," electronic music scores, and perceptual states. Proof systems, including axioms and transformation rules, are specified, but the theorems themselves are purely aesthetic and devoid of traditional knowledge claims.

For instance, in *Concept Art Version of Mathematics System 3/26/61* (later titled *Illusion-Ratios*, see illustration on page 227), an "element" of the system is defined to be a fixed perceived length-to-width ratio of the logical symbol ⊥. Flynt calls this perceptual state an "associated ratio." A "selection sequence" is specified as "a sequence of elements of which the first is the one having the greatest associated ratio, and each of the others has the associated ratio next smaller than that of the preceding one" [4, p. 28]. A theorem is a decreasing order of all associated ratios smaller than the initial perceived state.[11] Traditional aesthetic values associated with proofs, such as simplicity, economy of means, or novelty of conclusion, are replaced by the experience of the proof act itself. Indeed, in the logical framework of *Illusion-Ratios* there is a single theorem with a unique proof, assuming it can be constructed.

Like Young's *Arabic Numeral*, *Illusion-Ratios* requires retentions of memory of a purely experiential variety, however one must now reconfigure these perceptual experiences, possibly out of the temporal ordering in which they initially appeared. Instead of suggesting a continued construction of the basic elements of a system through the subject's perspective, Flynt's logical framework further entails recognition of this process of subjectivity. He writes [7, p. 6]

> The culture of tuning which Young transmitted to his acolytes let conscious discernment of an external process define the phenomenon. The next step is to seek the laws of conscious discernment or recognition of the process.

The proof procedure makes formal derivation, sometimes offered as a reliable substitute for intuition, dependent on the subject's discernment of experience.

While logic typically concerns itself with the interactions between formal derivation and models of a theory, with much thought occurring on the level of models, *Illusion-Ratios* is presented purely syntactically, with no independent notion of a model. The subject's attention is focused on the experience of the symbols themselves, apart from any external reference or intending meaning. This subjective process plays an important role in the development of Concept Art as a whole.

In *Derivation* (1987), the logical framework of *Illusion-Ratios* is reformulated in terms of Necker Cubes, two-dimensional line drawings which can be seen as having two distinct orientations.[12] In *Necker-Cube Stroke Numeral* (1987), Hilbert's

[11] Flynt later expresses this system in more familiar logical notation, stipulating "an associated ratio is a sentence," an "axiom is the first sentence one sees," and "sentence A implies sentence B if the associated ratio of B is the next smallest ratio of all sentences you see" [6, p. 24].

[12] Flynt believes this new framework simplifies issues surrounding the continuity of perception in *Illusion-Ratios*, and subsequently the cardinality of its language.

view of the natural numbers as "number-signs, which are numbers and... objects of consideration, but otherwise have no meaning at all"[13] is refigured in terms of a new subjective perceptual counting system, with Necker Cubes taking the place of number-signs. In line with Brouwer's first act of intuitionism, the separation of mathematics from mathematical language, *Stroke Numeral* is taken to criticize Hilbert's association of formal consistency with mathematical existence.

More generally, Flynt aligns his new perceptual logical systems with a criticism of mathematical formalism, given through the works of Young and John Cage (in his parlance, "applying new music to metamathematics" [5, p. 5]). He writes [8, p. 12]:

> What did Hilbert and Carnap do? Implicitly, they cut the content out of mathematics, leaving only a formal shell. Cage anyone?

However, while Hilbert's formalism sought to ensure mathematical existence by abstracting mathematics to a formal language and detecting mathematical patterns in this language, Concept Art ties formal syntax directly to experience, blocking this process of abstraction.

Flynt connects mathematical formalism with "structure art" such as total serialism,[14] or process art, which proceed syntactically but introduce knowledge claims at the level of metalanguage. In contrast to "structure art," Flynt argues that Young's word pieces "concern the metasyntax of music. [Not using the rules that define music, but twisting the rules]" [5, p. 6]. Similarly, Cage's use of chance procedures, and letting the subject's attention define the composition, calls into question the notion of a composition as an external set of relations. In a similar way, Concept Art navigates "unexplored regions of formalist mathematics" [4, p. 28] (or, more poignantly, performs "'a Cage' on Hilbert and Carnap" [8, p. 12]), by relativizing formal systems to the subject's attention, drawing focus upon the mind's presentational powers, apart from any external framework of relations.

III

In 1969, Young meets the 21-year-old composer Catherine C. Hennix. In the same year, he commissions her to realize one of his *Drift Studies*[15] at the EMS studio in Stockholm. Shortly thereafter, Hennix sets out writing computer music for rationally

[13]Translation from Hesseling [14, p. 140].

[14]The then current offshoot of twelve-tone music, where rhythm, duration, timbre, etc. are acted on by the permutation group.

[15]In these pieces, rationally tuned sine tones gradually go in and out of phase. Although Young refers to "tuning as a function of time" as one of his key theoretical constructs, it is interesting to note this philosophy may in part have stemmed from technological limitations of the time. In works such as *Dream House* (1969) Young envisions sustaining tuned intervals for weeks or longer by electronic means. However, the realization of such works proved difficult due to the instability of commercially available oscillators of the time. EMS had recently purchased phase-locked oscillators, which Young was interested in testing.

tuned sine tones. Her method of composition is closely modeled after Young's mid-1960s compositions, but she theorizes her approach in terms of Brouwer's second act of intuitionism, the construction of intuitionistic sets.

The basic tool Brouwer uses for constructing intuitionistic sets are choice sequences. A choice sequence can be understood as a sequence of mathematical objects, each element of which is selected by a creating subject and of which each choice may depend on all previous choices.[16] Some sequences may follow pre-ordained rules (law-like sequences), while others are generated quite freely by the subject (a lawless sequence). For instance, the continuum can be constructed by successively choosing nested closed intervals of the form $\lambda_n = [\frac{a}{2^n}, \frac{a+2}{2^n}]$, $a \in \mathbb{Z}$, $n \in \mathbb{N}$. Here the real numbers are not given as completed atomistic *points*, but as *sequences* developing in time, depending on an idealized mathematician's attention.

One can recognize in Young's compositional style a more immediately given and perceptual version of Brouwer's constructions. Indeed, choice sequences provide an interesting framework for understanding pieces such as *The Melodic Version* of the *Second Dream*, which are generated sequentially in time through the performer's continued attention and memory of previous occurring configurations. Hesseling's description of intuitionistic sets, which "do not collect mathematical objects that may or may not have been created before, but instead gives a common mode of generation for its elements" [14, p. 66], provides a surprisingly apt description of Young's compositional framework from the mid-'60s on. Pieces are no longer notated or fixed in advance, but continually evolve through a given harmonic framework. A composition is not treated as a set of completed external relations, but rather as a mode of generation, always developing in time through the performer's attention. Furthermore, Young's notion of tuning as a function of time could naturally be viewed in terms of Brouwer's construction of the intuitive continuum. Intervals are not treated as relations of completed points in musical space, but rather unfinished sequences of observation, subject to further refinement. Hennix appears to sense such implicit connections.

In 1970, she introduces her concept of algorithmic *Infinitary Compositions*. Like Young's compositions from the mid-'60s, these pieces specify "evolving frames of musical structures, rather than trying to obtain completeness" [11, p. 14]. However, instead of developing through the subject's perspective, Hennix proposes her compositions may be computer generated. As Brouwer's Creating Subject was an idealized mathematician with perfect memory and indefinite attention, Hennix views the computer as an idealized creating performer where "there are no obstacles for proceeding with infinitely long spreads of musical events, locked together by some appropriate algorithm that recursively generates each new step on the basis of

[16]More generally, choice sequences can be understood in terms of spreads. A spread consists of a *spread law* Λ_M, which is a lawlike characteristic function on $\mathbb{N}^{<\mathbb{N}}$, and a *complementary law* Γ_M which assigns a mathematical object to each finite sequence $\langle a_1, a_2, ..a_n \rangle$ such that $\Lambda_M(\langle a_1, \ldots, a_n \rangle) = 1$. See Hesseling [14, p. 65].

the preceding ones" [11, p. 16] (see footnote 16 for a discussion of Brouwer's notion of a spread). Here Young's generative approach is theorized explicitly in terms of intuitionism.

In part due to technological limitations of the time, Hennix's general proposal was never implemented. However, in 1976 one of her initial infinitary compositions,[17] *The N-Times Repeated Constant Event* (also referred to as \Box^N), is realized as part of the installation *Brouwer's Lattice* at Moderna Museet in Stockholm.

Following Young's sine tone compositions of the late-'60s (and referencing *Arabic Numeral (Any Integer) to H.F.*), the constant event is understood to be one complete cycle of a composite waveform of three rationally tuned sine tones. While in *Arabic Numeral* integers are linked to the "repetition as 'thing in time and thing again'" [1, p. 53] through direct experiential means, Hennix follows Brouwer in articulating a more idealized and primordial account of this procedure. Brouwer writes [1, p. 523]:

> mathematics is a languageless activity of the mind having its origin in the basic phenomenon of a move of time... which is the falling apart of a life moment into two distinct things... If the two-ity thus born is divested of all quality, there remains the common substratum of all two-ities, the mental creation of the empty two-ity. This empty two-ity and the two unities of which it is composed, constitute the basic mathematical systems.

From this intuition of time passing, one can generate each natural number, infinitely proceeding sequences of numbers, and even infinitely proceeding sequences of mathematical systems previously acquired.

Similarly, Hennix theorizes the moment the subject comes to intuit the fundamental process of a waveform repeating in time [12, p. 341]

> corresponds to a point in her life-world where a moment of life falls apart with one part retained as an image and stored by memory while the other part is retained as a continuum of new perceptions.

In this way, Brouwer's empty two-ity is linked to the experience of waveforms divested of familiar qualities (sine tones have no harmonics), and Brouwer's primordial intuition of time passing is linked to the notion of tuning.

This analogy is pushed further in *Brouwer's Lattice* taken as a whole. Using Brouwer's language of a spread, Hennix envisions a mapping between "just intonation intervals and intuitionistic mathematical entities, both concurrently constructed by the (intutionisitic) Creating Subject following an intuition of time evolutions" [10, p. 2]. Reflective of Young's interest in tuning through auditory detection of (sometimes remote) partials over a fixed fundamental, Hennix suggests this process as a continued labeling procedure between the set of all harmonics detected in a complicated acoustical event (such as the tambura drone), and the set of all finitely branching binary trees.[18]

[17]Although the title is suggestive of a finite process, Hennix refers to the piece as infinitary. She envisions it to be composed of three infinitely sustained sine tones [9, p. 2].

[18]For instance, a finite sequence like (1,0,0,1,0) would indicate which harmonics were detected · as present or absent, based on some enumeration of all harmonics of the fundamental. Hennix

It is worth noting that while Hennix follows Brouwer in introducing an idealized Creating Subject into her compositional framework, she later puts forward a somewhat subjectivized version of Brouwer's theory. While in her 1976 thinking about the *Infinitary Compositions* the computer is linked to an idealized creating performer in a fairly direct way, in later writings the Creating Subject is theorized much more broadly. For instance, in *Revisiting Brouwer's Lattice 30 Years Later* initial segments of \Box^N are specified as "subjective choice sequences," and "endlessly proceeding compositions corresponding to *subjective mathematical assertions* by the Creative Subject about the length of ordinal numbers" [9, p. 2]. Indeed, Hennix later emphasizes the freedom of the Creating Subject to create non-mathematical entities, and even the rules they choose to operate under [13, p. 389]. In line with Flynt's introduction of the subject into Hilbert's formalism, Hennix extends Brouwer's intutionism to include additional aesthetic considerations.

Although extending the framework of art to include things that were at one time viewed as non-artistic is now common practice, this process is less familiar in mathematics. Indeed, Brouwer's introduction of the subject into the framework of mathematics provides a unique example of this activity. Taken from an aesthetic standpoint, this process fits broadly in line with artistic developments of the twentieth century, from Duchamp extending through Cage and Young. Young's notion of musical intervals developing in time, and his concept of a composition as a mode of generation rather than a completed entity, each resemble more immediately perceptual versions of Brouwer's subject-dependent constructions. While this connection likely reflects a mutual interest in time as the basic compositional material (Young has frequently remarked that "time is my medium"), further connections could also be made. Flynt's subjective proof theory and Hennix's intuitionistic compositions detail such relations, and offer unique examples of mathematical frameworks approached from the perspective of artistic production.

References

1. Brouwer, L. E. J. *Collected Works 1. Philosophy and Foundations of Mathematics.* Edited by A. Heyting. Amsterdam: North-Holland, 1975.
2. Carnap, Rudolph. *The Logical Syntax Of Language.* New York: Routledge, 2010.
3. Curtis, Charles. "The Position of the Observer: Regarding The *Compositions 1960.*" ± *1961: Founding the Expanded Arts.* Madrid, Spain: Museo Nacional Centro de Arte Reina Sofía, 2013.
4. Flynt, Henry. "Concept Art." In *An Anthology of Chance Operations,* edited by La Monte Young. New York: La Monte Young and Jackson Maclow, 1963.
5. ———. "The Crystallization of Concept Art in 1961." Last modified 1994. http://www.henryflynt.org/meta_tech/crystal.html.

has more recently remarked that she associates the intuitive continuum with the spectrum of the tambura, the basic acoustical reference for Young's music since the 1970s.

6. ———. "Mathematics, Tokenetics, and Uncanny Calculi: 1961 Concept Art in Retrospect." Last modified 1996. http://www.henryflynt.org/meta_tech/token.html.

7. ———. "Christer Hennix, The Electric Harpsichord." In *The Electric Harpsichord*, book edited by Christer Hennix to accompany *The Electric Harpsichord*. Christer Hennix. Die Schachtel DSA10. CD. 2010.

8. ———. *2011 Concept Art 50 Years*. Berlin, Germany: Grimmuseum, 2011.

9. Hennix, Catherine Christer. *Revisiting Brouwer's Lattice 30 Years Later*. Unpublished manuscript, 2006.

10. ———. *The Hilbert Space Shruti Box*. Unpublished manuscript, 2007.

11. Hennix, Christer. *Brouwer's Lattice*. Stockholm, Sweden: Moderna Museet, 1976.

12. ———. "The Yellow Book." In *Being = Space × Action*, edited by Charles Stein. Berkeley: North Atlantic Books, 1988.

13. ———. "The Philosophy of Concept Art: An Interview With Henry Flynt." In *Being = Space × Action*, edited by Charles Stein. Berkeley: North Atlantic Books, 1988.

14. Hesseling, Dennis. *Gnomes in the Fog: The Recpetion of Brouwer's Intuitionism in the 1920s*. Basel: Birkhauser, 2003.

15. Schoenberg, Arnold. *Style and Idea*. New York: Philosophical Library, 1950.

16. Weyl, Hermann. *The Continuum: A Critical Examination of the Foundations of Analysis*. Mineola, NY: Dover Books, 1994.

17. Young, La Monte and Marian Zazeela. *Selected Writings*. Munich: Heiner Friedrich, 1969.

Collect 3 beetles from the Tenebrionidae family.

Avoid those from the Scarabaeidae family.

Economy of Thought: A Neglected Principle of Mathematics Education

Alexandre V. Borovik

Introduction

The aim of science is to seek the simplest explanations of complex facts. We are apt to fall into the error of thinking that the facts are simple because simplicity is the goal of our quest. The guiding motto in the life of every natural philosopher should be, "Seek simplicity and distrust it."
—Alfred North Whitehead

I contribute this paper to a volume on the fascinating topic of simplicity in mathematics; my paper is about the role of simplicity and "economy of thought" in mathematics education; it focuses on the early age, elementary level mathematics education. Originally I was planning to extend the narrative at least up to Bourbaki's project (it is worth remembering that the latter started as a pedagogical exercise,[1]) but I soon discovered that elementary school mathematics already provided more material than I could fit in a paper. So I mention Bourbaki only briefly, see the section "Uniform Convergence and Likeness."

This paper is not supposed to be a kind of theoretical musing; indeed many of its passages come from my letters to education professionals and civil servants written in 2011–2014, mostly in the context of discussions around the National Curriculum reform in England. The paper is written for adults, not for children—please do not

[1] Bourbaki's original aim was a compact textbook of functional analysis "where every theorem is proved only once"—and they succeeded in turning a few of their books or chapters from books— say, the celebrated *Topologie générale*—into true masterpieces of pedagogical exposition and simplicity in mathematics. See [14] for more detail.

A.V. Borovik (✉)
School of Mathematics, University of Manchester, Manchester M13 9PL, United Kingdom
e-mail: alexandre@borovik.net

© Springer International Publishing AG 2017
R. Kossak, P. Ording (eds.), *Simplicity: Ideals of Practice in Mathematics and the Arts*,
Mathematics, Culture, and the Arts, DOI 10.1007/978-3-319-53385-8_18

see it as a source of learning materials for primary school, even if most problems are very accessible. The selection principle for problems was the potential depth of didactic analysis that they allowed, not possibility of the immediate use in the class.

An emphasis on old Russian sources is easy to explain: I am frequently asked to comment on the Russian tradition of mathematics education. The latter might appear to be outdated (it suffices to say that the state and the social system where it has flourished no longer exist), but, I believe, it continues to be relevant. After all, as Stanislas Dehaene quipped in his book *The Number Sense* [15], "We have to do mathematics using the brain which evolved 30,000 years ago for survival in the African savanna." For that reason, I believe, a discourse on mathematics education should involve historic retrospection on a timescale longer than a few years or even a few decades.[2]

I focus on examples from arithmetic and from elementary set theory, mostly for lack of space for anything else in a short paper, and I wish to warn those readers who are not very familiar with mathematics: *Arithmetic is not the whole of mathematics, it is only one of its beginnings. Mathematics competence is more than "numeracy" because even competence in arithmetic is much more than "numeracy."* I hope that the present paper proves this thesis. I can claim more: *Restricting mathematics education to teaching "numeracy," "practical mathematics," "mathematics for life," "functional mathematics," and other* ersatz *products is a crime equivalent to feeding children with processed food made of mechanically reconstituted meat, hydrogenated fats, starch, sugar, and salt.*

Following this culinary simile, real simplicity in mathematics education is not fish nuggets made from "seafood paste" of unknown provenance; it is sashimi of wild Alaskan salmon or Wagyu beef. Unlike supermarkets, huge Internet resources provide ingredients for a simple, healthy, tasty, exciting, even exotic gourmet cuisine for mathematics education *for free*. But we have no cooks.

What Can Be Simpler Than 3 − 1 = 2?

What follows is a translation of a fragment from Igor Arnold's (1900–1948) paper [2]. It goes to the heart of the role of simplicity in mathematics education. For research mathematicians, it may be interesting that I. V. Arnold was V. I. Arnold's father.

> Existing attempts to classify arithmetic problems by their themes or by their algebraic structures (we mention relatively successful schemes by Aleksandrov (1887), Voronov (1939) and Polak (1944)) are not sufficient [...] We need to embrace the full scope of the question, without restricting ourselves to the mere algebraic structure of the problem: that is, to characterize those operations which need to be carried out for a solution. The same operations can also be used in completely different concrete situations, and a student

[2]See more about mathematics education in Soviet Russia in my forthcoming paper [10].

may draw a false conclusion as to why these particular operations are used. Let us use as an example several problems which can be solved by the operation $3 - 1 = 2$.

Igor Arnold then gives a list of 20 problems of which we quote only a few.

(a) I was given three apples, and then ate one of them. How many were left?
(b) A barge-pole three meters long stands upright on the bottom of the canal, with one metre protruding above the surface. How deep is the water in the canal?
(c) Tanya said: "I have three more brothers than sisters." How many more boys are there in Tanya's family than girls?
(d) How many cuts do you have to make to saw a log into three pieces?
(e) A train was due to arrive 1h ago. We are told that it is 3h late. When can we expect it to arrive?
(f) A brick and a spade weigh the same as three bricks. What is the weight of the spade?
(g) It takes 1min for a train 1km long to completely pass a telegraph pole by the track side. At the same speed the train passes right through a tunnel in 3min. What is the length of the tunnel?

These 20 completely different arithmetic problems, all solvable by the operation $3 - 1 = 2$, make it abundantly clear that the so called "word problems" of arithmetic involve identification of mathematical structures and relations of the real world and mapping them onto better formalized structures and relations of arithmetic, or, in Igor Arnold's words, "These examples clearly show that teaching arithmetic involves, as a key component, the development of an *ability to negotiate situations whose concrete natures represent very different relations between magnitudes and quantities.*"

And many of the 20 problems are deep—they are concerned with combinatorial properties of sets of objects in the world, with geometry of space and time, and even with what some adults call *simplicial homology*: Problem (d) is a one-dimensional version of the Euler Formula and a seed (well, maybe a spore) of the entire algebraic topology.

Even more important is Igor Arnold's characterization of arithmetic: "The difference between the 'arithmetic' approach to solving problems and the algebraic one is, primarily the need to make a concrete and sensible interpretation of all the values which are used and/or which appear at any stage of the discourse."

I suggest that Igor Arnold's observation deserves to be raised into one of the characteristic aspects of simplicity in mathematics: "An important, and, at the early stages of mathematics education, predominantly important class of "simple" definitions, arguments, or calculations in mathematics is the one where all intermediate structures and values have an immediate interpretation in some lower level and better understood mathematical theory, or in the "real world" of physics, economics, etc."

I suggest calling it the *Arnold's Principle*, intentionally blurring the line between Igor Arnold and Vladimir Arnold; the famously controversial writings by the latter about mathematics education made it obvious that he was much influenced by his

father's ideas [4]. Importantly, Vladimir Arnold republished his father's paper as [3] and endorsed it in his touching foreword.

For the needs of elementary mathematics teaching, Arnold's Principle can be reformulated in shorter form:

> A "simple" mathematical calculation or argument is the one where all intermediate values and statements have a concrete, immediate, and sensible interpretation in the "real world."

Among other, and much more advanced sources of simplicity in mathematics we find *abstraction by irrelevance*: removal of all irrelevant details from a concept or a statement and subsequent re-wording of the essence of the matter in a most general form. The classical examples here are Bourbaki's definition of uniform structure and uniform continuity and Kolmogorov's definition of a random variable as a measurable function. Remarkably, both of these celebrated definitions have elementary facets which allow them to be compliant with Arnold's Principle. I briefly discuss them later in the paper.

Encapsulation and De-Encapsulation

Arnold's Principle fits into the all-important dynamics of encapsulation and de-encapsulation in learning mathematics with precision so remarkable that it deserves some analysis.

The terms "encapsulation" and "de-encapsulation" are not frequently used, and a few words of explanation will be useful; I quote [33]:

> The encapsulation and de-encapsulation of processes in order to perform actions is a common experience in mathematical thinking. For example, one might wish to add two functions f and g to obtain a new function $f + g$. Thinking about doing this requires that the two original functions and the resulting function are conceived as objects. The transformation is imagined by de-encapsulating back to the two underlying processes and coordinating them by thinking about all of the elements x of the domain and all of the individual transformations $f(x)$ and $g(x)$ at one time so as to obtain, by adding, the new process, which consists of transforming each x to $f(x) + g(x)$. This new process is then encapsulated to obtain the new function $f + g$.

Mathematical concepts are shaped and developed in a child's mind in a recurrent process of encapsulation and de-encapsulation, assembly and disassembly of mathematical concepts. It helps if building blocks are simple and easy to handle.

My computer science colleague commented on the quote above that the importance of encapsulation goes beyond mathematics education: it is an important concept in practical computer programming, where it also helps if building blocks are simple.[3]

Anna Sfard [29, 30] uses a similar but subtly different concept of *reification*. I write this paper while wearing two hats, those of a mathematics teacher and

[3]Chris Stephenson, Private communication.

a mathematics researcher. For me as a teacher, encapsulation is the use and re-use of a ready-to-use capsule received from a teacher or learned from a book. For me as a researcher, reification is crystallization, in the mind of a particular problem-solver, and subsequent explicit formulation of a *previously unknown and non-existing* mathematical concept, object, etc.[4] At the level of school mathematics, reification, as I understand it, happens only in solving nonstandard, olympiad-class problems—and almost never in a mathematics class in a mainstream school. Reification suggests a high level of autonomy; it is used in an open-ended high-risk workflow. In this paper, I stick to the terms encapsulation / de-encapsulation.

De-Encapsulation in Action: "Questions" Method

Here is an example of encapsulation and de-encapsulation in action.[5]

In 2011 I was asked by my American colleagues to give my assessment of mathematical material on the Khan Academy website.[6] Among other things I looked for the so-called "word problems" and clicked on a link leading to what was called there an "average word problem" but happened to be a "word problem about averages": Gulnar has an average score of 87 after 6 tests. What does Gulnar need to get on the next test to finish with an average of 78 on all 7 tests?

Solution I. What follows are hints provided, one after another, by the Khan Academy website:

Hint 1: Since the average score of the first 6 tests is 87, the sum of the scores of the first 6 tests is $6 \times 87 = 522$.
Hint 2: If Gulnar gets a score of x on the 7th test, then the average score on all 7 tests will be: $\frac{522+x}{7}$.
Hint 3: This average needs to be equal to 78 so: $\frac{522+x}{7} = 78$.
Hint 4: $x = 24$.

Solution II. how the same problem would be solved by the "steps" or "ques-tions" method as it was taught in Russian schools in 1950–1960s.

Question 1: How many points in total did Gulnar get in 6 tests? Answer: $6 \times 87 = 522$.
Question 2: How many points in total does Gulnar need to get in 7 tests? Answer: $7 \times 78 = 546$.
Question 3: How many points does Gulnar need to get in the 7th test? Answer: $546 - 522 = 24$.

[4]The term "reification" is even used as a description of a specific computational procedure in my hard-core research paper [11].

[5]I re-use some material from my paper (actually, a blog post in the pdf format) [6].

[6]Khan Academy. http://www.khanacademy.org/about. Last Accessed 14 Apr 2011.

Questions 1 and 2 *represent the de-encapsulation of the concept of average.* And this disassembly, de-encapsulation, makes the solution very simple.

Solution III. There is a quicker solution[7] which requires understanding of averages beyond straightforward de-encapsulation:

Question 1: How many "extra"—that is, above the requirement—points did Gulnar get, on average, in 6 tests? Answer: $87 - 78 = 9$.
Question 2: How many "extra" points does Gulnar have? Answer: $9 \times 6 = 54$.
Question 3: How many points does Gulnar need to get in the last test? Answer: $78 - 54 = 24$.

Finding this solution is next to impossible without mastering some higher level thinking—I will return to this issue in the next Section.

Self-Directing Questions

Crucially, the whole point of the "questions" method is that questions are not supposed to be asked by a teacher: students are taught to formulate these questions *themselves.*

Teaching the "questions method" focuses on the development of each student's ability to start his/her "questions" attempt at a word problem asking *himself or herself* appropriate *self-directing questions* (they are called *auxiliary questions* in the Russian pedagogical literature, but in England, the words "an auxiliary question" are loaded with expectation that the question is asked by a teacher to help a struggling pupil).

In the case of Gulnar's problem, these self-directing questions are likely to be something like

Solution II, Question A: "Gulnar has an average score of 87 after 6 tests." *What questions can be asked about these data?*
Solution II, Question B: "Gulnar needs to get an average of 78 on all 7 tests." *What questions can be asked about these data?*
Solution II, Question C: "Gulnar has 522 points. She needs 546 points." *What questions can be asked about these data?*

Therefore the use of the "questions" method in mathematics education involves gently nudging a child towards *reflection* and analysis of his/her own thought process. This should be done, it needs to be emphasized, at a level actually accessible to the child—and this can be done, as it was confirmed by mathematics education practice of dozens of countries around the world. I prefer the term

[7]Suggested by John Baldwin.

"questions method" to the more commonly used, in British education literature, name "steps method" because the word "'questions" emphasizes the pro-active and reflective components of thinking, while the word "steps" might inadvertently imply a passive procedural approach.

And what is even more important, self-directing questions are *meta-questions*, that is, questions aimed at finding the optimal way of reasoning.

From a basic pedagogical point of view, if the didactic aim of the problem is to reinforce the understanding of particular concept (say, averages—as in Gulnar's problem) then the "questions" method appears to be more useful; it gives a student a joint and cohesive vision of the concept.

For a teacher, self-directing questions give a useful tool for assessment of didactic aspects of a problem and its potential solutions. Let us look at possible self-directing questions for Solution III:

Solution III, Question A: "Gulnar has an average score of 87 after 6 tests. She needs 78 points on average" *What questions can be asked about these data?*

We immediately see that, unlike in Solution II, a child has to handle two chunks of information simultaneously, not one. Even more: some of this information—namely, the number of previously taken tests—is unnecessary for the first step:

Solution III, Question A*: "In previous tests, Gulnar had an average score of 87. She needs 78 points on average." *What questions can be asked about these data?*

But initially discarded information re-appears at the second step:

Solution III, Question B: "In each of the 6 tests, Gulnar got, on average, 9 "extra"—that is, above the requirement—points." *What questions can be asked about these data?*
Solution III, Question C: "Gulnar has 54 extra points. She needs an average of 78 and has one more test to take." *What questions can be asked about these data?*

I think a teacher may see that this approach requires from a student confident handling of *"structural arithmetic,"* in terminology of Tony Gardiner [17, Sect. 2.1.1.2]. Indeed, a mental shortcut of Question A is meaningless if a student cannot see an arithmetic equivalent of an algebraic identity

$$\frac{a_1 + a_2 + \cdots + a_n}{n} - b = \frac{(a_1 - b) + (a_2 - b) + \cdots + (a_n - b)}{n}$$

hidden deep in the problem.

Tony Gardiner defines structural arithmetic as "an awareness of the algebraic structure lurking just beneath the surface of so many numerical or symbolical expressions, as in $3 \times 17 + 7 \times 17 = \ldots$ or $[\ldots] 16 \times 13 - 3 \times 34 = \ldots$." He adds: "This habit of looking for, and then exploiting, *algebraic* structure in *numerical* work is what we call *structural arithmetic*."

And I hope that it is obvious to the reader that a self-directing question is an application of Arnold's Principle, a pro-active response to "the need to make a concrete and sensible interpretation of all the values which are used and/or which appear in the discourse" as formulated by Igor Arnold.

Julia Brodsky, one of the leaders of American mathematics homeschooling and mathematical circles movement (see her book [12]), wrote to me:

> Self-directed questions is probably the most important skill the students need to learn—not only in math, but for their future life as well (and as a basis for critical thinking). In my experience, the best way to teach that is to model the self-questioning in front of the students by the teachers, as well as playing the "questions game" for novice students, where the students first ask all types of questions about the problem, and then select the most useful ones. This is a skill that takes time and nurturing, and should be taught to the teachers as one of the basic tools.

In my opinion, as far as didactics of mathematics is concerned, mathematics homeschoolers and mathematics circles volunteers are ahead of the game in comparison with the mainstream mathematics educators—this is a very symptomatic development which I discuss in [8].

Distributed Quantities

It is time to take a closer look both at the differences and at the deep connections between arithmetic and algebra (and other chapters of more advanced mathematics) as emphasized by Igor Arnold: "The difference between the "arithmetic" approach to solving problems and the algebraic one is, primarily the need to make a concrete and sensible interpretation of all the values, relations and operations which are used and/or which appear at any stage of the discourse."

Obviously, not every algebraic problem can be solved by arithmetic means. Still, the power of arithmetic should not be underestimated.

My favorite example is Markov's Inequality: If X is any nonnegative random variable and $a > 0$, then

$$\mathbb{P}(X \geq a) \leq \frac{\mathbb{E}(X)}{a}.$$

It is the first fundamental result of the theory of random variables—and a basis of entire statistics.

In its essence, Markov's Inequality is a primary school level observation about inequalities and can be formulated as an arithmetic "word problem" about anglers and fish.

What I formulate now is a result of a very straightforward didactic transformation of Markov's Inequality: de-encapsulation

- of mathematical expectation (or average—recall Gulnar's problem), and
- of probability in its frequentist interpretation,

followed by substitution of concrete values: If 10 anglers caught on average 4 fish each, then the number of anglers who caught 5 or more fish each is at most 8.

A proof of this statement is simple. Together, anglers caught $10 \times 4 = 40$ fish. Assume that there were *more than* 8 anglers who caught *at least* 5 fish each; then these 8 anglers caught together *more than* $8 \times 5 = 40$ fish—a contradiction.

Unfortunately, we cannot expect that all students entering English universities are able to produce this argument. There are three reasons for that:

- This is a proof.
- Even worse, this is a proof from contradiction.
- The argument requires simultaneous handling of two types of inequalities, "x is *more than* y," denoted $x > y$, and "x is *at least* y," denoted $x \geq y$. (I say more on difficulties caused by relations "x is at least y" and "x is at most y" in Section "Order and equivalence—and abstraction by irrelevance.")

But the statement still belongs to the realm of arithmetic and we can continue its *didactic transformation* ([9]) by replacing "proof" by "solving" and converting the statement into a proper "word problem": If 10 anglers caught on average 4 fish each, what is the maximal possible number of anglers who caught 5 or more fish each?

And here is a solution. Anglers caught $10 \times 4 = 40$ fish. So we have to distribute 40 fish between anglers in a way ensuring that as many anglers as possible get 5 or more fish. To achieve that, we should not give more than 5 fish to an angler—that way more fish are left to other anglers, and more of them get their 5 fish. Hence we give 5 fish to an angler. How many of them will get their share? $40 \div 5 = 8$ anglers.

Fish caught by anglers is a classical example of a *random variable*. In the context of arithmetic, I would prefer to use the words "distributed quantity": it is a quantity attributed to, or distributed among, objects in some class: fish to anglers, test marks to students in the class, and, the last but not least, pigeons to pigeonholes, as in the "Pigeonhole Principle."[8] Crucially, we are not interested in its specific values, but only in how frequently particular values appear and how frequently they exceed (or not) particular thresholds. Notice that, in the solution above, we manipulate fish as a distributed quantity, limiting its dispensation to five fish per angler.

In short, what we have is a toy frequentist version of Kolmogorov's definition of a random variable as a measurable function [20]. As simple as that.

[8]Indeed, I believe that the famous Pigeonhole Principle (it is traditionally formulated in one of the simplest special cases, rather than in a "general" form): "if you put 6 pigeons in 5 holes than at least one hole contains more than one pigeon" should be part of the standard arithmetic curriculum. In the world of adult science, it is one of the most basic concepts of Computer Science and Programming; mathematically, it belongs to Ergodic Theory.

The Arithmetic/Algebra Boundary

> *Everything should be made as simple as possible, but not simpler.*
> —Apocryphal, attributed to Albert Einstein

In previous sections we have explored implications of Arnold's Principle, now we turn our attention to is limitations.

I will be using a beautiful example promoted by Vladimir Arnold.

Vladimir Arnold once said in an interview to [23]:

> The first real mathematical experience I had was when our schoolteacher I.V. Morotzkin gave us the following problem: Two old women set out at sunrise and each walked with a constant speed. One went from *A* to *B*, and the other went from *B* to *A*. They met at noon, and continuing without a stop, they arrived respectively at *B* at 4pm and at *A* at 9pm. At what time was sunrise on that day? I spent a whole day thinking on this oldie, and the solution (based on what are now called scaling arguments, dimensional analysis, or toric variety theory, depending on your taste) came as a revelation.
>
> The feeling of discovery that I had then (1949) was exactly the same as in all the subsequent much more serious problems—be it the discovery of the relation between algebraic geometry of real plane curves and four-dimensional topology (1970), or between singularities of caustics and of wave fronts and simple Lie algebra and Coxeter groups (1972). It is the greed to experience such a wonderful feeling more and more times that was, and still is, my main motivation in mathematics.

This is a very strong statement, and deserves some analysis.

A classical solution makes use of a chapter of arithmetic almost completely forgotten nowadays: theory of proportions. This solution is given below, and it demonstrates a boundary between Arithmetic and Algebra: we see "intermediate values," in terminology of Igor Arnold, which have no obvious real world interpretation.

Assume that the two old women walked from *A* to *B* and from *B* to *A*, respectively, and that they met at point *M*. Then the first lady covered the distance from *A* to *M* in from sunrise to noon and then distance from *M* to *B* in 4h. Since she walked at constant speed,

$$\frac{\text{distance from } A \text{ to } M}{\text{distance from } M \text{ to } B} = \frac{\text{time from sunrise to noon}}{4\text{h}}.$$

Similarly, for the second woman

$$\frac{\text{distance from } M \text{ to } A}{\text{distance from } B \text{ to } M} = \frac{9\text{h}}{\text{time from sunrise to noon}}.$$

Since it does not matter in which direction we measure distance, from *A* to *M* or from *M* to *A*, etc.,

$$\frac{\text{distance from } A \text{ to } M}{\text{distance from } M \text{ to } B} = \frac{\text{distance from } M \text{ to } A}{\text{distance from } B \text{ to } M}$$

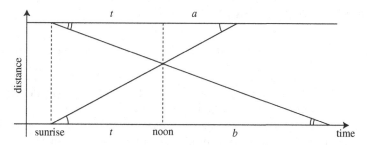

Fig. 1 We have from similarity of triangles $\frac{a}{t} = \frac{t}{b}$ and $t = \sqrt{ab}$

and consequently we get a proportion

$$\frac{\text{time from sunrise to noon}}{4\text{h}} = \frac{9\text{h}}{\text{time from sunrise to noon}}.$$

Solving it, we have: time from sunrise to noon is $\sqrt{4 \times 9} = \sqrt{36} = 6\text{h}$. Therefore the sunrise was 6h before the noon, that it, at $12 - 6 = 6$am hours.

What is remarkable, if we trace the world lines of the two ladies on the time-distance plane, we immediately discover that the proportions have immediate geometric meaning and are related to similarity of triangles, Fig. 1.

As we can see from this solution in its two shapes, arithmetic and geometric, we have an uncomfortable operation of multiplying time by time, and, even worse, extracting square root from the result.

Even worse, the diagram uses angles. I marked equal angles at the diagram due to a kind of a Pavlovian dog reflex, because I was conditioned to behave that way at school and retained the reflex for the rest of my life. But angles have no meaning on the time-distance plane unless we are on the Minkowski plane of special relativity theory with a fixed quadratic form relating time to space. So, if we use angles in the solution, we are in a modernised version of the problem: Two old women flew, on photon spaceships at speeds close to the speed of light, one from galaxy A to galaxy B, and the other from B to A. They set out at ... *whoops!* What does it mean "they set out at the same time" if we are in the relativistic context? There is no absolute time in the world of special relativity.

Luckily, angles can be removed from the geometric solution: instead of similarity of triangles, we can stay within affine geometry and use, in the proof of the proportion

$$\frac{a}{t} = \frac{t}{b},$$

properties of central projection from a line to a parallel line.

Still, this example shows that an attempt to look for an "immediate real world interpretation" of intermediate values in a solution of a relatively elementary problem can open Pandora's box of difficult questions about relations between mathematics, mathematical models of reality, and reality itself.

Uniform Convergence and "Likeness"

> *One day I will find the right words, and they will be simple.*
> —Jack Kerouac

Now I wish to discuss a beautiful application of the both Arnold's Principle and abstraction by irrelevance in "advanced" mathematics

The concept of uniform continuity of a function, after a long and torturous development (see [31]) was transformed, in André Weil's paper [32] into a strikingly abstract definition of *uniform structure* which uses only basic concepts of elementary set theory: sets and binary relations. Uniform structures had been immediately adopted by Bourbaki; the concept became one of the crown jewels of his *Éléments de mathématique*.

A definition of a *uniform structure* (and its developments, uniform space and uniformly continuous function) is remarkably simple and uses only intuitive elementary set theory; it is a classical example of abstraction by irrelevance: all the details and features of uniform continuity are stripped to the bare logical skeleton.

We start by defining a *tolerance* T on a set X as a *reflexive* (that is, for all $x \in X$, xTx holds) and *symmetric* (that is, for all $x, y \in X$, xTy implies yTx) binary relation on X. Tolerance is a mathematical formalization of similarity or resemblance relations between objects of the real world [28].

A *uniformity basis* on X is a non-empty family \mathscr{T} of tolerances on X which is

- closed under taking intersections (or conjunctions, which is an equivalent way of saying): if $T, S \in \mathscr{T}$ then $T \wedge S \in \mathscr{T}$, and
- allows decomposition: for a tolerance $T \in \mathscr{T}$ there exists a tolerance $S \in \mathscr{T}$ such that $S \circ S \subseteq T$.

Notice that the *inclusion* relation \subseteq and operations of *intersection* "\cap" (which is the same as conjunction "\wedge") and *composition* "\circ" of binary relations have very intuitive meaning.

For example, the relation on the set of people

$$xSy \Leftrightarrow s \text{ is a sibling of } y$$

includes the relation

$$xBy \Leftrightarrow s \text{ is a brother of } y$$

and therefore $B \subseteq S$.

Conjunction/intersection is also easy: let

$$xTy \Leftrightarrow \text{Tom thinks that } x \text{ and } y \text{ are alike}$$

and

$$xSy \Leftrightarrow \text{Sarah thinks that } x \text{ and } y \text{ are alike}$$

Fig. 2 Tolerance relation $xTy \Leftrightarrow |x-y| < \frac{1}{2}$ on the segment $X = [0, 1]$. It is reflexive because it contains the diagonal of the square $X \times X$ and symmetric because it is symmetric with respect to the diagonal

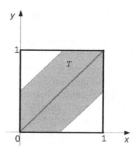

then

$$x(T \wedge S)y \Leftrightarrow \text{Tom and Sarah both think that } x \text{ and } y \text{ are alike.}$$

And here is an example of composition: if $x\,C\,y$ means that a person x is a child of a person y and $x\,G\,z$ means that x is a grandchild of z then $G = C \circ C$. (One more example of composition is given a few lines below.)

A canonical example of a uniformity basis is the one responsible for the uniform continuity of real valued functions on the real segment $[0, 1]$ (Fig. 2):

$$\mathcal{T} = \{T_n \; n = 1, 2, 3, \dots\}, \text{ where}$$

$$T_n = \left\{ (x,y) \in [0, 1] \times [0, 1] : |x - y| < \frac{1}{2^n} \right\}$$

or, if you prefer predicates to sets,

$$xT_ny \Leftrightarrow |x - y| < \frac{1}{2^n}.$$

The operation of composition is especially clear in that example: indeed,

$$T_{n+1} \circ T_{n+1} \subseteq T_n$$

because if

$$|x - y| < \frac{1}{2^{n+1}} \text{ and } |y - z| < \frac{1}{2^{n+1}}$$

then

$$|x - z| = |(x - y) + (y - z)|$$
$$\leq |x - y| + |y - z|$$
$$= \frac{1}{2^{n+1}} + \frac{1}{2^{n+1}} = \frac{1}{2^n}.$$

Fig. 3 "This game creates a chain of association between seemingly unrelated objects. Look at each object in the puzzle and place them in the *circles* so that objects in connected circles share a common trait" [26]. The objects are: tearing eye, star, onion, telescope, and glass ornament

(Actually, a *uniform structure* on X generated by a uniformity basis \mathscr{T} is the *filter* \mathscr{F} on $X \times X$ generated by \mathscr{T}, that is, the set of all binary relations on X which include some tolerance from \mathscr{T}.)

"Similarity," "resemblance," "likeness"—all that stuff formalized in the mathematical concept of tolerance are real life concepts, sophisticated but intuitively understood by young children. It looks as if kids can be really excited by real life problems about choosing, identifying and sorting built around "resemblance" and "likeness"; such problems make an excellent propaedeutic for more abstract mathematics.

I will show to the reader examples taken from a little gem of early mathematics education, the book *Socks are like Pants, Cats are like Dogs* [26]. As the title suggests, most problems are about resemblance. Some of them require construction of a tolerance relation (but the term is of course not used in the book) on a finite set, see Fig. 3.

Problems on sorting, if described in technical terms, are about constructing equivalence classes containing given objects when the equivalence is given as an intersection of several tolerances (perhaps with subsequent taking the transitive closure).

The book says:

> Too often the sorting jobs we give our children are not very challenging. Their young brains are capable of differentiating complex patterns like those of identifying beetle families. Let them flex these sorting muscles!

And children are asked to sort beetles, see the example on page 239. Children are given instruction "Follow the directions on the left side and collect only the beetles that are indicated."

I would not mention these problems in my paper if I had not had a chance to watch how 7 and 8 years old boys were sorting beetles with unbelievable enthusiasm; the youngest was even more impressive, his attention was totally focused on minute details of antennae, mandibles, legs, hairs, segmentation of bodies. Beetle Sort works! Pedagogical advice given in the book is realistic and sound:

> Encourage children to discuss why they think a beetle should be collected. Ask children to explain their reasoning. Accept all answers with explanations as possibilities. Mistakes

should be expected. When working on the book, one of the authors (Dr. Gordon Hamilton) solved two of the puzzles wrong, at least according to the current scientific classification of beetles in the answer keys. Free play on their own terms helps children feel good about math. Toward that goal, children can arrange beautiful beetles in their own ways. On the other hand, tenacity in the face of failure also protects against math anxiety. To build up tenacity, help kids to figure out how the scientific classification works.

I really love the last piece of advice: "If your child is getting frustrated, blame the beetles! It's their fault the puzzle is so difficult!"

Order and Equivalence—And Abstraction by Irrelevance

There is a class of binary relations which is simpler than tolerance and is more intuitive than any other kind of binary relations: *strict order* <. It is characterized by axioms of *transitivity*:

it $x < y$ and $y < z$ than $x < z$

and *anti-symmetricity*:

$x < y$ and $y < x$ cannot be true simultaneously.

Notice that the anti-symmetricity implies the *anti-reflexivity*:

$x < x$ is never true.

A classical "real life" example of a strict order is the relation on the set of people

x is a descendant of y.

A strict order relation is *linear* if

for every distinct x and y either $x < y$ or $y < x$.

The descendence relation is not linear. But the *counting order* (well-known to most children of age 4), that is, the strict ordering of natural numbers

$$1 < 2 < 3 < 4 < \cdots$$

is the mother of all strict orders. The counting order is easy for children; but the (non-strict) order $x \leq y$, that is, "x is less or equal y" might cause serious difficulties, and not only at the primary school level. Every year, I meet a freshman in my class (at a university!) who asks something like "How can we claim that $2 \leq 3$ if we already know that $2 < 3$?"

Various kinship relations are remarkably self-evident to children, and for very deep cognitive and evolutionary reasons—already apes and even monkeys have sophisticated kinship systems.

The remarkable book *Baboon Metaphysics* [13], provides some astonishing evidence—and please notice that the book contains a formal definition of transitivity of a relation:

The number of adult males in a baboon group at any given time ranges widely, from as few as 3 to as many as 12. Regardless of their number, however, the males invariably form a linear, transitive dominance hierarchy based on the outcome of aggressive interaction (a linear, transitive hierarchy is one in which individuals A, B, C and D can be arranged in linear order with no reversal that violate the rule 'if A dominates B and B dominates C, then A dominates C'). Although the male dominance hierarchy is linear, transitive, and unambiguous over short periods of time, rank changes occur often (Kitchen et al. 2003b), and a male's tenure in the alpha position seldom lasts for more than a year. [p. 51]

Human boys in less humane places such as various kinds of borstals, reformatories, and juvenile prisons form a similar strict linear order hierarchy recalculated every day as a result of fights.

The hierarchy of female Baboons is more sophisticated and interesting. As emphasized in the book, it is "Jane Austen's world."

Like males, female baboons form linear, transitive dominance hierarchies. There, however, the similarity ends. Whereas male dominance ranks are acquired through aggressive challenges and change often, female ranks are inherited from their mothers and remain stable for years at time. Furthermore, most female dominance interactions are very subtle. Although threats and fights do occur, they are far less common and violent than fights among males. Instead, most female dominance interactions take the form of supplants: one female simply approaches another and the latter cedes her sitting position, grooming partner, or food. The direction of supplants and aggression—and the resulting female dominance hierarchy—is highly predictable and invariant. The alpha female supplants all others, the second-ranking supplants all but the alpha, and so on down the line to the 24th- or 25th-ranking female, who supplants no one. [p. 65]

Therefore it is not surprising that the concept of linear strict order is so self-evident to humans. But anyone who taught freshmen knows that the concept of *equivalence relation* is incomparably harder. The reason is that the transitivity of dominance is obvious at the level of the monkey bits of our brains. But an equivalence relation is, by definition, a transitive tolerance relation. Therefore

- an equivalence relation is a transitive "likeness";
- a strict order is a transitive "unlikeness."

This makes all the difference. If we understand "equality" in its common sense, as in "all people are equal," not in the sense of "identity" or "sameness," then it appears that the transitivity of equality is a much later, in evolutionary and historic terms, social construct than the transitivity of "dominance" or "superiority."

In a powerful scene in the film *Lincoln*,[9] Abraham Lincoln says to his astonished aids:

Euclid's first common notion is this: Things which are equal to the same thing are equal to each other. That's a rule of mathematical reasoning. It's true because it works. Has done and always will do. In his book, Euclid says this is 'self-evident.' You see, there it is, even in that 2,000-year-old book of mechanical law. It is a self-evident truth that things which are equal to the same thing are equal to each other.

[9]*Lincoln*, http://www.thelincolnmovie.com/. Director: Steven Spielberg; in the title role: Daniel Day-Lewis; screenplay: Tony Kushner.

The scene is a fiction, but a brilliant and very convincing fiction expressed in simplest possible terms accessible to all cinema-goers. It is very true in its spirit to a number of well-documented quotes from Lincoln where he uses references to Euclid as a logical and rhetoric device:

> One would start with confidence that he could convince any sane child that the simpler propositions of Euclid are true; but, nevertheless, he would fail, utterly, with one who should deny the definitions and axioms. The principles of Jefferson are the definitions and axioms of free society. And yet they are denied, and evaded, with no small show of success. One dashingly calls them 'glittering generalities'; another bluntly calls them 'self-evident lies'; and still others insidiously argue that they apply only 'to superior races.'[10]

I write this paper from the position of a remedial teacher at the school/university interface, this is why I am keen to have a *holistic* view of mathematics education at all levels, especially interconnections between various parts of mathematics as they are presented to students starting from pre-school.

Unfortunately too many students reach mathematics courses at the university level with ability for abstract thinking suppressed; even after three years in the university, some of them still cannot make usable mental picture of abstract equivalence relations—you may find more on that in [7]. I wholeheartedly agree with one of the commentators on an earlier version of my paper, Wes Raikowski, who wrote to me "the series of abstractions and generalizations must, in my view, be rooted in one's own sensory experiences of bodily interactions with the physical world." Indeed, abstraction is negation, in Hegelian terms; it can start only when concrete real mathematics (of Igor Arnold's $3 - 1 = 2$ kind) is sufficiently interiorized by a child in all its richness. This explains why efficient abstraction by irrelevance is Arnold's Principle in its dialectically negated form: in his/her first encounters with abstraction, a student has to have a clear understanding of what he or she discards, treats as irrelevant, abstracts away from.

When writing the paper, I was thinking about, and would love to be useful to, a homeschooling parent or a leader of a mathematical circle, someone who was engaged in a direct Socratic dialogue with children. Abstraction by irrelevance can start by a casual remark from a teacher: "ah, it does not matter," especially if this remark is prepared in advance and strategically positioned. For example, write on a board a problem: Mary has some cats and some chicken, and together her pets have 5 heads and 14 legs. How many cats does Mary have? and in the process of collective solving the problem start talking about dogs instead of cats, triggering, with some luck, kids' protests, and then lead children to recognizing that, in this problem, dogs and cats are interchangeable because they have the same number of legs / paws.

One of the first examples of abstraction accessible to very young children is the use of numbers as *classifiers*—dogs, cats, rabbits are quadrupeds, they have four legs / paws. And what about kangaroo?

[10] A. Lincoln, *Collected Works*, 3:375, quoted in [25], who in his turn quoted [18, p. 72].

In Beetle Sort problems of the previous section, the number of legs is constant (six) but the number of body segments varies from one family to another, and acts as a classifier (not always sufficient—two different families of beetles might have the same number of body segments—but still useful).

My university colleagues widely accept that the fundamental theorem: equivalence classes of an equivalence relation E on a set X form a partition of X, is the *Pons Asinorum* of elementary set theory. In my classes, I do some propaedeutics by preceding the introduction of this theorem by explaining, to my students, that an equivalence relation E on a set X can in many cases be usefully thought about in terms of a *classifying function* $f : X \longrightarrow A$ to some simpler set A, with the characteristic property that

$$xEy \iff f(x) = f(y).$$

In practical classification problems, it frequently happens that one number valued function does not suffice, but even one function can make a decent approximation, like a number of petals in a flower in Linnaeus' celebrated classification of plant species.

To summarize this and the previous section: they provide an example of an advanced concept of mathematics—uniformity—reducible, within bounds of Arnold's Principle, to much simpler and much more intuitive concept of elementary set theory—tolerance relations, while the latter are further reducible, again within bounds of Arnold's principle, to simple intuitive real life concepts of likeness and resemblance. But we have also had a chance to see that two concepts closely related to tolerance relations: equivalence and order—behave very differently when we try to find for them simple, convenient, and intuitive "real life" interpretations.

Arnold's Principle and the "Questions Method" in the Historic and Social Context

Igor Arnold's paper of 1946 reflected *Zeitgeist* of Russian culture in the aftermath of WWII: a quest for simple, reproducible, *scalable* solutions to technological—and educational—problems.

Scalability (that is, feasibility of a wide, unlimited dissemination and implementation) is very difficult to achieve without simplicity, and a few words about scalability need to be said.

As a child, I learnt the "questions" method in my primary school in a direct face-to-face communication with a live teacher and with my peers, not from a video recording on the Internet—as Khan Academy's students learn mathematics—and I describe it here as it was widely and routinely used in all primary schools in Russia in the 1960s. A colleague, responding to an earlier version of my notes on the "questions method," indicated that I was lucky to have an "excellent mentor"

who was using "the richness of the Socratic questioning." I loved my teacher—but it needs to be explained that she was a village school teacher in Siberia and was educated (up to the age of 16) in the same village school and then for 2 years (up to the age of 18) in a pedagogical college in the town of Kyakhta—look it up on the GOOGLE map! Even now its location can be best described as being in the middle of nowhere—imagine what it was half a century ago!

If "policymakers" will ever read my paper, this is my message to them: My teacher's skills in arithmetic were a guaranteed and enforced *minimum* compulsory for every teacher.

Arnold's Principle was just one example of didactics generated by an approach to education based on scalable solutions at every level: in general education policy, in curriculum development, in methodology of mathematics education, in direct recommendation to teachers on classroom practice.

But it should not be lost from the view that the mathematics education policy of Russia at that time was concerned not only with achieving a "guaranteed minimum" outcome, but also with educating an engineering and scientific elite.

Only recently I learned how my *alma mater*, FMSh (the Physics and Mathematics Preparatory Boarding School of Novosibirsk University; I describe it in [5][11]), was born. It was one of four specialist mathematics boarding schools (the famous Kolmogorov School in Moscow was one of them) opened in 1963. What was not widely known for decades that the decree of the Council of Ministers of the USSR was signed by an immensely powerful man, Dmitry Ustinov, at that time the First Deputy Prime Minister. Ustinov cared about mathematics—including elite, research level mathematics—this was part of *Zeitgeist*. Actually, the FMSh came into existence before the decree was formally signed—and no-one knew where the funds for its upkeep were coming from. And the last but not least: the school was temporarily housed in a building built for a new military academy for training Red Army's political officers—and the opening of the academy was for that reason postponed. This is what I call policy priorities.

The Economy of Thought

A child of five could understand this. Send someone to fetch a child of five.
—Groucho Marx

Mentioning the FMSh, an academically selective establishment (to the extremes of selectivity—the school had the catchment area with population of 40 million people) allows me to move to discussion of a characteristic trait of many of so-called "mathematically able" children[12]: "economy of thought," a (mostly subconscious) inclination to seek clarity and simplicity in a solution.

[11]It is instructive to compare my paper with an insider's description of Lycée Louis-le-Grand in Paris, [22].

[12]All children have mathematical abilities but not all of them are given a chance to develop them in full.

In relation to arithmetic, Arnold's Principle shows that the "economy of thought" means, first of all, ability to see relations, structures, symmetries of the "real world" and use them to simplify arithmetic reasoning.

Vadim Krutetskii's classical study of psychology of mathematical abilities in children [21] was a serious work based on hundreds of interviews, numerous tests and statistical analysis (Kruteskii even received advice on the use of statistics from Andrei Kolmogorov). The tendency for "economy of thought" is emphasised as one of the most important traits of the so-called "mathematically able" children. This is what he writes about 8 years old Sonya L.

> Sonya is notable for a striving to find the most economical ways to solve problems, a striving for clarity and simplicity in a solution. Although she does not always succeed in finding the most rational solution to a problem, she usually selects the way that leads to the goal most quickly and easily. Therefore many of her solutions are "elegant." What has been said does not apply to calculations (as was stated above, Sonya is unfamiliar with calculation techniques). Consider a few examples.
>
> Problem: "How much does a fish weigh if its tail weighs 4 kg, its head weighs as much as its tail and half its body, and its body weighs as much as its head and tail together?"
>
> Solution: "Its body is equal in weight to its head and tail. But its head is equal in weight to its tail and half its body, and the tail weighs 4 kg. Then the body weighs as much as 2 tails and half the body—that is, 8 kg and half the body. Then 8 kg is another half of the body, and the whole body is 16 kg." (We omit the subsequent course of the solution. The problem is actually already solved.)

This remark: "Sonya is unfamiliar with calculation techniques" is very interesting: Sonya goes directly to what Igor Arnold describes as "concrete and sensible interpretation of all the values which are used and/or which appear in the discourse."

Sonya identifies mathematical structures and relations of the real world and maps them onto better formalised structures and relations of arithmetic, as it is obvious in another episode from Krutetskii's book:

> Problem: "A father and his son are workers, and they walk from home to the plant. The father covers the distance in 40 min, the son in 30 min. In how many minutes will the son overtake the father if the latter leaves home 5 min earlier than the son?"
>
> Usual method of solution [by 12–13 year old children]: In 1 min the father covers $1/40$ of the way, the son $1/30$. The difference in their speed is $1/120$. In 5 min the father covers $1/8$ of the distance. The son will overtake him in $\frac{1}{8} : \frac{1}{120} = 15$ min.
>
> Sonya's solution: "The father left 5 min earlier than the son; therefore he will arrive 5 min later. Then the son will overtake him at exactly halfway, that is, in 15 min."

Sonya sees symmetries of the world—and not only in space, but in time, too (the latter is more impressive)—and links the symmetry of time with symmetry of space. For an adult, this relation is best expressed by the world lines of the father and the son in the time-distance plane, Fig. 4. We will never know what kind of picture (if any) Sonya had in her mind, but she had a feeling of some essential properties of this relation.

In Krutetskii's words:

> To a certain extent she is characterized by a distinct inclination to find a logical and mathematical meaning in many phenomena of life, to be aware of them within the framework of logical and mathematical categories. In other words, her tendency to perceive many phenomena through a prism of logical and mathematical relationships was marked at an early age (7 or 8).

I wish to emphasize these words: "find mathematical meaning in phenomena of life."

Mathematics is simpler than life and for that reason helps to understand "phenomena of life." This is what mathematics education, especially early stages of mathematics education, should be about: teaching students

- to see "phenomena of life" and use at least some basic mathematics vocabulary and technique for their description and analysis,

and, conversely,

- use their understanding of "mathematical meaning in phenomena of life" for simplifying their mathematics.

These skills should not remain just an exotic trait of a small number of children who somehow attained them by absorbtion from their cultural environment and, as a result, are classified as "able" or "gifted."

I firmly believe that every child should be given a chance to see "phenomena of life" through mathematical lenses.

And the last but not the least: the anonymous referee suggested, in her/his most helpful and enlightening comments, to move the mathematical material of this Section to Section "The Arithmetic/Algebra boundary," and, as a consequence, put the world line diagrams of Figs. 1 and 4 next to each other. I have some difficulty with that: the development of elementary mathematics can not be linear because we have *mathematics for pupils* and *mathematics for teachers* which inevitably live in different dimensions. The time-space plane of world lines is too hard for children, but, in my opinion, it should be part of mathematics education of every primary school teacher.

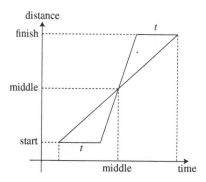

Fig. 4 This is what happens when two bodies move along the same distance from start to finish with constant speeds, but one of them starts t minutes earlier and finishes t minutes later than another: the faster body overtakes the slower one at mid-time and mid-distance. I leave it as an exercise to the reader to check that this follows from a well-known theorem of affine geometry: the two diagonals and the two midlines of a parallelogram intersect at the same point

A Bonus of "Economy of Thought": "Reduced Fatigability"

And this is another quote from Krutetskii:

> The reduced fatiguability in mathematics lessons that characterizes Sonya should also be noted. Not only is she very hard-working and fond of solving problems "on reasoning": she tires comparatively seldom during these lessons (excluding long, involved calculations, which she does in her head). Neither the lessons at home nor those with the experimenter were ever ended on her own initiative. Even prolonged lessons (for her age) did not lead to marked fatigue. For experimental purposes we set up a few lessons with her of an hour and a half, without interruption (a 45-min lesson doubled!). Only at the very end of this period did the little girl of 8 show signs of fatigue (mistakes, slackening of memory). When occupied with other types of work (music, reading, writing), Sonya tires normally.

In Krutetskii's voluminous book, Sonya is not the only subject. In particular, he interviewed a number of school teachers. This is Krutetskii's quote from one of them:

> "The mathematically able are distinguished by a striking ability not to tire even after extended lessons in mathematics. I have constantly noticed this. And for some of them mathematics lessons are relaxing. This is probably related to the fact that a capable pupil spends very little energy on what incapable pupils work to exhaustion doing" (Ya. D., 18 years of service).

Millions of parents could only dream of their children attaining "reduced fatigability" in mathematics work.

I understand that I commit the mortal sin of using introspection as a source of empirical evidence, but, as a research mathematician and teacher of mathematics with 40 years of experience, I suggest that "spending very little energy" is directly related to "economy of thought" and, in its turn, the "economy of thought," at least at earlier stages of learning mathematics, is determined by the right balance of encapsulation and de-encapsulation in mathematical thinking.

These are skills and traits that can be developed in children. They are well-known in pedagogical literature, and they are sometimes called "style."

I quote from *The Aims of Education* by Alfred North Whitehead [34] (of the *Principia Mathematica* [27] fame):

> The most austere of all mental qualities; I mean the sense for style. It is an aesthetic sense, based on admiration for the direct attainment of a foreseen end, simply and without waste. Style in art, style in literature, style in science, style in logic, style in practical execution have fundamentally the same aesthetic qualities, namely, attainment and restraint. The love of a subject in itself and for itself, where it is not the sleepy pleasure of pacing a mental quarter-deck, is the love of style as manifested in that study. [...] Style, in its finest sense, is the last acquirement of the educated mind; it is also the most useful. It pervades the whole being. The administrator with a sense for style hates waste; the engineer with a sense for style economizes his material; the artisan with a sense for style prefers good work. Style is the ultimate morality of mind. [...] Style is the fashioning of power, the restraining of power with style the end is attained without side issues, without raising undesirable inflammations. With style you attain your end and nothing but your end. With style the effect of your activity is calculable, and foresight is the last gift of gods to men. With style your power is increased, for your mind is not distracted with irrelevancies, and you are more likely to attain your object. Now style is the exclusive privilege of the expert. Whoever heard of the style of an amateur painter, of the style of an amateur poet? Style is always the product of specialist study, the peculiar contribution of specialism to culture.

In children, "economy of thought" is still not a skill to work "without waste," but an instinctive striving to think economically and choose among possible approaches to a problem the one which promises the most streamlined and elegant solution.

"Economy of thought" in young children can be compared with style in sport. There were times, say, in swimming, when young boys and girls frequently won over adults—and it was before steroids came into use. Interestingly, this more frequently happened in long distance swimming, where economy of effort was paramount, and not in short distances, where sheer power and force of adults prevailed.

As a boy in Siberia, I did a bit of cross-country skiing—without much success, I have to say, but with great enjoyment. Aged 15, I knew a 12 years old girl from my school who could beat me at any distance. She liked to tease 18 year old male army conscripts on their compulsory 5 km skiing test, by flying past them, effortlessly like a snowflake in the wind. For sweating and short-breath guys, it was the ultimate humiliation. The little girl had style.

But the correct technique, efficient style of swimming or skiing can be taught—if training starts at a right age and done properly. The same can be achieved in mathematics. It is simply a bit more expensive than the standard mass education because it requires investment in proper mathematics and pedagogic education of teachers, smaller classes, etc.—I do not wish to expand on the obvious. More generally, the entire socio-economic environment of Western industrial democracies is becoming increasingly unfavourable, even hostile, to mathematics education—I am writing about that in [8].

Still, "style" in the sense of Whitehead is not something which can be attained at a very young age in a fully developed form. But it is something which (in case of mathematics) can be irreversibly compromised at early stages of education if a student accumulates bad habits and mannerisms.

Acknowledgements I thank my mathematics homeschooler colleagues Maria Droujkova (see her book [24]) and Julia Brodsky—their heroism is a source of inspiration for me, and this paper is written with them as readers in mind. Maria Droujkova's new project, *Avoid Hard Work!*, [16], focuses on simplicity as a guiding principle of mathematics education.

I am grateful to Roman Kossak and Philip Ording, the initiators and editors of this volume, for their patience and persistence.

Ron Aharoni, Natasha Artemeva, John Baldwin, Rick Booth, Julia Brodsky, Ronald Brown, David Corfield, Yagmur Denizhan, Maria Droujkova, Julian Gilbey, Daniel S. Helman, Roman Kossak, Brendan Larvor, Josef Lauri, Azadeh Neman, David Pierce, Wes Raikowski, Peter Ransom, Carlos Santacruz, Seb Schmoller, Anna Sfard, Chris Stephenson, Natasa Strabic, Adam Sulich, Yusuf Ünlü, and the anonymous referee provided most useful feedback and corrections. Tony Gardiner kindly corrected my translation of a fragment from Igor Arnold's paper.

Some parts of the paper were written thanks to my involvement with CMEP, the Cambridge Mathematics Education Project. I thank my CMEP colleagues, and especially Martin Hyland and Tony Gardiner, for many useful discussions—but neither they nor CMEP are responsible for my views expressed here.

This paper was completed when I enjoyed the warm hospitality offered to me in the Nesin Mathematics Village[13] in Şirince, Izmir Province, Turkey; my thanks go to Ali Nesin and to all

[13]http://nesinkoyleri.org/eng/.

volunteers and staff who have made the Village a mathematics research paradise, an oasis of proper mathematics education, and a garden of philosophy and arts [1, 19]. *Simplicity is the cultural dominant of the Village.*

References

1. Alladi, Krishnaswami, and Gabriela A. R. Nesin. "The Nesin Mathematics Village in Turkey." *Notices of American Mathematical Society* 62 (2015): 652–658.
2. Arnold, I. V. "Principles of selection and composition of arithmetic problems." In Russian. *Izvesiya APN RSFSR* 6 (1946): 8–28.
3. ———. *Principles of selection and composition of arithmetic problems.* In Russian. Moscow: MCNMO, 2008.
4. Arnold, V. I. "On teaching mathematics." *Russian Mathematical Surveys* 53, no. 1 (1998): 229–236.
5. Borovik, Alexandre "'Free Maths Schools': some international parallels." *The De Morgan Journal* 2, no. 2 (2012): 23–35.
6. ———. "Relationality of teaching, the Khan Academy, and word problems." *Selected Passages From Correspondence With Friends* 1, no. 6 (2013): 45–50. http://www.borovik.net/selecta/
7. ———. "The strange fate of abstract thinking." *Selected Passages From Correspondence With Friends* 1, no. 3 (2013): 9–12. http://www.borovik.net/selecta/
8. ———. "Calling a spade a spade: Mathematics in the new pattern of division of labour." In *Mathematical Cultures: The London Meetings 2012–14.* Edited by B. Larvor. Switzerland: Birkhäuser, 2016.
9. ———. "Didactic Transformation." *Selected Passages From Correspondence With Friends* 4, no. 1 (2016): 1–8. http://www.borovik.net/selecta/
10. ———. "The Golden Age of Soviet mathematics education: The Ponzi scheme of social mobility." In preparation.
11. Borovik, Alexandre, and Ş Yalçınkaya. "Adjoint representations of black box groups $PSL_2(\mathbb{F}_q)$." Preprint. 2015. http://arxiv.org/abs/1502.06374.
12. Brodsky, Julia. "Bright, Brave, Open minds—encouraging young children in math inquiry." *Natural Math*, 2015.
13. Cheney, Dorothy L., and Robert M. Seyfarth, *Baboon Metaphysics: The Evolution of a Social Mind.* Chicago: University of Chicago Press, 2008.
14. Corry, Leo. "Writing the Ultimate Mathematical Textbook: Nicolas Bourbaki's Éléments de mathématique." *The Oxford Handbook of the History of Mathematics.* Edited by Eleanor Robson and Jacqueline Stedall. New York: Oxford University Press, 2009.
15. Dehaene, Stanislas. *The Number Sense: How the Mind Creates Mathematics*, New York: Oxford University Press, 2000.
16. Droujkova, Maria, James Tanton, and Yelena McManaman. In preparation.
17. Gardiner, Anthony D. "Teaching mathematics at secondary level." *The De Morgan Gazette* 6, no. 1 (2014) 1–215.
18. Havers, Grant N. *Lincoln and the Politics of Christian Love.* Columbia, MO: University of Missouri Press, 2009.
19. Karaali, Gizem. "Nesin Math Village: Mathematics as a Revolutionary Act." *The Mathematical Intelligencer* 36, no. 2 (2014): 45–49.
20. Kolmogoroff, A. N. *Grundbegriffe der Wahrscheinlichkeitsrechnung.* Berlin: Springer, 1933.
21. Krutetskii, V. A. *The Psychology of Mathematical Abilities in Schoolchildren.* Chicago: University of Chicago Press, 1976.
22. Lemme, Monsieur. "Utter elitism: French mathematics and the system of classes prépas." *The De Morgan Journal* 2, no. 2 (2012): 5–22.

23. Lui, S. H. "An Interview with Vladimir Arnold." *Notices of American Mathematical Society* 44, no. 4 (1997): 432–438.
24. McManaman, Yelena, and Maria Droujkova. *Moebius Noodles: Adventurous Math for the Playground Crowd.* Cary, NC: Delta Stream Media, 2013.
25. Morrissey, C. S. "Spielberg's *Lincoln*: Politics as Mathematics." *The Catholic World Report* 19 (2012).
26. Rosenfeld, Malke, and Gordon Hamilton. *Socks Are Like Pants, Cats Are Like Dogs: Games, Puzzles & Activities for Choosing, Identifying & Sorting Math!* Cary, NC: Delta Stream Media, an imprint of Natural Math, 2016.
27. Russell, Bertrand, and Alfred North Whitehead. *Principia Mathematica, Volume I-III,* Cambridge, UK: Cambridge University Press, 1910, 1912, 1913.
28. Schrader, Yu. *Equality, Similarity, Order.* In Russian. Nauka, 1971.
29. Sfard, Anna. "On the dual nature of mathematical conceptions: Reflections on processes and objects a different sides of the same coin." *Educational Studies in Mathematics* 22, no. 1 (1991): 1–36.
30. ———. "Objectifying symbols: The uneasy journey of the mathematical 'signified' from the world, to mind, to discourse." Preprint. 2016.
31. Sinkevich, Galina, I. "History of the concept of uniform continuity and the idea of coverings of a segment." In Russian. *History of Science and Technology* 4 (2016): 3–17.
32. Weil, André. "Sur les espaces à structure uniforme et sur la topologie générale." *Act. Sci. Ind.* 551 (1937): 3–40.
33. Weller, Kirk et al. "Intimations of infinity." *Notices of the American Mathematical Society* 51, no. 7 (2004): 741–750.
34. Whitehead, Alfred North. *The Aims of Education and Other Essays.* New York: Macmillan Company, 1929.

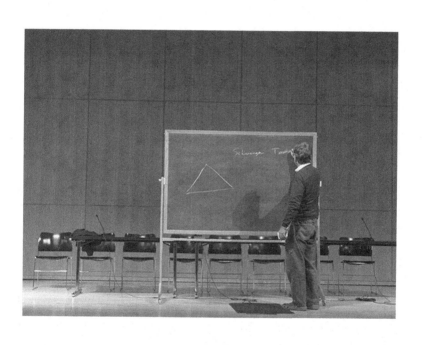

Dennis Sullivan
Photo by María Clara Cortés

Simplicity Is the Point

Dennis Sullivan

Editors' note: This text is an edited transcript of the author's conference talk.

I've been concentrating on mathematics for 52 years now, and I have a lot of opinions about it. I've tried to distill them down to a few things, which I want to share with you. That's the nature of this talk.

I've really liked the idea of simple things in mathematics, and I feel that it's incumbent upon a mathematical subject's participants to try to get it into the simplest form so that it is easy to communicate, easy to teach, easy to understand. Understanding is more important to me than proofs, although the way I come to understand things is often through just a few different proofs or proof forms, which you kind of move around in different settings. So, proof and understanding are intimately tied, but understanding is, for me, the primary goal, and simplicity plays a role in that. If you've found the simple organizing points of some discussion, then it's easy to understand. Now, it could be that you start from those points and develop fairly elaborate discussions from them while staying aware of what's essential.

I was just telling someone here at the conference—this is a digression—one way to find out what the important points are—I determined this when I was young and went to a lot of talks I didn't understand—is first of all you find out who the masters are and who they aren't. Now, since [Misha] Gromov is here, I should say that he is a master, but this doesn't work so well for him. For some masters, like Alain Connes, it works. You listen to them, you don't understand what they are saying, but you wait until they get excited about something. For example, Connes, he's very excited about the fact that L_∞ is a dual space. Some mathematicians here can try to

D. Sullivan (✉)
Department of Mathematics, Graduate Center of the City University of New York,
New York, NY, USA

State University of New York, Stony Brook, NY, USA
e-mail: dsullivan@gc.cuny.edu

© Springer International Publishing AG 2017
R. Kossak, P. Ording (eds.), *Simplicity: Ideals of Practice in Mathematics and the Arts*,
Mathematics, Culture, and the Arts, DOI 10.1007/978-3-319-53385-8_19

figure out why that's important, but it's a very banal fact if you're a graduate student and you might miss it even though it's very important. The reason it doesn't work with Gromov is that he's excited at every moment in time, so you have to listen until he repeats something, then you know that's an important point. So, there are these simple points, and one searches for these simple points when trying to understand a field.

The two stories I'll tell are about finding these points, whether it's before you understand something or after when you say, "Ah, these are the two, three, or four main points that make this thing build up." Often there's another aspect to simplicity—this is banal, everything I'm going to say is rather pretty banal—if something's very simple, it's easy to use. You can tell it to people. They can learn it, and it's easy to use. And you can use it many times. For example—I'm getting used to making jokes about Gromov, I'm sorry, it's only because he's here—I looked at all of his work and I decided he just knows one thing: the triangle inequality. The triangle inequality says that if you have a triangle, the sum of the distances along two sides is at least as big as the distance along the third. A lot of his work is just using that key point *[To Mikhail Gromov in the audience]*. Would you disagree or not? *[Gromov replies, "It's a good point."]* Okay, this inequality is a very simple idea, but because it's simple, you can use it a million times. And Gromov used it like crazy. Anyway, on to the first story.

I'm telling this story because I just finished reading a book about Richard Feynman, but the point I want to make isn't unique to him. So, Feynman along with Julian Schwinger and Sin-Itiro Tomonaga shared the 1965 Nobel Prize in Physics. Let's say it's for Quantum Electro-Dynamics (QED) and understanding what's called "renormalization." This is part of a big story which is still ongoing, and it's not something that's understood. It seems to be related to mathematics however, so let's say that some part of it can be understood as a so-far-not-understood part of mathematics as well as being very important in physics. Here's a two-minute lecture on this entire theory: When you look down into water at an angle and see an object below the surface, you don't see the object where it's actually located. It turns out that the light rays that contribute to your sensory response to this object in the water haven't traveled in a straight line path. Anyone who's ever looked at their own foot in the water knows that. There's this principle, called the action principle, which is the first simple idea. The idea is that physical systems work to minimize some function, some value, of the state of the system. Feynman generalized this idea by considering every path, whether straight or not, that the light might follow and weighted each path with a certain efficiency. If a path is very costly, then light will not use that path very much. Summing over all paths produces the outcomes of any physical experiments, and mathematically, you write this sum as an integral

$$\int e^{\text{Action}}$$

where the action, this thing to be minimized, goes in the exponent.

Fig. 1 "Once Feynman's idea emerged on the scene, the very fancy way of doing things that Schwinger had developed just disappeared." Photo by Wanda Siedlecka

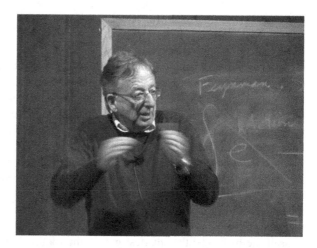

One thing that makes QED so famous is that, in some sense, it's the most successful scientific algorithm there is. It could compute a certain measurable quantity to a large number of decimal places, say ten. That's sort of remarkable to have a theory that could fit with experiment to that many decimal places, so they got the Nobel Prize. Tomonaga in Japan, Schwinger at Harvard, and Feynman at Princeton, CalTech, and Cornell, independently all achieved a certain algorithm for QED. (Freeman Dyson, a mathematician at the Institute for Advanced Study in Princeton, also proved this independently.) And the point of the story is that—well, I don't know what happened in Japan, I mean Tomonaga completed his work around 1941, and then there was the war and I don't know what propagated from then. But, to compare Schwinger's version and Feynman's version, first of all, it's interesting to compare the two scientists as individuals. Schwinger was distinguished, from a well-to-do family, a limousine would take him to his lectures at Harvard. He was the youngest full professor at Harvard of all time. His lectures were beautiful. He had 200 PhD students. His formulas were elegant, complicated, awe-inspiring. Feynman now, Feynman was a smart Jewish kid from Brooklyn who talked like a World War II guy. He figured out how to do integrals in high school, and he liked to do integrals. He found out that if you put a parameter, it's usually called h, in front of the exponent then you could think of the integral as a function of the parameter:

$$\int e^{h\text{Action}}.$$

Now you can play around with this and differentiate it with respect to the parameter and get an equation and you work out integrals with parameters. So, like a high school student, he just kind of did the integral for physics. He actually worked out this integral for examples and found a big infinite series and in terms of this parameter,

$$\int e^{h\text{Action}} = \lambda + \Delta h + O(h^2) + \cdots$$

Anyway, it's very simple to talk about this, I mean you have to have a little math, if you are a freshman in college you can understand this computation in form. But Feynman went further by making a graphical picture of this calculation in terms of so-called "Feynman diagrams" that imagine these terms as particles, photons, and things moving around and interacting. Feynman's idea, even though it involves fairly complicated ingredients, it's basically a simple idea.

Once Feynman's idea emerged on the scene, the very fancy way of doing things that Schwinger had developed just disappeared. Well, the fact that he was at Harvard and had 200 graduate students and gave excellent lectures, that kept it alive for a while. But Feynman, this guy had virtually no graduate students, maybe one or two, because of who he was; his personality was such that he had to do everything himself, he had to be the smartest guy in the room. He wasn't a good co-worker. But then he figured out something simple that would describe this idea and then, everything just switched. Schwinger and Tomonaga's techniques just got erased, I mean you don't hear about them anymore. But Feynman's idea, it has legs, as we say. An idea has legs if it just goes, and this idea just goes and goes.

Not everybody agrees with the principle that the goal of mathematicians is to reduce mathematical subjects to these simple essential points. I agree very much with what Gromov said earlier in the conference, that things may be simple only in appearance. When I look down and I immediately see my white shoes and another person's black shoes, that's super complicated actually. I remember having a big argument with [Shing-Tung] Yau. Many years ago, we were at a dinner, and he was talking about physics. I was saying, "you know, for me, this glass of water is a lot more complicated than a Riemann surface." So he started to argue with that. My reasoning was that I can go all the way back to Hugh Woodin's set theory and start from there, and I can build up the integers, the real numbers, Euclidean space, manifolds, differential structures, conformal structures, and I can define a Riemann surface. But, even deterministically speaking, I still can't say what a glass of water is. What is that water? Molecules moving around; looks like a fluid, while it's supposed to be made of atoms. Is there glass around? We are nowhere near understanding a glass of water. It's not simple, in fact, it's very complicated. The Riemann surface is abstract and it's simple. I can tell you what it is. I can take a smart high school student, and in a year, teach them everything that mathematicians know about the definition of a Riemann surface. That's one point about simplicity that agrees with Gromov's point. Actually, it also agrees with what Dusa [McDuff] said during the discussion this afternoon about definitions and proofs—actually, we want concepts and definitions that define and annunciate the discussion.

My second story is a personal story. It means a lot to me and it illustrates my abstract. I was an undergraduate at Rice University. In the first year we took Math 100, Physics 100, Chemistry 100—the big three. Those were hard courses, and you had to learn how to study, learn how to pass exams, learn the material. Then I went to graduate school. I kept the Rice method, I knew how to work, how to learn

things. For my oral exams, I was reading a book by [John] Milnor, called *Topology from the Differentiable Viewpoint*. I applied my Rice method. I read and understood the whole book. I can tell you everything about this book, because it's all in my head, like a computer program: homotopy, cobordism, transversality, manifolds, mappings between spheres, all this sort of stuff. But the day before the exam, even though I knew the book backwards and forwards, its theorems and proofs, I decided to go back and look at it one more time. I went to the library, and I took the book out. While I was looking at it I saw this picture of a slinky, which I will try to explain.

Take a flat piece of paper, you can wrap it over the surface of a ball, tie it all together at the top, and you get a sphere. Okay? That's clear. You can also do that in 3-space; you can take a volume of space, imagine you are outside of it, and wrap it all up the same way to form the 3-dimensional sphere. And the problem is to study all ways of taking this wrapped up 3-dimensional space and pushing it down around this wrapped up 2-dimensional space. This slinky picture tells you basically all the ways you can do this. If everybody is ready for it, I can sort of prove something now. Imagine a slinky made of some perfectly elastic and strong material, like mithril. It's very long, and I extend it, twirl it around in 3-space into some kind of knot, and then bring its two ends back together. This fills up a part of the 3-dimensional space. Now I want to define a map from the three sphere down onto the two sphere. Here's what I am going to do with the long knotted slinky loop. I cut it in one place and make a little mark on each side. Then I let the slinky collapse on itself the way they do. And since it's mithril, when it comes together, this large knot comes to almost nothing, just a very thin cylinder. Then I push this coil down on to the 2-dimensional sphere, and I make sure the marks line up. Remember, the two marks came from the spot where I pulled the slinky loop apart. Everything inside the slinky tube goes along with it and gets pushed down its edge. Whereas I map all the points in three space outside of the slinky to the one point on the 2-sphere where that surface is tied together.

Fig. 2 "Imagine a slinky made of some perfectly elastic and strong material, like mithril. It's very long, and I extend it, twirl it around in 3 space into some kind of knot, and then bring its two ends back together." Photo by Wanda Siedlecka

Okay, that's a picture. It turns out that all the maps from the 3-sphere to the 2-sphere are essentially like that, except you might have several slinkies. But, from that picture, that one picture, you could operate on my brain and remove the memory of having read that entire book and understood it as a Rice undergraduate, and with just that picture (assuming I know the language of homotopy, manifolds, bordism, etc.), I can write out the whole book. I had this great feeling: that's what it means to understand a piece of mathematics! I see this one picture, and the whole theory evolves from that picture. I studied the whole book up and down, and then I made this redundant step, like supersaturation. Of course, this picture is what the proof says, but they don't say it like this, they go through it logically. But that's the one simple point; if you understand that picture, you can explain it. So that's the way I'd like to see a mathematical discussion, it might look very complicated, but there are central points like these.

References

1. Milnor, John Willard. *Topology from the Differentiable Viewpoint*. Charlottesville, VA: University Press of Virginia, 1965.
2. Schweber, Silvan S. *QED and the Men Who Made It: Dyson, Feynman, Schwinger, and Tomonaga*. Princeton, NJ: Princeton University Press, 1994.

William Wegman
Dog Duet, (still) 1975–1976
Videotape with sound
Duration: 2 minutes, 38 seconds
Courtesy the artist

Appendix A:
Simplicity, in Mathematics and in Art

Allyn Jackson

Editors' note: This article appeared in *Notices of American Mathematical Society* vol. 60, no. 7, August 2013.

Simplicity is as hard to pinpoint in mathematics as it is in art. Certainly both subjects have their great exemplars of the quality. But is there a definition of simplicity? A criterion? A measure? Or a sure path to it? These kinds of questions were in the air at a conference called Simplicity: Ideals of Practice in Mathematics and the Arts, which took place at the Graduate Center of the City University of New York in early April 2013. Instead of trying to definitively answer such questions—surely a doomed prospect anyway—the participants gave in to the sheer joy of discussion in the stimulating atmosphere of each other's company. The conference featured lectures and panel discussions by an eclectic group of twenty-five artists, architects, art historians, mathematicians, and mathematically inclined philosophers, as well as a film program. The audience included academics from nearby institutions and local artists; as the conference offered easy and free online registration, a random smattering of folks wandered in out of curiosity.

Not an Absolute Notion

Simplicity often seems to be a timeless, absolute quality, and for good reason. Peter Sarnak, Institute for Advanced Study and Princeton University, offered Euclid's proof of the infinitude of primes as simplicity par excellence. The stark elegance of this ancient proof is as striking today as it must have been to people encountering

A. Jackson (✉)
Notices of the American Mathematical Society, Providence, RI, USA
e-mail: axj@ams.org

© Springer International Publishing AG 2017
R. Kossak, P. Ording (eds.), *Simplicity: Ideals of Practice in Mathematics and the Arts*,
Mathematics, Culture, and the Arts, DOI 10.1007/978-3-319-53385-8

it through the millennia. Of course, the proof is an exemplar of simplicity, not a definition. Indeed, Curtis Franks, University of Notre Dame, argued against the possibility of ever establishing for all time an absolute notion of simplicity. What we think of as simple emerges from conventions that are deeply embedded in how we live and how we see the world, and they have a long genetic history. "Our thinking occurs within those conventions," he said. "There is not really a way out of them." As conventions evolve, so do notions of simplicity. Franks mentioned Gauss's 1831 paper that established the respectability of complex numbers. The problem Gauss was working on—concerning quadratic and biquadratic residues—had only unsatisfyingly complicated and piecemeal solutions over \mathbb{Z}. Over \mathbb{C}, a far simpler solution emerged. The complex numbers revealed simplicity where previously there had seemed to be none. Mathematics is not engaged in a straightforward march toward absolute simplicity. Rather, by discovering simplicity anew, Franks said, "We will be more awake to the changing landscape of mathematical thought." He noted a parallel in art, where something new—like the work of Andy Warhol or Marcel Duchamp—acts as a sort of "shock treatment" that compels a new perspective. Several conference speakers mentioned the art of Fred Sandback, who used taut lengths of yarn to represent outlines of three-dimensional shapes. In photos, the works look unimpressive; as philosopher Juliet Floyd, Boston University, noted, they are "unphotographable". But walking around and through the constructions, she found them to be "extremely moving objects". Finnish architect Juhani Pallasmaa described how a Sandback construction, merely "a few lines stretched in space", sets off a chain reaction in the viewer's mind, causing the viewer to see figures of specific material shapes, to feel their weight and texture. "The air inside the imaginary figure seems to get denser and to have a slightly different consistency from the air outside," he said. Simple constructions that hold much complexity and meaning: That's just what mathematicians seek in their work. Pallasmaa's erudite lecture contained many striking quotations, including this one of Balthus: "The more anonymous painting is, the more real it is." The same can be said for architecture, Pallasmaa stated. Could a similar statement be made for mathematics? Are there mathematical results that are so natural, so pristine that one cannot perceive the fingerprints of the mathematicians who discovered them? Perhaps one example would be the previously mentioned proof of the infinitude of primes, its attribution to Euclid notwithstanding. Perhaps others are found in what Paul Erdős famously called "proofs from the Book". Pallasmaa also quoted the philosopher Gaston Bachelard, who in his book *The Philosophy of No: A Philosophy of the New Scientific Mind*, stated that scientific thought "develops along a predestined path, from animism through realism, rationalism, and complex rationalism, to dialectical rationalism." Pallasmaa did not say that mathematics develops in this way; his point rather was that art aspires to develop in the opposite direction, from the rational back towards "a unifying, mythical, and animistic experience". Perhaps mathematics shuttles back and forth between the two endpoints.

Visceral Encounters

Bachelard's "predestined path" at times echoed through the conference in comments that seemed to derive from the misconception, common outside of mathematics, that the subject consists entirely of proofs, progressing inexorably from one logical step to the next. This misconception was vividly countered at various points during the conference. In an open microphone session, Blaise Heltai pointed out that mathematics and art are actually very similar in process: When you are thinking about a mathematical object, you are right inside the thing, trying to puzzle out its structure and secrets. You're not thinking about how to prove anything—that comes later. The puzzling-out resembles the conceptual part of doing art. Heltai has a special perspective, as he is a painter with a Ph.D. in mathematics; he makes a living as a management consultant. The kind of visceral encounter with mathematics that Heltai referred to emerged at various times, such as in the lecture of Dennis Sullivan, CUNY Graduate Center and Stony Brook University. When as a graduate student he was preparing for the preliminary examination, Sullivan studied John Milnor's book *Topology from the Differential Viewpoint*. Sullivan knew the book inside and out, every definition, every proof. The day before the exam, as he took a final glance through the book, it suddenly occurred to him that he could compress the contents into a single, simple picture. Moving back and forth across the stage, he used gesticulations to indicate a 2-sphere on one side, a 3-sphere on the other, and a "slinky" curve between them. This curve, representing the preimage of a regular value of a map from the 3-sphere to the 2-sphere, provided a mental image summarizing the Pontryagin-Thom construction. If one knows the language of manifolds and transversality, Sullivan claimed, one can reconstruct the whole theory of cobordism in differential topology just from the intuition conveyed by his slinky picture. This experience made him realize, "*That's* what it means to understand a piece of mathematics." The visceral component of mathematical work surely evokes strong feelings, but mathematicians usually do not discuss their feelings about their work, at least not in public lectures. In an earlier panel discussion, Riikka Stewen, Finnish Academy of Fine Arts, asked whether mathematicians have strong love/hate feelings about their work. "Yes, very strong feelings," came the immediate reply from a mathematician on the panel, Andrés Villaveces, National University of Colombia. There is a loneliness in the work of an artist, and much mathematical work shares this quality. Just as a painter faces an empty canvas, he said, "Mathematicians are up against the empty page every day." The longing, even desperation, that is implicit in the remarks of Villaveces also emerged in Sarnak's lecture, titled "Is there a place for 'ugly' mathematics?". Sarnak considered the situation where the only known route to a proof is ugly, in the sense of being strewn with long and complicated calculations and verifications. The question then becomes, How desperate are we for a proof? When Sarnak gave an example of an ugly calculation connected with a beautiful result in the theory of automorphic forms, Mikhail Gromov, Institut des Hautes Études Scientifiques and New York University, piped up to say: "Maybe the mathematics is fine, it's your mind that's

ugly." Then there was Gromov's lecture. A fish says: "You want to understand what water is? Jump in and find out." Instead of plunging in, you could study the chemical and physical properties of water. But without the experience of plunging into water, you have no frame in which to talk about what water really is. Similarly, when the experience of plunging into mathematics is absent, there is no frame in which to talk about what mathematics is—much less what simplicity in mathematics is. That's a verbose description of one moment that flashed by in an instant in Gromov's stream-of-consciousness lecture. He jumped into Descartes's timeless statement, "Cogito ergo sum [I think therefore I am]". The important thing here, Gromov said, is the *ergo*, the *therefore*. In a sense, dogs think: Much of what goes on in a human brain is very similar to what goes on in the brain of a dog. Surely dogs are. But dogs do not understand *ergo*. This *ergo* is a major source of the kind of thinking that is characteristic of humans, Gromov said. And yet, "it is completely hidden from us. And there is a good reason why it is hidden. If it surfaces, you die. You will not survive. It's against survival, it's against evolution, it's against [natural] selection." So it went. Gromov passed so quickly over so many topics, diving to the depths, all the while leavening the presentation with flashes of subversive humor. The effect was dizzying. Afterward, during the open microphone session, an audience member demanded a one-sentence summary—with an example. An impossible request to fulfill. Nevertheless it can be said that one of Gromov's main messages was: Guard against the delusion of false simplicity. Many things that we assume at first glance to be simple are in fact highly complex. After seeing Gromov's effervescent mind bubble over for 30 min, audience member Al Thaler, known to many for his long service at the National Science Foundation and now an adjunct faculty member at CUNY's Hunter College, commented, "I could never live like that."

Contrasting Groups

The Simplicity conference was the brainchild of mathematician Juliette Kennedy, University of Helsinki, and two CUNY mathematicians, Roman Kossak of the Graduate Center and Philip Ording of Medgar Evers College. The conference was something of a follow-up to a 2007 symposium called Aesthetics and Mathematics, which took place in Utrecht and was organized by Kennedy and two University of Utrecht mathematicians, Rosalie Iemhoff and Albert Visser (Iemhoff was one of the lecturers at Simplicity). Participants in the 2007 symposium could drop in at an art exhibition at the Mondriaanhuis, Logic Unfettered—European and American Abstraction Now, which was curated by Kennedy. In addition to the film program at the Simplicity conference, there was an installation of a few works by artist Kate Shepherd in the lobby outside the hall where the lectures were given (Shepherd also participated in one of the panel discussions). But space constraints there, as well as the difficulty of securing exhibit space in New York City, meant that Simplicity offered few opportunities to experience art. As a result, art was represented mainly through the presence and words of the artists themselves.

By contrast, the mathematicians could actually present pieces of mathematics by using a computer and a beamer, or even just a blackboard, in the case of Sullivan. They tried mightily to avoid technical details, with imperfect success. Another contrast was socio-economic. As Kennedy pointed out in a panel discussion, the mathematicians and philosophers at the conference all work in academia, which provides economic security and social acceptability, while artists often lead far more precarious lives on the fringes of society. She noted the "heroic" efforts that many artists must put forth in order to carry out their work. What did each group absorb from the other? It's difficult to say. One participant observed that mathematicians tend to have a high opinion of themselves and their own knowledge and are therefore not so open to new ideas, while artists are pretty much the opposite: Receptiveness to impressions and influences from a wide variety of sources is the artist's lifeblood. One artist who attended Simplicity, Miyuki Tsushima, said she didn't follow all the details of the math lectures. She could simply sit and let the impressions wash over her as she made some sketches for her latest work. An inspiration for the conference was the so-called twenty-fourth problem of David Hilbert. This problem, which Hilbert considered adding to his famous list of twenty-three problems that he presented at the International Congress of Mathematicians in Paris in 1900, was unearthed by Rüdiger Thiele, University of Leipzig, from papers at the library of the University of Göttingen. Part of Hilbert's description of the problem reads: "Criteria of simplicity, or proof of the greatest simplicity of certain proofs. Develop a theory of the method of proof in mathematics in general. Under a given set of conditions there can be but one simplest proof" (translation by Thiele from his article "Hilbert's 24th Problem", American Mathematical Monthly, January 2003). Étienne Ghys, École Normale Supérieure de Lyon, pointed out the naiveté of imagining that such ultimate simplicity is possible. Yet, as the conference highlighted, simplicity as a dream, as an ideal, remains a powerful guiding light in mathematics and the arts. As Franks said, there are no absolute notions of simplicity. But do not relinquish the quest. "On the contrary, I want to say yes, find criteria for simplicity, continue to do so," said Franks. Don't imagine that the matter will ever be settled definitively; rather, "return to the task often."

Simplicity: *Ideals of Practice*
in Mathematics & the Arts

A Conference at the Graduate Center
City University of New York
April 3–5, 2013
Proshansky Auditorium
365 Fifth Avenue
New York, NY

This multidisciplinary conference aims to uncover criteria of simplicity in mathematics that are informed by perspectives from art and architecture, the philosophy and history of mathematics, and current mathematical practice. Each day of this conference will feature talks, roundtable discussions and film screenings.

Invited participants: Andrew Arana, *Philosophy, University of Illinois at Urbana-Champaign*, Rachael DeLue, *Art & Archaeology, Princeton University*, Juliet Floyd, *Philosophy, Boston University*, Curtis Franks, *Philosophy, University of Notre Dame*, Etienne Ghys, *Mathematics, Ecole Normale Supérieure, Lyon*, Mikhael Gromov, *Mathematics, IHES, Paris and New York University*, Rosalie Iemhoff, *Philosophy, Utrecht University*, Hanna Johansson, *Philosophy, History, Culture & Art Studies, University of Helsinki*, Maryanthe Malliaris, *Mathematics, University of Chicago*, Dusa McDuff, *Mathematics, Barnard College, Columbia University*, Juhani Pallasmaa, *Juhani Pallasmaa Architects, Helsinki*, David Reinfurt, *designer, New York*, Marja Sakari, *Kiasma Museum of Contemporary Art, Helsinki*, Amy Sandback, *art historian, New York*, Peter Sarnak, *Mathematics, Institute for Advanced Study and Princeton University*, Kate Shepherd, *artist, New York*, Riikka Stewen, *Finnish Academy of Fine Arts, Helsinki*, Dennis Sullivan, *Mathematics, Graduate Center, CUNY and SUNY at Stony Brook*, Andrés Villaveces, *Mathematics, National University of Colombia, Bogotá*, Dan Walsh, *artist, New York*, Stephen Wolfram, *Wolfram Research, Champaign, IL*, Hugh Woodin, *Mathematics, University of California, Berkeley*, Andrea Worm, *Art History, University of Augsburg*, Norma Claudia Yunez Naude, *Cognitive Neuroscience Laboratory, Aix-Marseille University*, Jan Zwicky, *Philosophy, University of Victoria*.

Film program: Andy Goldsworthy, David Hammons, Richard Serra, Andy Warhol and William Wegman

Organizers: Juliette Kennedy, *Mathematics, University of Helsinki*, Roman Kossak, *Mathematics, Graduate Center and Bronx Community College, CUNY* and Philip Ording, *Mathematics, Medgar Evers College, CUNY*

Conference admission is free and open to the public, but registration is required. For more information and to register, please visit

http://www.s-i-m-p-l-i-c-i-t-y.org/

Sponsors: Clay Mathematics Institute, Finnish Cultural Foundation; FRAME Foundation, The Graduate Center, CUNY (Advanced Research Collaborative, Committee for Interdisciplinary Science Studies, Comparative Literature Program and Mathematics Program) and the National Science Foundation

David Reinfurt
Conference poster, 2013
Courtesy the artist

Appendix B: Conference Program

The conference "Simplicity: Ideals of Practice in Mathematics & the Arts" took place in the Proshansky Auditorium of the Graduate Center of the City University of New York over three days, April 3–5, 2013. This appendix documents the schedule of talks, abstracts, panels, arts programs, and acknowledgements. The names of the panelists are followed by some questions raised for discussion. Please note that participant affiliations and biographical information has not been updated. Additional materials, including video footage, are available on the conference website: http://s-i-m-p-l-i-c-i-t-y.org/

Wednesday, April 3

MORNING SESSION

Étienne Ghys, École Normale Supérieure, Lyon.
Inner simplicity vs. outer simplicity.

I have always been struck by the fact that some mathematical ideas or theorems are crystal clear for me and very difficult to explain to others. Understanding and explaining are different concepts, especially in maths. As a result, one can distinguish two notions of simplicity. I will discuss some examples...

Rachael DeLue, Princeton University.
Simplicity, Doubt, and Desire in the Visual Arts.

This talk considers different forms of abstraction in the visual arts in order to develop an account of simplicity as an aesthetic criterion that both aligns with and unsettles conventional definitions of that term across disciplines, including mathematics. Indeed, by considering simplicity in art, where it operates on a visual register, alongside simplicity within mathematics, where the visual may be less important, the stakes of simplicity in both arenas emerge transformed. In art, for instance, simplicity or economy of means turns out to be at times blinding

© Springer International Publishing AG 2017

R. Kossak, P. Ording (eds.), *Simplicity: Ideals of Practice in Mathematics and the Arts*,
Mathematics, Culture, and the Arts, DOI 10.1007/978-3-319-53385-8

rather than enlightening, obfuscating rather than truth-giving, thus purposefully articulating failure rather than insight or knowledge gained. And in both art and mathematics, desire constitutes a driving force.

David Reinfurt, O-R-G design studio.
Mathematical Typography.

"I will be speaking today about work in progress, instead of completed research; this was not my original intention when I chose the subject of this lecture, but the fact is I couldn't get my computer programs working in time. Fortunately it is just as well that I don't have a finished product to describe to you today, because research in mathematics is generally much more interesting while you're doing it than after it's all done." When invited to give the Josiah Willard Gibbs lecture to the American Mathematical Society (AMS) in 1978, Stanford computer science professor Donald Knuth chose to speak not directly about mathematics, but instead about the shapes of letters. In "Mathematical Typography," Knuth discussed the typographic evolution of the AMS Journal and his own attempts to realize a computer automated typesetting system. Ten years later his programming efforts yielded the discipline-standard TeX and its helper program, MetaFont. This talk will begin where the previous ends.

Stephen Wolfram, Wolfram Research.
Perspectives on Mathematics and Aesthetics from the Computational Universe.

Fig. 1 Panel 1. From *left*: Philip Ording, Amy Baker Sandback, Rachael DeLue, and Étienne Ghys. Photo by Alejandro Martín Maldonado

PANEL

Amy Baker Sandback, international curator and writer, a director of Artforum magazine, the International Print Center of New York, and the McDowell Colony.

Rachael Z. DeLue, author of *George Inness and the Science of Landscape*, faculty member of Princeton's American Studies Program, Reviews Editor for *The Art Bulletin*.

Étienne Ghys, French mathematician of geometry and dynamical systems, member of the French Académie des Sciences, co-author of computer graphics mathematical movies *Dimension* and *Chaos*.

Philip Ording (moderator), co-organizer of the conference.

- The conference prospectus asserts that "simplicity and economy of means are powerful impulses in the creation of artworks." Have we got that right? What examples come to mind, current or historical?
- Do mathematicians agree that simplicity has come to represent such an important ideal in mathematical practice? How did this come about?
- Do mathematicians take more confidence from results that are simply stated? What, if any, is the relationship between simplicity and truth? Is simplicity truth-conducive? Or merely conducive of the truths we can apprehend?
- Do curators or artists speak in terms of truth? One hears the word "honesty," but "truth?"
- Mathematicians are ever aware of the truth value of a proposition. But outside of peer review reports, there is little in the way of public critical discourse. Unlike the arts, math does not seem to have a critical press. Where is the public critique of the exposition, quality, or style of mathematical work? Are mathematicians too polite? Where is the "art" of mathematics to be found?
- Where do artistic and mathematical practices intersect? What words, images, mental images, or questions could artists and mathematicians share? Be they in the past, present, future? Have we gotten past M.C. Escher?

FILM PROGRAM 1

William Wegman
Drinking Milk, 1974–1975
Videotape transferred to DVD, with sound
Duration: 1 minute, 55 seconds
Courtesy the artist

David Hammons
Phat Free, 1995–1999
Videotape transferred to DVD, with sound
Duration: 5 minutes, 2 seconds
Courtesy David Zwirner, New York/London

Richard Serra
Color Aid, 1970–1971
16 mm color film transferred to DVD, with sound
Duration: 36 minutes
Courtesy the Circulating Film Library of the Museum of Modern Art, New York

AFTERNOON SESSION

Andrea Worm, University of Augsburg.
Constructing the Timeline: Simplicity and Order as Guiding Principles for the Visualisation of History.

The timeline is a visual concept of fundamental relevance to the western apprehension of the world and also a key concept in mathematics. In graphs, time is usually represented as an axis, running from left to right, subdivided into regular intervals. However, the timeline is so deeply embedded within western culture that its genesis and history are seldom reflected. In essence, the timeline is a conceptualization that originated in Western Europe during the Middle Ages and is the result of a very specific mind-set. This paper will focus on the early history of the timeline, and present some ideas on how a sense of order and simplicity was of fundamental importance for how the enormous and confusing amount of historical data was put into a visually persuasive structure.

Dusa McDuff, Barnard College, Columbia University.
Thinking in Four Dimensions.

I will try to explain some simplifying ideas that make it possible for me to think about four dimensional space.

Thursday, April 4

MORNING SESSION

Juliet Floyd, Boston University.
Aesthetics, Mathematics, and Philosophy: Is there an Intersection?

I shall explore some of the difficulties surrounding talk of aesthetics (or taste) in mathematics. The focus will be on the notion of simplicity. (1) Shall we take "simple," as a term of criticism, to be truly "aesthetic"? (2) Can simplicity be considered epistemologically relevant? (3) How systematic do we take mathematicians' and artists' uses of this notion to be? (4) What might it mean, philosophically, to regard mathematical structures, concepts, and objects as aesthetic objects? I approach these questions through discussion of relevant works and remarks by Kant, Wittgenstein, Sheffer, Gödel, Turing, as well as artists Mel Bochner and Fred Sandback.

Rosalie Iemhoff, Utrecht University.
Simple proofs.

Beauty and simplicity play an important role in the design of proof systems. Even to the effect that forms of inference that lack them are usually treated with caution. In proof theory one can distinguish simple from complex proofs in a precise and fundamental way. On the other hand, many elementary questions regarding the form of proofs remain open. This talk will be about simplicity and complexity in proof theory.

Curtis Franks, University of Notre Dame.
The complexity of simplicity.

Simplicity in reasoning served as a focal point in mathematical research from Aristotle until the height of the foundations movement in the early twentieth century. The idea always was that topically pure demonstrations, by unearthing the simple truths on which a fact depends, do more than convince us of its truth: they provide its grounds. Modern mathematics betrays this ideal in several ways. Most obviously, impure proofs are often more explanatory than their counterparts precisely because they reveal hidden connections across topics. More crucially, our judgements of a single proof's simplicity or complexity often change in light of adjustments in the broader mathematical landscape (adjustments that we make in efforts to contextualize and foster an understanding of an initially complex proof). And in both cases, it is most natural to see relatively high level phenomena explaining more basic facts. Mathematical discovery rarely respects our preconceived notions of a problem's topic. What we deem simple thus changes in the course of our efforts to cope with innovation and does not reflect any criterion isolable independent of those very efforts. Reflecting on this, we can begin to appreciate that our judgements of simplicity are often underwritten by highly complex practices and prior understanding. We can trace this reversal of the foundational attitude familiar more generally in contemporary social science and aesthetics to some early remarks of David Hilbert himself. Hilbert asked that we shift our attention from the "objective" fetish of topical purity and towards its "subjective" counterpart.

Andrés Villaveces, National University of Colombia, Bogotá.
Simplicity via complexity via simplicity? Sandboxes for simplicity.

The one-way direction going from complicated proofs to their simplifications has been advocated by many [Rota, etc.] and seems to be addressed with some success in branches of mathematical logic. However, there is an interesting back-and-forth movement between the simple and the complex (and back to the simple) when one considers the question not just from the perspective of proofs but from the perspective of questions and proofs generating more questions and more proofs. Some disciplines have generated what could be called "simplicity sandboxes": special conditions under which a simpler "answer" may be tested (in the absence of a proof) and then transferred (with luck) to situations without the special conditions. In this case, the first "proof" may seem much simpler than later proofs (apparently reversing the one-way direction), but is also only a proof under "rarefied" conditions. I will present a couple of examples of the back-and-forth movement from simple to complex to simple and of the "simplicity sandboxes."

Fig. 2 Panel 2. From *left*, Riikka Stewen, Juliette Kennedy, María Clara Cortés, Kate Shepherd, Grigor Sargsyan, Juliet Floyd, Andrés Villaveces, Dan Walsh, and Hanna Johansson. Photo by Alejandro Martín Maldonado

Juhani Pallasmaa, Juhani Pallasmaa Architects, Helsinki.
The Complexity of Simplicity: the Inner Structure of the Artistic Image.

We think of simplicity and complexity as exclusive opposites. Yet, in artistic works this opposition disappears as the two notions merge. Artistic works are fundamentally about the world and human life. As Merleau-Ponty suggests, "We come to see not the work of art, but the world according to the work." The entire complexity of life becomes thus part of the simplest of artistic works. The viewer's imagination and autonomous search for meaning sets in motion a process of association and interpretation. A profound work is always a never ending rhizome.

PANEL

María Clara Cortés, National University of Colombia, Bogotá; artist and art historian.
Juliet Floyd, Boston University; philosopher.
Hanna Johansson, University of Helsinki; art historian.
Juliette Kennedy, (moderator) co-organizer of conference.
Grigor Sargsyan, Rutgers University; mathematician.
Kate Shepherd, artist.
Riikka Stewen, University of Helsinki; art historian.
Andrés Villaveces, National University of Colombia, Bogotá; mathematician.
Dan Walsh, artist.

• What relationship if any is there between simplicity and the artistic movement *Minimalism*?

- One way that you might hear someone distinguish a mathematician's sketch from an artist's sketch is to say that the former is objective while the latter is subjective. Is this fair? Beyond selecting one's chosen field of study in mathematics, is subjectivity present in mathematics?
- Do mathematicians have a fundamental love/hate relationship with the objects they study?
- Do you have in art that idea that someone sees your art and they understand it or do you have to explain your work even to people close to you?
- Mathematicians suffer the disparity between the elegance of a theorem and the ugliness of its justification or proof. Is there anything like that duality in what artists do?
- How individual or collaborative is an act of mathematics or art?

FILM PROGRAM 2

William Wegman
Spelling Lesson, 1973–1974
Videotape transferred to DVD, with sound
Duration: 49 seconds
Courtesy the artist

Richard Serra
Frame, 1969
16mm black and white film transferred to DVD, with sound
Duration: 14 minutes, 29 seconds
Courtesy the Circulating Film Library of the Museum of Modern Art, New York

Andy Goldsworthy
Two Rain Shadows / Waterfall.
Sante Fe.16 August 2008 / 17 August 2008
Unique HD video diptych, with sound
Duration: 16 minutes, 9 seconds
Courtesy Galerie Lelong, New York

AFTERNOON SESSION

Hugh Woodin, University of California, Berkeley.
Simplicity and the quest for ultimate (mathematical) truth.

Simplicity considerations can and have been used to justify axioms, however this has always occurred after the axioms have been generally accepted for other reasons. Can simplicity considerations actually play a role in the discovery of new axioms, or even be the source of new conjectures? The emerging evidence is that such considerations can play a vital role.

Peter Sarnak, Institute for Advanced Study & Princeton University.
Is there a place for "ugly" mathematics?

One of Hardy's well-known quotes is "...Beauty is the first test: there is no permanent place in the world for ugly mathematics." If by ugly he means complicated and not transparent, I will argue by way of some examples from number theory that at least as far as the proofs go, his claim may be too strong. On the other hand the truths that are being established must surely be simple, if they are to survive the test of time.

Friday April 5

MORNING SESSION 1

Jan Zwicky, University of Victoria.
The Experience of Meaning.

Once the question of truth is settled, and often prior to it, what we value in a mathematical proof or conjecture is what we value in a work of lyric art: potency of meaning. An absence of clutter is a feature of such artifacts: they possess a resonant clarity that allows their meaning to break on our inner eye like light. But this absence of clutter is not tantamount to "being simple": consider Eliot's *Four Quartets* or Mozart's late symphonies. Some truths are complex, and they are simplified at the cost of distortion, at the cost of ceasing to be truths. Nonetheless, it's often possible to express a complex truth in a way that precipitates a powerful experience of meaning. It is that experience we seek—not simplicity *per se*, but the flash of insight, the sense we've seen into the heart of things. I'll first try to say something about what is involved in such recognitions and then something about why an absence of clutter matters to them.

CURRENT/RECENT STUDENT PANEL

Terrence Blackman, Mathematics PhD, Graduate Center, CUNY, 2011; currently Dr. Martin Luther King, Jr. Visiting Assistant Professor of Mathematics, MIT and Assistant Professor of Mathematics, Medgar Evers College, CUNY.

Patrick Delahoy, Architecture M.Arch., Yale University, 2011; currently at Cannon Design in New York.

Spencer Gerhardt, Logic MS, University of Amsterdam; currently Mathematics PhD student, University of Southern California.

Helena Kauppila, Mathematics PhD, Columbia University, 2010; now pursuing a career in the arts.

Rachel Levanger, first year PhD student in Mathematics, Rutgers University; undergraduate degree in Mathematics with a minor in Art History.

Philip Ording (moderator), co-organizer of the conference.

Adriana Renero, fourth year PhD student in Philosophy, Graduate Center, CUNY.

Samuel Stewart-Halevy, Architecture M.Arch., Princeton University, 2012; currently works at Guy Nordenson and Associates in New York.

Fig. 3 Current/recent student panel. From *left*: Adriana Renero, Spencer Gerhardt, Patrick Delahoy, Rachel Levanger, Samuel Stewart-Halevy, Helena Kauppila, and Terrence Blackman. Photo by María Clara Cortés

- What makes a question simple? Are there aesthetics to the questions we ask?
- How does simplicity play a role in art forms that are necessarily collaborative?
- What is the relationship between simplicity and rationality? Simplicity and naiveté?
- How is simplicity connected to abstraction? How is simplicity connected to vagueness?
- What is the intent behind appeals to simplicity? What's at stake?
- To what extent is economy of means a criterion of simplicity?

MORNING SESSION 2

Marja Sakari, Kiasma Museum of Contemporary Art, Helsinki.
The art of being bored.

Susan Sontag said: "Boredom is just the reverse side of fascination: both depend on being outside rather than inside a situation, and one leads to the other." Can this be true? In my paper I will be looking at minimalist artworks that use simplicity to express meaning. I will frame a phenomenological approach to the question how such works touch us as viewers.

Maryanthe Malliaris, University of Chicago.
What simplicity isn't.

We will look at several examples in specific mathematical structures such as graphs, models, and ultrapowers.

Mikhail Gromov, Institut des Hautes Études Scientifiques and NYU.
Ergologic and Interfaces Between Languages.

We want to discuss possible mathematical models for how mathematics is perceived by/generated in a human brain/mind and expressed in a "quasi-natural language."

Fig. 4 Mathematics panel. From *left*: Roman Kossak, Marjorie Senechal, Grigor Sargsyan, Étienne Ghys, Hugh Woodin, Adrés Villaveces, Dusa McDuff, and Rosalie Iemhoff. Photo by María Clara Cortés

The first 15 min of the talk will be dedicated to a brief (highly) critical overview of possibilities/limitations/deficiencies of approaches in the contexts of mathematical/formal logic, experimental psychology, and artificial intelligence. Then I shall indicate an alternative frame and point toward mathematics that may be helpful for solving the problem.

MATHEMATICS PANEL

Étienne Ghys, École Normale Supérieure, Lyon; geometry and dynamical systems.
Rosalie Iemhoff, Utrecht University; proof theory, constructive theories, and the computational content of classical theories.
Roman Kossak (moderator) co-organizer of conference.
Dusa McDuff, Barnard College, Columbia University; symplectic geometry.
Grigor Sargsyan, Rutgers University; set theory.
Marjorie Senechal, Smith College; history of science and technology, discrete geometry, mathematical crystallography.
Andrés Villaveces, National University of Colombia, Bogotá; model theory.
Hugh Woodin, University of California, Berkeley; set theory

- In simple terms, describe your area of specialty in mathematics.
- Hilbert asked for "Criteria of simplicity, or proof of the greatest simplicity of certain proofs. Develop a theory of the method of proof in mathematics in general. Under a given set of conditions there can be but one simplest proof." He wrote that in 1900, well before formal proof theory was established. As formulated in the later Hilbert's Program, his goal was to formalize mathematics axiomatically, establish a complete proof system and then go on to prove

various metamathematical statements, such as mathematics is consistent. What is the role of formalism in your branch of mathematics? How "formal" is it in practice? Could there be informal, but somehow rigorous, measures of simplicity in your discipline?

- How about simplicity of concepts? The epsilon-delta definition of limit has been removed from some calculus texts, as the concept was declared too complex for certain levels of instruction. In 1950s Andrzej Mostowski proved a beautiful theorem which essentially implies that the concept of limit cannot be defined with fewer than three alternating quantifiers. It is indeed complex. This sheds some light on the question of simplicity/complexity of concepts. Are there examples in your area, where intuitively clear concepts require complex logical definitions? If there are, is this evidence that the concepts are complex or perhaps that the formal language we use to describe them is not quite adequate?
- Is it really so that original proofs of important (all?) results are rather messy, and as they are clarified and improved, one comes close to the ideal "simplest" proof? If true, why is it so? If one is looking for a proof, why is it harder to find a simple one?

FILM PROGRAM 3

William Wegman
Dog Duet, 1975–1976
Videotape transferred to DVD, with sound
Duration: 2 minutes, 38 seconds
Courtesy the artist

Andy Warhol
Empire, 1964
16 mm black and white film, silent
Duration: 46 minute excerpt of 8 hours, 5 minutes
Courtesy the Circulating Film Library of the Museum of Modern Art, New York

AFTERNOON SESSION

Andrew Arana, University of Illinois at Urbana-Champaign.
Simplicity and the interface of algebra and geometry.

In the seventeenth century, there was a striking broadening of geometrical methods to include algebraic methods. Descartes, who was chiefly responsible for this broadening, claimed that the new curves admitted by his geometry were just as simple as those studied by the ancients and thus were equally legitimate for geometrical study. I will firstly consider in what ways simplicity was a criterion of geometricity for ancient and Cartesian geometry. I will then explain how algebraic methods posed a challenge to this way of delineating geometry, and how Descartes resolved this challenge. If time permits, I will also consider the repercussions of this limitation for contemporary geometry.

Dennis Sullivan, Graduate Center, CUNY and SUNY at Stony Brook.

Simplicity Is the Point.

There is a famous theory due to René Thom in France and Lev Pontryagin in Russia that can be seen to directly evolve from one simple geometric picture. The feeling one has as a beginning topologist on realizing this is: "Now I know what it means to really understand a part of mathematics." Mathematicians often feel a mathematical story is not over until one sees the entire structure evolving painlessly from a quite small number of simple starting points. Four consequences: (1) One can research any fertile field of mathematics not so rendered to try to find its simplicity sources. One usually begins by thinking "What is really going on here?" (2) Sometimes some rather sophisticated heights are constructed from which the structure of the desired mathematical landscape is simply revealed. (3) The relative simplicity just described becomes pure simplicity when the sophisticated heights are gently lowered into the foundations by becoming part of any early study of the subject. (4) At this point one may be able to satisfy Hilbert's criterion: "Someone only really understands a mathematical subject if they can tell it to the person on the street." The talk will offer a few more comments/examples.

Art Installation

PROSHANSKY LOBBY

Kate Shepherd
String Drawings, 2013
Courtesy Galerie Lelong, New York

Acknowledgements

"Simplicity: Ideals of Practice in Mathematics & the Arts" was made possible by the generous support of the following sponsors:

Clay Mathematics Institute
Finnish Cultural Foundation
FRAME Foundation
The Graduate Center, City University of New York:
 - Advanced Research Collaborative
 - Committee for Interdisciplinary Science Studies
 - Comparative Literature Program
 - Mathematics Program
Medgar Evers College, City University of New York
 - School of Science, Health & Technology
 Umesh and Shailaja Nagarkatte Faculty Fund
The National Science Foundation

The organizers wish to thank Galerie Lelong, David Zwirner, The Circulating Film Library of the Museum of Modern Art, William Wegman, Brian O'Connell, and Kate Shepherd for help with the arts programming. We are grateful to Adrienne Klein and Science & the Arts, Graduate Center, CUNY for organizational support. Thanks to Eva Antonakos and Karen Kletter for help with registration, food planning, and reservations. Thanks to Alf Dolich for help with the leaflet, Joseph Quinn and Athar Abdul-Quader for help with registration. Special thanks to David Reinfurt for the conference poster design and help with the conference website.

David Hilbert, undated
Photographer unknown
Courtesy Konrad Jacobs and the archives of the Mathematisches Forschungsinstitut
Oberwolfach

Index

© Springer International Publishing AG 2017 301
R. Kossak, P. Ording (eds.), *Simplicity: Ideals of Practice in Mathematics and the Arts*,
Mathematics, Culture, and the Arts, DOI 10.1007/978-3-319-53385-8

Printed in the United States
By Bookmasters